DELACROIX: A LIFE

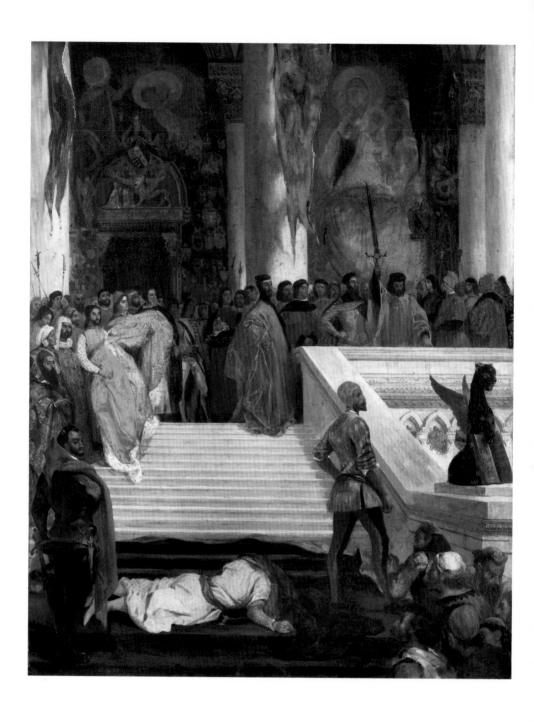

The Execution of the Doge Marino Faliero

Timothy Wilson-Smith

Delacroix

A LIFE

CONSTABLE · LONDON

First published in Great Britain 1992
by Constable and Company Limited
3 The Lanchesters, 162 Fulham Palace Road
London W6 9ER
Copyright © Timothy Wilson-Smith 1992
ISBN 0 09 471270 0
The right of Timothy Wilson-Smith to be
identified as the author of this work
has been asserted by him in accordance
with the Copyright, Designs and Patents Act 1988
Set in 11/13 Apollo by Servis Filmsetting Limited, Manchester
Printed in Great Britain
by St Edmundsbury Press Limited
Bury St Edmunds, Suffolk

A CIP catalogue record for this book
is available from the British Library

FOR PAM

Contents

Illustrations

The Execution of the Doge Marino Faliero (*Trustees of the Wallace Collection*)
Frontispiece

between pages 64 and 65

Homage to Delacroix, by Henri Fantin-Latour (*Musée d'Orsay*)
Delacroix's birthplace at Charenton (photograph by the author)
Valmont Abbey (photograph by the author)
Rear view of the Maison de gardes, Forêt de Boixe (photograph by J. Macdonald)
The barque of Dante (*Musée du Louvre*)
The Massacres of Scio (Chios) (*Musée du Louvre*)
Preparatory Studies for The death of Sardanapalus (Musée du Louvre)
The death of Sardanapalus (*Musée du Louvre*)
The murder of the bishop of Liège (*Musée du Louvre*)

between pages 128 and 129

Baron Schwiter (*National Gallery, London*)
Liberty leading the people (*Musée du Louvre*)
Self-portrait in travelling costume (*Musée du Louvre*)
Moûni Bensoltane and Moûni and Zohra Bensoltane (preliminary studies for Women of Algiers) (*Musée du Louvre*)
The Jewish Marriage (*Musée des Louvre*)
The Sultan of Morocco (*Musées des Augustins*)

Léon Riesener (Musée du Louvre)
Jenny Le Guillou (*Musée du Louvre*)

between pages 192 and 193

Joséphine, baronne de Forget, by David d'Angers (*Cliché Musées d'Angers*)
The château d'Augerville (*private collection*)
Bacchus and the leopard (photograph by D.C. Wilson-Smith)
The education of Achilles (*Musée du Louvre*)
Chopin (*Musée du Louvre*)
George Sand (*The Ordrupgaard Collection, Copenhagen*)
Jacob and the angel (*Church of Saint-Sulpice, Paris*)
Delacroix's house at Champrosay (photograph by the author)
The studio at place Furstenberg (photograph by the author)
Delacroix en académicien, 1858, drawing by Heim (*Musée du Louvre*)
Delacroix's tomb in the cemetery of Père Lachaise (photograph by the
 author)

The illustrations from the Louvre and the Musée d'Orsay are reproduced by
courtesy of the service photographique de la Réunion des Musées
Nationaux.

Preface

When I began to research into the life of Eugène Delacroix, I did not realise quite how daunting the task would be. About 1700 of his letters have been published. His Journal with its connected notes, in the most recent one-volume edition, runs to over 850 pages and has a cast of over a thousand people. In the Louvre alone there are over two thousand items in the museum catalogue of his drawings; and it has taken Professor Lee Johnson six volumes to provide a *catalogue raisonné* of the paintings. There is only one biography that is of a scale adequate for its subject, the three-volume life by Raymond Escholier; and Escholier had the unique advantage of having a family link with Delacroix's second cousin, who could recall having visited Delacroix when she was a child.

Delacroix's life, which falls roughly between the rise of the first Napoleonic régime and the fall of the second, touches on the political, literary and musical history of the age. He was so far from being a mere painter that some contemporaries thought of him principally as an agreeable man about town who dabbled, with unfortunate results, in the art of painting. Nowadays his work is again unfashionable; and only a few determined scholars are likely to have some inkling of his charm. If some of my readers come to understand why Eugène Delacroix has had such devoted admirers and friends, then my study will have served its function.

I am grateful to the people who have made the writing of this book possible. When at school I was fortunate to be taught by two inspired teachers of French, one of whom, Raymond Venables, discovered for me Delacroix's *Lettres Intimes* in a seaside bookshop in England. The other, the late Len Walton, an eminent scholar among schoolmasters, introduced me to French writing on aesthetics and so, indirectly, to Baudelaire's favourite painter. My oldest friend's mother, Gerta Calmann, recommended to me Philippe Jullian's life of Delacroix; and I am grateful to her and Marianne Calmann for their encouragement and advice.

Helen Garton, Patience Marshall and John Clayton have kindly read several versions of the typescript and made helpful suggestions. In 1990 my mother-in-law, Madame Odette Starrett, drew my attention to the publication of René Huyghe's latest book on Delacroix.

I have been lucky to have enjoyed the hospitality of Monsieur and Madame Boris Méra at one of Delacroix's favourite family homes and I owe to Madame Méra my copy of Maurice Sérullaz's biography and my knowledge of the Argonne branches of Delacroix's family tree. With help from the Eton College How and Busk Funds I have been able to go to Paris and to travel in Andalucia and Morocco. In Paris I have appreciated staying at the Séminaire de Saint-Sulpice, for whose grand church Delacroix painted his religious masterpieces. On two occasions, but especially in 1991, I have found a ready welcome at the Palais du Luxembourg and the Palais Bourbon. The Senate librarian showed me round not only the main library which is centred on Delacroix's dome but also the private apartments where Delacroix's pastiche portrait of the Maréchal de Tourville now hangs and the library which was a picture gallery in the early nineteenth century. At the Palais Bourbon Madame Rodenbach kindly arranged for me to be taken round by the palace architect, so that I could learn how Delacroix's murals in the Salon du Roi are being restored. The staff of the Louvre took me to see paintings by Delacroix which are not on public display, including his finest portrait of his cousin Léon Riesener; and I have special reason to be grateful to the staff of the Cabinet des Dessins for patiently producing for me so many of Delacroix's most beautiful watercolours and drawings.

I have enjoyed walking round Delacroix's haunts in Paris, from the recently redecorated house where he was born to the apartment in the place Furstenberg where he died; and like him I have taken the train to the little station opposite Champrosay and walked in the forest of Sénart.

Outside Paris I also have fond memories of the little village of Orcemont, whose mairie laid on a visit to *their* Delacroix. Monsieur Tokushige of the S.C.I. Château d'Augerville made it possible for me to see what is being done to revive the country house of Delacroix's cousin Berryer; and, at Augerville, Monsieur Barthelemy devoted an afternoon to answering all the questions I could think of, having first directed me to an excellent restaurant for lunch.

Most of the literary research for this book has been carried on through the good offices of the British Library, London University library, Cambridge University library, Royal Holloway and Bedford New College library and Eton College school library. I have tried to ensure that virtually all translations from French are my own and I hope that where this is not the case I have made the appropriate acknowledgements. I owe much to the professional translators mentioned in my bibliography. I have quoted from one English letter of

Delacroix's, which has recently become available in full in Professor Lee Johnson's edition. The translation from Goethe's conversations with Eckermann comes from the old Everyman edition of Lewes' famous life of Goethe.

Anyone trying to have a first book published is glad to be backed by a publisher; and I wish to thank Ben Glazebrook for showing confidence in me, not least by being such a good host. Thanks to the criticisms of Elfreda Powell, I believe that this book is better than in its first draft; and Richard Tomkins and others at Constable's have worked hard to make it more enjoyable to read.

My principal debt is to those who have had to live with Delacroix for many years, namely my daughters Pascale, Noëlle and Dominique and above all my wife Pam, who has corrected my French correspondence and to whom, as one whose painting technique derives ultimately from Delacroix, this book is affectionately dedicated.

Timothy Wilson-Smith
Eton, England

Chronology

	PUBLIC EVENTS	PRIVATE EVENTS
1795–99	*The Directory*	
1795–97	Charles Delacroix foreign minister	
1798	Napoleon in Egypt	Birth of Ferdinand-Victor-Eugène Delacroix
1799	*Coup d'état of Brumaire* sets up *The Consulate* (Napoleon First Consul)	
1804–14, 1815	*Napoleon I Emperor*	
1805		Death of Charles Delacroix (then *Préfet* of the Gironde)
1806–15		Delacroix at Lycée Impérial
1813		First stay at Valmont in Normandy with Bataille cousin
1814		Death of Victoire Delacroix (Eugène's mother)
1814	First abdication of Napoleon, first Restoration of the Bourbons	

	PUBLIC EVENTS	PRIVATE EVENTS
1815	Napoleon's 'Hundred Days' followed by second abdication and second Restoration of the Bourbons	Delacroix enters studio of Guérin
1814–15, 1815–24	*Louis XVIII King*	
1816		Delacroix enters Ecole des Beaux-Arts
1822		Delacroix's first painting in Salon, start of first Journal Death of his brother-in-law, Raymond de Verninac, ruin of Delacroix family
1824–30	*Charles X King*	
1824	Death of Byron at Missolonghi	Death of Géricault *Scenes from the Chios Massacres*, end of first Journal
1825		Delacroix in England
1826	Exhibition for Greeks	
1827	Battle of Navarino (naval victory for Greek cause)	Death of sister Henriette de Verninac
1827–28		*Death of Sardanapalus*
1830	*July Revolution*	
1830–31		*Liberty leading the people*
1830–48	*Louis-Philippe King*	
1832		Delacroix in Morocco
1833	Thiers Minister of Public Works	
1833–36		Delacroix's commission for Salon du Roi, Palais Bourbon
1834		Death of nephew, Charles de Verninac

	PUBLIC EVENTS	PRIVATE EVENTS
1837		First unsuccessful candidature for the Institut
1837–47		Commission for Library of Palais Bourbon
1840–46		Commission for Library of Palais du Luxembourg
1842, 1843, 1846		Holidays at Nohant with George Sand and Chopin
1844		First stay at Champrosay (south of Paris)
1845		Death of Charles Delacroix, his brother
1847–63		Second Journal
1848	*Second Republic* (Louis-Napoleon President)	
1849		Death of Chopin
1849–61		Commission for chapel of Holy Angels, Saint-Sulpice
1850–51		Commission for Galerie d'Apollon, The Louvre
1851	*Coup d'état* (Louis-Napoleon life President)	Delacroix City Councillor
1852–70	*Second Empire* (*Napoleon III*)	
1855	Paris Exhibition (visit of Queen Victoria)	Delacroix member of Commission (grand medal of Honour)
1857		Elected to Institut During illness works at Dictionary of the Fine Arts (in Journal)
1863	Salon des Refusés (Manet notorious)	Death of Delacroix

Prelude

funeral ceremony took place on 17 August 1863 at the church of Saint Germain-des-Prés. Afterwards, at the burial service near the top of the hill in the vast, gaunt cemetery of Père Lachaise, the sculptor François Jouffroy – in the name of the Académie des Beaux-Arts – briefly recalled some of Delacroix's more famous paintings before going on to praise his respectful deference to 'the painter of *The Apotheosis of Homer*', whom mourners would readily have recognised as Ingres – Delacroix's arch-rival. A more tactful encomium was delivered by the dead man's friend, the landscapist Paul Huet, who predicted that Delacroix would be 'one of the glories of our France'. Few people stood and listened at the graveside. Thus did the world bid farewell to the greatest painter of the Romantic movement: Ferdinand-Victor-Eugène Delacroix.

The small number of mourners was remarked upon with astonishment by three of his admirers, the poet-critic Charles Baudelaire and his young painter friends, Edouard Manet and Henri Fantin-Latour. As they walked away in low spirits, they noticed how the undertaker's men bundled up like so many old clothes the academic robes which the family had neglected to remove. It was the final irony in the story of a man who had for so long yearned to be a member of the Académie, so that he could influence the artists of the future. The mantle of Elijah had fallen to the ground and there was no Elisha to pick it up.

Fantin-Latour was so angry at the insult to the memory of a master that he conceived the idea of painting a picture in which the Realists would demonstrate their veneration for their Romantic predecessor. Baudelaire wished that there should be some indication of Delacroix's debt to his favourite authors, like Shakespeare, Goethe and Byron, but Fantin-Latour would allow no such appeal to the imagination. His own debt was to the newly fashionable Frans Hals, the seventeenth-century Dutchman, and to modern photographic artists

like Gustave Courbet; and he planned to paint just what he could see. Among a group before a portrait of Delacroix he placed the dapper figure of the American James Whistler and himself in neat working clothes, and Manet and Baudelaire. Of the seven artists not one was a pupil of Delacroix and of the three critics only Baudelaire had staked his reputation on the painter. The painting could have been called simply *My circle*. Instead it was given the portentous title of *Homage to Delacroix* and with that title it was exhibited at the Paris Salon of 1864.

The painting announces the start of that cult of Delacroix which would develop among artists of the school of Paris. Delacroix came to appeal in the late nineteenth century to painters of all kinds: to Manet and Fantin-Latour; to Pissarro, Monet and Renoir; to Cézanne, van Gogh and Signac; to Moreau, Redon and Gauguin; and in the twentieth century to the two greatest Modernists, Matisse and Picasso. He became a hero of the whole *avant-garde*, a painter's painter.

Even in his lifetime Delacroix was revered by youthful painters. Edgar Degas recalled watching Delacroix in rue Mazarine near the Ecole des Beaux-Arts. 'He had his collar turned up and a scarf around his neck. He was walking so quickly. I can see him stepping off the pavement, rapidly crossing the street, and stepping up on to the other pavement, still going fast. Whenever I go past that spot, which is often . . . I always recall Delacroix in a great hurry.'[1] Odilon Redon remembered his first sight of Delacroix, the artist who had kindled in him the flame of his art.

When I first saw Delacroix in 1859, he was as handsome as a tiger, with the same pride, delicacy and strength.

It was at an official ball of the Prefecture that I was told he could be found. My brother Ernest came with me and did not know him any more than I did, but by instinct he picked out a small, aristocratic person, who stood upright and alone, in front of a group of ladies in the dance hall. He had black flowing locks, sloping shoulders and bent forward. We approached him with circumspection and the master, for it really was him, turned on us that twinkling look of his, which seemed to outshine the chandeliers. He was very distinguished. High up on his right lapel he had the grand cross of the Legion of Honour and sometimes he lowered his eyes in its direction. He was stopped by Auber, who introduced to him a young Bonaparte princess, 'anxious', said Auber, 'to meet a great artist'. He shuddered and bowed with a graceful smile, 'look, he is not a fat one.'

He was of medium height, thin and highly strung. We spied on him all

evening in the middle of the crowd and till we left at the same time as he did. We followed him. He crossed Paris alone, his head bent, moving like a cat on the best pavements. A notice saying 'pictures' drew his attention; he went up to it, read it, went on, apparently in a dream, wrapped in some inner thought. He crossed the town till he reached the door of an apartment in rue La Rochefoucauld which he lived in no longer. Perhaps that was mere habit. He moved quietly on, still self-absorbed, till he came to the small rue Furstenberg, the silent street he then lived in.[2]

Redon goes on to mention how anxious he was to see Delacroix's apartment, and the little garden where he rested, to feel his benign presence there. He had also visited Delacroix's friendly cousin Riesener, at whose house he saw some Delacroix relics, which he touched and looked on as though he was in Delacroix's own home. It is no wonder that Cézanne wrote of Redon's 'feeling for and admiration of Delacroix', which was a passion he shared.[3]

The next generation of artists had never known Delacroix, so they constructed a Delacroix in their own image. Gauguin wrote, 'I like to imagine Delacroix come into the world thirty years later and undertaking the struggle I have dared to undertake. With his fortune and above all his genius, what a Renaissance would have taken place today.'[4] Gauguin admired Delacroix because he had 'the temperament of the wild beasts'.[5] Delacroix, however, had always known the difference between art and life; for him there would be no Tahiti; and after studying the wild beasts in their cages, he went out to the theatre with a friend or to dinner with a mistress.

Over Gauguin's art, as over the art of so many others, brooded the presence of Delacroix, protean and tantalising, accessible and remote at the same time, almost modern and yet the last of the Old Masters, beckoning back to a time when art had been public, dramatic and grand, like the art of the ancient Greeks.

Before younger artists made him their hero, Delacroix had had his admirers among those who commissioned his paintings, collected them and analysed their merits. Most of his murals had been done for the State, many of his canvases had been bought by the State and his talents as man of taste and man of the world had been recognised by the State. If the artistic establishment, as represented by the Institute, was slow to acknowledge his worth, the 'amateurs' – Adolphe Moreau or Alfred Bruyas or Victor Chocquet – were intensely proud of their Delacroixs. His funeral may have been ill attended. The sale of his artistic legacy – drawings, sketches, watercolours, engravings, lithographs and paintings – realised an enormous sum, over 350,000 francs.

Delacroix's art, it must be admitted, presents problems for the modern conoisseur. His subject matter is too often taken from books that are no longer read, his gestures seem stylised and because of technical faults many of his pictures have deteriorated. Delacroix himself, like the Delacroix industry, has made him inaccessible, like the grim, grey, granite and unadorned tomb in which he is buried. And yet he was a man who was deeply affectionate, courageous, attentive, observant, supremely imaginative, dedicated, sophisticated without being affected, patriotic without being chauvinistic, capable of feeling and inspiring fierce loyalty, magnetic, fascinating, intense and charming. Delacroix, as Monet, Baudelaire and Fantin-Latour thought in 1863, deserves the homage of recognition.

Birth and background (1798)

NOTHING in Delacroix's life has tempted the purveyors of gossip so much as the story of his conception. 'There is an old woman going round, who says that Delacroix [père], Minister of Foreign Affairs during the Revolution, begged Talleyrand to get his wife a genius as a child, that Talleyrand consented and that it was as a result of that request and gracious concession that Eugène Delacroix the painter was born.'[1]

The idea that Eugène Delacroix was not the son of his father must have been current long before the Goncourt brothers confided to their diary in 1876 the oft-repeated insinuation that his true father was Talleyrand. Less than a fortnight before he was born, a strange announcement appeared in the official newspaper, *Le Moniteur*. On the twenty-fourth day of Germinal in the Year Six of the Revolutionary Calendar it was stated that on the twenty-seventh day of Fructidor (14 September 1797) an operation for a *sarcocèle* had been performed on Charles Delacroix. The operation had been completely successful. On the seventh day of Floréal (26 April 1798) its success was confirmed by the birth of Ferdinand-Victor-Eugène Delacroix.

There is a further twist to the plot. A little more than twenty-five years ago a document was rediscovered, which dates from 12 November 1797, in which Charles Delacroix and his wife signed a description of how an enormous growth on one of his testicles, which had made him impotent for many years, had been removed and of how normal sexual relations between the pair had been resumed. In the cause of science the tumour was preserved in a jar. In the cause of art Madame Delacroix must already have been pregnant for two and a half months. What is hard to know is by whom.

The most 'popular' begetter, even in Delacroix's own lifetime (for the rumour was familiar in the circle of his cousin Berryer), has been said to be Talleyrand. Talleyrand, aristocratic by birth, a bishop by vocation, a womaniser by

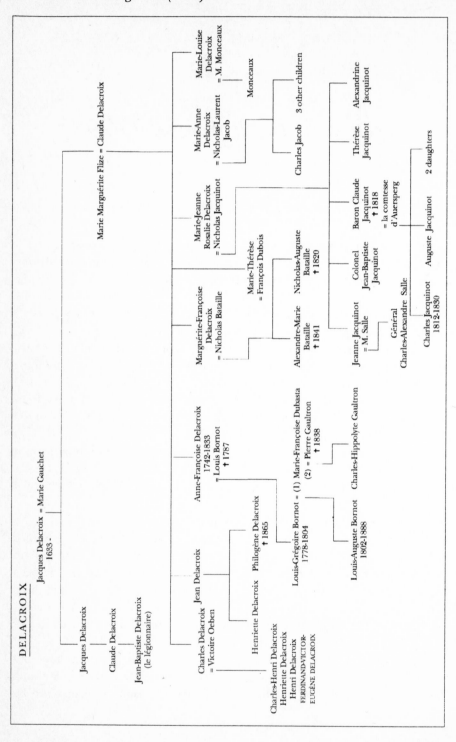

preference and a diplomat by occupation, had succeeded Charles Delacroix as Foreign Minister and promptly despatched him to be Minister to the Dutch or Batavian Republic, so that Delacroix senior was away when the notice in *Le Moniteur* was published and when Delacroix junior was born. Nothing, it would seem, became him in his life so much as his absence from Paris that spring. But if that was so, why did he correspond in tender terms with his wife? No hint of scandal was ever mentioned by Eugène Delacroix, who idealised both his parents and knew his father's medical history. His diary on 12 September 1822 mentions how the operation to remove the *sarcocèle* had been performed in five sessions. After the fourth Charles Delacroix had turned to the surgical team – no anaesthetics would have been used – and said: 'That's four acts . . . Let's hope the fifth will not end in tragedy.' Eugène called his father 'noble' and 'admirable'.[2] He was proud of his father and he kept the report on this singular proof of his father's courage in his library.

Physically, Eugène did not look like his brothers and sister. They were large and bovine, with chubby cheeks and flat noses. He was slight and delicate, with deep-set eyes, a firm chin and an upturned nose. His whole bearing was distant, polite and dignified. If his father was a *parvenu* and his elder brother gross, he seemed a natural aristocrat. Attempts have been made to argue that his profile looked like that of Talleyrand. Attempts have been made too to show that the hand of Talleyrand is evident in his early career. Delacroix was first commended by Baron Gérard, who painted Talleyrand and entertained in his Salon both eminent statesmen like Talleyrand and young painters like Delacroix. Delacroix was first praised in print by a young journalist, Adolphe Thiers, who was trying to catch Talleyrand's eye; and when there was in 1830 a revolution, encouraged by Talleyrand and controlled by Thiers, no painter benefited so much from the new régime as Delacroix. At no time, however, did Talleyrand, who was proud of his conquests, acknowledge Delacroix as one of his children. As he did not die till forty years after Delacroix's birth, he must have been marvellously discreet.

There is another possible father. Ferdinand Guillemardet, one-time ambassador at the court of His Catholic Majesty of Spain, witnessed both the operation and the birth. He was of the same bourgeois class as the Delacroix family, with similar aspirations. If Eugène's sister Henriette had just been painted by the greatest living French painter, Louis David, he was painted by the greatest living Spanish painter, Francisco Goya. He was a friend of the family. Eugène was friendly with his sons Félix and Louis from childhood. He might have been pleased to have them as his brothers. One of the greatest of Delacroix scholars believed that in Guillemardet lay the solution to the problem of Delacroix's birth, but he died before he could produce convincing evidence.

The puzzle has never been satisfactorily worked out, but what is clear are the

facts concerned with his birth. He was born to Victoire (née Oeben), wife of Charles Delacroix, minister to the Netherlands, in a dull, substantial eighteenth-century house, which still exists, in the main street of the Parisian suburb of Charenton Saint-Maurice. It was not a bad beginning to a distinguished life.

The Delacroix family can be traced back at least as far as the early seventeenth century, when Nicolas Delacroix lived in Givry-en-Argonne in the province of Champagne. In the seventeenth and eighteenth centuries there were various Delacroix in the service of the comte de Belval. One of them, Claude Delacroix (1718–1770), married Marguérite Flize and had twelve children, eight of whom reached adulthood. The oldest son, Charles (1741–1805), was a lawyer but he became secretary to Turgot, the brightest provincial administrator in France, and followed his mentor from Limoges to Paris in the mid-1770s. There 'his waiting room was filled with eminent people, grand ladies and those of every rank who came to ask for favours'.[3] He retired as *premier commis à la Marine et au Contrôle Général*, that is principal first secretary in the ministries of the navy and finance, in 1779. If he had shown some radical leanings, they emerged markedly in old age, when the Revolution brought him back into public life, first in the naval department, then in 1792 as a representative for the Marne, his native area, in the revolutionary parliament, the Convention. It was in the Convention that he voted in 1793 for the execution of 'Louis Capet', but he was not a supporter of Robespierre and he survived his fall in 1794. When in 1795 a Directory of five men was set up to rule France, he was regarded as safe enough to be made foreign minister. He was demoted in 1797, only to be sent off by Talleyrand to the Netherlands, where he was busy organising a *coup d'état* while his wife was expecting her baby. Delacroix knew a story of his father's bravery when at one moment he was threatened at dinner by rioters incited by the French government. He had dressed the drunkards down with no trace of fear; and when the French general in league with them had offered to arrange an escort for him, Charles Delacroix had replied that he refused to be escorted by traitors. Eugène probably did not know that others had less charitable views of his father's character, which he regarded as honest, but some took to be petulant, vain and capricious.

In its way the lineage of his wife was more distinguished than Charles Delacroix's, if not in social status, for he was an upwardly mobile bourgeois, then in the gifts which mattered most to her most famous child, for she came from an aristocracy of craftsmen. Descended on her mother's side from a Flemish cabinet-maker called Van der Cruse, whose name had been gallicised as Lacroix, she was the daughter and stepdaughter of two *ébénistes du Roi*. Her father, Jean

François Oeben (*c.* 1720–1763) had come from Lower Franconia to work under the youngest surviving son of the great Boulle, whose family over an eighty-year period had provided exquisitely inlaid furniture for Louis XIV and Louis XV; and it was to the Boulles, with a little help from the royal mistress Madame de Pompadour, that Oeben succeeded. On his death his widow chose another German, Jean Henri Riesener, to take over the business and be her second husband. Victoire Oeben (1758–1814), the painter's mother, might have been expected to marry into a family skilled with their hands. Instead her pretty face and easy charm attracted the stolid civil servant Charles Delacroix. While first the financial problems of the Crown and then the Revolution put a sad end to her stepfather's working life long before his death in 1806, she moved to a position of some importance. Her half-brother, Henri François Riesener, would redeem the Riesener fortune later on by spending time painting at the Russian court. In 1798 when Eugène was born she had the more agreeable lifestyle. She already had three children: Charles, born in 1779 and serving as a soldier; Henriette, born in 1780 and recently married to Raymond de Verninac, a diplomat; and Henri, born in 1784 and still a schoolboy. David had produced one of his finest portraits when painting Henriette in the fashionable Greek style, probably in the year of her marriage. Their uncle Riesener had painted the boys with sympathy and skill. By the time that Eugène was born, the Delacroix family had arrived.

The story that Delacroix heard from his elder brother Charles about their father's operation in 1797 is a reminder of the great gulf that age had placed between the brothers. As for the tales, which came from cousin Berryer's memories of what his father had told him, of their father's life under Louis XVI just before Charles himself had been born – they are a reminder of the even greater gulf which the Revolution had fixed between the generations of the two brothers. Between 1779 and 1798 France had changed more than in any previous twenty-one years in its entire history. In 1779 France was still an absolute monarchy: in 1798 it was an oligarchical republic.

In 1779 children were normally baptised at birth, adults normally married in church, received the last rites from a priest and were buried in Christian ground. No other religion but the Catholic faith was tolerated. The Church taught people and nursed them when they were sick or poor. The Church had vast properties, concentrated largely in the hands of abbots and bishops. All the clergy enjoyed privileged status. The nobility had their privileges too: exemption from taxation, the right to wear a sword, even the right to be executed in a distinctive way. The greater noble families had even grander estates than the bishops, but

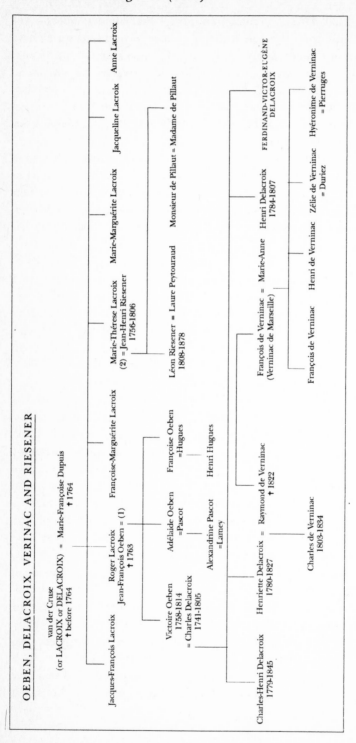

OEBEN, DELACROIX, VERINAC AND RIESENER

the distinction was misleading because virtually every bishop, like Talleyrand, was a member of a noble house, brother to a duc or a comte. France seemed to be still a medieval country. It had many conflicting systems of taxation – most of them unfair – and many systems of law – some of them contradictory – and many systems of administration – several of them confusing. For eight centuries France had been ruled by Most Christian kings who had descended in the male line from Hugh Capet; for centuries they had been crowned and anointed in the cathedral of Reims and they were possessed of healing powers. France's emblem was the fleur-de-lis. Its capital was Paris, but for one hundred years all roads of power had passed beyond Paris to Versailles, centre of government, court and culture.

After the Revolution Paris regained its dominant position in national life once again, but the national emblem was the tricolour, France had no king, the Catholic church was proscribed, all ranks and privileges had been abolished, everyone was a citizen; and taxes, the law and the bureaucracy had been rationalised. Charles Delacroix senior was a regicide, who had worked to dechristianise his department – not province – of France; and the birth of his youngest son Eugène Delacroix occurred on a day within a *décadi*, not a week: the infant was weighed in kilograms and measured in metres, for everything in France was now to be reckoned in multiples of ten. By 1798 the worse excesses of the Revolution were over, but many royalists and Catholics were in exile and France was a divided nation. A great transfer of property had taken place from aristocrats and churchmen often to peasant smallholders and more frequently to wealthy bourgeois. In the new France where all men were equal, the Delacroix family had become much more equal than most.

Eugène Delacroix was born into a large extended family. His father was the eldest of eight children, so that Eugène had numerous Delacroix uncles and cousins who like his father were civil servants, or soldiers as his brothers would grow up to be. There were Jacquinots, Jacobs and Monceaux. Eugène had a certain fondness in later life for his soldier cousin Philogène, who would come to visit him in Paris and whom he visited in the Delacroix stronghold in the Argonne. Two other cousins he enjoyed visiting were Alexandre-Marie Bataille, owner of the beautiful former abbey of Valmont, and Louis-Auguste Bornot, to whom the abbey was left.

On his mother's side there were worthy bourgeois: he was devoted to his older cousin, Henri Hugues, who worked for the post, and, in old age, to his cousin by marriage, Lamey, who was a judge. Closest to him among all the cousins was Léon Riesener, himself a painter of some ability and son of the painter who had gone to Russia and grandson of Eugène's stepgrandfather, the famous *ébéniste*. The Rieseners could understand the aesthetic ambitions of a

grandson of the great Oeben, who like them had moved from craft to art; and besides, after his mother's death, 'tante Riesener' became his favourite aunt. To his other relations he was a charming companion, invariably elegant and polite. Only to them was he a man of genius.

Family feeling extended not only to step-relations, but also to in-laws and more distant cousins. He could not avoid the Verninacs, the family of his sister's husband, because his sister Henriette came to occupy the role of a substitute mother when he was a young man; and no relation was as close to young Eugène as his nephew Charles, barely five years his junior. In Paris it was he who supervised Charles's schooling. It was he who tried to restrain Charles's extravagance, which caused Charles to sell off David's great portrait of Henriette (it was later redeemed). It was he who suffered most when Charles died, but that death did not sever his links with the Verninacs, and their château of Croze.

On the Delacroix side he discovered more remote cousins when he became an adult. He was already himself a famous man when he became friendly with his most celebrated relation, the royalist orator and lawyer, Antoine Berryer. Even though, as a sceptic, he might have been expected to annoy a devout Catholic, he had enough tact to be a welcome guest at Berryer's château of Augerville, which lies just off the road between Paris and Orléans. There the two of them could deplore the vulgar greed of the new aspirants to upper-class status. He could claim affinity also with a count, the comte de Lavalette, who had been Napoleon's postmaster, put on trial after the second fall of the Empire and sentenced to death. He escaped through the intervention of his wife, Emilie de Beauharnais, cousin to Napoleon's first empress, Joséphine, and of his daughter, also called Joséphine, later to be Eugène's mistress.

Eugène's cousin, Baron Nicolas-Auguste Bataille, and his brother, Baron Charles Delacroix, were both one-time aides-de-camp to Eugène de Beauharnais, stepson of Napoleon I and uncle of Napoleon III. By birth and by connection Eugène Delacroix was linked to that meritocracy which the great Napoleon encouraged and his own career was opened up before him by his talent. He was at home in the châteaux of Valmont, Croze and Augerville. He enjoyed a Napoleonic childhood and a Napoleonic old age.

In 1798 the baby Eugène had yet to discover the wider circle of his family. At its intimate centre was his mother, still pretty and vivacious if approaching middle age. His father was elderly and distinguished, his sister an arrogant young wife, his brother Charles a young soldier and his brother Henri a youthful teenager whom he would admire and love. He seemed born to be fortunate. In an uncertain world he was secure.

— 2 —

A Napoleonic childhood
(1799–1815)

TALLEYRAND had a way of fixing things. In 1797 he thought he ought to deal with embarrassing results in the elections, when royalist sympathisers had gained a majority in the assembly, so he organised a quiet *coup d'état*. It had the approval of the young general Napoleon Bonaparte, with whom Talleyrand had been carefully corresponding for some months. When Bonaparte came home from his campaign in Italy at once the two men took to one another. Talleyrand noticed how 'a score of victories go well with youth, with fine eyes, with paleness, and with an appearance of exhaustion'.[1] Soon the two would plan further exploits for Bonaparte. He was to go east, take Egypt, overrun the Turkish empire in the Levant and finally meet Talleyrand again, who by then would be ambassador there, in Constantinople.

Within a month of Eugène Delacroix's birth Napoleon would leave for Malta, Egypt, Syria and Turkey. Talleyrand, in the event, would never leave Paris and Bonaparte would return, quite suddenly, from the east in late 1799. The enemies of France threatened within and without. It was time for another coup, which Talleyrand would mastermind and Bonaparte would enforce. In the foggy month of Brumaire the Directory itself, set up to govern France in 1795, was swept away, and a new constitution was drawn up, which made Bonaparte the first of three consuls. Soon only the First Consul mattered and within a few years he tired of nominal republicanism. In the summer of 1804 a vote made Consul Bonaparte the Emperor Napoleon I. There was no need for any more coups. Henceforth, for the best part of the next ten years, it would be Napoleon who would fix everything.

For the Delacroix family the Napoleonic epoch provided many opportunities and established the condition of their style of living. As First Consul Napoleon reorganised the administration of France and its educational system. As Emperor he opened a career to administrative and above all military talent and he rewarded success with new titles. There were more subtle ways in which he influenced his subjects' lives. He redefined the role of religion in society, he re-affirmed the importance of private property and the authority of a father and he redirected the arts so as to embellish his imperial capital. Even had he not led his eagles to Vienna, Berlin, Madrid and Moscow, Napoleon's career would have been remarkable, but the addition of glory in war made his achievements heroic. In 1824 Eugène Delacroix noted, 'The life of Napoleon is the the epic of our century for all the arts.'[2]

The first benefit that his family experienced was that his father was once more, in his sixties, in government employ. He became successively prefect of the departments of Bouches-du-Rhône, with its prefecture at Marseille, and of the Gironde, with its prefecture at Bordeaux. It was at Bordeaux in 1805 that he died. His widow soon left for Paris, where she was able to place Eugène in one of the most prestigious of Napoleon's schools. His brothers, meanwhile, were away fighting. A family tale has it that they met while fighting on the field of Friedland in June 1807. Moments later Henri was shot and killed. Charles survived, to be one-time aide-de-camp to Eugène de Beauharnais, to be wounded during the retreat from Russia, to be captured, and to be made a baron of the Empire. Inevitably, Eugène and his mother were often in the company of his sister Henriette and his brother-in-law Raymond de Verninac, the one-time ambassador to the Sublime Porte in Constantinople. Sadly, de Verninac could not convince anyone who had influence with Napoleon that he should be kept at work. Th ex-ambassador fretted at his enforced idleness and occupied himself in giving financial advice, which turned out to be disastrous.

There are a few details of Eugène's early life. One day an idiot stopped him, examined Eugène closely and predicted that one day the child would be famous, but his life would be tough and tortured and full of conflict. A compliment that may have been more sensible came from the cathedral organist at Bordeaux. Once a friend of Mozart's, he gave music lessons to Henriette and, noticing the rapt attention of her little brother, he proclaimed that Eugène was a natural musician and must be taught. Yet a third story recalls how, staying with one of his uncles, Eugène recited verse with such vehemence that a young friend, Edouard Rodrigues, never forgot it. A fourth tale was known to Léon Riesener: Eugène admired the cameo relief portrait bust of his father by the Lyonnais sculptor Chinard.[3] All these vignettes suggest a naturally artistic child, but not a prodigy. What is much more endearing is his first recorded letter. On a little

calendar for the Year XII (1804 old style), which is lined with red leather and is entitled 'The raising of the curtain', an infantile hand has drawn in pencil a daisy, a young man in profile, two urns and two men standing while a thick pen painstakingly has written out its simple message:

> My dear Henri, I love you with all my heart, I think of you every moment, I would love to see you to kiss you. Come back soon to make us happy.
>
> Eugène Delacroix.[4]

Affectionate and sensitive, he was often a cause of acute anxiety to those around him. One time he was almost hanged by a halter. Another time the mosquito-net over his bed blew into a lighted candle and soon his bedclothes and night-shirt were on fire. At Marseille he fell into the harbour during a civic ceremony and had to be rescued by the prompt action of a sailor. In his father's study he found a pot of verdigris and, being attracted by the bright green colour, began to eat it. When his mother offered him a bunch of grapes, he swallowed the whole lot at one go and got the grapes lodged in his throat. Alexandre Dumas sums up his early life with the observation that 'at the age of three he had been hanged, burnt, drowned, poisoned and almost choked to death'.[5] It must have been with a sigh of relief that his parents sent him off to study, for some form of quiet regularity to come into his days. The sense that man lives a charmed life, when defying the elements of fire and water to do their worst, was one that he would later depict with great power in his paintings; and he would have a morbid attraction to scenes of violent struggle and sudden death. In his writings and in his behaviour, however, there would be an opposing urge to regulate human impulses by strict attention to good form. Of his private nightmares as a child no record remains. Instead there are the dull details of his satisfactory progress at school.

Eugène went to school for the first time in Bordeaux when he was seven years old. When his father died shortly afterwards, his mother was keen to rejoin her daughter and doubtless to resume her social round in Paris. Eugène went too and so in October 1806 he was enrolled at the famous Lycée Impérial.

Formerly the Collège de Louis-le-Grand, this school had endured the educational upheavals of the Revolution to become one of Napoleon's model schools. On a visit in 1801 he had made clear what sort of institution he wanted. Mathematics was practical for surveying – Napoleon himself had been a good mathematician at his own school – and it was important to wear military uniform and military discipline was to be followed. In 1803 he authorised a six-

year curriculum for lycées. The science course would lead to the study of optics, electricity and calculus. The humanities course involved history, geography, the French seventeenth-century classics and the Latin classics up to Horace and Tacitus. This was in accordance with enlightened eighteenth-century ideas. Nor were the arts discouraged, for there was provision for drawing teachers and singing teachers. Again, it was a traditional view that discipline should be strict. Offending students could be isolated at one end of the courtyard during recreation or put on a 'penitence' table or even 'imprisoned'. Throughout the day, which began at 5.30 except on Sundays and holidays, drums sounded to alert the entire school that it was time to get up, time to go to study, time to go to meals, time to go to class, time to go to recreation and, eventually, time to go to bed. Napoleon did not wish young Frenchmen to act on impulse. All students were taught the precepts of the Catholic religion, which Napoleon believed to be good for his subjects, and fidelity to the emperor, the imperial monarchy and the Napoleonic dynasty.

Despite his excitable temperament Eugène Delacroix seems to have accepted gladly many of the values that his teachers tried to instil into him. He constantly set before himself ideals of self-control and loyalty. He shared Napoleon's equivocal attitude to the Catholic church by being personally sceptical and yet admiring its effects on others, only he thought of religion's benefits as providing consolation rather than inculcating obedience. And as for loyalty to the Bonapartist cause, it would remain his deepest political instinct through all the many changes of political régime.

As a pupil he was a good if not distinguished follower of the humanities. Once early on, in 1808, he was top of his class in French Grammar, but his normal achievement was to be somewhere like fourth, whether in Latin composition or Greek translation or history and geography. The only time besides 1808 when he came first was in 1814 and this time the subject was drawing. But for that sign of artistic flair he might have been the sort of lycéen who turned into a reliable bureaucrat. Instead he turned into a much rarer species: an educated painter, one who could turn to Horace for pleasure and Marcus Aurelius for comfort and who, unlike most of the Neo-Classical artists then in vogue, knew the myths and legends and events which were the standard motifs of narrative pictures. All serious painting was based on literature, but in his case painting was a personal response to the literature he knew and loved.

His extant exercise books, with their fluent sketches of classical poses, medieval knights and modern soldiers and modern men of fashion may seem prophetic of his destiny. But he also must have thought of becoming a writer. In the end he was to be a fine writer, whether as correspondent, diarist or critic, but as a young man, some time just before or just after he left school, he tried his

hand at fiction. The most ambitious attempt was a short, sentimental novel in a late eighteenth-century vein, Rousseau with fewer tears if no more humour than the master.

A young man, son of a pastor in Appenzell in Switzerland, is led to discover in the snow an injured man, who turns out to be a count. The youth is fascinated by the glamorous possibilities of life at court and in the big city and is not impressed either by the world-weariness of the count or by his father's pleas for simplicity; and when a second nobleman appears, both expensively dressed and self-important, he begs to be allowed to serve him as his secretary. His new employer, who is a marquis from the kingdom of Piedmont-Sardinia, turns out to have a mistress and a bastard whom he neglects and a desire to marry Hortense, a beautiful aristocrat, whom he is anxious to use to perpetuate his line. As he has so little education, the marquis employs his Swiss secretary as a go-between, but otherwise treats him with contempt. On a hunt the poor young man is so cheaply mounted that he cannot keep up with the main party. This turns out to be fortunate since he rescues an isolated huntsman from a wild boar and in so doing finds that he has helped the prince. The prince befriends him and so the marquis, who had been furious that his servant had not kept up with him, is forced to show some forbearance. The prince confesses to our hero his love for Hortense. The young Swiss suggests that the prince should visit Hortense dressed in the marquis's livery. Unfortunately the prince is discovered with Hortense by Hortense's father. The father is angry at the threat to his daughter's honour, the king is angry at the thought of a potential *mésalliance*, the marquis feels deceived and the prince feels that he has been made to look foolish. Just in the nick of time for our hero the French ambassador turns up in Turin and everyone is obsequious, even to the hero, when he recognises that the ambassador is none other than the count whose life he had saved. The count offers to take the young man into his service and take him back with him to Paris, but the young Swiss has had enough. He is now finally convinced of the evils of life at court and cannot wait to get back to Appenzell, to his father and the idyllic simplicity of his beautiful, rural retreat.

Even at the age of seventeen or eighteen there was one side of Delacroix which appreciated the need for leaving behind the delights of Paris. He was already fond of visiting cousin Bataille at the abbey of Valmont. In middle age he bought himself a little house and garden to the south of Paris; and Champrosay by the Seine became his Rousseauite refuge, all the more appealing because he could return from it to Paris very quickly by train. It is doubtful, however, if he was ever enamoured of peasant life, let alone the life of a noble savage. As one of his oldest friends, Achille Piron, noted, he was 'well educated' and 'sought after in society'. He never had Rousseau's problems in coping with personal

relationships. In solitude he often thought about the people whose company he was missing. He was strikingly attractive and he was strikingly attracted.

A companion at the lycée, the littérateur Philarète Chasles, has left a description of Delacroix in his days at school. 'I was at the lycée with this lad with the dark-skinned face and the flashing eyes, the mobile features, the smiling cheeks and the lightly mocking smile. He was slim and elegant and he had a mass of dark curly hair, all suggesting a southerner.... Everything about Delacroix was passionate, even his friendship, which he kept towards me all his life.'[6]

Chasles may have exaggerated about his own closeness to Delacroix, but the evidence of the early portraits and letters and the remarks of other early acquaintances show that the description is accurate. At the Lycée Delacroix made at least three friends about whom he felt passionately all his life: Félix Guillemardet, son of that Spanish ambassador who had witnessed his father's operation and his own birth; Jean-Baptiste Pierret; and Achille Piron, who was the last to die and who was his universal legatee. To these friends in his late teens and early twenties he poured out his feelings with an eloquence that they must have found moving and even embarrassing. In 1856 Félix's brother Louis gave Delacroix a bundle of letters which he had written to Félix, who had died in 1840; and, having obviously read them at some stage, he told Delacroix that he was still the same man as the one the letters revealed. When his relationship with Pierret grew cold, he was devastated; and he clung all the more gratefully to Piron. Though Delacroix was to excel his friends in brilliance and become, unlike any of them, a national figure, he remained devoted to these people he had loved so long.

He found in his friends almost more than in his family the sheet-anchor of his emotional life. When his mother was dead, it was not to his cantankerous sister that he could reveal himself but to Pierret. Writing to Pierret in October 1819 to console him over the death of his father, he recalled his own reaction to his mother's death five years before. Finding himself alone with her corpse, he had given her the last kiss she ever received. 'My tears, my friend, stop me from seeing what I write ... I think that you will cry too when you read this letter.'[7] Whether it was the long-term effect of the enclosed atmosphere of a lycée or whether it was an offshoot of the contemporary cult of sensibility which made Delacroix write in these terms, his emotive language might hint that he was more than a little in love with his friends. But with none of them was he so involved as with his mother.

It was his mother's death, coming as it did during the last autumn of his schooldays, which brought his childhood to its end.

In the icy wastes of Russia and in the countryside round Leipzig Napoleon was shown to be no longer invincible. He had abdicated in April 1814; and Talleyrand later that month was among the first to greet a returning Bourbon as his king, whose return he, now the ruthless enemy of Napoleon, had encouraged. That autumn Madame Delacroix died, leaving family affairs in chaos. When Napoleon returned in March 1815 to try his luck for a hundred days, Delacroix was finishing his last few weeks at the lycée. He left school on 30 June 1815, barely a dozen days after the defeat of Waterloo and just under three days before Napoleon left the shores of Europe for good.

For French artists of the time Napoleon had provided a priceless education. In time Eugène Delacroix would be affected by Napoleon's Concordat with the Pope, which laid down the circumstances in which religious works of art should be made – it was because of this Concordat that at the lycée the offical religion had been Catholic. In time he would be even more affected by Napoleon's Institute, which gave official approval to French artists and so made the great and the mediocre long for State recognition. At the time, however, Delacroix was much more affected by the military ambience of the régime, which made him admire the exploits of his brother without being old enough to fight – he was brought up on the cult of glory. Most of all however he was affected by the existence of the Musée Napoléon. From all over Europe Napoleon had gathered masterpieces as the trophies of war and put them on display in the Louvre. All Eugène Delacroix had to do, if for example he wished to see Veronese's enormous *Marriage Feast at Cana*, looted from the monastery of San Giorgio in Venice, was to walk a short distance from his home. For an artist to whom temperamentally early impressions meant so much, it was a wonderful artistic education; and towards the end of his time at school art was becoming his favourite concern.

The state of family finances after his mother's death meant that he must settle on a profession. He admired his uncle Riesener and he was encouraged by the success he had had. His uncle Riesener introduced him to the competent Neo-Classicist, Pierre-Narcisse Guérin. The best of the Neo-Classicists was a spent force. Jacques-Louis David felt too committed to Napoleon to stay in France and he went into self-imposed exile in Brussels, where he painted sleek erotic pictures for patrons with jaded tastes and forgot what it was once like to paint his greatest, revolutionary work, *The Death of Marat*. David's most original pupil, Jean-Auguste Ingres, discreetly stayed on in Rome. Many years before he had caused a storm by painting Napoleon in the guise of Christ as shown in *The Ghent altarpiece*, which Napoleon had stolen from its Flemish town and which was now going back home. Ingres would wait a while before he, unlike his master, would make his peace with the Bourbons. The field was left to

competent men whose politics were as adaptable as their ideas on art were safe. Of those available in Paris Guérin, though not a pupil of David's, was probably the best instructor. To his studio on 1 October 1815 Delacroix went, to find out if a first prize in drawing meant that art was to be his métier.

— 3 —

Restoration and Romanticism (1815 and after)

THE Hundred Days when Napoleon I governed France for the second time never had much opportunity for success. They also spoilt any chance of a successful Bourbon Restoration, for, if the genius of Napoleon could no longer guarantee victory against the enemies of France, after the battle of Waterloo it was only too obvious that it was the enemies of France who had imposed the Bourbons. The restored monarchy was unlovable and unloved. Of the two surviving brothers of Louis XVI, the elder, Louis XVIII, was shrewd, sceptical, fat, old, lazy and impotent. His brother and heir, Charles, comte d'Artois, a former roué who had turned devout, was slender and active, arrogant, stubborn and foolish. For the sake of peace Louis XVIII accepted a charter, which tried to make France a constitutional monarchy like England, and the ardent royalists were scandalised. They were furious that there was no question of the restoration of lands which had been taken from the Church, like the estate of Valmont abbey owned by cousin Bataille, or from nobles who had fled the country to save themselves or help their king. They did not like the fact that France had become a country with no technical privileges. They despised the modern social order. The new Napoleonic nobles, like Delacroix's elder brother, were promised equality of status with the old Bourbon nobility, but at court it was soon clear that equality in law was nowise the same as social cachet.

The franchise was so restricted that only the very rich belonged to the political nation. In England, where the political nation was also restricted, if in quainter, less logical ways, postwar popular agitation never quite brought on a revolution. In France, however, the slightest hint of radical politics reminded the governing classes that a revolution might be imminent. The French ultra royalists were therefore more resolutely set than the British Tories against any

change of any kind. Immediately after the Restoration and again in the middle 1820s the ultras were in the majority in the Chamber of Deputies and their will prevailed. From 1827, however, no such majority existed, but the king, now Charles X, was the ultras' champion; and he was determined to take no notice of the electors' choice. He was so convinced of his cause that it did not occur to him that anybody who mattered would take amiss his sudden assumption of emergency powers. Unfortunately too many of the rich no longer cared for him and too many of the poor were ready to fight; and he incited the very revolution he had intended to prevent. The Restoration was undone by the line that had been restored.

The sudden demise of the Restoration was largely the fault of a stupid king. For a certain time the ideal of a union of throne and altar, of the Bourbon kings and the Catholic church, held a glamorous appeal to young intellectuals. Their most eloquent spokesman was François-René, vicomte de Chateaubriand. As long ago as 1802 the melancholy cadences of *Le Génie de Christianisme* had started a reaction against stark revolutionary rationalism in favour of the imaginative appeal of the ancient religion. Now Chateaubriand's pamphleteering skills supported the Bourbons and the ultras; and he was rewarded by becoming ambassador in England and then foreign minister. Where he led, younger men followed. Lamartine, the leading new poet, had briefly served in the royal army. The success of his *Méditations poétiques* in pious circles helped him on his way to diplomatic postings at small Italian courts. Vigny was an obscure officer in the royal army who first achieved fame as a religious poet. For a while it seemed right to be young, Catholic and monarchist.

Among these young men none was so ambitious, bright and precocious as Victor Hugo. That he was the son of a Napoleonic general nowise lessened his royalist sentiments. At the age of thirteen, in 1815, he entered Delacroix's own school, now renamed the Lycée Louis-le-Grand. He had no doubts of his aims: 'I want to be Chateaubriand or nothing', he wrote in 1816. In 1819, aged seventeen, he founded his first literary magazine. In 1820 the murder of the duc de Berry, third heir to the throne, gave him the chance of writing a poem to gain favourable official notice. When the duke's father, the comte d'Artois, was anointed and crowned Charles X in the cathedral of Reims with all the elaborate and splendid, not to say pompous, ritual of the past, Hugo was soon ready with another royalist poem. It was not the success he had looked for. *The Consecration of Charles the Simple* by the popular versifier Béranger set France laughing. Romantic royalists were not amused.

Neither throne nor altar meant much to those, like Béranger, who were

nostalgic for the Empire. To anyone, however loyal to the Bourbons, who had grown up under the rule of Napoleon the restored monarchy was something of an anticlimax. In 1835 Alfred de Vigny, who came from a royalist family, published his *Servitude et grandeur militaires*. It was a *locus classicus* of the feelings of his generation.

> Towards the end of the Empire I was a schoolboy preoccupied with matters outside school. The war was the first thing we thought about; the sound of the drums drowned the voices of my teachers, and the mysterious words of our books spoke to us in a frigid, pedantic tone. The only point of logarithms and figures of speech was to be the means of aspiring to the star of the Legion of Honour, the brightest star in the heavens, as far as we children were concerned.
>
> No subject of meditation could hold our attention for any length of time when our heads were turned by cannon-fire and bells pealing out the *Te Deum*. Whenever an elder brother, who had left the Collège a few months ago, reappeared in Hussar's uniform, with his arm in a sling, we blushed at the thought of our books and hurled them at our masters. The masters themselves kept on reading us the communiqués of the Grand Army, and our shouts of 'Long live the Emperor!' stopped all talk of Tacitus and Plato. Our masters were like heraldic kings-of-arms, our classrooms were like barracks, our recreation periods turned into manoeuvres and our examinations into military reviews. . . .
>
> War so clearly seemed to us the natural state of our country that when we had escaped from the class-room we raced to join up. . . . This idea remained with us throughout the Restoration. Every year brought renewed hope of war, and we dared not give up our swords in case the day we resigned might prove the day before a campaign. In this way the days dragged by and we lost precious years, dreaming about battles as we drilled in the Champ-de-Mars, wasting away in military shows and duels our strong but pointless reserves of energy.[1]

Vigny had been born in 1797, just one year before Delacroix, and had gone to a famous school in Paris in 1807, just one year after Delacroix entered the Lycée Impérial. His sense of frustration was even more intense because his loyalty to the new régime throughout the 1820s was never in doubt. France went to war only once in that decade, when Chateaubriand, who keenly felt the lack of glory, managed to engineer a campaign in Spain in 1823; and Vigny never even crossed the frontier.

For the youthful critics of the régime there was nothing to look forward to.

Some decided that the only way to fight was as revolutionary conspirators. Delacroix himself was no lover of the Bourbons. Himself the son of a regicide, he made one snide reference to the coronation of 1825 in his letters. His earliest attempt at an etching included a profile bust of Napoleon and in 1824 he was thinking of painting Napoleonic scenes. Did his lack of sympathy for the Bourbons extend to active revolt? Some young intellectuals became 'Carbonari', that is revolutionaries committed to armed struggle against the régime. It has been claimed that Delacroix was one of them, for a certain 'Lacroix, lithographical painter' was involved in a conspiracy in 1822. The banal truth seems to be that this painter was a little known near contemporary called Pierre Lacroix. Eugène Delacroix preferred to be revolutionary in art rather than in politics; and as the 1820s progressed, there was a general aesthetic revolt in which Lamartine and Vigny and above all Hugo took their parts; and in this revolt Delacroix's part would be prominent. The generation of 1820 became avowed Romantics.

In England those born around 1770 have been regarded as the first Romantics: in literature Wordsworth, Coleridge and Scott and in painting Turner and Constable. In France the key literary figures belong to the same generation: Chateaubriand and Madame de Staël. But in painting the French Romantic movement did not exist till around 1820. The beginnings of French pictorial Romanticism therefore coincided with the second generation of Romantic poets, with Byron, Shelley and Keats in England, with Lamartine, Vigny and Hugo in France.

For this reason, even more than in England, the French Romantic movement was based on changes in literary fashion. For the painters this was no disadvantage, for great art was meant to tell a story, but whereas earlier art had relied principally on the Christian and the classical traditions, now more modern stories were also attempted. Just as the leading French Romantic composer, Hector Berlioz, broadened his subjects to include Shakespeare, Goethe and Byron, so Delacroix responded to Shakespeare, Goethe, Scott and Byron. Nobody questioned the primacy of literature. To understand Romantic painters in France it is necessary to know what they read.

Being young and intelligent, Delacroix read fashionable authors. Some of his aesthetic ideas came from Madame de Staël's most famous work, *De l'Allemagne*. She had argued in France an unpalatable thesis: the value of German culture. In 1824 he confided to his diary: 'I find precisely in Madame de Staël the development of my idea about painting.'[2] From her he learnt that artistic activity is separate from practical activity, that the role of art is to 'elevate, not

indoctrinate the soul' and that painting like music transcends thought and as such is superior to literature. It is of course a very literary idea of painting. He also had some knowledge of Chateaubriand. He painted one work based on Chateaubriand's *Atala*, the subject of which appealed to him not so much for its cloying religiosity as for its primitivism – it is an elegy on the fate of a young Red Indian couple in eighteenth-century Louisiana. As he grew older, he came to appreciate the passing of time; and during moments when he could not paint, he copied out long extracts from Chateaubriand's masterpiece, the *Mémoires d'outre-tombe* (Memoirs from beyond the grave).

In the 1820s he looked above all to those nearer his own age. At one stage he ranked Lamartine with Dante and Michelangelo. But eventually he came to think of the poet's art as false. He had no patience with love-lorn souls looking for consolation in the waters of a lake lapping the shore and he was still less sympathetic to the republican political views which Lamartine propounded after the 1830 Revolution. Long before Lamartine declared in a famous phrase that France was bored, he had bored Delacroix.

Delacroix shared many attitudes found in the 1820s poets. They, like Lamartine, lost their religious faith, they, like Vigny, took refuge in a creed of stoical detachment much like Delacroix's own or, like Shelley in England or Lamartine in France, they sought relief from anxiety in a life of idealistic action. They lacked that sense of solidarity with the past which sustained their elders, Chateaubriand or Wordsworth. They were alone in an uncomprehending world. When Vigny dramatised the persecution of genius in his play *Chatterton*, he chose his subject from the story of the young English poet who committed suicide, to whom Keats had dedicated *Endymion*. Delacroix, who had equally strong opinions on the same theme of misunderstood genius, chose to dramatise them in paint in *Tasso in the madhouse*, a subject dear to the younger English Romantics, but taken from the troubles of a greater and Italian poet.

Where he was at one with Vigny and with Restoration taste as a whole was in his love for English literature. With the names of Dante, Michelangelo and Lamartine he placed that of Byron. Before Hugo and Dumas wrote historical plays or novels, he had discovered Walter Scott. Before Stendhal had compared Shakespeare to Racine, he had tried his hand at translating Shakespeare into French. It was from the English too that he had learnt to be interested in Goethe's *Faust* and so to some extent to be aware of that other foreign literature which Madame de Staël taught the French to value, the literature of modern Germany.

Delacroix could be called the Berlioz of painting. He was certainly called the Hugo of painting, a title which he emphatically rejected. If he thought of himself as sharing attitudes with any French Romantic writer, the person he thought of

would have been Stendhal. In the 1820s Stendhal was not yet a great novelist, but a travel writer and critic of note. Like Stendhal, his family had had some standing under Bonaparte. Like Stendhal, he would make his way, ambitious for recognition in the salons of Paris. Like Stendhal, he professed to be a libertine in love, a sceptic in religion, a man of style in behaviour as in art. In the last months of the Restoration Stendhal would chronicle the rise and fall of a hero avid for success in Restoration France. To that extent Julien Sorel, the protagonist of *Le rouge et le noir*, has much in common with many young men of the time, Delacroix among them. Delacroix, like Sorel, had to use the rich to make his name, to covet honours granted by a Bourbon and to seek for religious commissions which at that stage probably meant little to him. Sorel's main fault was impetuosity, a Romantic fault which brought him to his death. As a young man, Delacroix was much more impetuous than he liked to appear, especially later on. Like Sorel's creator Stendhal he was saved by his need to affect a cynical spirit when he was hurt. He like Stendhal was a Romantic because he looked back, but back to the values of the *ancien régime*. He did not wish to restore a time when Throne and Altar might have been at one, but to restore the mood of the critics of both absolute monarchy and revealed religion. Even as a boy Delacroix had read Voltaire voraciously and he would read, re-read and copy out passages of Voltaire all his life. Delacroix did not like the modern world and the older he got the more he disliked it. He would survive it by striving to avoid its sentimentality and vulgarity. He would be a Romantic without illusions about the present or the future, for the past had been better and was gone for ever. He would know that men and women cannot be happy and must endure.

In literature Romanticism had begun as Napoleon's power had begun to wane and it came of age under Bourbon rule. In their writings Chateaubriand and Madame de Staël had defied the emperor. In the visual arts Napoleon's influence had been stronger and it had left a strong tradition in favour of Neo-Classicism. The *style empire* in architecture, in furniture and in interior design, in painting too had been grandiose and austere, with its self-conscious reminiscences of 'the glory that was Greece/And the grandeur that was Rome.'

In painting the style had been created by Jacques-Louis David, whose remarkable career stretched back to the *ancien régime*. In the 1780s his great set pieces had seemed to the critic Diderot a moral critique of the frivolous rococo taste of a decadent court. In the 1790s his patriotic convictions had become so fanatically loyal to the idea of 'one, undivided republic' that he was lucky to survive the fall of Robespierre. He was saved from death because before his

accusers he was too incoherent. He was saved from disillusion by discovering Napoleon. His imperial faith was expressed magisterially in the enormous *Sacre de Joséphine*, which records that most poignant moment of the imperial coronation when the empress knelt before her husband, her head gracefully bowed, while the emperor held his crown up for all to view and the pope, enthroned and impotent, looked on. David was not always Napoleon's favourite artist, for his last great set piece Napoleon knew to be on the subject of *Leonidas at Thermopylae*, a fact of which he did not approve, for Leonidas was about to be conquered and to die. Napoleon preferred works that made visible his victories and his virtues; and he found such works painted by two of David's pupils, Gérard and Gros.

Gros was the more flattering. He glamorised French victories at Eylau and Austerlitz and he commemorated Napoleon's supposed compassion to *The plague victims of Jaffa*. For this last picture he had moved far from the hard, bright colours of David to a palette rich and strange which seemed appropriate to its oriental scene. He suggested to some younger men that air of dash and fluency which French artists instinctively associated with the grand Parisian canvases of Rubens. In 1812 an unknown young man, Théodore Géricault, outdid Gros in bravura with his *Charging cuirassier*. Idealisation of warfare could go no further – it was the year of the disastrous campaign in Russia. The painters soon had to respond to humiliating events, so in 1814 Géricault exhibited wounded horsemen who were not so enthusiastically received. When in that year Napoleon first abdicated, David showed his *Leonidas* privately. Géricault briefly served in the royalist army. In the case of David any accommodation with the Bourbons was psychologically impossible. For forty years he had been true to his Neo-Classical ideals, aiming to paint as men lived in ancient Sparta, and now Sparta in the person of Leonidas-Napoleon faced complete defeat. David went into voluntary exile.

Nobody left behind could manage his high seriousness. In Rome Ingres eked out a living, capturing well-to-do features with a wonderfully refined delicacy of touch. Antoine-Jean Gros tried to adapt. With a guilty conscience, while he kept on writing to David in Brussels to ask for advice, he took royal service; and as a reward he was granted the title of baron. Despite the respect of younger artists, Delacroix among them, he felt that he had lost his way; and eventually he took his own life. François Gérard had much more social flexibility. When he also became a Restoration baron, he thoroughly enjoyed the honour. For him at least there was no conflict between himself as the painter of Napoleon's legendary victory at *Austerlitz* (of 1810) and the painter as portraitist of Louis XVIII (of 1819): just as David had celebrated Napoleon's coronation, so he celebrated the coronation of Charles X. Being at ease in Restoration society, he

kept a salon that was open to many of the most cultivated spirits of the age and he was an important academician.

Delacroix sometimes ranked Gros with Rubens, and he admired Gérard's mastery of grand designs. Both of them had retained something of David's robust style of painting. Later in his writings Delacroix would show a fondness for another Imperial artist, Pierre-Paul Prud'hon, whose beguiling mood would appeal to him, precisely because it lacked the rigidity of David's Neo-Classicism. Prud'hon had never belonged to David's school, even in his youth, and he had painted the Empress Joséphine in a wistful moment. 'Prud'hon was the only painter of that period whose execution was equal to his idea.'[3] Prud'hon showed Delacroix how to be gently sensuous, but he lacked the strength of personality to be a leader of men. No more than Gérard or Gros did he found a Restoration school.

Compared with these eclectic rivals, Delacroix's master Guérin must have seemed a rock of consistency. He, like David, had won the most prestigious award for young French painters, the Prix de Rome. He had made his name with the grim *Return of Marcus Sextus* and under Napoleon he illustrated mythological themes from Racine – *Phèdre et Hippolyte* in 1802 – and under Louis XVIII – *Clytemnèstre* in 1817. In 1822 he received the reward for artistic purity when he was made director of the French Academy in Rome and in Rome eleven years later he died, while working on a picture of *The Last Night of Troy*. He had gone on painting as though a Romantic movement had never begun.

By a strange accident of fortune that movement had begun in *his* studio. His pupil Théodore Géricault was independent of the master well before 1815, but would return to the studio now and again to draw from the nude. In 1812 another rebel, Ary Scheffer, had arrived and Delacroix came in 1815. They were taught the austere techniques of the school: linear perspective, which Delacroix never mastered; copying while subtly idealising the model; reproducing the approved antique; and, above all, devotion to line. People said that Guérin was the only teacher besides David who was a natural teacher, because like David he recognised that it was not his duty to reproduce clones of himself but to help his pupils to develop their own salient qualities. There is contradictory evidence of Delacroix's reaction to Guérin. In 1813, when he first met him, he was thrilled. Maxime du Camp maintained that Delacroix never spoke of Guérin except in the warmest terms but, according to Achille Piron, Delacroix grumbled that Guérin had never encouraged him. Why then did he stick with Guérin, instead of moving away to become a pupil in the studio of Gros? Maybe no great principle was involved. Gros's studio was chaotic, whereas Guérin's had *le bon ton*; and Delacroix liked working in disciplined surroundings.

Delacroix said that from the age of fifteen he was a Romantic – he first used

the word in a letter written in 1814 – yet he behaved as all pupils did at that time, studying casts in the Ecole des Beaux-Arts, joining the life class, competing without distinction in the official competitions, wondering what it would be like to win the coveted Prix de Rome. As late as 1820 he was thinking of following the advice of uncle Riesener that he should go to Brussels to study under David. However, the normal academic path to greatness that the Neo-Classicists had taken was not to be his. In 1821 he decided to risk all, as Géricault had done in 1812, by entering a picture for the biennial exhibition, the Salon. And in 1822, like Géricault in 1812, he achieved instant renown.

— 4 —

The vocation of an artist (1815–22)

IT had taken Delacroix seven years to find his vocation as an artist, to become Romantic. Only in 1822 did he outgrow Guérin. For some time his handling of paint had been becoming freer. In 1816 he met Charles Soulier, a Frenchman, raised in England, who had learnt the English art of watercolouring, which he passed on to Delacroix. In the age-old French debate between the enthusiasts of line, like Guérin, and the enthusiasts of colour, like Gros, Delacroix began to side with the colourists. For the time being he did not desert the sculptural tradition of Renaissance art altogether in that he was under Géricault's influence, but he was becoming more painterly. He was forming friendships with artists in the circle of Gros – with Bonington, an Englishman younger than himself, and Charlet, who went to England with Géricault in 1820, and Jules-Robert or 'Monsieur' Auguste, who would teach him about the Orient. In 1822 Gros allowed Delacroix to study his Napoleonic masterpieces, carefully hidden away from public scrutiny, and he was dazzled by them. Instinctively he was drawn away from Raphael who meant so much to Ingres, and from Poussin who meant so much to David; instead he was drawn to the Titians, the one resplendent Veronese and Rubens' sumptuous Marie de' Medici series which now hung in the Louvre (the Veronese was Napoleon's acquisition which had proved too fragile to go back to Venice, and the Rubens series had recently been moved from the Luxembourg palace). He did not have the first-hand knowledge of Michelangelo which had meant so much to Géricault. He was starting to move away from Roman art to the art of Venice and Flanders and eventually to the art of the Netherlands and England. Later he would do justice to Michelangelo and Raphael and Poussin, but, being young, he needed strong likes and dislikes. It was not drawing or sculpture that moved him, but the delirium of paint, whether thin watercolour or thick oil. All he needed was a subject, which he could find only by reading.

 The principal clue to his reading, indeed to the state of his mind, in these years is found in his private correspondence.

Just under seventy of Delacroix's letters survive from his early youth. All but two were written to his schoolfriends Guillemardet, Pierret and Piron and to his new friend Soulier, and most date from 1818, 1819, 1820 and 1821. In 1822 he was preoccupied with his first Salon entry and his family finances, so that there are only six letters to friends for that year, but fortunately in September 1822 he began his famous *Journal*, so that there is another source that reveals his inner life even more exactly. Still, for his period of apprenticeship these letters are, in the phrase of one of their collectors, '*lettres intimes*', for that is what Delacroix chose to make them. Unfortunately they reveal but one side of four relationships, but it is possible to work out how much these relationships mattered, not just to him, but his friends, for they took care to preserve his letters even before he troubled to chronicle his reflections for himself principally in his *Journal*. Even if sometimes gauche in expression, they show that Delacroix was a master with words before he became a master with paint.
 The first three, two from 1813 and two from 1814, are letters written to schoolfriends, while he was on holiday at Valmont not far from Dieppe, staying with his cousin Alexandre-Marie Bataille. Until the Revolution, Valmont had been a Benedictine abbey with a Gothic church and with conventual buildings that dated from the late seventeenth century. Then, in 1792, its last abbot had been ejected for refusing to take the oath to the revolutionary civil constitution of the clergy, the monks had been dispersed and the monastery had fallen into a state of fashionable decay. It had been bought by the Batailles and had been looked after by Charles Delacroix till Alexandre-Marie came of age. As he told his schoolfriend Félix Louvet, the place made him think 'romantic' thoughts.[1] He loved to walk alone, day-dreaming, in the silent ruined church, listening to the echo of his own footsteps. He was not so sure that he would be happy alone there at night. As he wrote melodramatically to Guillemardet near his bedroom there was a spiral staircase, 'you find a very low little door . . . you go into the partly ruined church and down into the crypt, where there's a staircase and monks are buried in lead coffins. Besides, in the neighbourhood there's a girl who appears at midnight . . . Then there's also a wood. . . . '[2]
 From Gothick horror it was but one step to another experience: frustration in love. By 1815 the mocking tone of that letter to Guillemardet had given way to the impassioned tone adopted to Piron, who later noted on one letter '*Eugène amoureux de Mlle. de Villemessant. . . . Amour d'enfant.*' Having asserted that 'talking morality, philosophy, tranquillity of mind to the emotions is wanting to

put out a building on fire with a glass of water', [3] Delacroix goes on to recount how he had walked up and down outside his loved one's house in rue d'Anjou, looking in at the windows, looking in at the garden, lucky not to be shot for his pains by an Austrian guard stationed at the gate – the victorious allies had occupied Paris – and had been driven away eventually only by the coming of night. The storm subsided, only to be succeeded by another.

This time – his mother being dead, he often lived with his sister – it was Elisabeth Salter, Henriette's English maid. The year was 1817. He had met Charles Soulier who had been brought up in England and was studying English; and with the help of a dictionary he wrote to Elisabeth in 'that devilish English tongue'. Some of these letters survive and in 1962 and 1964, around the anniversary of his death, were made available. One draft shows how he had made progress in the language of love.

> I conceive you are wearied to see me instairs to the face of the whole house, and I confess it not to please me much. . . . Often when I go near the kitchen I hear your fits of laughing and I laugh in no wise. . . . I frame great many purposes to see you easily but needless. . . . Oh my lips are arid, since had been cooled so deliciously. If my mouth could be so nimble to pronounce your linguage, as to savour so great sweetness, I not should be so wearied when I endeavour to speak or to write you. . . . You will not omit, you will tell me Sunday a thing which interest me. I am sure you laugh at it and you prepare to amuse me with triflings. You are a cruel person which play afflicting the others. Nevertheless not be angry at it; I am a pitiful Englishman. [4]

Elisabeth showed some pity. She allowed him to portray her in a plain, incisive style. Two of his letters to Pierret give a tragicomic account of their relationship. In the first, dated 11 December, he describes how his whole day has been reduced to going up and down the stairs to the courtyard, listening at keyholes, sauntering out only to meet the disapproving eyes of his sister or racing out only to hear the rustle of a skirt disappearing into the upstairs room without having seen anything. . . . He has a painter's awareness of her looks, of her pretty eyes limpid like pearls and soft like velvet, of her unusual nose with its upward tilt, of her nostrils which dilate at the same moment as the pupils of her eyes, of the elegance of her mouth; and her cheeks, her little double chin and her head's connection to her neck is worthy of the utmost devotion. If his sister were to read this letter. . . . Some days later he wrote to tell how he had seized an opportunity when his sister had to go to the shops. They were alone, it was evening, they were on one chair, knee to knee and soon knee within knee.

Never had his heart beaten so fast. Yorick laid his head on Elisa's breast. Just at this moment there was a knock on the door. 'Friend of virtue. It was my sister. . . . It's a foolish occupation to be disappointed by coming to a door when people are making love behind it, but, what the hell, people must make love and so much the worse for the killjoys.' He then went back to the letter he had been writing to Elisabeth with the help of the dictionary. He signed his letter to Pierret 'Yorick'.[5]

The reference to Yorick and Elisa is, as Pierret would have known, a literary one. Besides Rousseau, whom he had mentioned in his letter to Louvet, the chief purveyor of sensibility to sensitive souls in the late eighteenth century had been Lawrence Sterne. Sterne had called himself 'Yorick' after the jester whose skull is held by Hamlet. He had advertised to the whole polite world, in *A sentimental journey through France and Italy*, his love for 'Eliza', a married woman called Elizabeth Draper. The incidents which Delacroix recounts are told in the manner of Sterne. As with the account of Valmont, so with a story of love – he saw life in terms of literature.

It was probably at this time that he embarked upon his literary endeavours. There was his short Rousseau-esque novel about the young Swiss from Appenzell. Another more bloodthirsty short novel called *Alfred* was set in the time of William the Conqueror and full of Gothic horror, which culminated in the accidental slaying of his father by the hero. A third work was a melodrama, *Victoria*, which was set in Italy, involving Ariosto, a jealous count, and Victoria his ward and Elfredi her lover.

These attempts at fiction mirrored his literary tastes and his linguistic interests. As well as English he was also studying Italian. If one of his letters has a translation from Shakepeare's *Richard III*, another had a translation from Dante's *Inferno*: the macabre story of Ugolino and his sons, which would become the subject of a painting as late as 1860. He was also familiar with another Italian author: Torquato Tasso, a taste for whom he could share with Pierret, who as secretary and collaborator was helping a poet called Baour-Lormian to improve on a mediocre translation of *Gerusalemme Liberata*. The thought of Tasso brought him back to modern English literature. He had heard that Lord Byron had written a *Lamentation of Tasso* and he wished he had read it. None of this reading would keep him from continuing to read Latin, especially Horace and Virgil. He sent Pierret a prose translation of the tenth eclogue of Virgil. The poem treats of how a discarded lover finds consolation in hunting game. If Delacroix felt like a discarded lover, he also could go hunting.

During this period of his life three other places came to matter to Delacroix: Le Louroux in the Touraine, where his brother lived; the Château de Croze near Souillac, where his brother-in-law's family came from; and above all, the family property, the Maison des Gardes in the forest of Boixe in Angoulême. After the death of his father the seven-year-old Delacroix and his mother had moved back to Paris, initially to live with his sister in rue de Grenelle. The following year his mother had rented the house at 114 rue de l'Université, a little closer to the left bank of the Seine and just beside the military hospital of the Invalides. This was to be the town house where Eugène lived till 1820. The country home in the Forêt de Boixe, near Mansle in Charente, had been acquired by his mother in 1812. He spent the autumn of 1818 there, and was there again in the autumn of 1819, when his sister and her husband and son made it their principal home. Early in 1820 he arranged to let the house in rue de l'Université, but it was so large that he still used part of it as his studio as late as 1822. In August 1820 he went first to Le Louroux, then in September to the Forêt de Boixe and finally to Souillac. In 1821 he took a much shorter holiday, this time at Saint-Cyr. In April 1822 he heard of the death of his brother-in-law, but could not go to join his sister, being preoccupied with the opening of the Salon and the exhibition of his first entry, *The Barque of Dante*. At the end of July he went to stay with his brother in Le Louroux and there in September he began his diary. The catastrophe of the inheritance of the two brothers and their sister was upon them. The property in the forest had to be put up for sale. By the time it was sold, his brother Charles and his sister Henriette were irreconcilable enemies and he was destitute. But for his career as an artist he would have starved.

Fortunately for his sanity the story of the family property scarcely impinged on his relationships with his friends. Used to the delights of country life at Valmont, he could enjoy his time at his own country home, the forest at Boixe – that is, until its dullness and loneliness oppressed him. 'I'm almost at the centre of a forest 4500 *journaux** broad at the junction of two pathways thirty feet wide, one of which runs straight for some two leagues. . . . Here, at a place known as La Croisée, you suddenly come on a white house with green shutters and no first floor, therefore just one storey high. Outside it looks less grand than a lot of houses in the area, but inside it's as comfortable and elegant as a Paris house, which makes it unlike the houses of the rich round here.' He goes on to explain to Pierret how tasteless these houses are, so that 'our house makes the neighbours jealous – I mean within two or three leagues of us. . . . I get up very early, sometimes at daybreak. Sometimes I go out alone, sometimes with a companion, but always with a dog and a fine gun I almost always have with me. I

* A *'journal'* represents land that can be ploughed in a day.

walk for three or four hours without stopping, burning up the powder and tearing my clothes as I go after game in thickets and green clearings. I love hunting. . . . Just seeing a small bird fall to the ground gives you the sort of thrill a man gets at the moment he's realised his mistress loves him.' Yet Eugène soon recalled that he could not live without his friendship for Pierret. 'Whatever pleasure you could find in a new and active way of life, that can't get rid of the memory of the ties of sentiment linking me to different places and to earlier times. . . . With what happiness I think back on our affectionate conversations, when we poured out our feelings to each other. With what pleasure I'll look forward to embracing you my dear friend, who's listened to all my mad ideas.'[6]

The tone of the letters is mercurial. The following year, in the autumn of 1819, his journey to the forest was full of incident. At Montbazon before Poitiers his cat Minette gave him the slip while the horses were being changed and he found himself just about to give up the search – it was one o'clock in the morning – when the postilion thought he saw her walking up and down in the courtyard of a nearby house. He gently rang the bell and eventually a man appeared in his nightshirt and joined in the chase from the chicken house to the pigsty, till at last he grabbed her on a ladder. Worse was to follow, for after Poitiers one of the springs went and so they were delayed even more. He was less happy, he told Guillemardet, that he had arrived, because he could not help thinking that he had left him and Pierret behind in Paris. Hunting was all very well but much better if you were with friends, and he wasn't much good at it, so he was reading a lot and trying his hand at translating out of English.[7] He also wrote a number of letters encouraging Piron to carry on with his Italian, explaining in one of them that he was translating parts of Dante and giving Guillemardet in another letter an example of what he was doing. In October he could tell Piron that the first frost was turning the vine leaves yellow and that, in the morning, when he went out to hunt, there was a thick mist over the forest.[8] By the end of the month he was trying to console Pierret for the loss of his father and passing on the sad news to Guillemardet in case he hadn't heard it already.[9]

The following year he had an experience which was to have life-long consequences. He had stopped off to see his brother, who since the end of the wars had retired and was living quietly with his wife, who was not socially acceptable, in Touraine. At the start of September it was very hot as Eugène made his way from Le Louroux to the forest. To save money he decided to make part of the journey on foot from Sainte-Maure. Then he caught a chill, which developed into a light fever, so that by the time he reached Châtellerault he had to put up in an inn before going on to the forest. Once there he found himself without appetite or energy, and feeling giddy if he stood up. Not till October could he write to Guillemardet to say that the fever had just about left him, even

if he was still pale and green, still unsteady on his feet. He was, however, good-humoured enough to pun on the word '*bergère*', which could mean either an easy chair or a shepherdess. 'Tender *bergère* of the Charente, whom I have come to seek from so far, sweet companion of my hours, during such a long time, when will I leave your arms?' His spirits revived only when he crossed the Limousin to go to his brother-in-law's country house near Souillac. He was enchanted, he told Guillemardet, by what he had seen, in spite of the endless rain, by the grand scale of the landscape with some valleys stretching away as far as the eye could see and with several immensely high mountains with pastureland from their feet to their peaks and everything broken up by granite rocks of all sorts of colours.[10] Here perhaps began that love of the dramatic scenery of Périgord and later of the Pyrenees which would inspire some of his most beautiful sketches. One result of his fever was that he found himself eating and eating, though, as he told Piron, digesting the food wasn't easy. From 1820 for ever more he would be liable to attacks of fever. But he was already working out an attitude that would keep him going. 'I feel an increasing need to work hard at those tasks which are necessary if I am to realise my potential.'[11] As he told his sister in December, 'this fever puts obstacles in the way of everything I undertake'.[12]

In 1821 his principal correspondent was Charles Soulier, who had gone to Italy as secretary at the French Legation in Florence. Soulier, he was sure, would not be interested in his amorous adventures, for he was timid in love, whereas Soulier was 'a cruel Lovelace' (when writing to Soulier, he often remembered that he was writing to his old English teacher). In Paris – it was January – he was writing by his fire and not even poking it could keep him warm. 'It's hot in Florence. You see bright sunshine, a blue sky . . . beautiful women. . . . You've got cheap ice creams and you can eat as much tagliardini and macaroni as you want.' He liked to fancy what it would be like when he too went to Italy. 'I shall go at nightfall to breathe in the cool sea air of Naples and spend the day sleeping in the shade of the orange trees. I shall go to Rome, to live with the dead and to forget everything but painting and friendship.' In February he was more rational. 'You miss Paris, I miss you and the Tuscany I do not yet know. I hate Paris, with its noise, damp and filth, and with the harsh cries of street traders and beggars. . . . Italy with all its attractions is just what one wants when one lives in the North. . . . One sighs for something that never comes.' By March he was practical again, having failed to place some watercolours Soulier had sent him and wanting to make some suggestions that could make them more marketable. As for his own *Sacred Heart*, that was not going well because of his dreadful fever. At the end of April he was back to being envious of Soulier's opportunities, but the letter did not go till the end of July, by which time he was

giving up all thought of entering for the Prix de Rome and thinking instead of entering a picture for next year's Salon. As late as September he was wondering about working on some subject from the war between the Greeks and the Turks (the Greek war of independence had just begun). He would have liked some scenes of Naples, where Soulier now was. For him, at that moment, Italy meant opera at the *Théâtre Italien*, with its beautiful music and its beautiful singers. The year's correspondence closed with a joint letter from himself and Pierret to Soulier, grumbling that he was an even worse letter-writer than they were.[13] It was almost 1822 and Delacroix's life was moving to a crisis.

When he wrote to Soulier in April 1822 he was about to exhibit *The Barque of Dante* and he had been to call on Soulier's mistress.[14]

Art and love affairs were suitable topics for Eugène's correspondence with his friends, but when writing to his sister he had to remember that art was his métier, a means of making money, and that love affairs, as he found out when attracted to Elisabeth Salter, were not likely to be encouraged. What mattered to Henriette was her position and the wealth necessary to sustain it. How that position was threatened is the story of the forty-three letters from Eugène to Henriette written between 1819 and 1822.

In 1805 their father had left a fortune of some 810,000 francs, consisting largely of property – the house at Charenton where Eugène was born, land in the departments of Beauce and Oise, and houses in Paris from 'national' property, that is property which had once belonged to the clergy and which at the suggestion of Talleyrand had been sold off to solve France's financial problems. Unfortunately Charles Delacroix had acquired many of these properties with the help of an agent, Jean-Pierre-Louis Boucher, a speculator who had used the opportunity provided by the selling off of much clerical and emigré land to amass huge properties without paying for them. In 1805 he owed the Delacroix heirs 174,000 francs and in order to safeguard the inheritance Madame Delacroix at once took out a mortgage on his goods. When the bills came in – he owed money to many other families – Boucher could not pay and so he was imprisoned for debt. In 1812 the courts awarded Madame Delacroix a property he had had since 1805, the forest of Boixe near Angoulême, which had once belonged to the noble family of La Rochefoucauld. The property, which had not been paid for, was said to be worth 237,549 francs 93 centimes. Madame Delacroix paid the cost of the legal fees, some 20,000 francs, but she never managed to pay anything else. She had no wish to live in the department of Charente and hoped to sell off the property at once to the State, which might see its usefulness for boatbuilding in the dockyards of Rochefort. Unluckily,

extensive maritime warfare was not on Napoleon's mind in 1812 and Madame Delacroix was left with the unpaid-for property on her hands.

Her widow's pension and some private means should have been enough to enable her to live comfortably in the large house they rented at 114 rue de l'Université and to educate Eugène at the Lycée Impérial. Her daughter Henriette and grandson Charles also came to live with her there, but on 3 September 1814 she died insolvent.

As Eugène was a minor and his brother Charles was away at war, Henriette's husband Raymond de Verninac inevitably became the manager of the family estate. When Eugène came of age, after litigation he was awarded, for about 300,000 francs, the major part of the inheritance – the forest – then mortgaged to the sum of 350,000 francs. This manoeuvre was disastrous. To develop the forest, keep creditors at bay, carry on various legal processes in Angoulême and in Bordeaux, his sister and brother-in-law soon realised that they must leave Paris and settle in Boixe. Boixe became not only Eugène's holiday home: it also became the unstated basis of his relationship with his sister.

The letters he wrote to Henriette begin in November 1819, when he had returned to Paris. Eugène had to try to sublet flats in the house they rented in the rue de l'Université. There was the concierge to pay, the chimneys to be swept, a laundress to be found. By the end of the month he had found one possible tenant, the Saxon ambassador or attaché, for two rooms on the second floor. In December he had to report the decrepit state of his clothes, a bitter blow to one so fastidious. Worse followed in January. He had to write to her from Guérin's studio because he could not afford to keep warm at home. M. Roger, one of the Verninacs' principal creditors, was demanding his interest and Eugène was alarmed that Henriette had sent money along with a hare. Had the package been opened, as it might have been, there would have been a large fine to pay. This time he was writing from home. The Seine was frozen over so that people could walk across it, his hands and his feet were cold and the water in the carafe beside him had turned to ice. Next month he had to confess paying forty francs for a harpsichord, but defended himself on the grounds that he could not have bought a violin for so little. He was bored with having to live alone. Soon he would be apologising for not acknowledging the money she had sent him. He had been unable to send her financial details in his last letter, since he had written to her again from M. Guérin's. In March he had a lot more news. The tenants would pay only 1,400 francs, there were tradesmen to pay, he had had to buy a cartload of wood, he had hoped that the Prime Minister, M. Decazes, would buy a picture, but the recent political crisis caused by the assassination of the duc de Berry had ruined Eugène's chances as well as Decazes's career. All he could report in the line of profitable work was the fact he had sold some

lithographs, which, after paying the expense of doing them, had covered the cost of some shopping. He added by way of postscript: money is owed for the shutters; the tenancy agreement has fallen through; and he has a month to find some other person to take some part of the house.[15]

Within a short while the themes of the correspondence had been set. Always there were the same problems: how to let part of the house; how to pay taxes; how to pay for repairs or maintenance. While he supervised his nephew Charles at the Lycée Impérial, there was not just the question of Charles's reports and his health – he usually seemed more robust than his uncle – there was also the question of finding his school fees. To save money Eugène dined in a cheap restaurant. All that cheered him up was the time he spent with his friends Pierret and Félix (Guillemardet) and Soulier. Uncle Pascot and cousin Lamey were kind and helpful, but they had little in common with him. Uncle Riesener, the painter uncle who wanted him to go to Brussels to study under David, was just back from Russia, and loaded with diamonds and cashmeres and beautiful furs and 10,000 roubles. Delacroix was encouraged when Géricault handed on to him a commission to produce a *Sacred Heart* for the bishop of Nantes. This had to be painted in Géricault's style. Work, friends, family, money, above all saving money dominated his thoughts. And there was his own physical weakness to contend with. He went to see a doctor and thus doctor's bills and chemist's bills had to be added to the others. He had to work fast, so that models would not stay too long and be too expensive. He had to invent reasons for not paying the mason; and the decorator wanted to know the Verninacs' address. He hated writing, because every letter told her of a new expense and asked for more money. Sometimes she pleased him with her little presents, above all her delicious pâtés. He was hurt that she could think that he could think that she was flush with money. He could occasionally smile wryly at his condition. With some money he could do better: even his hat was beyond repair. He wrote regretting that he would not be coming with Charles to Boixe. Something beside the anxieties he shared with them all had begun to surface in his letters: he was thinking of preparing a painting for next year's Salon . . . then he would have to pay for his models and to eat and to wait to be paid.

That autumn and following spring matters came to a head. His nephew Charles had given up his legal studies and did not return to Paris. When he wrote, Eugène added a note to Charles in Latin of an Italianate kind, *quid possem dari matri tuae per il principium anni proximi?* (what may I be able to give your mother for next New Year?) He wrote to wish all happiness for 1822. For him, as we know from his correspondence with his friends, New Year's Eve, the feast of Saint Sylvester, was an important reunion. It would have to take place without Charles. He knew Henriette was worried about her husband's health. He still

had to write her business letters and the tone grew colder. 'I am surprised that in asking me what you did in your last letter you should have forgotten to tell me your motives.' Faced with her recriminations for his conduct, he tried to reassure her that he truly cared for her and Charles. The subject for his painting for the Salon, he said, was taken from Dante and he had made a sketch for it when he had been ill in the forest.[16] When he next wrote, his painting was already exhibited, the day after his brother-in-law, as he later found out, had died.

The death of Raymond de Verninac precipitated the fall of the house of Delacroix. Though the forest might have been worth 560,000–580,000 francs if sold off in separate lots, the principal creditors, the brothers Roger, were determined to force a quick sale. In the end the courts granted the forest to the Rogers for 222,000 francs, an enormous sum, but not enough to cover the Delacroix family debts. Eugène's brother continued to live in his sordid ménage near Tours, his nephew Charles had to find a job and began in commerce, which Eugène tried to argue was an aristocratic occupation, and Henriette had to come back to Paris. For the once proud beauty who had stared out of David's great portrait there was a cruel destiny in store: Madame l'ambassadrice ended her days, the last five years of her life, as a lady's companion.

By luck and ability Eugène's father had risen from the provincial bourgeoisie into the ranks of the Parisian haute-bourgeoisie. Within only eighteen years of his death – the property of Boixe was finally surrendered in 1823 – his three surviving children had lost the basis on which their social position stood: wealth. Neither Charles nor Henriette had any hope of redeeming their situation and relapsed, he into provincial boorishness, she into metropolitan genteel poverty. Only Eugène and young Charles had hopes that their father and grandfather's name might once more mean something in society.[17] Much of Eugène's subsequent behaviour – his careful attendance at social gatherings which bored him and his fight over a period of twenty years to be elected to the Institute – shows his acute awareness of the importance of social position. Whoever his true father was, he always struck those who met him as instinctively an aristocrat, but he became very, very careful with money. He was also an instinctive bourgeois.

To succeed as an artist precisely when he needed to do so, in 1822, he had to have great confidence in his abilities. As a student at the Beaux-Arts he had a far from distinguished record. In April 1822, just before his first Salon painting was on show, he was placed 59th out of 61 in the competition for places in the Salle du Modèle at the Ecole des Beaux-Arts; and yet the one important work of art for

that year produced by any young artist was by him. Before that year his surviving paintings do not show anything like the precocious talent of a van Dyck or a Picasso. Most are unremarkable. His first commission, a Madonna and Child for the village church of Orcemont, is a pastiche of Raphael. Some feeling for his own situation animates the gloomy mood of his self-portrait as Ravenswood, for Walter Scott's hero from *The Bride of Lammermoor* had also lost his land, but he neglected to finish it. His *Sacred Heart* had been done in the manner of Géricault, as the commission depended upon his copying Géricault's style; and the resulting picture was so little noticed that not until 1930 was it rediscovered, a century after having been sent not to Nantes, as originally intended, but to Ajaccio in Corsica. But for the link with Géricault, until 1822 Delacroix too might have passed unnoticed. He can be found, however, in Géricault's masterpiece, *The Raft of the Medusa*. He had posed as one of Géricault's models and his naked back at least had achieved fame.

He himself had achieved fame in his own right with a boat scene more terrible in subject even than the story of the survivors of the wreck of the Medusa. Géricault's picture had dramatised a naval scandal. Callous officers had left most of the passengers and crew behind while they made good their own escape from a sinking vessel. After horrific moments, which had included an outbreak of cannibalism, a tiny remnant had lived to be picked up by a ship called the *Argus*. When the story was published Géricault had been determined to be its illustrator: he was careful to be authentic; he interviewed survivors, studied corpses in the morgue, had the raft reconstructed. The painting was life-size. It could not be so accurate as to be unacademic; and critics could notice debts to Michelangelo in the nudes, to Rubens in the occasionally fluent brushstrokes and in the composition, and debts to Caravaggio in the stark mood and in the earthy colours. Géricault also chose to make the painting a message of hope, for some of the crew are hailing the boat which will rescue them and which lies just off the canvas. The painting was an inspiration to younger artists, Delacroix among them.

Delacroix shared Géricault's disdain for the restored Bourbons. He had amused himself by producing anti-royalist cartoons and he had gone so far as to produce a romanticised engraving of Louvel, the assassin of the duc de Berry. But when it came to a painting for the Salon he moved beyond politics to a more universal theme. His picture is set in a Dantesque hell, where all hope is left behind. He chose the moment when Dante and Virgil are ferried by Phlegyas to the city of Dis across the lake where flounder guilty souls eaten up by violent anger. As with Géricault's painting perceptive commentators could find what he had learnt from Michelangelo – *la hardiesse de Michelange* – or Rubens – *la fécondité de Rubens*; and more modern commentators have discussed the novel

treatment of the waterdrops. What is much more astonishing is that, whatever his academic borrowings or technical traits, Delacroix had projected onto canvas that poetry of torture which Chateaubriand had found in Dante. At one bound Delacroix became like Géricault a supreme master of the art of despair. Frustrated fury, over which he had first meditated when sick with fever in the forest, is raised from a purely selfish preoccupation to a universal human experience. In this way he was the first French artist to express Dante's vision in paint.

The Journal of a
Young Romantic (1822–24)

O N Tuesday 3 September 1822, while staying with his brother, Delacroix began to keep a diary. 'I am putting into execution the project I've set myself so many times of keeping a diary. What I want most keenly is not to lose sight of the fact that I am writing for myself alone. I hope then that I'll be truthful. Because of it I'll become better. These pages will reproach me for my changes. I start it in a happy mood.'[1]

September 3 was an important day in Delacroix's life, for it was the anniversary of his mother's death. Within a few days he would face the consequences of her mismanagement. On 7 September he and his brother Charles made a legal agreement with M. Thiffeneau, the lawyer in charge of their case in the litigation involving the forest. Five days later he wrote the last extant letter in his long correspondence on financial affairs with his sister Henriette. He thought of his mother, however, only with respect. He hoped that her spirit would be with him while he wrote.[2]

Delacroix's diary is therefore not just a record of daily events, of conversations with his brother, of the copying of some engravings after Michelangelo, of a mild flirtation with his brother's maid Lisette, whose voice reminded him of Elisabeth Salter. It was also a confession and a spur to action. He would write of his social life, his art and his *amours*.

Even while he was enjoying himself at Le Louroux, he knew he had to return to Paris, where there would be no Lisette, no peace, no moonlight. While with his family he knew he could not escape the past. On 7 September his uncle Riesener, cousin Léon Riesener and cousin Henri Hugues arrived unexpectedly. The party talked about his father and Delacroix was keen to listen; and so it was that he learnt of his father's bravery in the Netherlands when confronted with

plotters in government employ and of his father's bravery under the surgeon's knife. 'Think of strengthening your principles', he commented, 'think of your father and overcome your natural frivolity.'[3]

Luckily Delacroix had his future to think about. On 1 September he had received word from Félix Guillemardet that his picture was hanging in the Luxembourg palace. On 24 September he would see it in place. He would be sad to say goodbye to his brother, but it was in Paris, not in the provinces, that he had to pursue his career. When his uncle Riesener saw and liked his picture, he knew that he must follow his own path.[4]

From October 1822 to October 1824 Delacroix's diary is virtually the sole source of information about his inner life. It shows him preoccupied with art, with girls and with friends – it is the journal of a young Romantic.

Perhaps it was the success of his picture which encouraged Delacroix to begin his diary. *The Barque of Dante*, which the State bought for 2000 francs, made his reputation, a reputation confirmed by his *Scenes from the Chios massacres*, for which the State paid 6000 francs; and page after page of his diary records his progress in the painting of his picture. And after it was hung on temporary display in the Louvre, there are only three days of entries in the diary before it stops abruptly, not to be resumed for more than twenty years. His juvenile *Journal* is framed by these two paintings.

For the Salon of 1822 Delacroix had abandoned his original idea of taking a subject from the 'recent wars of the Turks and Greeks'[5] in order to work on his Dantesque theme. The Greek theme, however, must have stayed at the back of his mind. Like his numerous fellow Philhellenes – Russians, Germans, Italians, Englishmen as well as Frenchmen – he had learnt a love of the classics at school. Now that Greece was in the news, ever since the outbreak of the war of independence in 1821, it seemed no great imaginative leap from the ancient to the modern Greeks. Despite his classical training in literature and his Neo-Classical training in art, he was a Philhellene of a most up-to-date kind. What attracted him was the exotic world of the contemporary Near East. His brother-in-law had been ambassador in Istanbul and his brother had been in Turkey. One evening in 1822 his brother had told him of a rough Turkish custom. 'When the Turks find the wounded on the battlefield or even the prisoners, they say to them "Nao bos" (Don't be afraid), then they hit them on the face with the hilt of their sabre so that they lower their head, and then they cut their head off.'[6] If he were honest, Delacroix was as much fascinated by the violence of the Turks as he was led to sympathise with the sufferings of the Greeks.

The contrast was of course a false one, for both the Turks and Greeks were violent and both Turks and Greeks suffered terribly. The war had begun with the wholesale massacre of Turks by Greeks and it had continued with successive

acts of vicious reprisals. That was not how the war was reported in western Europe or Russia: to youthful idealists it was simply a war between right and wrong. The Greek bandit leaders or klephts appeared as so many Spartans or Athenians fighting the heirs of the Persian hordes. Mentally they were clad not in their Albanian kilts but in the naked beauty of ideal bodies, like the soldiers in David's *Leonidas at Thermopylae*; and if, alas, none of the klephts were so called, there was one crafty scoundrel called Odysseus.

As with his Dante painting, Delacroix was anticipating taste when he wrote in his diary: 'I have decided to create for the Salon scenes from the massacres of Scio [Chios].'[7] He had chosen some of the most horrific events of recent times, which made the story of the wreck of the *Medusa* seem insignificant. He had chosen a subject worthy of a successor to Géricault, a Dantesque incident of hell on earth. Instead of the mere hundred and fifty or so involved in the *Medusa* story thousands of Chians had been butchered, raped, sold into slavery, tortured and executed; and sacks of human heads, ears and noses from Chios had been thrown into the streets of Istanbul, to be trampled on and to rot. Neither the Chians nor the Turks had started the trouble. It was men of Samos, jealous perhaps of the quiet prosperity of Chios, who had implicated the Chians by invading their island, burning a mosque or two and encouraging a few islanders to join the revolution. The Turks had struck back not just to punish the Chians but chiefly to warn their neighbours that rebellion did not pay. What the Turks failed to understand were the feelings of revulsion which their actions would cause in the West. A plausible French sailor, Olivier Voutier, publicised his romantic version of what he had done in the Greek army in his *Memoirs on the Present Greek War*, which came out in 1823. Through his brother-in-law's brother, Verninac de Marseille, Delacroix gained an interview with Voutier. Just as Géricault had sought information on the adventures of those who had survived on the raft of the *Medusa*, so Delacroix tried to find out the truth about the war of the Greeks.

The meeting with Voutier occurred on 12 January 1824. Delacroix made mental notes. 'Massacre of Chios lasting a month. It was at the end of this month that captain George of Ipsara with, I believe, a hundred and forty men burnt down the Turkish flagship. The chief Turkish officers and the captain-pasha himself were killed. The Greeks were safe and sound. A boat which was taking the head of the brave Balleste, a French officer, from Candia to Constantinople had put into port in Chios and was deprived of its horrible trophy. The ship was fired on and the head of the brave Balleste had a grave worthy of him. . . . It's strictly today, Monday 12, that I am starting on my picture.'[8]

For all the early part of the year and well into the spring and early summer Delacroix records the parts of his picture he was working on, the names of his

models (some of them friends and relations), how Thales Fielding and Soulier came to work with him (they helped with the background) and how 'Monsieur Auguste' received him (he helped with the accessories). He was nettled by the comments of a Neo-Classicist visitor to his studio. When a pupil of David's, Georges Rouget, saw the picture, it looked a mess and he said as much.[9] Delacroix was buoyed up eventually by the praise of the finished product by no less a painter than Baron Gérard. He does not record how he reacted to the criticism of Baron Gros, that his work was 'a massacre of painting'.

Two entries for June just hint at one of the most persistent legends of Delacroix scholarship: the impact on him of the Constables he saw at the Salon. From Géricault, who had been to England in 1820, he already knew of the excellence of Constable; and in Paris in 1824 *The Haywain* was a sensation. It may well have been the sight of that painting that led Delacroix to rework the surface of his painting to achieve an English freshness, to transfer the glistening light of a Suffolk noon in May to the parched earth of an Aegean island in April under a brilliant sun. Delacroix would write to Théophile Silvestre in 1858: 'I have already told you about him [Constable] and of the impression that he produced on me at the moment when I was painting *The Massacre of Scio*.'[10] Years later Andrieu, his old assistant, told how under Constable's influence Delacroix, with the permission of the comte de Forbin, worked at highlighting the canvas while it was in place in the room of ancient art in the Louvre. And yet the finished work, however eclectic its sources, remained unmistakably French. One critic implied this when he contrasted it with David's Greek masterpiece: 'I call classic *Leonidas*. . . . and romantic the *Massacre of Scio*.' Another thought it an inferior painting in the manner of Gros's *Plague at Jaffa*. A third, Thiers, was more complimentary about its Frenchness, calling Delacroix 'the cleverest colourist of our school': and Thiers wrote with the blessing of Gérard. Fourthly, Delacroix's friend Auguste Jal seized on the importance of its political message, arguing that Delacroix had 'amply deserved the friendship of the enemies of despotism which he has shown in all its horror'.[11]

Finally, a much greater writer than any of these critics, Stendhal, took an intermediate position. He had recently met Delacroix at the salon of Baron Gérard, but, though the two would become friends who warmly appreciated one another, at this stage they viewed each other warily. Delacroix did not think much of Stendhal's *Life of Rossini* and Stendhal was at best a sceptical enthusiast for Delacroix's *Scenes from the Chios massacres*. Having stated at the start of his review of the 1824 Salon that Delacroix exaggerated sad and sombre moods, he continued: 'I cannot admire M. Delacroix and his *Massacre of Scio*. This work seems to me always a painting originally meant to represent a plague and of which its author, according to the news in the gazette, has made a Massacre of

Scio . . . M. Delacroix has a feeling for colour. I seem to see in him a pupil of Tintoretto; his figures have a sense of movement.'[12] Stendhal had seized on the paradoxical nature of Delacroix's achievement. The painting is languidly exotic, suggesting nothing so much – in some of the foreground figures – as rotting flesh. At the same time – especially in the mounted Turk to the right – it has in places a quality of quicksilver vitality. It is the second quality which Delacroix valued the more highly. As he wrote on 7 May, 'If I'm not wriggling like a serpent in the hand of a pythoness I am cold; I must acknowledge and accept the fact, and it gives great happiness. Everything that I have done well has been done in that way.'[13]

It does not need the special skills of a psychologist to understand that instinctively Delacroix thought of artistic activity in terms with sexual connotations. Side by side with the theme of the art of painting another theme runs through his youthful *Journal*: his romantic and physical relationships with women.

The affair with Lisette at Le Louroux was yet another of his encounters with pretty maids. Writing to Pierret in August 1822, just before starting his diary, he compares her to 'an antique huntress' and thinks of her as a hind 'worthy of drawing Diana's chariot'.[14] The classical language is scarcely fitting to a peasant girl, but it does suggest that precisely what attracted him was her chastity. He enjoyed chasing her and being repulsed. When his cousin Henri Hugues came to call, he was shocked by the crude remarks Henri made to her. 'I have respect for women . . . I don't think my poor reserve is the way to succeed with them.'[15]

Back in Paris in the company of professional models it was a different matter. Just three weeks after saying goodbye to Lisette, he recorded the visit of a young woman called Marie, who came to pose for him on 15 October, and he noted, 'I risked syphilis with her'.[16] There are too few entries for 1823 to be sure how often he behaved in this way, but the following year, however preoccupied with his *Scenes from the Chios Massacres*, he still had time to chronicle his rake's progress with Emilie, Laure, an unnamed black girl and others. His careful accounts seem to imply that services in bed numbered among the services for which he paid these girls. It is also revealing that he often uses an Italian slang expression for sexual intercourse with them: *la chiavatura*. His recourse to a foreign language suggests that he was embarrassed by his behaviour. An entry for 7 April 1824 seems to bear out this interpretation. 'This morning Hélène came. Oh, disgrace, I couldn't.'[17] Thereafter there were fewer mentions of *la chiavatura* and on 1 June he went to see Doctor Bailly about the general state of his health, worried chiefly it seems that he might be becoming impotent. On

returning home, he was frightened of the face he saw in the mirror. Bailly, he reflected, was the man who must bear into his soul a fatal torch which 'like the candles of the dead lights up only the funeral of what remains of the sublime'. He adds, addressing himself: 'Lover of the muses, you devote to their worship your purest blood, ask again of these learned divinities the lively, shining eye of youth, the joy of a free spirit. These chaste sisters have done you more harm than courtesans ... The true wisdom of the philosopher ought to mean the enjoyment of everything.'[18] But he found it hard to persuade himself. He felt guilty and inadequate. Was he really trying to keep his promise to the soul of his dead mother? 'May her shade be present while I write [my diary] and may nothing in it make her shade embarrassed about her son!'[19]

Torment was an essential part of his relationships with women. One evening he followed a tall working girl as far as rue de Grenelle, then failed to approach her.[20] Another time, when he had a crush on the housekeeper of the marquise de Puységur, he saw her with a servant of the marquise and would have loved to have taken them both by the hand but automatically backed away.[21] He was susceptible, with all an artist's sensitivity, to good looks; and he spent one evening at the Théâtre Italien looking 'incessantly' – he used the English word because he was with an Englishman, Fielding – at Madame Conflans, the lovely sister of Félix Guillemardet.

The most tantalising woman in his life at this moment involved another of his friends. Soulier had written from Italy to ask him to visit his, Soulier's, mistress; and so began a tortuous affair with 'J' or 'La Cara'. He was torn between his feelings of guilt, even betrayal, his need for sensual pleasure and his search for enduring affection. In June 1823 he was thinking wistfully about the advantages of having a wife: 'a wife at your level is the greatest of goods'. For five months he writes nothing in his diary, till quite suddenly he records a sexual encounter with '*l'amie*'.[22] Next day he drafted two letters to her, one altruistic and pleading, the other a passionate farewell. Characteristically it was not the end. He was still drafting a letter to her in June 1824 and wondering, 'Shall I send it or no?' He remained irresolute. He did nothing.[23]

Fortunately for Delacroix his dealings with his own sex were less problematic, unless, that is, there was a woman involved, as there was with Soulier. His masculine relationships were far wider in their range and he found in them a sociableness which balanced his isolation as an artist.

In his more pessimistic moods he considered that he had just two or three friends, but the diary shows that he had many acquaintances, almost all of them artists. In time he would be drawn into a wider world that included writers and

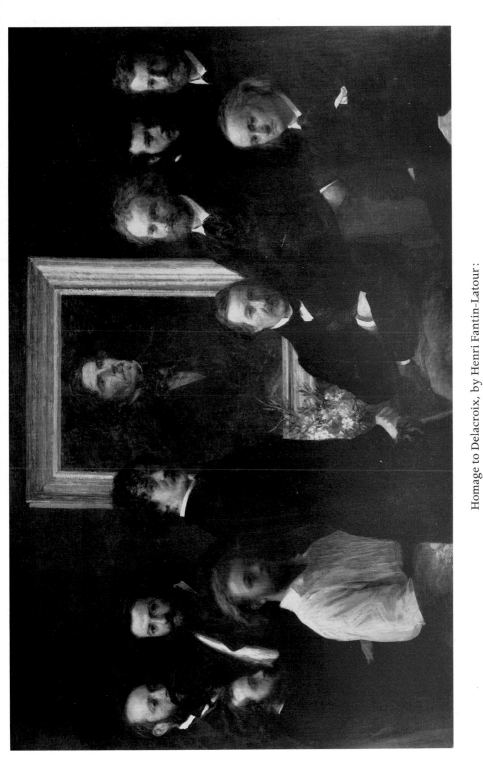

Homage to Delacroix, by Henri Fantin-Latour:
fourth from left, Fantin-Latour, fifth from left Whistler, seventh from left Manet, eighth from left Baudelaire.

Delacroix's birthplace at Charenton

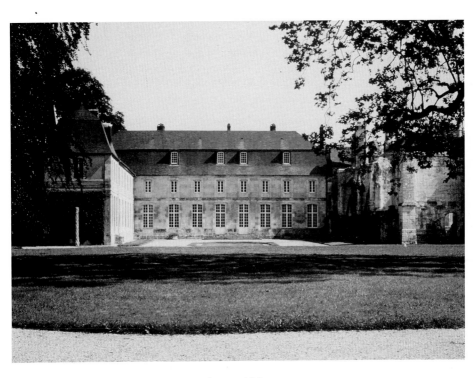

Valmont Abbey

Rear view of the Maison de gardes, Forêt de Boixe

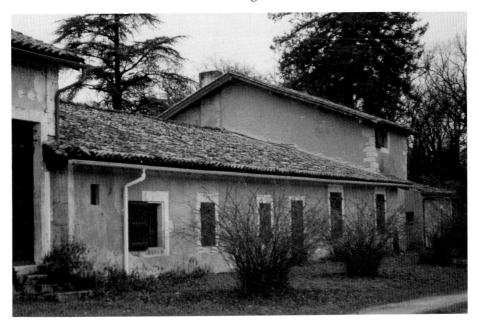

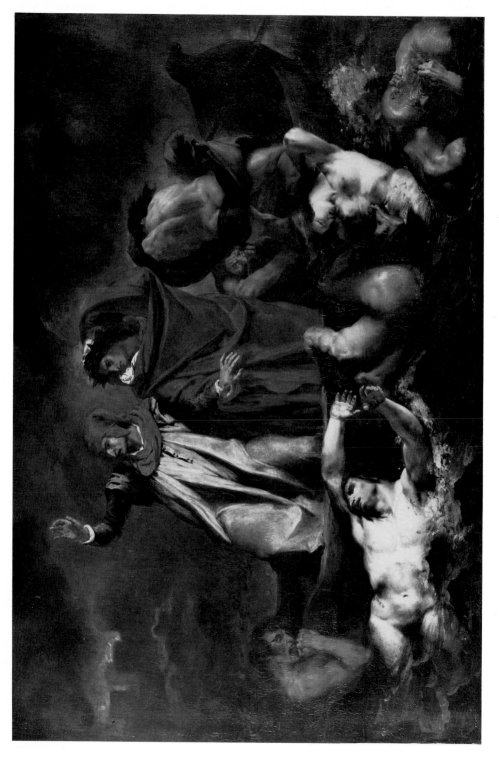

The barque of Dante

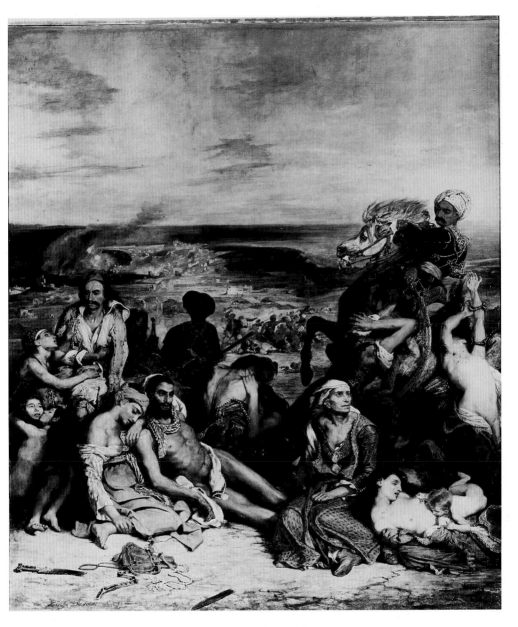

The Massacres of Scio (Chios)

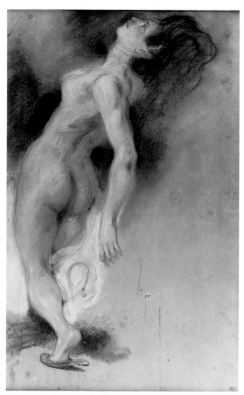

Preparatory studies for the Death of Sardanapalus

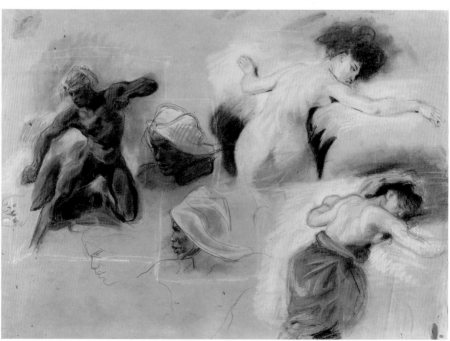

The death of Sardanapalus

The murder of the bishop of Liège

musicians and politicians, but the early diary shows who was who in the narrow world of a youthful painter whose student days were scarcely behind him. One or two of the artists were to be well known. Ary Scheffer, for example, he got to know through his younger brother Henri. They were both former pupils of M. Guérin and both active in revolutionary politics. He also knew, but less well, the somewhat older artist Horace Vernet, son and grandson of well known painters, a keen Bonapartist in his sympathies who would become a millionaire. Only one of these artists, other than Delacroix himself, has ever been considered great. He was the only young artist whom Delacroix mentions with something like awe.

Théodore Géricault was more than an acquaintance and less than a friend: he was a mentor, the leading personality among the artists who had become famous during the Restoration. He had lived near Delacroix in rue de l'Université, he had been at the Lycée Impérial, he had been a pupil of Guérin's. For him Delacroix had posed and for Delacroix he had passed on the commission of the *Sacred Heart*. From him Delacroix had acquired a love of modern English painting, especially for Constable and for English equestrian art. From *The Raft of the Medusa* came the theme and colouring of *The Barque of Dante* and the compositional organisation of *Scenes from the Chios Massacres*. By 1823 Géricault was a very sick man and Delacroix was moved by a visit from him in May.[24] When he in turn visited Géricault in December, he was saddened to notice how thin the invalid's arms had become – Géricault had been something of an athlete and an impressive horseman – and how like the head of a dying man his head was and how poignant to think that someone 'in all the passion and vigour of youth' must soon die.[25] On 27 January 1824 he heard of Géricault's death. 'Though he wasn't exactly my friend, this unhappiness has pierced my heart.'[26] At various moments that year he went to Géricault's sale and tried to salvage what he could ill afford. He was flattered to learn that Géricault had thought highly of his own picture.

Many years after Delacroix would be more critical of Géricault's art, which he found far too academic. But he also saw him in the line of those who, like Rubens, had evolved a free Michelangelesque style and he saw him in the line of the great French painters who had followed David, the most Romantic of them but also the one who had best assimilated the vigour of the Florentines. With the more graceful Prud'hon he had opened up 'infinite horizons' and made possible 'all novelties'.[27]

Delacroix reveals in his youthful diary how he came to quick maturity as an artist while failing, especially in his relationships with women, to mature early as a man. Ambitious for success, hard pressed for money, sometimes excited,

often depressed and tired, both shy and affectionate, unsure of himself but sure of his ideas, he was alternately exalted and worried by the problems he faced. Meditating at night on the beauty of the stars, he was convinced that a loving Father must have ordered the world.[28] At other times he cursed his weakness. Conscious that without memory his life would lose meaning for himself, he tried to capture its fugitive nature in his day by day account of his actions and his thoughts. 'The future is all black. The past which hasn't remained at all is equally so . . . In preserving the story of what I experience I live twice over; the past will come back to me again. The future is always there.'[29]

He wanted to be great, inspired by Michelangelo and Rubens and looking for inspiration to Dante and Byron. The inevitable consequence was to heighten his sense of isolation. 'Nature has put a barrier between my soul and that of my most intimate friend.'[30] His attempts to cross the barrier led to disappointment. After he kept *le Saint-Sylvestre* with Guillemardet and Pierret he felt let down.[31] He could not find the woman with whom he could share his life. He was doomed to solitude, for only in solitude could he create and through creation communicate.

Silence falls on his life when the *Journal* stops. When next he speaks, he is in England.

The English Style (1824–30)

AT the Salon of 1824 Constable, Copley Fielding and Bonington were awarded gold medals. The occasion was a triumph for the English school; and Delacroix, whose *Scenes from the Chios Massacres* had been called Shakespearean, had owed much to his Anglophile leanings and English connections.

According to Soulier, his friendship with Delacroix dated back to 1816. The son of a Frenchman who had emigrated to England, Charles Soulier had been educated there before returning to France. Soulier had learnt watercolouring from Copley Fielding, the most talented of a family of painters. He gave evening lessons in English to Andrieux of the Académie Française; and in his attic rooms in place Vendôme, which he occupied as secretary to the marquis de la Maisonfort, he spent his spare evenings entertaining other young people. One of his fellow secretaries was Horace Raisson, who had known Delacroix at school, and it was Raisson who introduced Delacroix to Soulier. Soulier later recalled how at this stage Delacroix was 'an admirer of Shakespeare, Byron and the English classics as well as of the painting of Reynolds, of Füssli, of Turner, of Constable and of the Fieldings'.

This information about the early years of their friendship was supplied by Soulier himself in a note which he attached to the first letter he ever received from his famous pupil, which was couched in Delacroix's special brand of halting franglais.

10 décembre 1818

Dear Friend,

I am very displeased to cannot to go Saturday to pass the night in your pleasant company; for I have promised another person to see her that day; it is not, as you shall imagine as M. Horace (Raisson) also, without a great

discontentement. But I hope it will not be the last time, we shall have the opportunity of come together. I thank you at your Italian-english-french and grateful letter. I conjure you to excuse my bad english language. I dare a little time past with your obligeant lessons, I will better speak and write in that fair tongue, in which I am so desiderous to be readily instructed ...

<div align="right">Your sincere friend and thankful disciple.[1]</div>

From Soulier Delacroix learnt besides the rudiments of the language the rudiments of the quintessentially English art of watercolouring. He soon became an admirer of other, more talented Anglo-French artists, first of Richard Parkes Bonington (1802–1828), then of the brothers Fielding. In his letter of 31 December 1858 to Théophile Silvestre,[2] Delacroix said that he first met Bonington in 1816 or 1817, but, as Bonington and his parents did not move from Nottingham to Calais till 1817 and as Bonington does not seem to have come to Paris before 1818, the meeting cannot antedate that later date. In 1820 Bonington was placed 25th and Delacroix 32nd of the 64 candidates for the Salle de la Bosse at the Ecole des Beaux-Arts, and in 1821 Bonington studied briefly under Baron Gros, an artist who was to have a profounder influence on Delacroix himself. But there is no evidence that the two were then close friends, nor is Bonington mentioned in the 1822–24 *Journal* nor in the few extant letters of those years. At that time newer English arrivals in Paris mattered more to Delacroix. In March 1824 he records no fewer than nine meetings with 'Fielding'. The problem is to know who 'Fielding' was. Frederick (1784–1853) and ultimately the *most* famous brother Copley (1787–1855) were at this stage working from the family home in Newman Street, London – Frederick was to come to Paris in 1825 and Copley had great success in the 1824 Salon. The oldest brother of all, Theodore (1781–1851) had come to Paris and gone back to England in 1823. 'Fielding' therefore must be one of the two younger brothers, both nearer in age to Delacroix: Thales (1793–1837) or Newton (1797–1856), both of whom had been in Paris since 1821 or 1822. Delacroix first mentions the Fieldings in May 1823. By the following year he was a close friend of the brothers, studying the process of aquatint with them, improving his mastery of watercolouring, and, when Thales left to return to London, moving into his friend's atelier in rue Jacob. A portrait of Thales and perhaps a portrait of Newton commemorated the friendship in oil. In return Thales painted a portrait of Delacroix, which survives only in the recently invented English medium of lithography. Thales shows Eugène's handsome face under his curly black hair, a gentle smile just breaking on his lips, his elegant figure dressed *à l'anglais* with cravat, collar and shirt all white, set off against a smart black morning coat, the epitome of an Anglophile dandy.

With Soulier and the Fieldings English was the language of friendship: with Elisabeth Salter, briefly, it had been the language of love. That love Delacroix had thought of in English literary terms, influenced as he was at that time by Laurence Sterne's writings.

By 1815 the delicate indecencies of Sterne were becoming old-fashioned, but never before had there been such a fashion among Frenchmen for English literature. Napoleon had always sensed the dangerous partiality of the French for things English and had wanted to place round France a *cordon sanitaire* to keep out English culture as surely as English cloth. He had met his Waterloo and with the conquering tradesmen of the nation of shopkeepers came the conquering books.

The most puzzling of English authors to French critics had long been William Shakespeare. How could he offend the canons of good taste by mixing comedy with tragedy and by failing to observe, except on rare occasions, the unities of time, place and action? He had been known to Voltaire in the 1720s, but the leap of sympathy which enabled Voltaire to understand odd English attitudes to religion or odd English institutions like Parliament and the Stock Exchange did not prevent Voltaire from continuing to write plays as if there was no viable alternative to the classical tradition of France. Only in the 1820s did a famous Frenchman argue the merits of the English eclectic tradition, when Stendhal published in two parts *Racine et Shakspeare*. A first attempt to introduce Shakespeare's plays to a French audience had been made in 1822, and it had been a disaster. Next year, enraged by the complacency of his conservative compatriots, Stendhal struck a blow for artistic innovation. 'Romanticism is the art of presenting to people the literary works which, in the contemporary state of their customs and beliefs, are able to give them the most pleasure possible. By contrast classicism presents them with the literature which used to give pleasure to their great-grandfathers.'[3]

Delacroix was to be a life-long admirer of Racine. As a young man he decorated the rooms of Talma, the foremost classical actor of the day; and he would paint a portrait of Talma in one of his most celebrated roles, as Néron in Racine's *Britannicus*. That did not prevent him from early discovering the delights of Shakespeare in English. In 1820, when he had written to Soulier from the forest of Boixe, he told how he had found during his illness consolation in Shakespeare. 'I live tristly, without any stomach. I see with impatience from my window the murmuring trees and singing birds. But nor the barking dogs in sonorous groves, nor the raising sun with all its splendor refresh my senses or rejoice them ... Through my lucid moments I take my faithful *Richard III* who was not, I believe, so sweet and delightful to his brothers, nephews and attendants, that to my mind and in my hands. I know not for what reson [*sic*] this

tragedy is not placed in number of the betters of Shakespeare. I own there are some long things and needless, but there is always to be felt the talent of author in the living painting and investigation of secret motions of human heart.'[4] His interest in the play dates back at least to the previous year, for in a letter of 23 September 1819 to Félix Guillemardet he summarises the troubles of the house of Lancaster before giving a prose translation of the speech delivered by Ann Nevill, future wife of Richard, over the body of Henry VI, whom Shakespeare supposes he had murdered.

The simple 'set down, set down your honourable load' becomes the dignified '*Posez, posez à terre votre charge honorable* . . . '[5]

The love of Elizabethan England which usually goes with the love of Shakespeare was converted by Walter Scott into a general love of the past. The first of the Waverley Novels appeared in 1814. Then came a mania for Scottish songs, even for Scottish dialect poems; and after George IV's visit to Edinburgh the tartan returned; and later, after Queen Victoria went to the Highlands, the bagpipes and the kilt came to court. But in the 1820s the Scottish revival had just begun. What Scott fed above all was the taste for the literary picturesque. *The Bride of Lammermoor* had dramatised the strain suffered by a girl from the dispossessing classes who falls in love with a laird who has been dispossessed. What made the story a hit was its romantic, not its political, theme. It was also Scott's shaky knowledge of the English early middle ages which was sometimes appreciated more than his grasp of the recent Scottish past; and *Ivanhoe* enjoyed a European fame denied to *The Heart of Midlothian*. In France for obvious reasons a finer medieval novel, *Quentin Durward*, being set in the France of Louis XI, was an instantaneous as well as a deserved success. It was time for a French Gothick Revival.

Delacroix and his friends quickly responded to the new writer and to the new genre of writing. Around 1821 or 1822 Delacroix painted himself as Ravenswood, hero of *The Bride of Lammermoor*. Some critics have thought that the seventeenth-century black costume and the introspective melancholy of its wearer are better suited to Hamlet, the withdrawn intellectual of Coleridge's analysis, but the documentary evidence and Delacroix's circumstances – the sale of the property in the forest of Boixe would soon leave him like Ravenswood dispossessed – show that the portrayal is indebted to Scott. In 1823 he tried his hand at illustrating *Ivanhoe*, not very well, he thought. Meanwhile a liking for Scott spread to other artists, to Bonington, with his sounder knowledge of English, and to Paul Huet, who had been in Baron Gros's studio when Bonington had been there. Already in 1823 one young Romantic writer, Victor Hugo, had singled out a chapter of *Quentin Durward* as among the finest in the book: the 'hideous and revolting portrayal of the orgy' in the course of which Guillaume

de la Marck, the so-called 'Wild Boar of the Ardennes', himself cut down and killed the bishop of Liège. Four years later Hugo would be wishing Delacroix well with his version of that very scene; and the resulting picture would be his most powerful rendition of Scott's historical romancing.

Among English authors, however, none mattered so much to Delacroix and the generation of 1820 as Byron. News of the poet's *Childe Harold* first reached France in 1812, the year of Napoleon's retreat from Moscow, and the man who had been everywhere, done everything and enjoyed nothing brought an exciting thrill to prospective young readers who had had no experience and had no hope of having any. In 1816, the year after Waterloo, *Zuléïka et Sélim, ou la Vierge d'Abydos*, was the first poem to be translated into French. It opened up the exotic Mediterranean in a more immediate way than Chateaubriand had done with its talk of 'harems' and 'bulbuls', 'beys' and 'pashas', its hint of incestuous love and its inevitable tragic *dénouement*. *The Bride of Abydos* was so successful that within two years all Byron's published writings were available in France. As it came out, the French *Don Juan* quickly followed the English; the unactable plays were produced in Paris; and Byron's cloak and dagger life in Italy was exciting and his martyr's death in Greece glorious and moving. Byron was a Milord. He also had three other unfailing assets: he had a handsome face; he had travelled in unfamiliar places; and he was agreeably wicked. It was irrelevant that some of the poetry was bad: the French read it in the dull prose translations of Amédée Pichot. What mattered was that Byron was a hero for men of the time. *Childe Harold* had their sense of futility; in the Turkish tales they felt the lure of forbidden loves in far-off lands; and in *Don Juan* they took a comic antidote to lust. His death for liberty had canonised the libertine. Byronists of an active nature took ship for Greece. Delacroix, being a reflective Byronist, stayed at home, painting a subject from the Greek war of independence, talking much about Byron, writing about Byron in his *Journal* and planning Byronic paintings for the future.

In March 1824 he thought of painting *The Execution of Marino Faliero* and *The Shipwreck of Don Juan and his companions*,[6] then in April he hesitated between three Byronic stories: *Mazeppa, Don Juan* and *The Lament of Tasso*.[7] That month he was one of a group who discussed at the home of Perpignan, editor of *Le Miroir*, Lord Byron and 'that sort of mysterious work which has a remarkable power over the imagination'.[8] Later he reflected how certain passages in Lord Byron stimulated him: the death of Selim in *The Bride of Abydos*, the death of Hassan in *The Giaour* and the curses of Mazeppa against those who bound him to his horse. He thought carefully about comparing Byron to Rousseau or, again, to Dante; and one day he spent explaining the meaning of *Childe Harold* to his favourite aunt, aunt Riesener. A fashion for translating Byron to canvas had

been set in his final years by Géricault. Horace Vernet and Louis Boulanger, Victor Hugo's pet artist, would both paint stirring versions of the fate of Mazeppa, the Cossack leader, who as a young man had been punished for making love to the daughter of a Polish count by being roped backwards to the back of a wild horse, which was then released. As a Byronic artist Delacroix would be first – the rest would be nowhere.

It was in Delacroix's early manhood that Byron and Scott and Shakespeare were *à la mode*. One English fashion outlived the fashion for these three poets. The tousled hair of Byron and his liking for Albanian dress may seem romantic now, but both were soon *passé*. The Regency style in male dress had a much longer life. At Watier's, which Byron called 'The Dandy Club', Beau Brummell, favourite to the Prince Regent, had set the tone. While the French court of Napoleon was bedecked in the gaudy colours and plumes of the *parvenu* nobility, the English court took to white and black. After the war English stiff high white collars and tight black trousers were soon copied in every continental capital city. Gentlemen even took to Brummell's habit of being fastidiously clean. Ironically, just at the moment of his most complete sartorial triumph Brummell had to go abroad as an exile from debts. He arrived in Calais just a year before the Boningtons brought to Calais their trade secrets as lacemakers from Nottingham. By chance Richard Bonington was to be one of the first young artists to be a dandy; and Delacroix would later boast that he and Bonington had done much to introduce English shoes and English clothes to France.

Few Frenchmen were ever so ready to admire England and the English as Eugène Delacroix when in 1825 he crossed the Channel.

The story of his English visit is told by Delacroix in a series of six letters to his friends. There is some corroborating evidence of his stay from other artists, since in June 1825 beside himself there was a whole group of young artists from Paris in London then – Poterlet, Isabey, Enfantin, Colin and Bonington – and the Fielding family both helped Delacroix find lodgings and entertained some of his Parisian friends. 1825 was a good year for Anglo-French painterly relations.

Arrived at Dover, Delacroix found the time to see the castle and to walk along the cliffs, which he knew already from a beautiful watercolour by Copley Fielding; and he was disappointed, for reasons which he does not explain. The sense of disappointment stayed with him when he reached London. Despite his desire to think himself cosmopolitan he felt lonely when confronted with a city so vast that its bridges stretched away as far as the eye could see; and he was surprised to find himself hostile to the people – towards a fat drunken 'goddam'

whom he and a fellow Frenchman had abused on the coach from Dover – and to the architecture, which appeared a mess to him. The sun seemed to be permanently in a state of eclipse. On the other hand the shops were fine and luxurious and the banks of the Thames charming. On 26 May he had been with six other young men, including the Fieldings, on a boating trip upstream to Richmond, and he had held the rudder while the others rowed in a boat which was astonishing in its construction, its gracefulness and its speed, the best thing he had seen so far in England. He had been to a play called *The invasion of Russia* and found it very funny, not so much because the English Napoleon had addressed his soldiers as 'Gentlemen' as because all the uniforms were wrong. But then Fielding had found him cheap lodgings, for just forty francs a month; and he had learnt that, contrary to his expectations as a Frenchman, the word 'goddam' was not a basic word in the English language. Much more important was the expression 'one shilling, Sir'. On going to see the gallery of Benjamin West, the American-born President of the Royal Academy, he had had to pay, guess what, one shilling.[9]

Delacroix had arrived in London on 20 May and had moved into rooms in Charles Street. By early June he was in better spirits, for he had started to work. Thales Fielding was 'le meilleur enfant possible', but he saw little of Copley and found him unsympathetic. The English sun had done nothing for his French cold, but he could see why the sky and the river banks suited a watercolourist like his friend Soulier. The English school, unfortunately, did not understand its strengths and weaknesses. Noblemen would spend a fortune on dreadful history paintings, but modest paintings were the best things in England. When he called on Wilkie, he was struck by the excellence of his sketches – Wilkie was then working on his famous picture *John Knox Preaching before Mary Stuart* – and was fearful that Wilkie would ruin the effect of the sketches when he came to the finished painting.

At the theatre he had seen *Der Freischütz* twice and also an opera based on Goethe's *Faust*. He was delighted to see Edmund Kean, whom he thought a very great actor, as the protagonist in *Richard III* and *Othello* and as Shylock in *The Merchant of Venice*. He was not so impressed by Young in *The Tempest*, but he regretted missing him play Iago to Kean's Othello and regretted missing seeing his Hamlet. It was only the Shakespearean performances which excelled anything that could be seen in France. The performances of *The Barber of Seville* and *The Marriage of Figaro* which he had seen struck him as atrocious; and he blamed the English love of the trumpet as one reason why the orchestras were so bad. But he had enjoyed his visits to the theatres enough to feel that, when they were closed in August, it was time to bring to a close his English trip.

Even though he thought that not many Frenchmen would miss him

celebrating the coronation of Charles X that summer in Reims, his short stay in England initially reinforced his sense of patriotism. Sometimes he took a detached view of English habits, as when he drily noted that hangings occurred often, yet he was not tempted to go and watch them. At other times he was harsher: there was something savage and ferocious in the English lower classes, the nobles were arrogant and class distinctions were shocking; the women were badly dressed, the English were mean and it was only a caprice of nature that Shakespeare was born an Englishman. He would have preferred Italian easy-going ways, he was sure, to the orderliness of the English. And yet he had pleasant memories. Thomas Lawrence was the flower of politeness and a truly aristocratic painter. He had been impressed by the political liberty which the English experienced. He had loved riding lessons with Mr Elmore, who had put him up in his house off Edgware Road, and he had loved it when a friend of Mr Elmore's took him yachting, for Delacroix loved the sea. He and Isabey discussed going on a trip by sea along the wilder coasts of England as far as Cornwall; and a nobleman did take him by sea to his country seat in Essex, where he stayed a few days. By mid-August, however, he was oppressed by the heat, the lack of carriages in the streets – the upper classes had left town or were hiding at the back of their houses to seem away – and the realisation that the only entertainment left in London was the English opera, which not even English skill at stage effects could rescue. It was time to go home.[10]

He left just too soon to speak English fluently. His friends told him that fluency would have come with a rush. He had not stayed long enough to gain a just impression of contemporary England. In 1820 Géricault had spent several months in England, in order to show off *The Wreck of the Medusa*; and he stayed into 1821. He too had been in England with French artist-friends, with the painter Charlet and with the sculptor Auguste, but he had been struck chiefly by the life of the poor and by the world of the race-course. He has left carefully observed lithographs of an aged beggar and a paralytic woman, a watercolour of men ploughing, pencil and watercolour sketches of a cockney porter, of a man carrying a pot of beer and, in the manner of Stubbs, of tigers, lions and horses. He also had been a friend of Mr Elmore, who was a fashionable horse-dealer and probably his landlord as well as Delacroix's. He had revelled in the spectacle of the Epsom Downs on Derby day and, unlike Delacroix, he had witnessed a public hanging. All this activity revealed an artist much more adult than Delacroix, whose reactions to England were stereotyped and chauvinistic.

The gain to Delacroix from his brief English trip was long-term and aesthetic. He had first seen a sketch by Constable in Paris in 1823 and there a year later, thanks to Géricault's enthusiasm, he had had the opportunity to see *The Hay Wain*. A French dealer, Claude Schroth, gave him a letter of introduction to meet

Constable. Unfortunately Constable was out of town when Delacroix tried to meet him, but it seems very probable that at some time they met, for the letter of introduction is in the possession of the Constable family and Delacroix himself at one time owned a sketch-book which Constable used at Brighton around 1825. After the artist's death he knew Constable's view that the convincing greens of his meadows were created out of a multitude of different hues of green, a view which he is more likely to have learnt from the artist's lips than from any written source. In 1858 he told Théophile Silvestre that Constable like Turner was a true reformer.

He had not always been so charitable about Turner, whose art, in its tempestuous grandiloquent moods, its literary pretensions and its blood-red-golden-orange colours, was temperamentally closer to his than the gentle green and brown domesticated landscapes under half-cloudy skies that Constable was painting in the mid-1820s. In summer 1825 Turner too was out of town. He certainly wanted to meet Delacroix and some time between 1829 and 1835 called on him in Paris. 'I remember having received him once,' Delacroix wrote of this occasion in 1855, 'when I lived on quai Voltaire. He left a poor impression on me: he looked like an English farmer, with black clothes, fairly fat, with large shoes and a hard, cold face.'[11]

He was more impressed at the time by Sir Thomas Lawrence, who was in every way the gentleman artist that he aspired to be himself. In 1829 he greeted the production of an engraving of his portrait of Pius VII with an encomium on the art of the portraitist. In this article, he claimed, Lawrence showed 'the particular talent he alone perhaps has to such a high degree, that of rendering in a striking manner the age, complexion, the whole character of his model'.[12] Portraiture was often seen as a lower form of art, yet it requires the skill not just to copy a given face, but to suggest the living soul that animates the face. Lawrence had no rivals in the painting of women and children – this portrait of the Pope was a proof of his versatility. Delacroix's remarks were no idle comments, for he bought a copy of the print and referred to it in his will.

He was attracted by other British artists, maybe by the animal paintings of Stubbs, certainly by the grandiose nudes of Etty, by the studies of Wilkie and by the delicate art of his friends the Fieldings. Of one English or rather Anglo-French artist he was a lifelong fan. It seems that it was their common adventures in London in 1825 which made Richard Parkes Bonington and Delacroix friends. In 1861 he wrote some letters in which he recalled his memories of Bonington.[13] In Paris he had noticed a tall young man in a short jacket sketching away in watercolour, then a novel form of painting in France, mostly in the style of Flemish landscapes. In Schroth's gallery, which specialised in small pictures, he soon noticed some watercolours that were charming in composition and colour

and found out that they were by Bonington. Bonington had studied briefly under Gros, who admired his talent; and he took to painting seascapes in thickly impasted oil, a technique which he later abandoned.

The only incident Delacroix mentions of their time together in London was the occasion when the two of them went to draw some of the armour in the collection of the antiquarian Dr Meyrick. Back in Paris, where for a time Bonington shared his studio, Delacroix had many opportunities of admiring his friend's casual brilliance. 'You are a king in your domain,' Delacroix told him, 'and Raphael could not have done what you do.'[14] Notes in his journal show that Bonington's name occurred to him automatically as the example of a natural talent. He was aware that he could not match Bonington's lightness of touch, he told the critic Thoré, and he admired the diamond-like quality his paintings drew from it.[15] He also reacted favourably to Bonington's British sang-froid and his dandyish pose.

Bonington did not stay long at Delacroix's. Soon he was off again on his travels, this time to Venice. It may have been an astute business move: it may have been the result of the restlessness which is typical of a consumptive. Bonington died in London in 1828. Delacroix continued to work in the grand manner, with a new sense of freedom.

It was in the second half of the 1820s that by learning much from the British the French Romantic movement came of age. In 1825 Stendhal published the second part of *Racine et Shakspeare*. Two years later a second English company came to act Shakespeare at the Odéon and this time transported Parisian audiences to new heights of excitement, none more than the composer Hector Berlioz who determined that the star actress Harriet Smithson should be his wife (with less *éclat* Lamartine and Vigny also took English wives). In 1828 Victor Hugo adapted the story of *Amy Robsart* from Scott's *Kenilworth*, but it was hissed off the stage. Hugo was not to be defeated. French Romanticism must be vindicated in the theatre. In February 1830 *Hernani*, his version of *Romeo and Juliet*, was presented at the Théâtre-Français as though it was a declaration of war; the Romantics were carefully placed in the most important places in the auditorium; and their contests with their opponents among the spectators were more enthusiastically applauded than the actors' triumph on the stage. Within a year Hugo had finished the manuscript of *Notre-Dame de Paris*. If he had failed to emulate Shakespeare, he had equalled Scott.

During the same period Byron's influence became more pronounced than ever. His death at Missolonghi, which had filled the English Philhellenes with gloom, stimulated the French Philhellenes to fresh exertions on behalf of the

Greeks. Chateaubriand, recently dismissed as Foreign Minister, wrote his *Note on Greece* partly to attack his late colleagues, but also to rouse his fellow countrymen from their disregard of the Greek cause; and where his pamphlet led the way, in 1825 and 1826 one hundred and twelve others followed. The artists put on one exhibition in May 1826 and another in September 1826. By this time the Greek cause had become desperate, for Missolonghi itself had fallen to the Turks and their Egyptian allies after a year's siege; and in 1827 Athens fell and among the Philhellene dead the largest national group was French. Even the French government had turned discreetly pro-Greek and it despatched French ships to join the British and the Russians in watching the Muslim navy. A chance shot produced a full-scale naval engagement; and in the bay of Navarino on 20 October the Christian victory meant that Greece would indeed be free.

The event was celebrated poetically by Hugo's ode *Navarin*, which he published in 1829 in the collection *Les Orientales*. Besides intending to be the French Shakespeare and the French Scott, he also wanted to be the French Byron. He tried to make his own Byron's world, with its harems, muftis, pashas, dervishes, djinns and Caliphs, its nostalgic evocation of Muslim Granada and of the centuries-long contest between Christians and Moors in Spain. Hugo had been brought up in Spain, but he did not have Byron's first-hand knowledge of the modern Mediterranean. Where he was genuinely Byronic was in his love of freedom.

What Hugo never acquired was Byron's mocking sense of detachment. That spirit was found only in an older Romantic. In his first great novel, *Le Rouge et le Noir* (1831), Stendhal created a hero, Julien Sorel, who was a Restoration outsider, a Don Juan without charm or luck.

The alternative artistic values that Stendhal and Hugo represented battled in the late 1820s within the soul of Eugène Delacroix. He had corresponded with Stendhal after reading his review of the 1824 Salon, but he does not seem to have become friendly with him till after his stay in England. Henri Beyle, to give 'Stendhal' his true name, knew Italy as well as England and praised Italian music and painting as much as he praised Shakespeare. Delacroix at first was not much impressed by Stendhal's *Life of Rossini* and took a poor view of it in the *Journal* of his youth: in the *Journal* of his maturity he reproduced a passage from it. In the interval his view of the author had changed. He met Stendhal at Baron Gérard's. In 1829 a cousin of his, Alberthe de Rubempré, had a brief stormy affair with Stendhal; and, when in 1853 Delacroix went to call on her and found her living in an unheated room and eccentrically dressed like a sorceress, his

natural thought was: 'Where is Beyle?'[16] He kept on reminding himself of one of Stendhal's maxims: 'Neglect nothing that can make you great.'[17] In his impressionable early manhood he was much under the older man's influence. In April 1830 he confessed to Dumas that he and Beyle and Mérimée, a mutual friend, and others had been too drunk together for him to acknowledge Dumas's call;[18] and shortly afterwards Mérimée cynically reported to the absent Beyle Delacroix's frantic behaviour at a sexual orgy.[19]

In the late 1820s Hugo was encircled by adoring disciples and an adoring wife; and Delacroix must have found the devout atmosphere stifling. He had first met Hugo in 1826 and was soon introduced to the encircling group, the *petit cénacle*. It was Hugo who encouraged him to paint Scott's grim assassination scene from *Quentin Durward* and Hugo who supported his orgiastic painting of *The Death of Sardanapalus*; and it was for Hugo that Delacroix designed the costumes of *Amy Robsart*. But the two never became close to one another; and it was Delacroix who made sure their relations were distant. He would write in 1849, à propos Hugo's style, that 'it has never approached within a hundred leagues of truth and simplicity'.[20] The last years of the Restoration were the last years of Delacroix's excessive Romanticism; and gradually in art and in behaviour he became more restrained. When Laurent, librarian of the Chamber of Deputies, saluted him as 'the Victor Hugo of painting', his reply was steely: 'Sir, I am a pure classic.'[21]

In the 1820s it was not his love for the French classical tradition but his memories of the English stage and of the English style of acting and above all his love of English literature which were paramount as an influence on his art.

When hard up for money he sought for orders for lithographs from the Paris printer Motte and hit on the idea of illustrating the first part of Goethe's *Faust*, which he knew from the operatic version which he had seen in London.

He told Pierret that he had seen a version of *Faust* that was 'the most diabolical thing you could imagine'. 'Mephistopheles is a masterpiece of character and intelligence. It is Goethe's *Faust* adapted but with the main features intact. They have made it into an opera that's a concoction of black humour. In the church scene you see the priest chanting and organ music in the distance. They could go no further with their theatrical effects.'[22]

Delacroix began work on the series within a year of seeing the production. His seventeen pictures were to be accompanied not by the great translation of Gérard de Nerval but by a lesser version by one Albert Stapfer. His use of a relatively new technique, his careful avoidance of Neo-Classical conventions in

favour of an updated Northern Renaissance manner and his concentration on the figure of Mephistopheles all emphasise the Romantic proclivities of Delacroix. Goethe was delighted. After seeing just two of the pictures, he told his friend Eckermann: 'This M. Delacroix has a great talent, which in *Faust* has found its true nourishment. The French public reproach him for an excess of savage force, but it is perfectly suitable here. . . . ' And when he had seen all the plates Goethe added: '*Faust* is a work which passes from heaven to earth, from the possible to the impossible, from the gross to the exquisite; all the antitheses which the play of bold imagination can create are here brought together; this is why Monsieur Delacroix felt at home in it . . . as though among his own family.'[23]

In the late 1820s Goethe was preoccupied with the second part of *Faust*, to which he had recently added the Euphorion episode in honour of the dead Byron. Delacroix as yet did not know that part of the work and when he read it much later he was bored. But he retained his affection for Goethe and he would produce in the 1830s and 1840s seven lithographs of Goethe's story *Goetz of Berchlingen* and in 1855 he was delighted to see once more, this time in Paris, the Anglo-American actor James William Wallack whom he had seen in London exactly thirty years before to the month playing the title-role of Faust.

In 1828, when the complete *Faust* lithographs appeared, he was too poor to arrange to see Soulier, by then in the countryside to the south of Paris. When next they would meet, 'Mephistopheles alone knows.'[24]

He was then at his most powerful when dramatising evil. In these years he produced nothing truly memorable in his versions of Shakespeare: an unfinished canvas of *The Capulet Ball* and a painting which shows again his fascination with satanic powers, *Macbeth and the witches*. Scott too, though in fashion, inspired nothing specially notable in the costumes for *Amy Robsart* (from *Kenilworth*) and a *Cromwell* (from *Woodstock*). One Scott painting, however, was remarkable. This owed something to Bonington and something to Hugo. With Bonington in England he had sketched Westminster Hall and Dr Meyrick's medieval armour; and it is probable that he used this building for the setting and the armour for the clothing of the military participants in the horrific scene. Hugo had praised as specially fine the chapter where the murder of the bishop of Liège occurs; and maybe it was he who recommended it to Delacroix's attention. A small painting for such a crowded action, in Gautier's words Delacroix's work 'howls, shouts and blasphemes'.[25] The gloom and horror Delacroix depicts are illumined by a dazzling white table-cloth and flickering candles. Here if anywhere Delacroix shows himself to be what Stendhal had remarked of him in 1824: the pupil of Tintoretto. But he is Tintoretto without the sense that it is God's light which illumines the darkness

and that it is the darkness which cannot comprehend the light of God. Delacroix shows in light evil triumphant. Could he have been more disturbing?

The murder of the Bishop of Liège was not exhibited till 1831. By then Delacroix had already made clear to the public that he could be much more outrageous than he revealed himself to be in that picture, for by 1831 he was known as the painter of *The Death of Sardanapalus*.

No English writer who inspired his art meant so much to Delacroix as Byron. His youthful Journal of 1822–1824 shows him to be preoccupied with Byronic subjects; and his artistic output shows that preoccupation to have been a motivating force of much of his finest work of the period 1824–1831.

Byron's tales – *The Giaour, The Bride of Abydos, The Corsair, Lara, Mazeppa* and *The Prisoner of Chillon* – and his dramas – *Marino Faliero, The Two Foscari* and *Sardanapalus* – and one dramatic monologue – *The Lament of Tasso* – and his comic epic – *Don Juan* – provided a wonderful series of incidents to which Delacroix could return over and over again. In 1844 Gautier wrote: 'Delacroix is dependent on Byron. He has the same love of Greece and the Orient, the same instinct for travel, the same passion for horses, lions and tigers.' Twenty years later, only a year after his death, Charles Blanc called him 'the Byron of painting'.[26] It was not a description to which Delacroix would have objected. The vogue for Byron in France may have been over by 1835, but so far as Delacroix was concerned his youthful craze became a settled love. One of his most beautiful Byronic paintings was his fourth and final version of *The Bride of Abydos*, dating from as late as 1857, where Zuleika and her pirate lover Selim are trapped beside the shore

> Where the tints of the earth, and the hues of the sky,
> In colour though varied, in beauty may vie,
> And the purple of ocean is deepest in dye.

The note of vigour and the rich colouring are still present in this late work, together with a care for composition and a lyrical tenderness of mood which Delacroix did not often express so convincingly as a young artist. During the 1820s in his calmer moments he was more overtly pathetic and when excited he was more inclined to dwell on horror.

Under the spell of Byron he became an ardent Philhellene. In 1826 an exhibition in two sessions was mounted at the galerie Lebrun to raise money for the Greeks. For the second session Delacroix produced *Greece on the ruins of Missolonghi*, in which 'Greece' herself, modelled on a classical figure but in

modern dress with a generous *décolletage*, opens her arms to appeal for aid, while below her a dead Philhellene's hand emerges from the rubble of the fallen city, over which in the background a victorious Egyptian sits in splendour. 'This woman, who is Greece', noted Hugo, 'is so beautiful in attitude and expression.' Everyone who saw her knew that Missolonghi was where Byron had died. Everyone knew that in 1826, after Missolonghi had fallen to Muslims, that death might have been in vain.

For the first session of the same exhibition Delacroix had shown *The execution of the Doge Marino Faliero*; and it was exhibited again at the Salon of 1827–28. This time the story was wholly Byronic and nowise Greek. The picture portrayed the moment just after the Doge, convicted of conspiring against the Venetian Republic, had been beheaded on the grand staircase of the Palazzo Ducale in Venice and one of the Council of Ten held the still bleeding sword of execution up, while announcing that Justice had punished the traitor. Though Delacroix had never been to Italy, the setting is accurately recorded; and it is possible that he had learnt the architecture from Bonington, just back from Venice. But the solemn mood of the watching grandees, the rich flamboyant Venetian colours of their robes and the harsh contrasts between black hats, dark carpet, dark statue and darkened shadows and the bright white marble stairway – all these are purely his style.

At the same Salon Delacroix had hoped to show *The Combat of the Giaour and the Pasha*, but the picture was rejected. This time the modern contest between Christian (in Turkish 'Giaour') and Muslim has been projected back into the past, when Venice had just lost its precarious hold on the Greek Morea or Peloponnese. A young Venetian is determined to take revenge for the death of the girl who had been his lover and had been thrown into the sea for her infidelity to her husband (Hassan the Pasha). The Giaour contrives to engage Hassan in single combat and kills him, only to realise that

> There's blood upon that dinted sword,
> A stain its steel can never lose:
> 'Twas shed for her, who died for me,
> It warm'd the heart of one abhorr'd . . .

Delacroix chose a scene which Byron only adumbrates: the actual fight between the two men. With swirling motion, the horses circle round, one horseman in pure white, the other in gorgeously coloured clothes. The violence, the vitality and the virtuosity recall Rubens, but the picture was too wild for the Salon jury. These gentlemen soon had a greater shock to absorb.

In January 1828 they saw and accepted *The Death of Sardanapalus*. The idea

of the painting came from the last scene of Byron's play *Sardanapalus*, the spirit of the painting is Byronic, but for many of its details Delacroix looked beyond Byron. No more here than anywhere else was he a literal-minded Byronist. He had gone to great lengths to study literary and visual sources: Quintus Curtius' account of the burning of Persepolis, possibly Herodotus' description of a Scythian burial, possibly an Etruscan relief and certainly Indian architecture. Before his trip to Morocco Delacroix's orientalism was eclectic, working as he did before Nineveh was excavated and cuneiform deciphered. What worried the public were errors not of fact so much as of taste.[27]

The scene is an orgy of destruction. On a bed that slants leftwards in an awkward diagonal, Sardanapalus, last King of Nineveh, lies brooding, while fair-skinned slaves slaughter women from his harem and a Nubian slave stabs a horse that careers towards a glittering mass of jewels at the foot of the bed. In the right background smoke and fire billow over the doomed city.

Victor Hugo welcomed this affront to the bourgeoisie.[28] The bourgeoisie – and that included most of the jurors and the critics – sensed the disturbing eroticism, evident in the swirl of naked bodies, the plunging daggers, the blood-red bed, the golden cup full of poison, the profusion of *objets d'art* strewn carelessly at the front of the picture space and – most sinister of all – the blasé King languidly watching it all without emotion. *The Death of Sardanapalus* is a sado-masochistic fantasy. It is a hymn to perverse self-indulgence.

In 1824 Etienne-Jean Delécluze, doyen of the Neo-Classicists, had called Delacroix's art 'Shakespearean': the art of which he approved he called 'Homeric'. The Salon of 1827–28 conveniently juxtaposed both kinds of art. In *The Death of Sardanapalus* he criticised the confusion of lines and colours, the lack of cohesion between the details – he had not seen Delacroix's wonderfully fluent sketch – and its defiance of the rules of art. What such men looked for in a painting was supplied in Ingres' *Apotheosis of Homer*, where the great and good of the arts are placed in groups parallel to the picture plane before a Greek temple that looks more like the Madeleine than the Parthenon. For all his technical skill, which Delacroix acknowledged, Ingres had no sense of epic grandeur. There is in Ingres' frigid picture only pretentiousness and nothing which Delacroix would call truly Homeric: what 'speaks to us as men, our sweat, the elemental actions we perform etc.'[29] By contrast, if not himself 'Homeric' in this sense, Delacroix had reached at least the level of Shakespeare's *Titus Andronicus*. *Sardanapalus* is juvenile in its sensuality, its extravagance of mood and its love of cruelty.

The authorities were not amused. Delacroix was privately reprimanded by the *surintendant* of the Beaux-Arts and told that, unless he changed his ways, he would not sell the picture and get no commissions.

At the time even the Romantic critics preferred another Byronic scene to his: Boulanger's *Mazeppa*. Never would Delacroix be so shamelessly Byronic again.

English literature mattered to Delacroix for many years after the Salon of 1827–1828. In 1827 he had been carried away by the acting of the English players. 'A general invasion: Hamlet raises his hideous head, Othello prepares his dagger expressly to undermine the good dramatic thought-police. . . . Fear the classic daggers, or rather sacrifice yourselves bravely for the pleasure of us other barbarians.'[30] In the 1840s he tried to do for *Hamlet* what he had already done for Goethe's *Faust*, but he could interest no publisher in his scheme. He privately published thirteen lithographs in an edition of 80 copies and after his death Paul Meurice published these plus three extra lithographs in an edition of 200 copies. Only in this century has the whole set been reproduced alongside a text of the play.

In the 1840s Delacroix was no longer the penniless artist that he had been fifteen years earlier; and the *Hamlet* venture was a labour of love. Four times he would paint Hamlet with Horatio in the graveyard, three times Ophelia drowning, twice Hamlet with the body of Polonius and once Hamlet and the king at prayer. No single literary figure, not even Faust, interested him so much as Hamlet. His Hamlet is a figure of almost feminine sensitivity – he used a woman as model – but his sudden changes of mood, his bursts of action, his encounters with ghosts and corpses and skulls, his feigned madness, his lonely life at court, his strained relations with the mother and girl he loved and his death in the arms of his one constant friend made Hamlet the perfect flawed hero for an age of disillusionment.

If *Hamlet* was Delacroix' favourite Shakespeare play, he would also illustrate scenes from *Henry VI, Romeo and Juliet, Othello, Macbeth* and *Antony and Cleopatra* and would plan to illustrate *King Lear*. He copied out critics' views of Shakespeare and even attacked his beloved Voltaire for being too set in his Neo-Classical views. He could be a perceptive critic in his own right. 'The inspiration for beauty,' he noted, 'comes to Shakespeare in an inn, almost by chance, as he comes back from a walk where he was talking with friends about hundreds of things other than beauty.'

No more than Shakespeare and Byron did he forget Scott. In an inventory of paintings compiled in 1842 or 1843 he lists four scenes from *Quentin Durward*, one of them *The Murder of the Bishop of Liège*; and as late as December 1860 he was thinking of making twenty-four pictures from *Ivanhoe*. One moment especially caught his imagination: the moment when the Jewess Rebecca is abducted from the sacked castle of Front-de-Boeuf. The theme was an old one,

for over the centuries in every European art gallery thousands of Sabine women had been snatched by thousands of Romans, but this was at least a Romantic version of an old idea.

In the second part of the 1820s Delacroix was preoccupied with causes: he joined battle for Shakespeare and Byron, he was an enthusiast for the Greeks and even his love of Scott and Rossini could seem subversive. Matters of aesthetic taste were linked in his mind with questions of political allegiance and moral behaviour. He was part of a movement.

Respectability in all its *bien pensant* forms was the enemy. For a student rebellion might seem natural, but in 1828 Delacroix became thirty. His friend Pierret was and his friend Soulier soon would be settling down as married men. For him the best day of the year was still New Year's Eve, *la fête de Saint-Sylvestre*, when he tried to drink the cares of life away. For them the occasion was a memory of their youth and they were no longer bachelors. Only he and Guillemardet were unattached.

He wanted to be secure. He admitted to a longing for the advantages enjoyed by a *rentier*, the envied status of the French bourgeois, who knew that every month a tidy sum would be paid into his bank account from invested money. It was all very well to affront the bourgeoisie by painting pictures of orgies: he must have work. He was relieved to find that after *Sardanapalus* not only was he patronised by the Liberals' sponsor, the duc d'Orléans, but he was also asked to paint a *Battle of Nancy* for the State.

While illustrating Byronic fantasies, he could have casual sex with working class models. He wanted love. He found Aimée or Eugénie Dalton, *la belle de la rue Godet*; and their liaison became accepted by his friends.

In 1828, when he was most vilified by the critics for his reckless portrayal of a Byronic action, Delacroix told his Anglophile friend Soulier that he had kept his sang-froid.[31] It was an English quality that he badly needed. He said he had not enough money to seem attractive to women. He had been asked to paint portraits of schoolboys who had won prizes in the Concours général at a school run by a former schoolmate, Prosper Parfait Goubaux, and he was grateful for the commissions. Despite Goethe's praise, as a venture the *Faust* lithographs failed. Delacroix needed consoling. While Newton Fielding wrote to tell Soulier that he was 'devilish glad' that Soulier had a position in the company of miners and sappers, Delacroix in the same letter commiserated with Soulier's troubles. He wrote to Soulier about his boredom and depression, as he wrote to Soulier about his pleasure in Bonington's company, his thoughts on the English actors

and his recent problems with the Salon. He could not yet manage the joky epicureanism of Byron masked as the commentator of *Don Juan*:

> How pleasant were the maxim (not quite new)
> 'Eat, drink and love, what can the rest avail us?'
> So said the royal sage Sardanapalus.

He was not in the mood for bad rhymes. His defence was his dandyism. One picture – his 1828 portrait of his artist-friend Louis Schwiter – gives elegant form to his ideal. Tall, thin, impeccably black, Schwiter stands in front of a terrace beside a pot full of flowers in front of an English park. The portrait shows that Delacroix can compete with Sir Thomas Lawrence, whose work and presence he had so admired in England. It is fitting that the portrait has become part of the collection of the English National Gallery in London. In Paris at the time it was rejected by the Salon committee.

Delacroix's love of the English style of doing things put him at odds with his conservative compatriots. Not till there was an English-style Revolution in France did he gain the chance to achieve lasting patriotic fame in his own country.

From the windows of his new apartment on quai Voltaire, to which he had moved in 1829, he watched that Revolution happening.

— 7 —

Liberty and Louis-Philippe
(1830–31)

EFORE France had yet another political revolution in 1830, there had been
a radical change in the way in which educated Frenchmen viewed their
past.

It was in the 1820s that French historical writing came of age; and its finest
practitioner was an Anglophile Protestant professor from Normandy, François
Guizot whose sweep and coolness of scholarship distinguished him from his
contemporaries. His greatest work concerned the English revolution of the
seventeenth century. Guizot was an admirer of those English institutions, like
Parliament, which were marked by the constitutional conflicts of that period.
He was a known liberal, rational, factual and objective in tone.

History books had become popular; and those authors with a flair for popular
writing turned their literary gifts to history. Among the popularisers none was
as formidable as Adolphe Thiers, a Marseillais lawyer and journalist, who had
come to Paris to be rich and to be powerful. He made himself the chronicler of
the French Revolution. In the 1820s he and Guizot had their career prospects
blocked by the Restoration; and they needed a new régime to give them freedom
to become national figures. Once vested with political authority, they
patronised those who could bring the past to life. In 1833, thanks to Guizot, then
Minister of Education, Jules Michelet the historian was made Professor at the
Sorbonne.

In the same year, thanks to Thiers, then Minister of the Interior, Delacroix
was commissioned to paint the Salon du Roi in the Palais Bourbon. The
Revolution that brought Guizot and Thiers and Michelet to national prominence
also made a national figure of Delacroix.

The new cult of history first affected Delacroix towards the end of the 1820s. Although disappointed of State approval after the débâcle of *The Death of Sardanapalus*, he got some compensation from the favour shown to him by two members of the royal family: the duchesse de Berry, widowed mother of the second heir to the throne, and the duc d'Orléans, the third heir to the throne. Among the tedious Bourbons they stood out. The duchesse was herself a Bourbon-Parma, a princess from the line which ruled in Naples, flamboyant, indomitable and courageous. By contrast, Louis-Philippe, head of the junior or Orleanist line of the French Bourbons, was the epitome of caution. As a young man, the son of the proto-revolutionary Philippe-Égalité, he had fought for the revolutionary armies, before making his well-judged escape from France. Back home after the fall of Napoleon, he found himself the heir to several Bourbon fortunes. He prudently became friendly with astute bankers, Laffitte and Casimir Périer. He was conspicuously modest. He sent his sons to the Lycée Henri IV; and there were many sons to send. While the duchesse de Berry favoured Anglo-French artists of the Bonington circle, Louis-Philippe was known to have a valuable collection of Spanish paintings. In the century of Prosper Mérimée and Georges Bizet and Edouard Manet it was a judicious taste to encourage.

When they wanted visual reminders of the French past, both duchesse and duc turned to Delacroix. For each of them he provided a scene from Scott's novel of fifteenth-century France: for the duchesse *Quentin Durward and the Balafré*, for the duc *The Murder of the Bishop of Liège*. For each he also painted scenes whose historical basis is factual, scenes which have an ironic relevance to those who commissioned them. The duchesse asked for *The Battle of Poitiers*, a story of royal defeat. The duc asked for *Cardinal Richelieu Celebrating Mass*, a pious incident more likely to appeal to his clerical cousin the King than to a royal duke as genially sceptical as himself. Though the latter painting has been destroyed, neither it nor the battle scene added much to Delacroix's reputation. He was not emotionally stirred by events that concerned the throne and altar view of the French past.

Charles X, whose coronation Delacroix had missed, was not a tactful king. History had taught the younger brother of Louis XVI nothing. He had no time for the recent past. His one reaction to the Revolution of 1789 was to wish that it had never happened; he saw a continuity from 1789 to the execution of his brother four years later; and, as Napoleon had made a point of seizing and executing Charles X's Bourbon relation, the duc d'Enghien, the Napoleonic régime had no more appeal. Charles had no time for any authority but his own.

Whereas Napoleon had been Emperor *of the French* 'by the grace of God and the constitutions of the Republic', Charles X was King *of France* by the grace of God. He did not like the idea of a constitutional monarchy. The idea of monarchy according to the Charter, to which his brother Louis XVIII had been resigned, appalled him. 'I would rather chop wood than rule after the fashion of the King of England,' he declared; and by acting on his principles, he ensured that he would have six years of old age with the chance for some chopping.

From 1827, when the government lost an election, to 1830, when it lost another one, Charles X moved quixotically along the road to ruin. In 1829, irritated by the moderation of his ministers he felt able to install in power his old friend, the Prince de Polignac, a man who saw himself as a Saviour of the Crown, chosen by God; for, like many round Charles X, Polignac had mistaken the century. Opposition journalists became increasingly impatient. In January Thiers helped found a new newspaper, *Le National*, which was financed by Louis-Philippe's banker Laffitte and blessed by Talleyrand. Being historians, the editors compared France in 1830 to England in 1688, the year of the Glorious Revolution.

They implied by the comparison that a king who threatened the Charter should be replaced by one who would guarantee it. Unfortunately the Charter allowed the monarch reserve powers in case of national emergency; and that state, so far as Charles X was concerned, was precipitated by Liberal success in the elections of June 1830. He had sent a large force to attack Algiers and on 9 July he heard of the fall of Algiers. He was ready for a show-down and suspended civil liberties. Louis-Philippe was horrified. 'I've been exiled twice and I don't want any more. I shall stay in France.'[1] He was trying to be judicious. The journalists whom his banker backed were more energetic. A meeting at the offices of *Le National* led to an open act of defiance by forty-four of them. They declared that in the circumstances obedience ceased to be a duty. Having signed their declaration, they wisely dispersed. It was the evening of 26 July.

The French refer to the Revolution which followed as the 'July' Revolution and the monarchy which was eventually established as the 'July' monarchy. The new monarchy came in August. It was only the popular uprising that occurred in July, when by the three 'glorious' days of 27, 28 and 29 July the Restoration was brought to an end.

The rioters gradually came closer and closer to the seat of royal power, just opposite Delacroix's home on quai Voltaire. On the first day revolt spread through the poorer areas of Paris. By the morning of the second day there were barricades all over the city and, though for a time royal troops held the Hôtel de Ville, by the evening all troops were withdrawn to defend the Louvre and Tuileries palaces. Next morning these buildings were under attack, by noon

soldiers were fraternising with their assailants and by nightfall the whole of central Paris was in rebel hands. This very French style Revolution, spontaneous in its origin, violent and decisive, was soon over. Within a few days even Charles X realised that he must leave France for England. It was only then that a much more English kind of Revolution was engineered. Without any bloodshed, as one of Delacroix's royal patrons, the duchesse de Berry, went into exile, the other, the duc d'Orléans, was helped by Thiers and Guizot and Laffitte and Casimir Périer to be made first lieutenant of the kingdom and then King of the French. He embraced in public the ageing Lafayette, who had helped the Americans during their Revolution and later sent Washington the keys of the Bastille during the first French Revolution. That embrace meant that there would be no republic. As the Austrians were intent on keeping Napoleon's heir in their country, there could be no Bonapartist empire. By 7 August France had a revised charter and a new kind of constitutional monarchy. Though the national flag would be the tricolour, the new men thought that this would be a very English sort of monarchy; and in place of the sword of Charles X, defender of throne and altar, there would be the umbrella of Louis-Philippe, who had done well with his investments.

In neither the July nor the August Revolutions had Delacroix taken much part. Nor had several of his friends. Stendhal, at the sound of the fighting, closed his windows all the more tightly, because he was writing the classic novel of the Restoration that was over, *Le Rouge et Le Noir*. Victor Hugo was worried about his wife, who gave birth on 28 July, and about his debts and, besides, he was writing about another mob that had swirled around Notre-Dame in the middle ages. Some artists were braver. While Paul Huet, Bonington's friend, manned the barricades and Daumier, another radical, received a sabre cut to the forehead, the conservative Ingres and his disciples, swords in their hands, stayed for the two worst nights in the galleries of the Louvre, ready to die for ideal art. Delacroix, according to Alexandre Dumas, played a less commendable role. On the night of 27 July Dumas claimed that he had met him by pont de la Grève, which would be renamed pont d'Arcole after a martyr of the Revolution. Delacroix pointed out two men, one sharpening a sabre and the other a foil on the cobbles. He appeared to be terrified. When he saw the tricolour flying from Notre-Dame – it was the standard of the Empire as well as of the Revolution (and would be that of Louis-Philippe) – as a 'fanatic for the Empire', he could not contain himself. Enthusiasm replaced his fear and he praised the people who had terrified him.[2]

The story was not written down till 1864, a year after Delacroix's death, by

which time Dumas was doing well out of his colourful reminiscences. Dumas did Delacroix an injustice. However timid Delacroix may have been, he had been stirred. In a letter of 17 August 1830 to his nephew Charles, then a vice-consul in Malta, he tells of the three days of fighting. 'The simple walker like me had the chance of being hit no less than the spontaneous heroes who marched towards the enemy with bits of metal in their broomsticks. Up to now all has gone as well as possible. All people of good sense hope that the republicans will agree to keep the peace.'[3] That was the timid Delacroix. On 12 October he wrote to his brother Charles, the Napoleonic ex-general, to say: 'I have started on a modern subject, *A barricade* . . . and if I haven't conquered for my country, at least I'll paint for her.'[4] That is the Delacroix who had been stirred.

It is through the resulting painting that those with historical imagination now see the events of the three glorious days.

Never at any stage had Delacroix sympathised with the Restoration, which had reduced his older brother to the status of a half-pay officer. He had thought of painting Napoleonic subjects and he probably frequented a café which was a Bonapartist haunt. He had associated with artists like the Scheffer brothers, Vernet and Géricault who were all critical of the Bourbon régime. He had painted in favour of the Greeks; and in the late 1820s he had become a member of the group of intellectuals and artists whose Romanticism was bound up with their Liberalism. Hugo, who was the leader of the group, said that Delacroix was a republican. Delacroix painted from conviction.

The events of 1830 made Delacroix an Establishment figure. One sign of this was that he became a member of the revived National Guard, which had been founded in 1789 to protect the principles of liberty, equality and fraternity; and Lafayette, the personal symbol of those principles, had been made its commander. On the fall of Napoleon a reconstituted National Guard supported the Bourbon Restoration. The Comte d'Artois was made its commander, but, as king, Charles X disbanded them for criticising his ministers. When, therefore, they were reformed, they stood again for the ideals of Lafayette, for had not Lafayette embraced the new king? To join such a body proclaimed loyalty to the new régime; and Delacroix would have understood as much. He was to fulfil his duties punctiliously. He had another reason for being pleased to be a citizen-soldier. As a dandy, he was glad to wear a smart uniform.

There was a more advantageous way that he could show his attachment to the new régime. The Comte d'Argout, Minister of Commerce and Public Works, announced that the King would commission works of art. The chief assistant to the minister, who happened to be Prosper Mérimée, wrote to his friend Stendhal that the minister was proposing 'such eminently picturesque subjects as the

following: "the King recognising the cottage where he spent the night before the battle of Valmy; His Royal Highness the duc d'Orléans receiving a prize for an exercise at the Collège d'Henri IV; the King drawing blood from an elderly savage in America, etc." It would be impossible to tell you about the whistles and curses he got from painters treated in this way. Delacroix, who had I know not what subject of that kind, intends to do another; he says, in a year, the king, the ass, or I will be dead.'[5]

Delacroix was asked to paint one of the revolutionary battles in which the king had fought almost forty years before. He chose instead to ignore the history he could only hear about in favour of the history he had seen. The battle he would paint would be the revolutionary battle of 28 July, 1830.

It earned him another addition to his wardrobe, for he was awarded the Legion of Honour.

Liberty leading the people, which was shown in the Salon of 1831, enshrines the legend of the July Revolution and the myth of all struggles against oppression.

Against a distant view of Notre-Dame the bare-breasted figure of Liberty, tricolour in her right hand and rifle with bayonet in her left, leads onwards a band of followers, prominent among whom are an urchin brandishing pistols, a bourgeois in top hat with a gun and an artisan with a sabre. Before her a suppliant peasant crawls, while lying at the front of the space to her right is the thin, half-dressed body of a worker, and to her left are two royal soldiers. Just behind the dead or dying worker there is a small boy sporting a stolen helmet and in the centre background, emerging from some imagined crowd, a young man wears the cocked hat of the Ecole Polytechnique.

There has been discussion of the picture's reliability as visual evidence. The vantage point would be not exactly pont d'Arcole, but must be somewhere on the left bank, from which decisive attacks were made on the Hôtel de Ville. The artisan with the sabre stands for the group who took the lead in the fighting. Many lesser members of the bourgeoisie were involved, so that Dumas thought that the top-hatted figure was Delacroix himself; more likely the theatre manager, Etienne Arago, is meant; possibly Delacroix merely wished to indicate a solidarity which transcended class. Nobody disputes the right of the *polytechnicien* to be there, for this was in part a student revolt. About urchins and women there is less agreement.

Few small boys were killed, but Dumas and a subsequent report agree on their prominence, Vigny gives to a *gamin* a prominent role in the section of *Servitude et grandeur militaires* that treats of the July days, and experience of rioting in Belfast and Beirut bears out the soundness of Delacroix's judgment. As for the women, there are some stories of heroic female fighters in 1830 and many more

in subsequent revolutions. But Delacroix is not just concerned just to raise history to the level of legend. The dominating Amazonian figure of Liberty gives the painting the quality of myth.

In *Greece on the Ruins of Missolonghi* Delacroix had painted 'Greece' as an allegorical figure which is a free version of the Greek idea of 'Tyche' – Fate or Destiny – whose melancholy mood she represents. In *Liberty Leading the People* he painted 'Liberty' as an allegorical figure which is also derived, loosely, from another ancient Greek idea. Either she is based on a winged Victory, similar to the famous and as yet undiscovered winged Victory of Samothrace, or she is based on the recently discovered 'Aphrodite of Melos'. A 'Victory' has obvious relevance to the theme and the 'Aphrodite' had just been put into the Louvre. It is the spirit of victory and love which animates the painting. It is Liberty also which brings colour to life. At the bottom of the picture Delacroix uses the earthy, dark colours reminiscent of Géricault's *Raft of the Medusa*, but round the head of Liberty glow bright white, the colour of light, and red and blue, two of the primary colours. The tricolour stands for hope.

At the end of the Salon the State bought *Liberty* and for a time exhibited it at the Palais de Luxembourg. Soon, however, it was put away in store and in 1839 it was returned to Delacroix himself – and he asked the Rieseners to keep it. Just as Neo-Classicist critics were disturbed by the hints of body hair which David's art had erased from artistic memory, so the government sensed that Liberty was a seditious value; and when in 1848 a fresh revolution sent Louis-Philippe again on his travels, the revolutionary artists sensed so too. As late as 1968 the painting still had revolutionary meaning.

Was Delacroix disappointed by the rejection the Orleanist régime gave to his masterpiece? Most of the republicans, as he had hoped, had kept the peace, bought off by the tricolour. Louis-Philippe could not satisfy the Bonapartists, whose nominal leader, Napoleon 'II', *L'aiglon* or the eaglet, died in 1832, but at least like Napoleon I the new King was ruler 'of the French'; and to support him he had to employ the services of the Bonapartist ruling class, of which Delacroix himself was a member. The career open to talent enabled Guizot and Thiers to become the most influential of Orleanist politicians, Guizot to give France stability (and incidentally money to the financiers and posts to the teachers) and Thiers to give France dreams of glory (and incidentally walls to Paris and commissions to Delacroix).

There is another way in which Delacroix's painting can be linked to Orleanist ideals. After 1830 in France, as after 1688 in England, the winners got rich. *Liberty Leading the People* and Delacroix's face are most familiar today not so much in the Louvre as in a more obviously Orleanist way, on the one hundred franc banknote. The July Revolution paid.

The journey to Morocco (1832)

ONLY a few months after he had finished his great picture of *Liberty* Delacroix made his own bid for freedom. He went to Morocco.

It is difficult now to imagine the lure of the orient – not the distant shores of the Far East, but the nearby Muslim lands of North Africa and the Levant – to early nineteenth-century Europeans. The area had belonged to an alien culture since the Arabs overran it in the eighth century. Since the sixteenth century most of it, with the significant exception of Morocco, had been ruled by the Ottoman Turks from the Sublime Porte in Constantinople; and they also ruled the mainly Christian Balkans. In the nineteenth century the Turkish empire had been opened up to European influence by the expedition of Napoleon to Egypt and by the successive intervention of the Philhellenists and of the governments of Russia, France and Britain in the Greek war of independence. The discovery of the Rosetta stone by Napoleon's savants had provided a key to the hieroglyphics of ancient Egypt; the travels of Byron had drawn attention alike to the cruel pasha of Albania and the sunset over Sunium; and in his poems and in those of the young Victor Hugo the Orient had kindled poetic fire. The Orient awaited only its artists; and of them Delacroix was to be the first and the finest.

From Charles X, Louis-Philippe inherited the conflict with Algiers. For a millennium Barbary corsairs had preyed on Christian commerce in the Mediterranean. The young American republic had been unable to protect its own merchantmen against them. After the Napoleonic wars the exasperated British had assaulted the port of Algiers to punish them. It was, however, the French who neatly turned a diplomatic incident, when the dey slapped their consul with his fan, into an excuse for an all-out war for conquest; and so it was that, just before he was ousted by a domestic revolution, Charles X had half his army in North Africa and that, just after that revolution had succeeded, Louis-

Philippe was obliged to decide whether the war should be continued. It was the paradox of his situation that made him decide to do so. As a king who owed his power to a revolution, he was suspected of revolutionary intentions by the legitimate rulers of Europe. As the man who had fought in revolutionary armies, he frequently felt obliged to fight for the glory of France. A colonial war in the western Mediterranean would worry only the British, the power most favourable to the new French régime; it had no implications for Italy, in Austria's sphere of influence; and Russia's client, Turkey, was impotent. A colonial war would give employment to the ageing Napoleonic veterans who had recently turned on the Bourbon forces in Paris and to his own vigorous sons; and it would restore French prestige among the nations.

Louis-Philippe was anxious that nobody should interfere in his cautious adventure. It was for this reason that a mission to Morocco was proposed for 1832, so that Algerians could not seek protection from their western neighbours or, worse, have their aid in a holy war against the infidel.

Delacroix's chance of a lifetime was the reward of his social graces. Through Duponchel, Director of the Opera, he knew Mlle Mars, celebrated actress and middle-aged *maîtresse en titre* of the young comte Charles Edgar Mornay, who, as a relative of the minister of war, was to lead the mission. Another useful intermediary was Armand Bertin, a good friend since early manhood, who was director of the famous *Journal des Débats*. Delacroix would be an agreeable companion during the *longueurs* of oriental diplomacy. In December 1831 he wrote excitedly to Frédéric Villot, 'I'll probably leave for Morocco next week. Don't laugh, it's true. Come tomorrow, Friday, about eleven o'clock if you can. Any later and you may not find me.'[1] In the event the boat, the corvette *La Perle*, did not sail till 11 January 1832.

En route for Toulon Delacroix travelled through snow between Lyon and Avignon and through driving rain along the coast route. He was delighted, he told Pierret, to be in the Midi, with its fine views and beautiful mountains. In Marseille he had been touched to come across memories of his father, who had been prefect there some thirty years before. He was looking forward to the journey ahead, feeling good and glad that his travelling companion, Mornay, could not be better. He meant his letter to be also for Félix Guillemardet and sent best wishes to Mesdames Guillemardet and Pierret. When next he wrote, he was already in Tangier.

Delacroix kept no proper diary of his journey, but there were almost daily letters to his friends, he kept notes to accompany drawings, sketches and above

all watercolours of great fluency and refinement; and where necessary, his observations can be corroborated by official memoranda. The result is one of the most unusual records of a voyage to 'the Orient' by any European traveller of the time. He knew nothing of Arabic, he did not come to terms with Islam, but he captured the external appearances of a civilisation with a fidelity which a more learned man would have found it hard to achieve.

After a short stop-off at Algeciras *La Perle* made for Tangier. There the small group would stay, from 24 January to 5 March, from 16 April to 11 May and from 31 May to 9 June. So far as Europeans were concerned, it was the most important city in the country, commanding as it did the Straits opposite Gibraltar and being as a trading post the leading emporium of western Barbary. For a sophisticated Parisian it was a gentle introduction to Africa. There was a whole social life gravitating round the consuls and vice-consuls of France, England, Sweden, Denmark and Sardinia. Delacroix could try his broken English, he could flirt with the few young ladies around – he seems to have taken a particular fancy to the Scottish Miss Drummond-Hay – and, as an accomplished horseman, he could ride with the men into the surrounding countryside.

Mornay's chief business was with the Moroccans. On 24 January he called on the pasha, Sidi Larabi Saidi, and next day he was received in the Casbah by the pasha and the city notables while the corvette waited in the harbour to demonstrate French naval power. On the third day, which was a Friday, before public prayers he had another interview with the pasha and with Sidi Ettayeb Biaz, amin of the customs and Tangier's habitual negotiator with foreigners, whose alert old face and strong simplicity Delacroix would record for him in a pencil and watercolour sketch. On the Saturday Mornay was busy drafting a memorandum for his hosts outlining France's official position. There followed a week of polite calls on Europeans till next Friday the muezzin announced the start of Ramadan and a month of virtual inactivity enveloped the delegation.

Delacroix's first notes were typical of his manner of recording his observations.

Tangier, Thursday, January 26, 1832
 At the pasha's.
 The entrance of the castle. The bodyguard in the courtyard. The façade. The little street between the two walls, at the end, under a kind of vault, men seated standing out in brown against a little sky. – Once on the terrace three windows with a wooden balustrade, Moorish door to the side through which soldiers and servants came. Before the file of soldiers under the trellis yellow *caftan*, variety of headgears. – Pointed bonnet without turban especially up

on the terrace. [The pointed bonnet was part of the uniform of the Emperor and his government.]

The handsome man with green sleeves.

The negro slave who poured tea, with yellow *caftan* and *burnous* tied behind. Turban. The old man who gave the rose with *haik* and deep blue *caftan*.[2]

These 'painter's notes' were intended only for himself and are so detailed because he was afraid of forgetting anything he saw. As he had written to Pierret on the 25th, 'You would need twenty arms and forty-eight hours a day to do quite well and give an idea of it all.'[3]

Soon after his arrival in Tangier he had begun to explore the town on his own, till he found an admirable guide in the Jewish dragoman, Abraham Benchimol. In North African society, right down till the creation of the modern state of Israel, the Sephardic Jews had a unique role as intermediaries between their Arab neighbours and Christian outsiders. By means of Abraham Benchimol Delacroix found his *entrée* into Moroccan society that was not Moorish yet which was sufficiently exotic for his tastes. Abraham had a large family, ranging from his father Moses, who had been French dragoman before him, through his brothers Jacob, Isaac, David, Haim and his nephew Haim Azencot, who would succeed him, to the women of the family, his sister Guimol and her daughter Leditia and his wife Saada and their daughters Preciada and Rachel. Rembrandt would have found it all reminiscent of the Old Testament. Just a little less aware of the Bible and equally sensuous, Delacroix noted down his impressions. 'The Jewesses are wonderful. I'm afraid it may be hard to do anything with them except paint them: they are pearls of Eden.'[4]

On Tuesday, 21 February he witnessed a Jewish wedding which he eventually pictured in the full-blown Salon painting of 1841. On this event he made meticulous notes,[5] which became the basis of a description written up in 1842 for an art journal, *Le Magasin pittoresque*.

A Jewish wedding in Morocco

Wedding ceremonies among Jews and Muslims are very unlike most European marriages . . . Nothing is as cold as it is with us . . . As opposed to us, among oriental people, among Jews, who live under hard constraints which serve to strengthen the links that bind them and to give greater importance to their ancient traditions, the great events of life are marked by physical actions which go back to the most ancient customs. Marriage above all is surrounded by ceremonies that are largely symbolic and is an occasion for great rejoicing by relatives and friends of the couple. . . .

In the courtyard of the house a large crowd rushes about: the upper galleries, the bedrooms and the staircase are open to the guests, who are made up of the whole town. At one of the weddings which I went to like everyone else, I found the passage leading to the street and the inside of the courtyard so full that I found it hard to get in. The musicians leant against one side of the enclosure and all the upper reaches of the courtyard were filled up with onlookers. On one side were the Jewish women in special dress for the occasion, their heads weighed down with a large piece of material on top of a high, very graceful turban, which they put on only for weddings. On the other side were all the important Moors, standing or seated, who had decided to honour the wedding by their presence. It is not easy to give an idea of the racket the musicians make with both voices and instruments. . . . It is to this accompaniment that the *danseuses* appear one by one. I say *danseuses* because only women devote themselves to behaviour which is beneath men's dignity. Everyone who has been to Algiers knows this sort of dance, which is, I think, common to all oriental people and which would be thought of among us, at least in respectable circles, as in bad taste. . . .[6]

There were sights even more exciting than belly dancing. On 29 January he had seen two horses fighting with a passion that had made him tremble for those in charge of them but which was wonderful for painting as Gros and Rubens might have imagined and as he would recreate for the next Salon. The grey hung on to the other's neck and could not be prised off him. Mornay came down. While he held the grey by the reins, the black stallion kicked viciously. The other still went on biting. In the midst of the battle the consul fell over, the animals were left to their devices and carried on fighting as they went along the riverside, fell in, went on fighting while struggling to get out and only after blows would the grey let go. . . . The soldier and the groom argued. 'Sublime in his mass of draperies, the bearing of an old woman and yet something military.'[7] He explained the circumstances more fully in a letter to Pierret. 'I go for rides on horseback outside the city walls which give me unlimited delight. . . . I don't know if I was able to tell you in my last letter about my reception at the pasha's three days after the reception he gave us in the harbour. I think I also haven't written to you since a ride we had outside town with the English consul who has a fetish for mounting the toughest horses in the country, and that's saying something since the gentlest are all devils. Two of these horses had a set-to and I watched the most furious battle you could imagine. . . . ' He goes on to retell the story on which he had made notes, complete with the comparison to Gros and Rubens.[8]

An even more alarming experience was in store for Mornay and Delacroix

together. It seems that the two of them hid to observe the 'fanatics' of Tangier, the Assaiouas. Of this Muslim sect John Drummond-Hay, son of the British consul, has left a vivid account in his book *Western Barbary*, which appeared in 1839.

> The individuals of this sect, of which there are many in most of the towns throughout West Barbary, resemble in some respects the jumping dervishes of the East, assembling, like them, on certain feastdays, in houses appropriate for the purpose, and there celebrating the rites of their faith. They conceive that their love and reverence for their patron and saint arrive at so high a pitch as to surpass the bounds of man's reason, and this creates for the time in which they indulge in their worship an aberration of the senses, which causes them to suppose that they become wild animals. . . . This state of madness is partly brought on by an intoxicating herb called hasbeesh, which is swallowed in small quantities and a glass of water taken to wash it down, or by smoking leek, likewise a herb found in Morocco. When the Eisowys [i.e. the Assaiouas] are in this state, they are sometimes paraded through the streets, chained or bound together, and preceded by their Emhaden, or chief, on horseback. They utter the most horrible sounds and leap about in every direction.[9]

Had Delacroix and Mornay been discovered, they would have been lucky to stay alive. Happily, they did not have to test their luck and Delacroix lived to commemorate the Assaiouas leaping about and uttering horrible sounds on a canvas, *The fanatics of Tangier*.

Tangier provided not only thrilling, but also sweet sensations. 'I have moments of delicious idleness in a garden at the city gates, beneath a profusion of orange-trees in flower and covered with fruit.' When calling on the Danish consul, he remarked on the tombs amid aloes and irises . . . 'The purity of the air. M [Mornay] as struck as I am with the beauty of nature here. The white tents against all the dark objects. The small tower in the background. . . . The almond-trees in flower. The Persian lilac large tree. The beautiful horse under the oranges. Interior of the courtyard of the little house.' That evening he was unwell and he stayed in alone. He jotted down: 'delicious reverie in the moonlight in the garden'. He was at peace.[10]

Light as strong as he found in Morocco was a novel experience. He noticed that white tended to annul all colours around it and its brightness troubled him. The tiny sensitive self-portrait he sketched in pencil showed him as elegant as ever, but with his face screwed up. 'My health is good,' he reassured Pierret. 'I fear only a little for my eyes.'[11] Gradually impressions prepared the way for

ideas. These were not all new, for he inevitably had the preoccupations of a Romantic aesthete. He began to elaborate his views towards the end of February. 'This is a place just for painters. . . . The heroes of David and company would look in poor shape with their pink limbs next to these children of the sun; but in return, ancient costume is better worn here, I'm sure. If you have some months to spare, come to Barbary, you'll see naturalness which is always disguised in our part of the world, you'll feel the precious and rare effect of the sun which gives everything profound vitality.'[12] Or again: 'Imagine, what it's like, my friend, to see sitting in the sun, walking in the streets, mending slippers, personalities of consular rank, Catos, Brutuses, who aren't even without the disdainful air that would have befitted the rulers of the world; these people own only one covering in which they walk, sleep and are buried and they have as contented a look as Cicero must have had in his curule chair. . . . Antiquity had no more beautiful sight.'[13]

By this time Delacroix was a little homesick for Paris, reproaching his friend Pierret for not writing more frequently, yet looking forward to what lay ahead. The day after tomorrow they would be off for Meknes, one of the three capitals of the country – Fez and Marrakesh were the others – and the one where they would be received by Sultan Moulay Abd er Rahman Ben-Hicham. In the interval Delacroix occupied himself putting his notes in order and watercolouring for Mornay *Sidi Ettayeb Biaz, The Benchimol Family* and *Abraham Benchimol's Daughter*. The life of gentle social occasions was coming to an end. On one of his last recorded meetings with the British consul, he had handed Miss Drummond-Hay a drawing of a seated Moorish woman. In 1896 she would write a memoir of her father in which there was to be no mention of the gallant Delacroix.

The caravan was en route by 6 March at the latest. The French delegation led by Mornay and the Moroccan delegation led by Sidi Ettayeb Biaz were accompanied by 120 soldiers under the Caid Sidi Mohammed Ben Abou, commander of the Tangier cavalry, and by 30 servants in charge of the baggage and by 42 mules to carry it. For the first hour they were accompanied by the foreign consuls and the pasha of Tangier. They soon left the coastal plain and wended their way towards their first encampment at El-Arba Ain-Dalia. Delacroix noticed the black, wild mountains to the right, with the sun above them, the dwarf palm trees and the stones that they walked among, the tribesmen who had looked down on their cavalcade from the heights above and the imam calling the faithful to evening prayer.

The whole journey to Meknes he estimated at some fifty leagues. It took him

along the road which had been followed in 1578 by Sebastian, king of Portugal, on a crusade that would end on the field of Ksar el-Kbir (Al-cassar-El-Kebir), where Dom Sebastian and the ex-Sultan of Morocco and the current Sultan had all met their deaths. Delacroix began to gain a closer acquaintance with Moorish habits. He tried to write down correct equivalents to Moroccan names: the oases where they stopped, the wadis they had to cross, their phrases – *Ammar Seidna*, part of the greeting *Allah I bark Ammar Sidna*, May God bless our Lord's life – or the word for a simpleton – *bonhali* – and for their favourite food – *couscoucoussou*, as nineteenth-century travellers usually called couscous. He keenly recorded the Moorish customs he experienced. One of the most disturbing incidents happened during the '*jeux de poudre*' before they reached Ksar el-Kbir. John Drummond-Hay has a tale of what the Moroccans called *lab el Baroda* and he himself 'powder play'. An Arab told him: 'Our tribe mustered about two hundred horse; we charged in line; some stood on their heads at full speed; others changed horses with their companions at full gallop, then reining in, as we dashed within a gun's length of the sheik, we fired our muskets, wheeled round, and gave place to others who charged close to our rear.'[14] Of such scenes Delacroix was to make some memorable pictures, but this occasion could have been the last. 'One man emerged from the crowd of soldiers and came to fire under our noses. He was grabbed by Abou.'[15] Mornay had managed to appear calm and he kept the sword which was used to cut off the man's head and in later years he would enjoy dining out on the incident at polite parties in Paris.

On Thursday, 15 March, after bypassing the sacred city of Moulay Idriss of Zar Hone, access to which was forbidden to non-Muslims, the party came through a gap in the mountains into a large valley; and before them on the crest of a hill stood the city of Meknes.

The departure for Meknes had originally been fixed for 26 February, but was delayed by the death of the Sultan's brother at the siege of Marrakesh. Ramadan ended on Sunday, 4 March and the French delegation was asked to come before the court would be preoccupied with further religious events. Despite rain and the stops on Friday for the Muslims to pray and the delays on Saturday caused by the Jews and one attack on the delegation the day after the attack on Mornay, they had at last arrived.

Sultan Moulay Abd er Rahman Ben-Hicham, who had been on the throne for some ten years, had had his domestic troubles, such as a military revolt in 1832, but his chief concern was his external relations with European powers, of whom England and France were the most important. Whereas the British had been content with a treaty signed in Tangier which gave them commercial

ascendancy over their rivals, the French were worried principally about the impact which the Sultan might have on Algerian affairs; and indeed he had already intervened in Tlemsen, which lay in Algerian territory. He had to be persuaded to withdraw partly by local resistance, partly by troubles within his own forces and partly by the protests of the French commander-in-chief, the Duke of Rovigo. It might require just a little more pressure to make him agree to have nothing to do with Algeria – it was this pressure that Mornay was instructed to apply. Mornay, he had decided, must be received in style.

Next day Delacroix wrote to Pierret:

> our entry here was very beautiful and it was a pleasure you would want to experience only once in your lifetime ... We were first made to take the longest route to go round it [Meknes] and get an idea of its significance. The Emperor had ordered everyone to enjoy themselves and to entertain us under the severest penalties, so that the crowd was enormous and the disorder in proportion. We knew that during the reception for the Austrians, who came six months ago, a dozen men and fourteen horses were killed by accident. Our little group found it hard to keep together and to keep in touch amidst the thousands of rifle shots that went off in our faces. We had musicians ahead of us and over twenty flags carried by men on horseback. The musicians were on horseback too, with some kind of bagpipe, and, hanging from their necks, a sort of drum which they struck with two sticks one after the other and from both sides. This deafening din mingled with the shots from the cavalry and infantry and from the most daring who charged round us letting off their guns in our faces. The whole hullabaloo simultaneously irritated and amused us – now the feelings of annoyance are largely forgotten. This triumphal entry, which reminded me of nothing so much as a march to the gallows, lasted throughout the morning till four in the afternoon. *Nota bene* we had had just a snack for breakfast in our tent at seven o'clock. While feeling in a temper I noticed some strange buildings all in the Moorish style, but grander than in Tangier.

Four days later he added another section to the letter explaining that he had been under something like house arrest, unable to go out before they were received by the Sultan, thrown back on one another for company; and with just the house to admire, which reminded him of pictures he had seen of the palaces of Granada, he ended by appreciating that in time you become insensitive to the picturesque. When the mail came from Tangier, his heart had beaten a little faster in the hope that there would be something for him, but everyone had been unkind to him – a word from any one of his friends would have meant more to him that the whole of Africa.[16]

Two days later came the climax of the whole adventure: their audience. They left around nine or ten o'clock on horseback, preceded by the Caid on his mule and some footsoldiers and followed by men with gifts. They went past the great mosque of Jamaa el-Kbir, with its fine minaret, passed through the Souk el-Hdim, under overhanging bamboos, till they reached the square in front of the great gate to the market. Dismounting, they went through a second courtyard between serried ranks of soldiers till they came into the grand Mechouar Square where they were to meet the Sultan. Gradually the square filled up with small detachments of soldiers in the familiar pointed black bonnets and next two lancers.

Then the King who came towards us and stopped close by. Great likeness to Louis-Philippe. Younger. Thick beard. Lightly tanned. *Burnous* of fine material, almost closed in front. *Haik* beneath it, worn over the chest and almost totally covering thighs and legs. String of white beads round his right arm hard to see. Silver stirrups. Yellow slippers open at the back. Saddle and harness pinkish and golden. Horse grey, with hogged mane. Parasol with unpainted wooden handle; a little golden ball on top. Red on top and in each of its sections. Red and green underneath.[17]

What he had witnessed Delacroix would later make famous in his picture of *Moulay Abd er-Rahman Leaving his Palace in Meknes Surrounded by his Bodyguard.*

The rest of the stay in Meknes, from 4 March to 5 April, was spent in some eleven meetings between Mornay and his assistants, prominent among them Abraham Benchimol, and Sidi Ettayeb Biaz and other advisers of the Sultan, before Mornay was handed back the Sultan's favourable reply to Louis-Philippe's plea for Franco-Moroccan friendship. The meetings gave Delacroix the opportunity for some discreet sightseeing and painting. 'Yesterday,' Delacroix quickly wrote to Pierret, 'we were received in audience by the Emperor. He granted us a favour he never grants to anyone, the chance of visiting his private apartments, gardens and so on.'[18] In the royal palace built by the great Sultan Moulay Ismail, the contemporary of Louis XIV, he saw round the audience chamber, the Koubat el Khayattine. Fountains played in the midst of marble courtyards, walls were decorated in ceramic tiles, doors were coloured green, red and gold, there were exquisite carpets and brocaded beds. Small, rather scruffy children, mostly black, were in some of the smaller rooms. He spied Abou and one or two other men leaning against the wall by the main entrance. Outside, when he had admired the ambitious irrigation system which watered the extensive gardens, he noticed the general in charge of the cavalry

squatting in front of the doorway to the stables. 'From that door looking back beautiful effect the lower parts of the whitened walls.'[19]

Now that the audience was over, Delacroix as a foreigner could start to look around outside Berrima, the part of the city where the French party was lodged. On Friday, 23 March he made his first excursion into the Mellah, the Jewish quarter, where he bought small leather goods, took a child by the hand and watched a man playing chess. He was back next day in the house of a friend of Abraham's and, as it was the Sabbath, a young woman showed her respect by kissing his hand. Next Friday the Sultan sent them Jewish musicians up from the coast at Mogador, who had inherited the musical traditions of Andalucia, to entertain them; and the Caid Abou came to listen. To remember the Frenchmen Abou wrote down their names on a sheet of paper which he kept in his turban. Delacroix's name was accounted too hard for him to transcribe.[20]

Near the end of the stay he set down some of his reactions for Pierret's benefit. He had been the only one of the group to take advantage of the permission to be a tourist.

As the people here hate the dress and appearance of Christians . . . it's always necessary to be accompanied by soldiers, which didn't prevent two or three quarrels which could have been very nasty because of our position as envoys. I am escorted, every time I go out, by an enormous gang of onlookers who heap insults on me, . . . who push and shove to get near me to pull faces at me . . . I need all my curiosity to see things, to put up with this dreadful treatment. Most of the time I have been very bored, because I cannot openly draw anything from nature, even a hovel; even going on a terrace exposes you to be stoned or shot at. Moors are very possessive, and it's on the terraces that their women usually take the air or see each other.

The other day we were sent horses from the King (I've just got one), a lioness, a tiger, ostriches, antelopes, and a kind of savage stag, which took a dislike to one of the poor ostriches and ran it through with its horns, so that the ostrich died this morning. Such are the events which vary our existence.[21]

He was in a mood for less black comedy when writing the same day to Armand Bertin and his brother Edouard. After grumbling in much the same tones as he had to Pierret about Moroccan behaviour to Christians, he went on: 'The picturesque is all around you. At every step there are ready-made pictures which would make the fame and fortune of twenty generations of painters. You believe you're in Rome or in Athens without Atticism but with the mantles, togas and a thousand of the most authentic antique touches. A scoundrel who repairs the upper part of your shoe for a few sous has the dress and bearing of Brutus or Cato of Utica.'[22]

On 5 April, mission accomplished, they began the long trail back to the coast, very aware that the Moroccans had no proper roads or bridges. This time, however, when they came to the wadi Sebou, the crossing of which before he had compared to Napoleon's crossing of the Rhine, Delacroix proudly noted: 'Crossed the Sebou. Mounted on my horse.'[23] Soon they were in the large plain where Dom Sebastian had been defeated and on Thursday, 12 April, small children came out to salute Abou, who spoke to them and gave them money. The party had regained Tangier.

Back in Tangier, he had an attack of fever – he had been ill once in February and once in March – but was well enough to go out after a few days. He wrote down his impressions of the Moroccans.

'This people is completely antique. . . . Life outdoors and houses firmly shut: women withdrawn. . . . Custom and ancient habit rule everything. The Moor thanks God for his bad food and his inadequate clothing. He thinks he is still too lucky to have them. They must find it hard to understand the restless spirit of Christians which makes us seek out novelty. We notice a thousand things they lack. Their ignorance gives them peace and happiness: we perhaps have reached the final stage of what a more advanced civilisation can produce. They are closer to nature in a thousand ways. Their costume; the shape of their sandals. Also, beauty goes with everything they do. We by contrast with our corsets, our rigid shoes and our stiff clothes. We have gained technology, they have preserved grace.'[24]

He soon found some Moorlike Christians. While waiting to take ship for France, Delacroix had the chance to go to Spain, which he had just seen on his way to Morocco. This time he would have almost three weeks in al-Andalus, Andalucia, that most Moorish part of Spain, seven days of which were spent in quarantine in Cadiz and none of which took him to the most beautiful of Moorish remains in Córdoba and Granada. But he had a week in Seville.

In 1832 France had a special allure for Spaniards and Spain had a special allure for Frenchmen. For Napoleon French soldiers had fought all over Spain during the Peninsular War against the Spanish Bourbons and for Louis XVIII they had conquered the country rapidly to protect the Spanish Bourbons. In Spain the afrancesados had initially welcomed the French as liberators from a hated Crown and a hated Church, but French cruelty and national pride combined to make a man of the Enlightenment like Goya turn patriot and in the noble canvases of The Second of May and The Third of May dramatise Spanish resistance and French revenge. Goya remained of the party of humanity and in the etchings of The Disasters of War he turned on war itself. But he was not overjoyed at the

Spanish Bourbon Restoration. He retreated into the countryside outside Madrid and there in the 'house of the deaf man' (the Quinta del sordo) concentrated his feelings of disgust into his terrible Black paintings. His reaction to the French invasion of 1824 was to leave Spain and to take refuge in Bordeaux, where he died in 1828. It was the closeness of Goya to the Bonapartist court in Madrid and his death in France which helped to make his art known in France. Delacroix had long heard of Goya, for had he not painted the father of Félix Guillemardet? As early as 1819 he had studied Goya's *Caprichos*, which satirised Black Spain, and he possessed a set of them by 1830. In 1816 Goya published his series of 33 plates on bullfighting; and this set of etchings must have been also known to Delacroix.

He was on tolerable terms with the leading Hispanophile among young French writers. During the late 1820s once a month, in the company of Stendhal and four or five others, he dined with Prosper Mérimée. In 1830 Mérimée had spent six months in Spain and his letters from there to the *Revue de Paris* were printed from early 1831. Mérimée shows a fascination with the harsher sides of Spanish life which would have appealed to his fellow diner: bullfighting, an execution and bandits.

When Delacroix left for Seville, Mornay wrote to Delaporte about him: 'the artist leaves us to go and see Seville and will come back only with *La Perle*, that is about the 28th. Spaniards, bullfights, monks – all that sets his imagination on fire, and if he comes back any fatter, I wish that the devil would take me off.'[25]

'I am very glad,' Delacroix told Pierret, 'to have been able to get some idea of this country. At our time of life, if you miss out on a chance like this, it doesn't come again. I found in Spain all I'd left behind in Morocco. Nothing has changed except the religion – there's the same sort of fanaticism. I've seen beautiful Spanish women who are above their reputation. The mantilla is the most graceful thing in the world. Monks all colours of the rainbow, Andalucian costume. Churches and a complete civilisation just as it was three centuries ago.'[26]

A few sketches and jottings preserve the events of Delacroix's short stay in Spain.

Off Cadiz while still in quarantine he drew the city as it lies as though floating just above the surface of the water; and once on shore – 'extreme joy' – he noted down how, as the boat approached, the houses had looked white and gold under a beautiful blue sky. He heard midnight struck by the Franciscan clock, studied the faience stairway in the convent of Saint Augustine and in the darkened Capuchin church saw Murillo's *Madonna*, with her cheeks perfectly painted and her heavenly eyes, and the painting with the skeleton and a little sculpture of a *Pietà* encrusted with jewels above a small picture of a monk in ecstasy

before a crucifix. He saw the incomplete cathedral – it was not finished till 1838 – and felt the burning sun and remembered a bull, perhaps at a bullfight. But what most struck him was the French chancellor, M. Gros, who drank only water throughout the meal and did not smoke at dessert, though once he had smoked three or four dozen cigars a day, drunk a bottle of brandy and been past counting the bottles of wine. A little while ago he drank six or eight bottles of beer; and there had been a similar story of excess in the matter of women. What had cost him most had been giving up his cigars. . . . What a type! Wine and above all tobacco meant to him inexpressible sensuality. He was a character out of Hoffman.*27

As a place Seville was more exciting. Everywhere Delacroix recognised the Moorish influence. There were large doorways, ceilings with inlaid wood, gardens, a brick causeway bounded by faience, crenellated walls. One morning he went into the cathedral and felt its magnificent darkness, and was struck by the Christ – probably the wonderful wooden sculpture by Montañes – and the enormous wrought-iron grille round the high altar and the tiny windows behind the altar and the entry to the crypt. Two days later he walked up the Giralda, the famous Moroccan belltower which he noticed has no steps inside, and saw the view from the top. The neighbourhood looked just like Paris.

But what was captivating was distinctly Sevillian: the arcades, the woman lying by the door of the church with brown arms contrasting with her black mantilla, the beautiful Zurbarán in the Carthusian monastery across the Guadalquivir, the terrace by the river which reminded him of a time when he had been in Montpellier, the beautiful Murillos in the Franciscan convent, the double walls round the city, the melancholy he felt echoed in a guitar, two Goyas in the cathedral sacristy, the troop of horsemen on the bridge, the superb Alcázar with its Moorish style unlike anything he had seen in Morocco – though he did not know it, the Alcázar was a more ancient building – and that most elegant of Renaissance villas, the Casa de Pilatos with its fine stairway, its faience everywhere and its Moorish gardens.

All the time he contrived to have an enjoyable social life. There was no one quite like Monsieur Gros, but instead there was Señora Dolores, whom he drew, Messieurs Hartley and Muller, with whom he went in a carriage to see the famous Charterhouse and above all Monsieur Williams, Madame Ford and a mysterious 'M.D.' He saw Monsieur Williams every day. He heard in his company the story of two famous toreros, Romero who scarcely moved to avoid the bulls and Pepillo who had been killed by a bull in Madrid by being carried

* The vogue in France for the stories of Hoffman had started in 1829.

round the ring impaled on its horn. Dancers showed him how castanets worked. He had spent one day wandering in the streets like a Spanish lover. He said goodbye to Madame Ford in the English style and then goodbye to Monsieur Williams and his family. He would not be able to say goodbye for ever to these fine people. He had just one moment alone with Monsieur Williams, who had been moved too.

The boat made its way down the Guadalquivir, he felt it was a sad night, he felt isolated while people he did not know played cards on the badly lit and uncomfortable between-decks – but at least a woman turned up her sleeve to show him her wound. He felt in a bad way when he was woken up because they had to get off at Sanlucar. And so back in a two-wheeled carriage, a *calesa*, to Cadiz.[28]

He had sketched the Plaza de San Lorenzo, he had sketched the five wounds of Christ on the arms of the Capuchins, the cemetery in the evening, the walls, the men on horseback. He also painted a graceful watercolour of a picador in a blue jacket and yellow trousers. He had also drawn in a large room beside the cathedral, perhaps in the Archivio de India. He must have remembered the connection of Seville and Cadiz with the Indies, for in 1838 he would paint Columbus at the convent of La Rábida – he set it in the Dominican priory in Cadiz, of which he had a sketch.

He wrote to Pierret about Spain when he was back in Tangier.[29] He also took care to write to Auguste Jal, the art critic who had first given him so much help in 1824, when in *Scenes from the Chios Massacres* he had first tackled oriental themes in painting by imagination alone. Jal had been to Algiers and would understand that Morocco was pure Moorish, unalloyed by Turkish influence.[30] But it was in the former Turkish outpost, in Algiers, where after a short stop-off at Oran *La Perle* called on the way back to Toulon, that Delacroix is said to have had the ultimate voyeuristic experience for a westerner in a Muslim land: the view of the interior of a harem.

In his travel notes Delacroix makes no mention of any such experience. The first detailed tale of a visit by Delacroix to a harem dates from 1883, when Philippe Burty wrote up for the magazine *L'Art* an account based partly on the reminiscences of Mornay and partly on what a French painter, Charles Cornault, who had lived in Algeria, had been told by a French engineer, Victor Poirel, who had been in Algiers in 1832, when Delacroix had been there for three days. This story about a story about a story tells how Poirel had introduced Delacroix to a former corsair, now turned port official, who had secretly admitted Delacroix into his harem. Mornay explained that the official was a renegade Christian,

which might account for an easy-going departure from normal Muslim custom. Cornault's remarks are in other particulars more revealing.

Delacroix, 'wanting to visit the interior of a house, where he could draw Moorish women, which he had been unable to do at Tangier, where he had got inside Jewish homes only, begged Monsieur Poirel to help him. He invited along the *chaouch*, a kind of dogsbody who acted as bailiff for the administration. After long negotiations Monsieur Poirel managed to persuade him to take Eugène Delacroix into his own house without anyone knowing. The women, who had been warned, put on their most beautiful clothes and Delacroix used them as models for watercolour sketches which he afterwards used to paint his picture of *The Women of Algiers*. Monsieur Poirel loved to recall this memory from his youth.'

Cornault comments: 'Among orientals the women of Algiers are considered the most beautiful on the Barbary coast. They know how to set off their beauty against rich silk cloth and velvet embroidered with gold . . . when you've gone down a darkened corridor and reach the part of the house reserved for them, your eye is dazzled by the gleaming light and the fresh complexions of the women and children when you suddenly come across them . . . Monsieur Poirel told me that Delacroix was almost drunk with the sight in front of him. . . . From time to time Delacroix would call out: "How beautiful! It's like in the times of Homer. Women in the women's quarters coping with children, spinning wool or embroidering marvellous fabrics. That's women as I understand them."' [31]

The story has been doubted. Delacroix may have been taken to a brothel. And yet he left Cornault arms and clothes he had acquired on his journey; and among the mass of preliminary studies for his masterpiece he noted down the names of four women, along with notes on the the colours of their clothes. And when he showed his first version of *The Women of Algiers in their Apartment* in 1834, Delécluze, while admitting that the lighting and the variety of tones were admirable, added sourly: 'if this is what the houris of Mahomet are like, we are not going to become Turks straightaway.' [32] This was a backhanded way of saying that Delacroix had not shown the large expanses of naked flesh which Europeans expected to see when artists represented Muslim women. His painting was unusually restrained, even chaste. Since his day the colours may have faded and the paintwork may have cracked, but as a sensitive, sensuous and serene evocation of the way of life of Algerian women of the time, it remains unequalled in European Orientalist painting, indeed it transcends the genre, for the subtle hues of Delacroix's palette and his sure sense of texture were worthy of one of the great Venetians, like Giorgione or Titian, and the exquisitely judged interior might seem exotically Dutch.

Louis-Philippe bought the picture.

One reason why this picture, not the meeting with the Sultan, was Delacroix's major picture for the 1834 Salon was because as early as 1833 the expedition of the previous year seemed to be a failure. Louis-Philippe's army in Algeria soon found out that their most determined enemy, Abd el-Kader, was in receipt of regular Moroccan aid. It was not till 1845, when good relations were restored between France and Morocco, that Delacroix felt able to exhibit his depiction of the Sultan's reception of the French at Meknes.

For Delacroix personally the expedition had been a turning-point, an unqualified success. He had gained a new friend, Mornay. He had happy memories of personal kindnesses from Abraham Benchimol and from Caid Ben Abou Mohammed, the Moroccan who could not write down his name in Arabic. He would not become a limited orientalist, like many lesser artists, French and British, who would make their living from providing glossy paintings of North African and Levantine scenes for people whose idea of 'the Orient' came from a visit to the Alhambra in London or the zoo at the Jardin des Plantes in Paris. Though Delacroix remained culturally a European, so that his lion hunts look more Rubensian than Moroccan, there was nothing mean about his sense of that world he realised would have to stay remote, beautifully remote, but remote none the less. There would be no going back; and he never again went south of the Pyrenees – he never even went south of the Alps.

At some stage Delacroix drew up a miscellaneous list of facts and observations about Morocco. His biographer can note similarly unrelated results of his six months in 'the Orient'. He had acquired a series of motifs which would provide subjects for his pictures till the year of his death. He had acquired a few oriental possessions, which he kept till he died, excluding the Arab horse the Sultan had given him, which was not mentioned after his return to Tangier. He came back to France certain that he knew more about true classicism than all the followers of David. He came back to France able to understand Muslim ideals of beauty, if not the faith of Islam, which forbade his kind of representational art. He came back to France sure of his way.

In July 1832, while he was enduring the four weeks of quarantine off Toulon, with only a short distance to walk in his treeless enclosure and with a fine view over three cemeteries ideal for burying people like himself who had died of boredom, he confessed that, even if he had been away longer than he had anticipated, he had been quite pleased to have been able to compare Oran and Algiers with 'my Morocco'. He had heard of the riots in Paris and of conspiracies. 'Go to Barbary to learn patience and philosophy.'[33]

Intimate relations (c. 1825–1854)

I N matters of love and friendship Delacroix had need of both patience and philosophy. In 1827 his sister Henriette, once the subject of David's masterpiece, had died. Delacroix does not discuss his feelings towards her in any surviving letter from that year – there is just a brief, formal excuse to Victor Hugo for missing the reading of *Cromwell* on the grounds of her illness and death – but she is mentioned in a brief aside in his Journal when on 10 July, 1850 he was travelling from Belgium into Germany. 'Passed Aix-la-Chapelle without being able to go into the town. How long ago I came here with my dear mother, my dear sister and my poor Charles! The two of us were just children at the time. For quite a long time I could see the Louisberg where we went to fly kites with my mother's cook Leroux. Where are they all now?'[1] They were of course all dead. In 1834 he was deeply disturbed by the news of the death of his nephew Charles, who, closer in age to him than his sister or either of his brothers, was more like a normal brother to him, for they had been brought up together, he had supervised Charles' education in Paris, he had tried to restrain Charles' spendthrift habits and, at the time when the collapse of the family finances halted briefly a legal training for Charles, he had cheered his sister up with the thought that a commercial career would be socially acceptable. In the end Charles managed to make his way more in the family line, when he entered the consular service, for his father and his grandfather had been diplomats before him. In April 1829 he was appointed *Elève-Vice-Consul* without pay, but after passing his law exams he was sent, this time with a salary, to join the French consulate in Malta.

From 1830 and 1831 there survive a number of letters from Delacroix to his nephew which show that in young Charles he had his closest confidant in the immediate family. In March Delacroix wrote to tell of the deaths of their distant relative, the comte de Lavalette, and uncle Jacob, Charles's great-uncle, and of

the grave illness of another of the great-uncles, uncle Pascot. Such events were, after all, the normal tribulations of a large extended family like theirs. What was much more agreeable was his recent return with cousin Léon Riesener to Valmont, which they had not visited for fifteen years. Everything was exactly as it used to be: the same entrance between two stones one on top of the other and the same engravings and drawings hanging in the same places. Nothing had changed except the humans.

He soon had reasons for cheering up. One result of his dutiful involvement with the Lavalette family was the opportunities he was now taking to see the count's daughter, Joséphine de Forget. 'As for Madame de Forget, I have made a little progress, she has taken a step back, then she is more forward, then she retreats again. . . . There's a lot of pleasure to be had from a little flirting. If I had received any true favours, I mean palpable ones, perhaps I would not so quickly return for more and I would soon come to my senses; for a woman is just a woman and basically always very like any other woman; and that proves it's the imagination that matters and it's often the most striking beauties who leave you cold and indifferent. As for Madame Dalton, I find myself in the same situation as usual, except that there's a greater sense of reality and excitement. . . . The life of lovers, especially when the lover loves two or three women, tends to take up all his energy and nothing is more necessary in this situation than the 25,000 pounds' *rentes* I expect from my fairy godmother.'[2]

By the late summer politics had replaced love as their principal topic of discussion. In August Delacroix confided his considered reactions to the July Revolution. Next month he tried to reassure Charles that the number of people killed in the Revolution had been greatly exaggerated, at most two or three thousand. It was exactly like all those millions which the English were supposed to have sent to the cause of the wounded French and which amounted in fact to only 53,000 francs. What had saved the day had been not so much the moderation of the new king – he had admittedly taken a great deal of trouble to manage his affairs with skill – as the stirling qualities of the National Guard, who numbered 50,000 at the review on 27 August. He added his congratulations on Charles's latest romantic conquest and commented encouragingly: 'she's not so likely to deceive you as others may have been.'[3]

Promotion for Charles came in May 1831: he was to be Vice-Consul in Valparaiso, Chile. From Valmont again Delacroix wrote to wish him well. 'You have love and what makes love and war possible, I mean money. Make the best use of your opportunities. . . . I embrace you tenderly.'[4] Six months later Charles left France on his final trip abroad. In Chile he had problems with his superior and was recalled in 1834. On the long journey home he fell ill and died.

This time Delacroix was devastated. 'I am so upset I cannot put my hand to

my head,' he told Elise Boulanger on 19 July. 'I've just heard of the death of my poor friend, so I scarcely know what I'm doing.'[5] Next day he wrote a quick note to Pierret, asking him to pass on the sad news to Félix Guillemardet,[6] and at greater length to Soulier. 'I have learnt of the premature death of my good Charles, the only remaining member of my sad family and who should have been my last living friend in the order of nature, since his age meant that I expected he would be with me when I came to die. He was coming back from Valparaiso, charged with important missions which would have furthered his career. I was looking forward to his return. At Vera Cruz he caught the yellow fever germ which killed him in New York. You can imagine how much I've suffered.

'You hardly knew this excellent fellow of whom I expected so much for the time of life when our ties of affection weaken. You can understand what I've lost and why I feel I must write to you to tell you all about it.'[7]

Charles the nephew, just five years his junior, was dead: Charles the brother, nineteen years his senior, was still alive.

With his big and boisterous brother, who had settled into an unrespectable way of life in the country, Delacroix must have had very little in common. At the time when André Joubin published in the 1930s the then known correspondence, he included only one early letter from Eugène to Charles. In the 1940s, however, Alfred Dupont produced a dozen more, all but two of which date from the last fifteen years of Charles's life, that is from 1830 to 1845. What they reveal is a relationship which was affectionate, concerned on the younger brother's side, but not one of kindred spirits. If, as Dupont believes, there never were many more letters, the two brothers were hardly close.

In 1830 he wrote not just about his plans to paint his *Liberty* but also about his attempts to use the new political situation to his brother's profit, so that Charles could return to active service in the army, attempts which would end in failure. Eighteen months later, in May 1832 from Tangier, near the end of his stay, he again wrote to Charles. He promised to give him an account of his time there, expressed his worries about the cholera spreading throughout France and agreed with Charles that he would prefer to live in the south – only the presence of friends in the north would keep him where he lived. He ends affectionately: 'Good-bye, dear brother, your African embraces you very tenderly and your wife too.' His kindly feelings, however, did not make him write any more frequently, as he noticed in his next letter, which dates from 1835. He would like to come and stay, but a fortnight would be all he could allow himself. He had so much work to do that he could not possibly give up one or two months. He was still making the same excuse in 1839, in a letter where he also apologises for his bad business sense in trying to handle some of Charles's legal affairs for

him; and in 1841 he began a letter with what had become almost a formula. 'I am very ashamed as you can imagine at starting a letter to you after such a long time.'[8] His principal reason for writing was to tell Charles of the death of their cousin Henri Hugues, but clearly he was conscious of the mutual neglect evident in the behaviour of the two brothers towards one another. He did not even know his brother's new address in Bordeaux.

The last letters to his brother were less sporadic and show that Eugène was becoming more assiduous, thanking his brother for a gift of wine, worrying about the floods in Bordeaux, passing on the good news that he had succeeded in getting the plaster sculptures of their parents cast in bronze, recalling with pleasure their stay together in Vichy and hoping that, when for his health he was advised to rest in the Pyrenees, he would be able to call in on Charles.[9] That visit never occurred, because Eugène himself was too weak. He did not go to Bordeaux till he heard that his brother was seriously ill. By the time he could arrive, Charles was dead. From Bordeaux he wrote to his most faithful correspondents – to Joséphine de Forget, to George Sand, to Villot, to Pierret and to Berryer – to express his sadness. As he told Hippolyte Gaultron, half-brother to his cousin Bornot and his own assistant, he had lost someone who had been to him both brother and father. He had been touched by the respect in which soldiers held his brother and, though vexed by the problems he would have from sorting out his brother's estate, he had the satisfaction of ensuring, before he left, that there would be a fitting memorial for his brother and his father in the cemetery of the city.[10]

Separation could divide brother from brother. Relations nearer home could be seen more easily. One of them was the cousin Henri Hugues whose death was mentioned in the 1841 letter to Charles and the others were Léon Riesener and his mother.

One of the earliest entries in Delacroix's juvenile diary had recorded a day in September 1822 when he and his brother had the pleasant experience of a surprise visit to his brother's home by their mother's nephew Henri Hugues and her half-brother Henri-François Riesener with his young son Léon.

After the death of Henriette Eugène found in tante Riesener a substitute mother; and Léon, who had been just fourteen in 1822, became in his twenties an aspiring painter and one of Eugène's best friends. Frépillon, where north of Paris the Rieseners lived in some style, became a favourite retreat. It was with them he could leave his great picture of *Liberty* and have his likeness done by the new technique of Monsieur Daguerre. Tante Riesener had been in attendance on the empress Joséphine and possibly had had an affair with Napoleon himself before marrying, with Joséphine's approval, the young painter Henri-François Riesener, half-brother of Eugène's mother, in 1807. She

was cheerful, spontaneous and cultivated; and in 1824 Eugène had enjoyed translating parts of *Childe Harold* with her. It was probably at her home in 1834 or 1835 that Eugène painted two of his finest portraits: one of her, now a widow, and one of Léon. She is shown as intelligent, warm, once beautiful and Léon as handsome and self-willed.

Somewhat later Delacroix painted the ageing Henri Hugues. In 1822 young Eugène had been shocked by his indelicate language, but later he came to value the unpretentious attitude of this gentle cousin. He enjoyed the company of Léon and Henri. For many years the three of them would meet for a weekly meal, either at one's apartment or at some restaurant. Delacroix, according to Riesener,

> brought to these dinners a friendly, diplomatic gaiety and an attentive, affectionate friendship for cousin Henri, our elder, a charming, innocent and courteous man, whom Delacroix loved with all his heart and the memory of whom he always carefully preserved. . . . Henri, who worked for the Post Office, a would-be poet, looked very dishevelled. I remember one occasion when we were leaving a play . . . put on . . . by Frédérik Lemaître. Henri's hat and dress as he left the theatre were very comical. Delacroix, who was so elegant and careful about his appearance, quietly took his arm in the middle of the boulevard and, as happy as a lark, carried on enjoying his old friend's wit. I owe to the friendship of these two men whatever goodness I may have in my own eyes. . . . We lost Henri about 1840 [in fact 1841]. . . . We were the only ones to accompany him . . . to the church of Neuilly where on our knees beside one another we wept over him together.[11]

With Léon Riesener himself Delacroix would not always be on such good terms. In 1839 Riesener married a Parisian, Laure Peytouraud, who was as strikingly good looking as he was. He became a competent artist, eclectic in style, and worked alongside his cousin in the library of the Senate at the Palais du Luxembourg. He was not overawed by Delacroix's fame and sometimes criticised his paintings. For his part Delacroix could be critical of Léon: 'he has been a fool all his life. There's a basis of good sense in his mind and he always lacks it in his behaviour.'[12] But the cousins maintained their ties and it was Léon who took the part of his long dead cousin Charles when Delacroix was dying and it was Léon who was his principal heir, recognised as the most intimate member of the surviving family.

With cousins on his father's side he was probably more distant. They were always acknowledged if they came to see him in Paris, and in his fifties, after the numbers of his close family had contracted, he became more energetic in seeking

them out, just as he made the effort to seek out the Verninacs, the family of his sister's husband. For one of these cousins he probably had especially tender feelings, since Alexandre Bataille had made him welcome as a child at his estate at Valmont, the converted abbey whose 'Gothick' ruins had first inspired him to call himself a Romantic and whose indoor gallery he had decorated with his own brand of fresco paintings. There he was at ease. When at Valmont he could enjoy country-house life such as he had known it with his sister and brother-in-law in the forêt de Boixe, without noticing the financial cost, and such as he came to know with Berryer at Augerville, without having to be intelligent. In 1841 Bataille died childless. He left Valmont to another cousin, Louis Bornot, a Paris lawyer who was younger than Delacroix as well as himself. Delacroix still came intermittently to Valmont – it was there that he learnt of the death of Chopin in 1849 – and through his visits he came to enjoy Rouen, the main coach or rail link with Paris, and the Normandy coast round Fécamp and Dieppe, where he painted boats bobbing on the sea with the sketchiness of a proto-Impressionist.

In Delacroix's later years, probably only Léon Riesener would be an 'intimate' relation, thought of as a '*bon ami*'. Most of those so called he had known for twenty or thirty or even forty years. Some like Baron Rivet, an Orleanist politician who was in the 1830s a prefect and in the 1840s in opposition, and Frédéric Villot, a poor engraver, a fine scholar and after 1848 a controversial conservator at the Louvre, were friends of his for many years. His inner circle of friends, however, had hardly changed. It still consisted of those with whom he had kept Le Saint-Sylvestre, New Year's Eve, in the 1820s – Félix Guillemardet, son of the former ambassador to Spain who had witnessed Eugène's birth, and Jean-Baptiste Pierret and Achille Piron, who had been at the Lycée Impérial with Eugène. Raymond Charles Soulier had also been a friend since just after leaving school. It was with these four that Delacroix felt most free.

In the early 1830s Félix began to suffer from a debilitating illness which would lead to his premature death in 1840. Soulier married and settled in the country to the south-east of Paris. Piron remained faithful, detached and undemanding and would be at the end the friend whom Delacroix would call on to be the chief executor of his will. In the 1830s and 1840s it was Pierret who occupied the most constant place in Delacroix's life and Pierret with whom in the end he would feel most disillusioned.

Like all Delacroix's most intimate friends Pierret aspired to be a man of culture and became a career bureaucrat. He was some two and a half years older than Delacroix, but despite the age difference they had become friends at school – a sign perhaps of the dominance which the younger man already exercised

over other people. In 1820 Pierret married and soon became father of a numerous family. As many of the children died in infancy, Delacroix was lucky that the youngest, his god-daughter Marie, survived. In the mid-twenties Pierret, who had posed as a model for *Scenes from the Chios Massacres*, still described himself as an artist painter, but necessity forced him to follow his older brother Claude into the Ministry of the Interior; and there he rose to become Chef de bureau and was rewarded with the title of Chevalier in the Légion d'Honneur. He was a model of bourgeois success, the type of man whom Napoleon had wanted to run France and who has kept France running for much of the past two hundred years. What made him unique among such men was his friendship with Delacroix.

For many years Delacroix relied on him to organise his life. It was Pierret who after his own work was over would put his friend's drawings in order and who would hang his pictures and studies on the studio walls. If he went away, Pierret would run commissions for him and look in to see that all was well. In his middle years Delacroix spent most of his evenings at Pierret's, drinking tea, at home with the children, waited on by Pierret's wife and sister and talking not only with Pierret or Guillemardet or Villot but with more celebrated guests like Mérimée, another bureaucrat, or Feuillet de Conches, yet another one, the diplomat who had had charge of the Moroccan correspondence, or Lassus, who was collaborating with Viollet-le-Duc in reviving Gothic at Notre-Dame.

When he was away, it was instinctively to Pierret that Delacroix would turn. Half of the extant letters he wrote from Morocco were addressed to Pierret. When staying with the Rivets at Vaux, he asked Pierret to give a message to his doctor and he would let Pierret know how he was enjoying himself at Valmont with Bataille or at Frépillon with the Rieseners and enquire after the health of young Charles. He even felt he could ask Madame Pierret to cope with a problem over his shirts and he relied on her to find him a housekeeper. It was this request which was to prove almost fatal to the friendship.

Jenny Le Guillou, who became Delacroix's principal servant some time between 1835 and 1837, about the time he had moved from quai Voltaire to 17, rue des Marais-Saint-Germain, was a Breton peasant by origin, plain and tough in appearance, loyal, stubborn and jealous in character. Almost at once she decided that she would dedicate her life to Delacroix's preservation. In return she tried to dictate who would be allowed to see him and how his business affairs would be conducted. She objected to what seemed to her to be Pierret's meddling and Delacroix told Pierret that he need no longer have charge of his expenses. In 1853 he commented grimly on the change in their relationship, when they had been walking together arm-in-arm in the Champs Elysées, as they had done thirty years before: 'Was it really the same Pierret I held? What

fire was in our friendship, what ice at present!'[13] When Pierret died the following June, he noted sadly that his friend's death left a special gap in his life and left his family in a bad way, because Madame Pierret, instead of learning an occupation and teaching her daughters one, had wished to behave like a lady. All those elegant *soirées* had done nothing for their economy, nor enough for his friendship.[14] By contrast, a month before Pierret's death he was writing that Piron was the only friend he had, 'as can happen at our age.'[15]

How far Jenny was to blame for her master's isolation is not easily gauged. Riesener, who felt that he had not been well treated, was harshly critical of her after Delacroix's death; Piron, who was never out of favour, was more relaxed.

'Monsieur Delacroix,' wrote Riesener,

slowly came to say in front of Jenny just what he was thinking, grumbling to her about his friends, whom she was replacing in certain respects, using her as a confidante in his most intimate affairs and hopes, asking her advice about everything and discussing everyone with her. This unlimited, daily confession became a need, a pleasure and eventually a source of true friendship – she was always available to follow and agree with whatever idea he had in mind. This friendship during his first illness gave him the maternal nursing which maybe enabled him to live some years longer and to create several new masterpieces – a steady, untroubled friendship without any of the flirtatiousness which marked Delacroix's worldly liaisons.

Many times Delacroix said to me: 'What would happen to me without her, without all the attention from her I have got used to?'

But every medal has its reverse side and Jenny, with her character hardened by unhappiness and bad health, was inclined to hate anyone ranking above her, men or women who used to see her master and to have over him an evil influence which went so far as to make him cold and make him break his oldest relationships . . .

'She found that his friends did not show the respect due to the talent of the academician' – Riesener was writing many years after Delacroix was elected to the Institute – 'and the deference he had thereby earned. She found that they had no right to criticise his works.' Riesener, himself apt to be disturbingly frank, has a story to illustrate her sly use of flattery to dominate Delacroix. On one occasion Jenny said that one day Monsieur would have a statue, but that it ought to be of gold. Riesener protested against such exaggeration. 'Exaggeration!' Delacroix interrupted, 'The word was well said. It's exaggerations that give me courage and enable me to do great things.'[16]

Piron, who like Delacroix never married, was more tolerant:

Molière had his servant, Piron had Mademoiselle de Bar, Delacroix had Jenny. Delacroix consulted her about everything: about the appearance of his house, which she ruled despotically, about his expenditure, about the character and value of his relationships in the world outside, about the care he should take of his health. He even asked her about his paintings, since Jenny gave her opinion on that as on everything else. She testified to her love of art and Delacroix believed her, as he left some specific works to her in his will.

Jenny was not a servant like Molière's, she did not live in the kind of intimacy which linked Piron to Mademoiselle de Bar. She was a housekeeper-like Egeria [King Numa's wife and adviser] in an intermediary role ... The intimate, continual society of such a gracious man had polished her manner and enlightened her mind.

People entered only with her permission and most of the visitors, at least in the final years, were brusquely shown the door. Any man who talked too much and above all who made Delacroix talk too much, who contradicted him or finally who stopped him working was banned by Jenny herself, and he could not come in ...

Since his earliest attacks of fever in Angoulême at the age of twenty, till his death, Delacroix's life was just a succession of continual illness ... Jenny was not wrong when she said that love of the world would have killed Delacroix several years earlier, without her active care of him ...

Jenny loved a lot and must be forgiven a lot.[17]

It was to her that Delacroix bequeathed the magnificent self-portrait which dates from around 1838 and which she left to the Louvre. And of her and her master together there is a charming vignette by Baudelaire, who recalled seeing the two of them in the Louvre together: 'he, so elegant, refined and learned, did not disdain to reveal and explain the mysteries of Assyrian sculpture to this excellent woman, who incidentally was listening with innocent attentiveness.'[18] Jenny presided over his middle and old age.

What exactly was the nature of their relationship? At least one person who knew Delacroix claimed that she had been his mistress. Gustave Lassalle-Bordes, who was his pupil and collaborator till Delacroix dismissed him in 1847, is the authority for believing that it was Jenny who got rid of his mistress Madame Dalton (which seems likely). Is he also to be trusted for implying that Jenny replaced Eugénie in Delacroix's bed? What undermines the credibility of this story is partly his unreliability on other matters, such as the exact responsibility of master and pupil in their joint painting ventures, and partly the extravagance of his story about Jenny. He identifies her with a maid called

Caroline whom Delacroix had flirted with in 1819 before she was dismissed from his sister's household and found a post with the Pierrets. But there is no evidence that Jenny had ever been called Caroline. 'Jeanne-Marie' was the full version of her name. And if she had an illegitimate daughter, there is no evidence that Delacroix had been the father.

Ranged against Lassalle-Bordes is the oral memory of the Pierret and Rivet families and the descriptions of her influence by those who knew Delacroix best: Riesener, who was famed for his frankness and who said nothing; and Piron, who himself had a mistress and yet denied that Jenny played such a role in Delacroix's life.[19]

That does not mean that sexual feeling was not involved. Jenny's plain and tough features in the Louvre portrait hint that she held vehement emotions in check with something of a struggle. Delacroix's frustrations were released in devotion to art, hers in devotion to his genius.

'Without doubt,' Baudelaire claimed, 'he had loved women very much in the agitated days of his youth . . . But long before his death, he had excluded women from his life. Like a Muslim, he would not have perhaps chased them from his mosque, but he would have been astonished to see them enter, unable to understand what sort of communication they could have with Allah.'[20] Less exotically, he explains that Delacroix reserved 'all his sensibility' for 'the austere emotion of friendship'.[21] And Théophile Silvestre made equally clear that he believed that Delacroix's interest in women was purely aesthetic. Only careful research by Raymond Escholier has shown that this was not true.

The agitated days of Delacroix's youth lasted beyond the 1820s, for it may be reasonably doubted that the promiscuous behaviour of the painter of *Scenes from the Chios Massacres* and *The Death of Sardanapalus* ceased with the painting of *Liberty Leading the People.* The orgy described by Mérimée and Delacroix's evident frustration when confronted by the inaccessible beauties of Morocco, southern Spain and Algeria do not suggest a diminution of sexual desire. But gradually lust was replaced by love. Delacroix does not seem to have been a victim of venereal disease, like Beethoven or Schubert or even, briefly, Keats, nor was he a philanderer on the scale of Byron nor did he favour open relationships like Shelley. The tragedy of Delacroix's love life was that it never quite led to the permanent attachment which for so long he sought.

Already from 1825, when he painted for her a picture based on Burns's *Tam O'Shanter*, he had one principal mistress. Eugénie or Aimée Dalton had danced at the Opera, had married an Irishman and then became mistress to three painters, first Horace Vernet, then Bonington and finally Delacroix. For about

ten years she had the insecure role of being his principal mistress. Mme Dalton was ambitious to become a painter herself; she exhibited at the Salon between 1827 and 1840; and when she emigrated to Algeria in 1839, she went to make her career as an artist. From the evidence of a pencil sketch of about 1827 she was not exactly beautiful, but lively and entrancing. To his friends she was *'ma belle'* or *'cette bonne petite amie de la rue Godot'*. Imprudently, he asked Soulier to visit her and kiss her from him, a task which Soulier fulfilled with only too much enthusiasm and for which he was temporarily demoted to *'vous'*. When in Tangier, he was more cautious and got in touch with her through the ever-reliable Pierret.

Most of the few letters surviving from Eugène or Eugénie date from around 1827. Their mood is passionate and open. 'Dear little friend, If you prefer the society of your little Eugénie to your Englishmen, as I don't want to doubt, come this evening at eight o'clock ... ' She could be even more direct: 'We'll eat together and go to bed. Your Eugénie.' But the following year, when he went to stay with his brother, she was jealous. 'What the devil has led your brother to make you race to Tours as if he couldn't have come here to see us like a good fellow, alone. We would certainly have entertained him well. Write to tell me that you'll take a carriage for good rue Godot. Yours, Eugénie.' His letters were just as ardent, if more literary.

The weather's dreadful. I'm locked indoors since I've lost ten or twelve umbrellas which I've forgotten wherever I've been. I've given up having any. I wanted to write to you for no special reason, but just because being concerned with you is the best way of passing my time. You were very charming yesterday evening as you embraced me when I arrived earlier; besides, the rest of the evening wasn't spoilt, the presence of your male friend wasn't disagreeable. How your bed tempted me. I'm quite overcome when I remember the place your body has been, a woman is so graceful. A large clumsy man with his bones and hair is unbearable. You don't understand, you delicate and delectable creatures, the happiness of clasping against one such a sweet, heavenly body ...

Would you like me to describe your lovely body ... Language is too coarse for love.

It seems that Mme Dalton was not available because her husband had come back. A little later he was writing feverishly: 'I love you more than ever ... Yesterday evening I felt a mixture of bitter emotions, which left me on edge. The most foolish thing I could do would be to tell you I love you a lot. I'll make you pity me, and it's just one step from pity to indifference. I've seen you more

tender before. Tell me if I'm wrong and if you have cooled towards me. Is it my imagination that makes me see everything askew? . . . Remember what Rousseau said: "Ladies, glance at your lover as he leaves your arms." I will say as much. I must say this by writing, because I cannot say it in front of a witness. And then, I prefer to write it. Your bright chestnut hair, your face, your lips that I love and that have been unlucky for me at other times, you've all had your full effect. It'll be better if I thought about my painting – people come to ask me about it and I forget what I meant to say . . . '[22]

The relationship remained tortuous. Delacroix forgave Soulier, who married shortly after their quarrel; his Eugénie was accepted back by her husband, without apparently promising not to be unfaithful; and Delacroix himself no longer felt tied to her. Soon after her arrival Jenny decided that Mme Dalton was bad for her master's health. It does not seem that Delacroix protested against the decision, but he went on taking a distant interest in her welfare. Eventually she decided to emigrate; and it was for her that in 1839 he made tactful enquiries how a lady-painter of his acquaintance could join her relations in Algeria. They never met again before her death from cancer of the breast in 1859, when her daughter wrote to him: 'At her home I found all the drawings and pictures she had from you.' She asked him to send her her mother's portrait. 'She says goodbye to you and has asked me to tell you she has always kept the memory of your friendship.' Delacroix had other mistresses, but in some public place the sight of a pretty woman would recall to his mind the pert and graceful features of Madame Dalton.

It was shortly after his return from Morocco that Delacroix received a letter from Elise Boulanger, a pupil of the Romantic painter Camille Roqueplan. She wished to make a copy in pastels of his *Romeo and Juliet*. A correspondence ensued. The tone became coquettish: 'Poor Romeo will be very embarrassed by the honour shown him.' His style of signing off became progressively more confidential, as '*Recevez encore, Madame, mes actions de grâces bien dévouées*' gave way to '*Recevez mes hommages affectueux*' and then, by 1836, '*Votre devoué*' and '*Je me remets à vos pieds*' and, at some later date, '*pardonnez-moi en faveur de mon humble adoration*'. This was clearly a surprising way to write to a married woman, to whose husband Clément Delacroix sometimes sent his best wishes.

'In 1839,' according to Baron Rivet, 'Delacroix let himself be dragged off to visit Holland.'[23] It was Elise Boulanger who took him there, to renew his knowledge of Rubens and to improve his knowledge of Rembrandt. The escapade was carefully planned. Delacroix left first on 4 September, then two days later she joined him with a chaperone. He took pains to keep the journey

secret from his reigning mistress, Joséphine de Forget, by asking Soulier to forward Delacroix's letters to her from his, Soulier's, home. Quite suddenly in Antwerp Elise left him and made her way back to Paris, while he went on to The Hague and Amsterdam alone. Some have claimed that she had made a fool of him, but if so then why was she trying to arrange another rendezvous in November? What seems more likely is that once again Delacroix was trying to be in love with two women at the same time. It was too complicated.

Their relationship was not, however, at an end. When Boulanger died in 1842, she was quick to contact Delacroix. 'I have decided, to punish you, not to write to you that I love you.'[24] The punishment was all the more severe because she used the intimate 'tu'. This time he was too proud to respond to her advances. In 1844 she married François Cavé, Director of the Beaux-Arts and a man with whom Delacroix was bound to have dealings. If this event signalled that the love affair was over, Riesener determined that they should stay friends. He arranged without his cousin's knowledge that the two should meet at a dinner party. Delacroix's good manners and Madame Cavé's beguiling charm led to a rapid reconciliation. In 1850 he made a fine pastel portrait of her and agreed to read her pamphlet called Drawing without a Master. He was impressed and in September wrote an article commending it for the Revue des deux mondes; and eventually he wrote an enthusiastic report on it for the Minister of Education. 'This', he began his review, 'is the first drawing method which teaches something'. He concluded after quoting some of her wise words: 'Each painter has his taste, his predilection. Each has painted women as he has loved them, and nobody has been wrong. He has painted the beauty he saw.'[25]

His romantic feelings for her never completely died, for he left her in his will two little Delft vases, which perhaps he had bought in Holland in 1839.

Duet (c. 1830–47)

I F ever Delacroix knew profoundly the joys and the troubles of an extended, sometimes intense and sometimes remote relationship with a woman, if ever he came close to understanding marriage, that was because of his long liaison and even longer friendship with Joséphine de Forget, his *consolatrice*.

'J', as he often named her in his *Journal*, was born of notable Bonapartist parents. Her father, Antoine-Marie Chamans, the comte de Lavalette, came from the village of La Neuville-au-Bois in Champagne and was therefore a near-neighbour and distant relative of Charles Delacroix, born at Givry-en-Argonne, and the Berryers, whose home was Le Châtelier. Lavalette rose to the position of director of the imperial postal service; and as a reward for his loyalty he was married off to Emilie de Beauharnais, niece to Empress Joséphine and therefore cousin to Hortense de Beauharnais, mother of the future Emperor Napoleon III, and to Eugène de Beauharnais, whom so many of the Delacroix family had served. During the 'Hundred Days' in 1815, when Napoleon returned to Paris before his second abdication, Lavalette had rejoined his former master. For his loyalty he was condemned to death by the Bourbon courts. His beautiful, timid wife, sick since the birth of a son in September, appealed in vain for clemency to members of the royal family and the government. On 20 December she made one of her last calls on her condemned husband in the Conciergerie, escorted only by the thirteen-year-old Joséphine, who had been expressly released from her convent school to say goodbye to her father. For them all it was a tense moment. While Joséphine was simply dressed in her uniform, her mother wore a large bright red, fur-lined woollen dress and a black hat adorned with feathers. It was already nightfall, for they had arrived at five o'clock. At seven o'clock mother and daughter were ready to go, one hour before the time when the countess normally finished her visits. Joséphine held her parent's hand with her usual composure as they walked past the guards; her father, for it was he who now

accompanied her dressed in her mother's clothes, carefully weeping into a large handkerchief to hide his face. Outside friends drove the pair, together with a servant, away in a carriage, till with the connivance of the Englishman General Wilson and of French officials from the foreign ministry Lavalette could be whisked out of the city and the country. As soon as news of the escape reached the police, there was a hue and cry for the coach, but, when it was stopped, only young Joséphine and the servant were found. The count had already escaped. He was soon at the court of Eugène de Beauharnais near Munich, where he stayed till it was safe for him to come back to France.

For the countess the aftermath of the adventure was less happy. Repeated questioning and isolation played havoc with her nervous system, so that she never recovered from her ordeal and lived on till 1855 in a miserable state of mind. The king, Louis XVIII, admired her for doing her duty; and among Bonapartist sympathisers she became a heroine. When cousine Lamey wrote to tell young Eugène in 1824 that 'Madame de la Valette' would call on her to see his sister, he hurried from the studio to be at her house by noon.

Joséphine took the incident more coolly. She was also interrogated, but she feigned a detached indifference and gave nobody away. At the convent she was treated by her royalist fellow-pupils as a criminal's accomplice and she must have been relieved when her mother, immediately after her own release from the Conciergerie, took her away from boarding-school and brought her to live at home in the hôtel in rue de Grenelle. Her unlucky mother had to face the horrors of internment for some years and Joséphine had to be provided for. So it was that at the early age of fifteen she was married off to Tony de Forget, an aristocrat of impeccable Bourbon connections who was heir to a property at Riom in Auvergne. Her new status proved convenient to her father, who was allowed to return to France in 1821. However he did not live an edifying old age. Instead of returning to his wife, to whom he owed his life, he moved in with a mistress in rue Matignon. There, probably shortly before her father's death in 1830, the young baronne de Forget met Delacroix, for a letter of hers survives, which recalls how the two of them used to eat salad in rue Matignon with 'my excellent father'. Her upbringing had ensured that Joséphine de Forget was already destined to be a survivor, a presence in Parisian society and a woman of the world.

When Delacroix wrote his first extant letter to her in 1833, Joséphine was the mother of two sons, Eugène and Emilien (both good Beauharnais names), and virtually separated from her husband. She was also the mistress of Delacroix's friend, Cuvillier-Fleury, whom she had recently presented with a daughter.

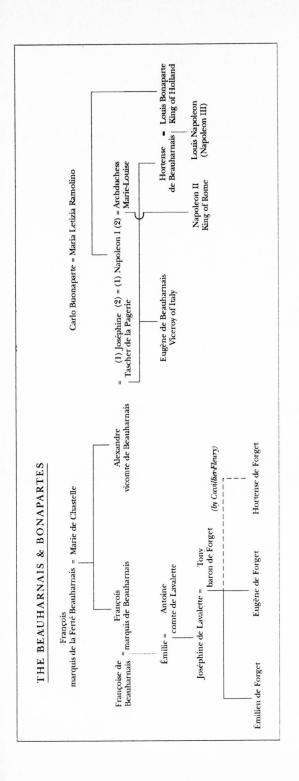

THE BEAUHARNAIS & BONAPARTES

François
marquis de la Ferté Beauharnais = Marie de Chastelle

Carlo Buonaparte = Maria Letizia Ramolino

Alexandre
vicomte de Beauharnais

François
marquis de Beauharnais

Françoise de
Beauharnais

Émilie =

Antoine
comte de Lavalette

Joséphine de Lavalette =

Tony
baron de Forget

(by Cavillier-Fleury)

Émilien de Forget

Eugène de Forget

Hortense de Forget

= (1) Joséphine (2) = (1) Napoleon I (2) = Archduchess
Tascher de la Pagerie Marie-Louise

Eugène de Beauharnais
Viceroy of Italy

Napoleon II
King of Rome

Hortense ■ Louis Bonaparte
de Beauharnais King of Holland

Louis Napoleon
(Napoleon III)

Delacroix's tone to her was polite, a little distant and a little teasing. 'Philosopher that I have become and detached from all emotions, I want to throw myself into painting the emotions of other people.' His tone would soon change. She was acknowledged as his *'chère cousine'* when he wrote to her next year from near Frépillon, where he was staying with the Rieseners, and as for himself, whom he described as 'a poor monk of no account who writes to you from the depths of his cell', he was *'votre cousin devoué'*. Shortly afterwards they must have become lovers. One reason for thinking this is that after her death the executors of Joséphine's will set about destroying his letters to her of the period 1834–44. Another reason is that there survives one letter from him which uses the intimate *'tu'* as an expression of the language of love.

> Dear, dear darling, a thousand thanks for your charming letter and the feelings of your heart. How can one not love life when one is loved? I would be very ungrateful to fate which has willed you to take notice of me. I am much better in spite of the sadness that always follows good moments and the hope of enjoying a good evening on Tuesday will keep me going. My evening yesterday with my former friend was very different from the evening before. We were ill at ease the whole time and annoyed with one another. It's very sad and without remedy, whereas the sadness that comes after happy moments gradually goes away at the thought that we will find each other again. You must have been unhappy once more yesterday morning. I was thinking of you, my darling. You must speak to me about it another time. Good-bye, my good consolation. Tenderly and gratefully yours.[1]

The date of this letter is uncertain but it would seem to be written by someone who has just fallen in love and who alludes to the common experience of lovemaking. In that case the friend with whom he has fallen out would be Cuvillier-Fleury, and the cause of Joséphine's distress could be either the death of her husband, who was drowned in the river Allier while rescuing one of their sons, or her temporary separation from her new lover.

Fortunately for the biographer of Delacroix the years from 1834 to 1844 are not a blank, because several letters from Joséphine to Eugène survive. She was aware that he needed taking care of. 'I will not go to the theatre tomorrow, but as you are still unwell I am asking you to dine with me. You can pass the evening on my sofa. . . . In a few days' time I'll take a box to see *Iphigenia* and you'll come with me. In this way you'll not miss your show and you'll be better off with me than alone in your Italy, won't you dear friend? . . . I send you thousands of loving caresses.' In 1840 he evidently had had a hard knock from life – it was the year when Félix Guillemardet died – for she offered him all her sympathy. 'My

poor dearest, I beg you, just one word; tell me that you need me, need my tenderness, I want to be everything to you, as you are everything to me. Please give me the happiness, the consolation of holding you against my heart, which belongs entirely to you and has done for a long time. Whenever you want me, I am completely available to you and I'll come to your home, very glad to show you my tenderness; so do not think twice about asking ... '[2]

As this letter reveals, the lovers did not live together. For both there were advantages in such an arrangement. Joséphine could occupy herself with family affairs, with her mother, with her mother's half-sister Madame de Quérelles and with her children, while pursuing the social round of calling on friends and acquaintances, taking a box at the theatre or the opera and taking her seat at a concert. Both she and Delacroix enjoyed artistic occasions and both also enjoyed *soirées* in intelligent salons. He had other ambitions, however, which she could admire without fully comprehending. Never did he work so hard as in the 1830s and early 1840s; and he had begun to feel the need of a quiet life for which she had no desire. At the same time he must have been glad of some sense of freedom. He did not immediately discard the charming Eugénie Dalton, who did not leave for Algeria till 1839, and in 1839 he hurried off to Belgium and the Netherlands with the provocative Elise Boulanger, an escapade which he was careful to hide from Joséphine. He was not tied, he was a free spirit – and so was she.

Probably in 1840 she wrote another letter from Geneva, where she had gone for the sake of little Hortense (another child blessed with a Beauharnais name) and where she revealed no deep Romantic longings for an alpine landscape. 'I pity her for having to live in a foreign land, my heart sinks at the sight of all those white mountains. One must have a very exalted kind of tenderness to put up with the sadness of exile!' When she wrote on another occasion in the mid-1840s, she could feel for his loneliness in the mountains – he was at Eaux-Bonnes in the Pyrenees in 1845 – and she grumbled about the continuous rain at Ville d'Avray, where she was staying, and she hoped he would visit them on his return in hot weather, so that they could dine out of doors. Such was her scheme, but she well knew her plans might not all come off. 'You'll enthusiastically get down to work which I know you must, so that you can make up for lost time.'[3]

In the 1840s house moves would both ease their relationship and confirm their emotional independence. By the end of 1844 they could see each other more conveniently in Paris, for in the same year Delacroix left his beloved left bank for the fashionable rue de Notre-Dame-de-Lorette, quite near rue de Matignon, where Joséphine lived, and just round the corner from square d'Orléans, which was home to another unattached couple, George Sand and

Fryderyk Chopin. It was in June of that same year that a more significant move occurred. Delacroix wrote to tell her that he had found a little cottage in Champrosay, a small village to the south within reach of Paris. 'You will see that people can be happy in an unpretentious retreat.'[4] He seems to have been persuaded to spend his free time in Champrosay by his good friend, Frédéric Villot, whose parents-in-law the Barbiers had a house there. With them they often had their daughter-in-law, Madame Barbier the younger, and their daughter, the delectable Pauline Villot, who added charm to Delacroix's visits to the village. He immediately hastened to assure Joséphine that when the Villots had gone, he would invite her down, but the mention of other attractive women, as he was soon to learn, did not please her. When he next wrote, he thanked her for sending him some flowers, looked forward to receiving a portrait of her in daguerrotype and put off her arrival yet once more. She replied straightaway on her own notepaper with its letter-heading J-F and its baronial coronet:

At last, dear friend, I learned yesterday evening that you are neither drowned nor lost; I am very relieved to hear from you, for I was on the point of becoming worried by your late return home. In the little letter you sent two days ago you made no mention of any other plan, so I thought you would be coming back as you assured me at the moment of your departure – that is why I did not reply to you. I was counting on you for Monday or Tuesday, especially because the weather is so appalling. I must admit I didn't think about your maid, the dust-covers, your supply of paper for the country, the agreeableness of the neighbourhood and the thousands of reasons that prevent you from coming back to Paris, and thinking that you have a friend there who is utterly alone and made sad, as you could guess, by your long absence. It would have been at least kind of you to have written sooner, to let her know you intended to stay longer in the country, and to soothe her worries and console her a little for not being with you. But then you have so many other things on your mind!!! All the same, you know how tenderly I feel for you and also that I cannot resist the slightest signs of affection from you. So now, my resentment over, I am delighted that you enjoy your country house so much, and that your health is so good and that you make such good use of your time. I am not so self-absorbed, my dear friend, and if you are happy, then so am I. Only my feelings are still hurt and I am depressed that I wasn't the first person you thought of. Didn't you know, then, that I needed you to remember and comfort me? I still don't know which day you will come, but you are going to decide after waiting for the *advice of your womenfolk*, and when the work is done you will come back to me, and I don't

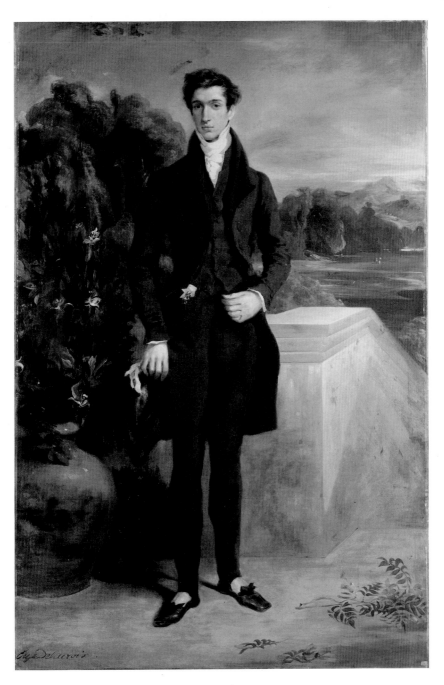

Baron Schwiter

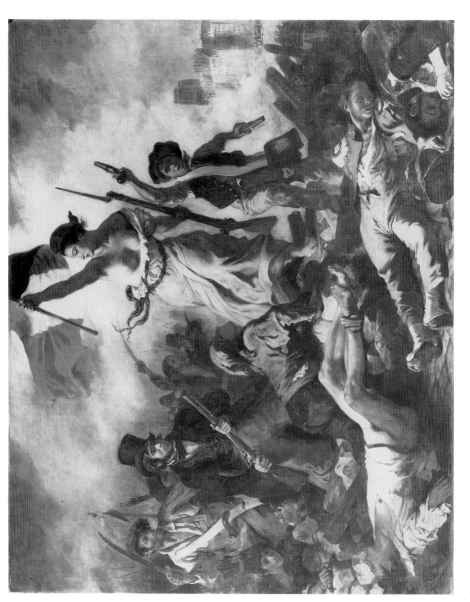

Liberty leading the people

Self-portrait in travelling costume

Moûni Bensoltane and Moûni and Zohra Bensoltane
(preliminary studies for Women of Algiers)

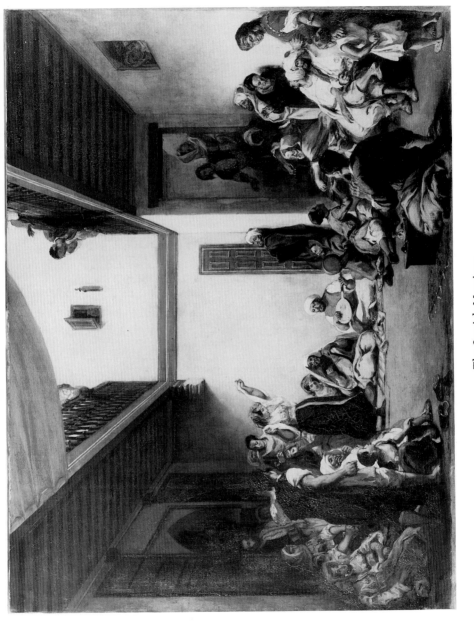

The Jewish Marriage

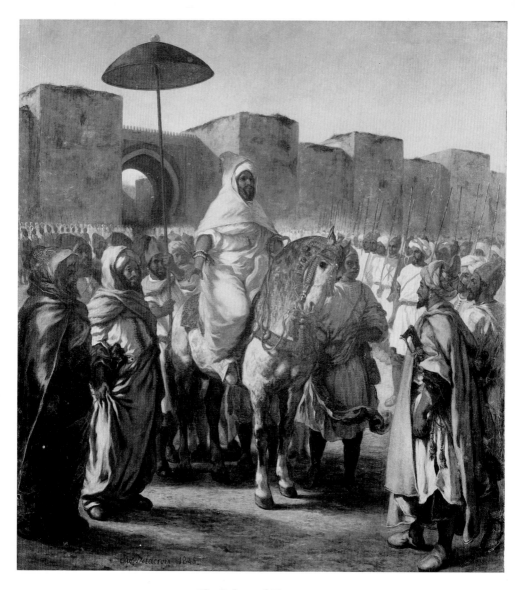

The Sultan of Morocco

Léon Riesener

Jenny Le Guillou

have to say how happy I will be to see you again. I hope I shall be the first to congratulate you on looking so fit and good looking. I've got a lot to say to you. . . . '[5]

Delacroix wrote back to apologise for the bad tempered mood in which he had left her, promised he would be with her for dinner next Tuesday, begged her to forgive him and complained of his fits of melancholia. He did not keep his word. The Sunday after the planned rendezvous she took pen to cheer him up, but also to make clear her impatience:

'I am sure, my friend, that this brief stay of yours in the country will do you some good, since rest is good for your health. You ought to see that you're wrong to curse the necessity of working for your living, since the idleness you wish for would bore you to death. That's one more reason to be grateful for your fate. What are you grumbling about, my poor friend? You're a *privileged* artist, because your painting is your whole life. It's your strongest passion and comes before everything else. . . . '[6]

After the initial jolt their lives resumed a more tranquil course. In 1847 the comte d'Ideville, manager of the business affairs of the comtesse de Lavalette, acquired for his client an hôtel in rue de la Rochefoucauld, which was even closer to Delacroix's new apartment. Life for both of them was becoming comfortable.

1847 was for both an interesting year. In that year Joséphine decided to have her face sculpted in profile by David d'Angers, France's most distinguished master of the genre. Delacroix, whose opinion of David d'Angers' monumental work was not high, was ready with advice. 'Madame de Forget tells me that you have not even seen the superb portrait of the Empress Joséphine by Prud'hon – it is at the home of her cousin, Madame de Quérelles. It seems to me a very good likeness, though idealised, and it could help you. Call on the comtesse de Quérelles, 14 rue de Matignon, at any hour, even the morning. Only be so good as to say why you came, if she is not there.'[7] The finished medallion shows the clear-cut features of Joséphine from the right, with prominent, slightly Grecian nose, firm chin and mouth, her hair tightly combed flat to the head and shaped into three long ringlets between cheek and ear and at the back of the head into a circular plait. The only jewellery she wears is a pendent flower earring and a discreet single string of pearls. This is not a Romantic, wilful beauty, but an elegant aristocrat, who should have been painted by Ingres rather than by Delacroix.

In the course of 1847 Delacroix met the sculptor at the house in rue de Matignon. The information is recorded in his *Journal*. It is surprising how relatively few entries involve his *consolatrice*. There is one gap of a year from May 1850 to June 1851, then several gaps of six months and from the end of 1857 no mention at all. This pattern may suggest a growing estrangement. Their letters, however, tell a more complex story. Till his last days Joséphine was, with George Sand, the woman to whom Delacroix wrote most frequently and with least constraint. Possibly it is the gradual disappearance of '*tu*' in favour of '*vous*' which provides the most telling evidence. There was never any question that anyone, not even his servant Jenny, could ever take her place in later life, but sexual intimacy and emotional commitment went, at what precise date it is hard to be certain. What began to emerge in their place was a polite relationship between friendly, slightly distant cousins.

— 11 —

The Social Round
of a Literary Painter (1830–48)

ELACROIX'S diary makes clear that, as a young man, the circle in which
he mixed consisted largely of young painters. In the late 1820s he was
almost absorbed into the *cénacle* of Victor Hugo, which included at least
one competent artist, Louis Boulanger, but which was largely literary. Under
Louis-Philippe, however, he moved into ever widening circles of writers, men
about town and society ladies, courted by the original, the bright and the
sophisticated, as he progressed from the seat at the theatre or the opera to the
dinner table, the drawing-room and sometimes – but very discreetly – the
boudoir. Two pencil-and-wash sketches by Eugène Lami, which date from
around 1850, indicate the sort of social occasion where Delacroix would be
found. In one case he stands beside a mantelpiece in a grand living room
listening to a pianist playing in the company of, among others, Mérimée,
Musset, Auber and Gounod. In the second sketch he is seated at the back of a
group which includes Musset and Berryer. The testimony of these pictures is
borne out by the evidence of his diary, which he resumed in 1847, the last
complete year of Louis-Philippe's reign. Besides the references to the activity of
painting and the company of painters, what stand out most in Delacroix's record
are the continual gyrations of his social round. He would call on Thiers, listen to
his indiscretions about the Prime Minister or talk with his formidable mother-
in-law, Madame Dosne; and sometimes he was bored with the non-stop political
discussion, for few of the other guests shared Thiers's omnivorous curiosity
about art and Delacroix did not care for political intrigue. Though for 1847 he
mentions neither Auber nor Gounod, there were frequent meetings with
musicians. Once he had a long conversation with the singing teacher Garcia,
brother to the most celebrated diva of the time, Pauline Garcia-Viardot, who

would be celebrated later also as the enduring love of the Russian novelist, Turgenev.

He made much shorter notes on his words with *cher Chopin*, his favourite musician, whom he saw on a regular basis, along with George Sand, Chopin's mistress, and her confidante, Madame la comtesse Marliani, wife to yet another composer, and Chopin's aristocratic Polish friends. Delacroix also dined with Elie Halévy, who had written the opera *Les Juives* and who was a member of the distinguished Jewish family which in another generation would befriend Degas.

Inevitably there were tête-à-têtes with his distant cousin and by then principal mistress, Joséphine, baronne de Forget; and at one family gathering he noted the presence of 'certain cousin Berryer'. Berryer he saw principally in the country. In Paris his closest relationships were with the literary intelligentsia. He was on good terms with many of the most gifted writers of a gifted period; for it was in the age of the drab Louis-Philippe that Romanticism shone in France.

As a part-time journalist himself, Delacroix was acquainted with many of the editors and critics. In the 1820s he had been friendly with Edouard and Armand Bertin, sons of the editor and themselves later editors of the influential *Journal des Débats*. Their father is best known to history because there is a magnificent portrait of him by Ingres. Delacroix too could make fine portraits of literary figures; and it was a commission by Buloz, the editor of the *Revue des deux mondes*, which led to his first meeting with George Sand. He also got to know the young men who defended his art: Théophile Thoré, whose chief claim to fame will always be his championship of Vermeer; and two writers whose chief claim to fame would be their poetry – Théophile Gautier and Charles Baudelaire.

Some of his closest links with literary men were based on common outlook or shared pleasure. From the early 1820s he had had the *entrée* to the salon of Baron Gérard. There he had met Stendhal and Mérimée. He also frequented the Bibliothèque de l'Arsenal, where each Sunday from his appointment in 1823 till his death in 1844 the librarian, Charles Nodier, and his wife received a throng of painters and writers. There he probably first met Alexandre Dumas *père* – who could miss him? – and a very clever young poet who was almost still a schoolboy, Alfred de Musset.

The ties between Delacroix and Stendhal and Mérimée were kept close when Stendhal was in town, that is, when he was not in Italy. Stendhal was a professional diplomat and Mérimée a professional bureaucrat. They therefore both could afford to treat writing as a diversion, which suited their pose. Both were widely travelled and both adorned Orleanist culture with novels set in foreign parts – *La Chartreuse de Parme* largely in Italy and *Carmen* wholly in Spain. Both had Delacroix's strange combination of passionate intensity and

cool detachment. Both were masters of a simple style – indeed Delacroix criticised Mérimée for trying too hard to write simply – and both were as determined as Delacroix not to have life complicated by a wife.

Delacroix did not regard Musset as a close acquaintance; and he did not like his poems and probably did not like his self-indulgent love affairs or his self-indulgent drunkenness. Musset for his part, unlike his hero-worshipping elder brother Paul, was not always complimentary about Delacroix's pictures. He had, however, some memorable meetings with Delacroix. One evening in summer 1831 he met Delacroix as they were both leaving the theatre. They began talking about painting and talked on and on, going first to his door and then to Delacroix's till they separated at two in the morning. Another evening a mutual friend, Horace de Viel-Castel, was with Musset and Delacroix while the snow was falling fast. Once again Delacroix would not stop talking when they had taken him to his apartment on the quai Voltaire and he carried on talking outside for an hour, oblivious of the snow that was steadily covering their shoulders in the icy streets.

At this stage Dumas knew Delacroix less well, but his expansive good nature slowly wore down Delacroix's careful restraint. He gives a delightful account of a *soirée* at Nodier's where he and Delacroix would become habitués. At dinner there were some learned men as well as newer faithfuls like Dumas. The meal was over at eight o'clock, when the company moved to the salon; and in came the usual crowd, among them the animal sculptor Barye – an artist whom Delacroix would justly respect – and Boulanger the painter friend of Hugo's, then Vigny and Musset and 'those two kings of poetry', Hugo and Lamartine. By the chimney Nodier would tell a love story, a story set in the Vendée during the time of the counter-revolution, or a story about the place de la Révolution, while all listened in rapt silence, till he sought the comfort of his favourite armchair and, turning with a smile towards Lamartine or Hugo, exclaimed: 'That's enough prose, let's have some poetry.' The recital over, his daughter Marie played the piano, tables were put out for cards and there was dancing, till Madame Nodier decided that her husband should go to bed. . . .[1]

In 1832 Dumas staged a costume ball, at which Delacroix appeared in his favourite role of Dante. Dumas asked his artist friends to decorate the four rooms of his apartment; and Delacroix, it was decided, should represent the King Rodrigues after the defeat of Guadelete. The day of the ball came. Delacroix's panel was still empty. He turned up just as the company was about to eat breakfast and ate with them. Then, without removing any of his elegant clothes, he set to work and painted non-stop for two to three hours, finished his picture just in time for it to dry and then prepared to enjoy the ball. Dumas admired Delacroix as a man 'full of faults impossible to defend, full of qualities

impossible to deny' and he was glad to own several of his paintings.[2] Delacroix reacted in a similar way to Dumas. He criticised him for his lack of discretion and his novels for his verbiage, but he found that, even if there was nothing profound in *The Three Musketeers* or *The Count of Monte-Cristo*, they made exciting holiday reading; and he fell victim to Dumas' charm. After Delacroix had died, Dumas took to lecturing on him and found that his reminiscences were popular.

Popularity was not a reward which Delacroix wished for. He wanted to be valued by those he valued himself. It was on such a basis that he developed first the acquaintance and then the friendship of his most distinguished relative, Antoine Berryer. The Berryers, distant cousins on his father's side, had stayed loyal to the Bourbons and the Catholic church. By repute, Antoine Berryer had made himself the finest advocate in France when the July Revolution left the cause of Charles X's heir without an able defender. What Chateaubriand had abandoned Berryer rushed to rescue; and for the next thirty-five years he kept the Legitimist case before the political nation. Delacroix was neither a Legitimist nor a Catholic, but he discovered in Berryer a passionate lover of the music he loved – Mozart and Rossini and Chopin. They became proud that each was a member of the same extended family; and Delacroix became a regular house guest at Augerville, Berryer's château by the Paris-Orléans road. Finding out that Berryer was an ignoramus in artistic matters, Delacroix would leave his brushes behind him and take a holiday. Both he and Berryer liked the literature of the *grand siècle* – Berryer would proudly point out an inscription that Louis XIV had visited Augerville – and they could recite from memory whole scenes from Molière or Racine. They would listen to music side by side, Delacroix withdrawn into his inner world and Berryer, the extrovert, revealing his emotions as the tears rolled down his cheeks.

These details are known from a delightful account of Augerville in 1840 published many years afterwards by one of Delacroix's fellow guests, Madame Caroline Jaubert. She was amused to notice that Delacroix would do anything provided that he was given time to change. He had clothes for every temperature (she did not realise that he was already suffering from the ultimately fatal proneness to laryngitis, which had first manifested itself in 1836). His manners were impeccable. He was thin, of average height and distinguished in the way he was turned out. The pallor of his face was emphasised by his mop of deep black hair, his eyebrows and his dark eyes, almost hidden by his dark eyelashes. His nose was straight, his smile discreet and circumspect, his teeth fine.[3]

This description fits exactly the two contemporary portraits which date from this period. One, in the Louvre, shows the well-dressed dandy, self-confident

almost to the point of arrogance. The other, in the Uffizi, reveals a quieter, more reflective man. Delacroix was both a man about town and a contemplative.

It may take an intelligent woman to give a precise account of the physical appearance and bearing of an attractive man. Anyone wanting the most imaginative descriptions of Delacroix must turn instead, however, to the two poet-journalists who knew him more as he appeared on social occasions in town where a painter has a role to play and an audience to satisfy. There is nothing finer than the analyses of Delacroix by Gautier and Baudelaire.

'Though his way of speaking was cool,' Gautier wrote, looking back from 1864,

> Delacroix felt the feverish impulse of his times more vividly than anyone else. He possessed their restless, tumultuous, lyrical, confused and frenzied character . . .
>
> Delacroix, whom I first met sometime after 1830, was then an elegant and frail young man . . . His pale, olive skin, his luxuriant black hair, which he kept all his life, his dark brown eyes with their feline expression . . . his thick eyebrows . . . and thin lips . . . covering his excellent teeth and under a slight moustache, his wilful strong chin . . . gave him an appearance of wild, strange, exotic, almost disturbing beauty. You might have thought that he was an Indian maharajah, who had been given a perfect education as a gentleman in Calcutta and who had come in European dress to experience civilisation in Paris. His nervous, expressive, changeable face sparkled with wit, genius, and passion. People found that he resembled Lord Byron . . . The triumphs he failed to have as an artist came easily to him as a man of the world, which Delacroix always was. Nobody was more charming than he was, when he took the trouble to be so. He was soft, smooth and coaxing like one of those tigers whose supple and frightening grace he rendered so well. People said in the salons, 'Such a pity that such a delightful man paints in such a dreadful way.'[4]

Baudelaire had a more tortured relationship with Delacroix. No critic had such a staunch loyalty to any contemporary artist as he had to Delacroix over almost twenty years and yet Delacroix, who needed all the allies he could find, seems never to have understood the generosity of Baudelaire, let alone his intelligence. His uncouth appearance, though Baudelaire affected dandyism and wrote a whole chapter on the subject in *The Painter of Modern Life*, and possibly a tactless request for money may have put Delacroix very much on his

guard against his obscure admirer, when Baudelaire tried to get to know him. The references in his correspondence and his *Journal* to Baudelaire are sparse. He seems to have been sent a copy of *Les fleurs du mal* by the author and acknowledged the gift correctly and without warmth.

Baudelaire's first attempts to become a serious critic used the approved method of discussing the pictures of one Salon, in his case the exhibition of the year 1845, but, despite the inevitable diffuseness, he already had a thesis that he would elaborate over the years: 'Monsieur Delacroix is definitely the most original painter of ancient and modern times.' In his *Salon* of 1846, Baudelaire elaborated his ideas more systematically. After analysing the nature of Romanticism and the role of colour, Baudelaire naturally came to the subject of Delacroix.

> Delacroix is universal; he has painted genre pictures full of intimacy and history pictures full of grandeur. He alone, perhaps, in our unbelieving century, has thought up religious paintings which are neither empty and cold like competition pieces nor pedantic, mystical or Neo-Christian ... It is because of this modern quality of his that Delacroix is the ultimate expression of progress in art. Inheritor of the great tradition ... and worthy successor of the old masters, he has greater mastery over grief, passion, gesture ... Take away Delacroix and the great chain of history is broken.[5]

There would be more praise of Delacroix in the 1850s; and one poem, '*Les Phares*' (the beacons), is devoted to the celebration of his talent as the culmination of European painting:

> *Delacroix, lac du sang hanté des mauvais anges,*
> *Ombragé par un bois de sapins toujours vert,*
> *Où, sous un ciel chagrin, des fanfares étranges*
> *Passent, comme un soupir étouffé de Weber.*

(Delacroix, lake of blood, haunted by bad angels, /Shaded by a wood of evergreen firs, /Where, under a lowering sky, strange fanfares /Pass, like a stifled sigh of Weber.)

Somewhat banal explanations were given for the imagery: 'lake of blood' refers to red, 'haunted by bad angels' to the supernatural, an evergreen wood to green, the complementary of red, and a lowering sky to the tumultuous and stormy backgrounds of his paintings, and 'the fanfares of Weber' to the idea of Romantic music which the harmony of his colours reveals.[6]

Baudelaire's most considered account of Delacroix came in the essay which he wrote on Delacroix's work, ideas and habits, which he published in instalments in *L'opinion Nationale* towards the end of 1863. He had no doubts of Delacroix's pre-eminence:

Flanders has Rubens, Italy Raphael and Veronese, France Lebrun, David and Delacroix . . . He has inherited from the grand republican and imperial school a love of the poets and an indefinable mischievous spirit of rivalry with the written word. David, Guérin and Girodet were inspired by Homer, Virgil, Racine and Ossian. Delacroix was the moving translator of Shakespeare, of Dante, of Byron and of Ariosto.

Delacroix was passionately in love with passion, and coldly determined to find the way to express passion in the most visible way. It was above all in his writings that the two sides of Eugène Delacroix's nature I have mentioned were revealed. Many people . . . were astonished by the wisdom of his written opinions and the moderation of his style, some regretting them, others approving of them . . . What marks most clearly Delacroix's style is its concision and unostentatious intensity.

Eugène Delacroix was a curious mixture of scepticism, politeness, dandyism, of wilfulness, of cunning, of despotism and finally of a kind of special kindness and moderate tenderness which always goes with genius . . . He always kept the traces of his Revolutionary origins . . . Like Stendhal . . . he had a horror of being taken in. Sceptical and aristocratic, he understood passion and the supernatural only by his compulsive attention to dreaming . . . Another characteristic reminiscent of Stendhal was his fondness for . . . brief maxims, for good conduct in life.

Everything about him seemed energetic, but the energy came from his nerves and his will; for physically he was frail and delicate. The tiger attentive to its prey has less of a gleam in its eyes and impatient quivering in its muscles than our great painter showed, when his whole soul was concentrated on some idea or wanted to catch a dream . . . More than once, looking at him, I imagined one of the ancient rulers of Mexico like Montezuma whose hand skilled in sacrificing could offer up in just one day three thousand human beings on the pyramidal altar of the Sun or else a Hindu prince who, in the midst of splendid festivities, conveys a sense of unsatisfied desire and irrational nostalgia . . .

If any man had an *ivory tower* well defended by bars and locks, that man was Eugène Delacroix. Who has loved his *ivory tower* more, I mean his secret life?

I have heard him accused of egoism and even avarice . . . Delacroix was

very frugal – it was the only way in which he could be occasionally very generous . . .[7]

Baudelaire liked to give the impression that he knew Delacroix well. This was never true, but it is also true that one or two meetings in the mid-1840s gave Baudelaire an insight into the mind of his hero which perhaps nobody else has ever equalled. Instead of being like Boswell to Delacroix's Johnson, the confidant in on the secrets of a great man, he became like Johnson (in *The Lives of the Poets*) to Delacroix's Pope, merely the critic who best understood the genius of the generation before his own.

One of Delacroix's undated reflections starts with this observation: 'Artists, in general, write little.'[8] He was aware that his status as an artist-critic was a rare one. Poet-critics, like Pope, like Johnson, like Gautier, like Baudelaire, form only a minority among important poets, but very, very few artists have had the education or the inclination to write about art – pre-eminently Leonardo and others like Vasari or Reynolds or Van Gogh. Delacroix is one of the most select of that select group.

For some nowadays, who are not attracted by the monumental paintings on display in the Louvre, the most appealing side to Delacroix's personality is that revealed in his *Journal*, especially perhaps in the *Journal* of his maturity, which begins in 1847. Any intent reader will become aware that the writer had one of the most acute minds of any commentator on the arts. This mind had been trained by conversation in Parisian salons and by his own researches as well as by his reflections on his own intentions, practical problems and achievements.

The first fruits of that mind were two articles published in 1829, the year of the July Revolution. Between 1830 and 1848 came a few more articles – on Raphael and Michelangelo and Michelangelo's *Last Judgment*, on the French Baroque sculptor Puget and on the French pre-Romantic painter Prud'hon. Delacroix was still intensely active as a painter, but by 1847 most of the great works were accomplished and he was moving into a more meditative phase of his life, during which period his writing would become more important and more personal.

A fragment written at Champrosay in 1846 gives a sense of the more sombre Delacroix who was beginning to emerge. He had been in the forêt de Sénart.

Matter always falls into sadness: the murmur of the winds and the sea, the long night with its terrors and its silence, the sunset with its melancholy, solitude, when you come across it, brings back black thoughts, apprehen-

sions of nothingness, of destructionIf man is animated in action and in the society of other men, given up to solitude and the spectacle of his misery and weakness, he becomes sad, and all the sadder the more exalted his nature, the more delicate the temper of his mindThe whole world doubtless seems to look forward to a kind of happiness; but the Being of beings shows almost always to his sad creatures only the angry side of his face.[9]

The Delacroix who was so charming in literary society could withdraw, as many guessed, into an interior world which knew few consolations. His Hamlet complex was evident in his face.

From 1842, three years after the invention of photography, there dates the first daguerrotype portrait of Delacroix. It gives him the same high cheek-bones, the same firm chin, the same shock of hair, thick eyebrows, neat moustache and small beard as the self-portrait of 1842 from the Uffizi. He wears, as might be expected, an elegant, striped cravat. There is, as might be expected, an air of melancholy and determination in the face. But the face is less animated, for the portrait was made by a machine and was a Realist not a Romantic portrait.

The beginnings of Realism may be dated from the 1840s, when a few painters began to try to copy the effects of photography on canvas with paints. Their aim would involve the representation of actual life, as Daumier had begun to show it, not life as it could be imagined. In a famous essay published in 1863, the year of Delacroix's death, Baudelaire argued for a complex belief in the union of an eternal and a temporal element in great art; and the temporal element involved a self-conscious effort to be an artist of modern life. To Delacroix, who disliked modern life, what mattered above all was what was eternal. If there was modernity in his work, as Baudelaire was subtle enough to understand that there was, it came from his modern emotions, his Romantic world-weariness and anxiety, his Romantic inwardness.

During the reign of Louis-Philippe there was one great writer who was, as it were, the precursor of Realism, while still of the generation of the Romantics: Balzac.

Balzac and Delacroix never knew one another well; and Balzac had a greater respect for Delacroix than Delacroix for him. In 1833–5 he wrote a series of stories collected together as *Scenes of Parisian Life*, one of which, 'The girl with golden eyes', he dedicated to Delacroix. He already knew enough about painting to know that Delacroix was famous as a colourist. 'The soul has some sort of affinity with white, love delights in red and gold flatters the emotions.' In 1832 he sent Delacroix a copy of his novel *Louis Lambert* and Delacroix drafted a

reply which indicated his sympathy with Balzac's hero, who had experienced like Delacroix the loneliness of a solitary childhood; for Delacroix had been fourteen years younger than the brother closest to him in age, and his older brother and sister belonged virtually to the previous generation. In the second part of *Lost Illusions* Balzac invented a young, gifted painter struggling, like Delacroix, against conventional taste. For this reason, when the same painter, Joseph Bridau, became a major character in *A Bachelor's Establishment*, and was given an elder brother who was a Napoleonic veteran and who, having failed to adapt to the changing situation since 1815, had opted for a sordid life in the country, then some of the critics were sure that Balzac had Delacroix in mind; and the writing of the novel has been seen as a reason for the cooling off of relations between the two. It seems, however, that relations had never been warm. Even if Delacroix and Balzac met at Nodier's and through editors like O'Reilly of *Le Temps*, even if Delacroix could recall after the death of the novelist a time when Balzac had been young, slim and dressed in a blue suit, none of this proves the identification of Delacroix with Joseph Bridau. Balzac knew many painters, including Louis Boulanger who painted his portrait, and Delacroix's fellow-pupil Ary Scheffer. Besides, Delacroix copied out part of the novel without comment. There is no evidence that he found it offensive.[10]

Delacroix copied out sections from several of Balzac's novels. He saw the importance modern novelists attached – and in this case he must have been thinking of Balzac – to exact description, and he wondered whether they went too far. He did not object to detail, for that gave a novel its sense of authenticity, but he insisted that detail must be significant. He disliked Balzac's obsession with money-making, which was also the obsession of the period. He knew it was vulgar. That was one way in which Balzac was more in tune than he was with the mood of the times. Balzac told the story of *la comédie humaine*: Delacroix painted stories of human tragedy.

Two events in 1844 show the two sides to Delacroix's character, the sociable and the withdrawn. He moved his town home to rue Notre-Dame-de-Lorette, not far from Thiers and Auber and George Sand and Chopin and Madame de Forget. In the same year, on the recommendation of Frédéric Villot, he rented a little house in the village of Champrosay, just by the banks of the Seine to the south of Paris. By the time he began writing his diary in 1847, his short retreats to Champrosay were part of his annual routine. It is easy to see why he needed to escape.

April 3 was a typical day. He got up early to see Gautier to thank him for a kind article and there met Francis Wey, whom he would have known from the evenings at the Bibliothèque de l'Arsenal. From Gautier's he went on to

Monsieur de Morny, half-brother of Louis-Napoleon Bonaparte, where he was much taken with a Watteau. He then called on Mornay, his friend from Moroccan days. Next he went to see Madame Delessert, wife of the prefect of police and mistress to Mérimée. She was out, so he took himself off to visit Hippolyte Maindron, the sculptor, who was also not at home, so his mother showed Delacroix round the studio and told him that just one block of marble had cost 3,000 francs and he still had not sold the group carved from it. That evening, *chez* George Sand, he chatted with Alfred Arago, inspector general of the Beaux-Arts, about an idea of bypassing art dealers to sell paintings.

Social events lightened the next day, when he was feeling low, for he and Madame de Forget went to a concert at the Conservatoire and he and Pierret had a quarrel after dinner because he had not had time to dress, so he sent Pierret away, but they were reconciled when Pierret came back as his old self and Delacroix became easier in his turn and Pierret praised the *Christ* in rue Saint-Louis. He had a bad cold on 5 April, but still called on Alberthe de Rubempré, who had been Stendhal's mistress long ago, and on George Sand. He then was back to his painting: a *Saint Sebastian* on 6 April and a sketch for the Palais Bourbon library on 7 April. And so on to dinner *chez* Pierret, with Soulier and Villot present. He came home tired.[11]

Month after month, throughout most of his adult life, Delacroix kept up this exhausting behaviour, distracted from work or social life only by his intermittent poor health. To survive he needed to escape from the pressures that came from his position in Parisian society, to draw strength from relationships that were not superficial, to find friendship and love. Like Keats, he believed passionately in the holiness of the heart's affections. Unlike Keats, however, his bad health did not prevent him from having quite a long life. He would not be remembered just for the extravagant anti-Establishment art of his youth. The 1830 Revolution gave him a chance to make his mark as an approved artist of the Liberal monarchy.

Official approval (1833–47)

D URING his stay in Morocco in 1832 Delacroix had heard news of the alarming outbreak of cholera in Paris which had killed more than 18,000 people including the Prime Minister Casimir Périer. In 1832 nobody knew what had caused the epidemic, but it was clearly related to the crowded slums, and to the low wages and weak health of those who could not follow the Orleanist injunction 'make yourselves rich', yet who still hurried to the capital like lemmings at the rate of almost a quarter of a million in fifteen years.

The death of Casimir Périer was a sad loss for Louis-Philippe, who had no strong man to turn to among his trusted advisers, and it provided an opportunity for the younger politicians anxious for royal favour. Before the end of the year the intellectual heir of Casimir Périer, François Guizot, was in charge of the education of Frenchmen and a new tough minister, Adolphe Thiers, was given responsibility for order. Between them, whether as allies or opponents, Guizot and Thiers would dominate the politics of the Orleanist régime. Whereas Guizot, the former professor, was in touch with English Whig opinion, Thiers, the professional journalist, for all his avowed Liberalism shared the popular nostalgia for Napoleonic adventures.

On 1 January 1833 Thiers was given the congenial post of Minister of Commerce and Public Works. In April he presented to the French parliament a bill to spend over a period of five years one hundred million francs not only on public transport – on roads, canals and railways – but also on an ambitious programme of completing Napoleon's plans for Paris. The Arc de Triomphe, place de la Concorde, the Panthéon and the Madeleine would be finished and the basilica of Saint-Denis, the Collège de France, the Bibliothèque Royale and the Palais Bourbon restored. Louis-Philippe had a fellow feeling with Thiers for reviving a national and dynastic sense of glory. At Versailles he had knocked into one a number of rooms on the first floor of one wing, so as to open up a huge

gallery some four hundred feet long, which would celebrate French victories. In 1836, while he was prime minister, Thiers would enjoy the satisfaction of seeing the ashes of the martyrs of the July Revolution installed in the massive column in the centre of the Place de la Bastille and of seeing an obelisk sent by Mehemet Ali, pasha of Egypt, placed in the centre of the Place de la Concorde. The Arc de Triomphe, a somewhat ambiguous tribute to Bonapartist and Bourbon successes in its final form, was finished in the same year. When he was next prime minister, in 1840, Thiers organised the ceremonial return of Napoleon's ashes to the Invalides church and proposed the erection of a massive defence system round the capital. Before one of his sons had gone to Saint Helena, the king had got rid of Thiers, because his bellicose support of the Egyptians against their nominal Turkish overlords had roused European fears of a French return to a Napoleonic style of diplomacy. Despite his dismissal Thiers was prominent at Napoleon's reinterment in the Invalides and eloquently supported the new government's 1841 bill for his walls and bastions.

The grand schemes of Thiers and the lesser schemes of Louis-Philippe gave employment in the first place to architects. As men who both had valuable art collections of their own, they realised that they would also need the help of many painters, for the French government and the French king planned to decorate on a scale envisaged by nobody since Colbert and Louis XIV. Just as Louis XIV had had Le Brun and Napoleon had had David, the Orleanist monarchy would have Delacroix.

Even before he had become King of the French, Louis-Philippe had bought works by Delacroix, notably *Cardinal Richelieu saying Mass*, which had been painted for the Palais Royal. The theme was more appropriate to the place – the Palais Royal had once been the Palais Cardinal – than to the occupant – Louis-Philippe was a sceptic. Delacroix's next painting for Louis-Philippe, *The Murder of the Bishop of Liège*, showed how well Delacroix could portray the middle ages as Scott taught his readers to imagine them, colourful and violent. He was just the man to paint medieval scenes for Louis-Philippe's Galerie des Batailles at Versailles. One such scene, which was exhibited in 1837, was of *The Battle of Taillebourg*. In 1242 the young Louis IX, St Louis, had won his first important victory over the English, by dislodging them from a bridge over the Charente. To Delacroix battle scenes on bridges meant Rubens; and, especially in his preliminary sketch, it is clear that Delacroix derived much of the swirling, chaotic motion of his picture from Rubens's *Battle of the Amazons*. Unfortunately, he also was influenced by his rivals' studied gestures, so, if the young Louis was luckily more prominent in the finished work, the dash and coherence

of the sketch had been sacrificed; and few critics other than the friendly Théophile Gautier liked the painting. The verdict of later generations has been somewhat kinder. While most of the battles have been considered, in Thackeray's words, as 'the worst pictures that eye ever looked on', Delacroix's is regarded as an honourable exception.[1]

He could do better. In 1838 Louis-Philippe invited him to illustrate the entry of the western knights into Constantinople in 1204 as one of a series of moments in the history of the Crusades. Delacroix's painting was shown in 1840, the year when Thiers's protégé, Mehemet Ali, seemed likely to threaten another successful attack on the city on the Bosporus. Delacroix painted with no awareness of contemporary events, therefore with no hint of irony. His conquerors ride into Constantinople in a pensive mood, equally oblivious of the old man at the left dragged towards them under a portico and of the young woman over to the right who bows her bare shoulders before them. They are set in shadow at the crest of a hill, while far below stretches the shining, burning imperial metropolis. To paint those shaded figures Delacroix had learnt all he could from Veronese's gigantic, glittering *Marriage Feast at Cana*. Veronese taught Delacroix that absence of direct sunlight modifies, but does not destroy, colour, so that in the *Entry of the Crusaders* all colours are opulent everywhere and brilliant somewhere.

Louis-Philippe valued Delacroix principally because he valued history. He also commissioned a portrait of Maréchal de Tourville for Versailles and for Chinon a *Rabelais*. His son, the new duc d'Orléans, valued Delacroix for his art. He responded to every major literary concern of the painter. He bought a *Hamlet*, he gave *The Jewish Wedding* to the Luxembourg; and at the sale of his widow's pictures in 1853 there was a Gothic painting – *Melmoth* – and a Scott painting, for *The murder of the Bishop of Liège* had become hers, and a Byronic painting, *The prisoner of Chillon*. None of the other sons of Louis-Philippe was as responsive as his heir, but it did not matter. There was compensation for the dubious taste that had created the Galerie des Batailles and which Delacroix commented on when he visited the former king's château at Eu. Governments now mattered more than kings; and in the history of patronage in the nineteenth century Thiers counted for more than Louis-Philippe. For Delacroix that was a lucky chance.

On 2 September 1833 Delacroix was officially informed that he was offered the task of decorating the Salon du Roi in the Palais Bourbon, seat of the Chamber of Deputies, at a price of 30,000 francs. As he later admitted, the commission surprised everyone. 'He [Thiers] did it in spite of the charitable recommenda-

tions of my enemies and even of my friends who told him over and over again that it was doing me a disservice, seeing that I had no understanding of monumental painting and would dishonour the walls I was painting.'[2]

Even before the official notification arrived Delacroix had been concerning himself with the technical problems involved. His first idea was to paint directly on to the walls, using a mixture of oil paint and wax, a method dear to Sir Joshua Reynolds. His knowledge of art history must have made him think of using *fresco* – fresh plaster which fuses with watercolour paints – on the grounds that what had been good enough for Michelangelo and Raphael might be good enough for him; and perhaps he had already painted three frescoes at Valmont, home of his cousin Bataille, frescoes which were executed more freely than during the Renaissance, occasionally with thick oil paint. Eventually he decided, for his later murals, to paint on canvas in the studio and then to glue the canvas to the wall. The procedure was hazardous, for the canvas might come unstuck and it was hard to calculate in a studio the effect a picture might have when seen from below, often high above the spectator's head. Willy-nilly Delacroix found out that he came to need help. The architects must furnish scaffolding, his supplier of paints – Haro – was always at hand and Delacroix relied on assistants as well. Four years were needed, from 1833 to 1837, to paint a room of moderate size, the Salon du Roi, but in nine years, from 1838 to 1847, he painted the ceiling of one much larger room, the library of the Palais Bourbon, together with the ceiling of the library of the Palais du Luxembourg and one chapel wall in a Paris church, while all the time he produced a steady stream of works, many of them enormous, for Versailles, for the Salon and for connoisseurs.

The three Valmont frescoes – of the Greek lyric poet Anacreon with his muse, of Leda and the swan (Jupiter in disguise) and of Bacchus offering a drink to one of his leopards – are delicately sensuous in the mood of Pompeian murals. In the Salon du Roi Delacroix's classicism became grave, public and allegorical. Not song, women and wine but Justice, Industry, War and Agriculture were his themes, along with a touch of geography, as revealed in the seas and rivers of France. The critics treated him with fitting earnestness, referring for comparison to Raphael or Le Brun or the colour of Veronese, the dash of Rubens and the design of Michelangelo. Some were surprised to find themselves impressed. Delécluze, self-appointed defender of the school of David, who had once dismissed *The Barque of Dante* as a mess, now maintained that the decoration of the Salon du Roi was 'the best production of M. Eugène Delacroix' and added: 'I admire it greatly and have taken great pleasure in looking at it.'[3]

By the time he could read these words in the *Journal des Débats* early in 1839 Delacroix already had a more lucrative commission. At the end of August 1838

the Minister of the Interior wrote to him to say that he had been awarded the task of painting the library of the Chamber of Deputies for 60,000 francs. On the ceiling he would have to paint two large hemicycles at either end of a rectangular room and five intervening cupolas. He had no doubt of the source of this award. On 27 October he wrote to Thiers, who had been out of office for more than a year:

> You may recall that you made me hope that, provided there were adequate funds, you might be willing to allot me this new task. . . . Arguments which seem to me of little value have tipped the balance in my favour and my first thought has been to turn towards you, Sir, as the person to whom I owe my first, my only thanks. . . . You have offered me, in the way of pure friendship, one of the decisive occasions which open up an altogether new career to an artist. . . . A spirit like yours understands the charm and attraction of the struggle which doubles one's strength and raises a man above himself. You'll grasp better than anyone how grateful I am. Your rare talents make you reach out for the glorious goal which is the dream of all generous hearts and even your hours of leisure are devoted to high ideals.[4]

At the time he received this letter Thiers was still devoting some of his leisure hours to political plans to return to office, but he was already starting on his project to chronicle the story of Napoleonic France. The letter-writer too had in mind a heroic task; and at first Delacroix also thought in terms of a nationalistic epic. But since Morocco he had become more cosmopolitan; he abandoned his French bias for one that would include all history as the history known to any educated European contemporary, embracing the ancient Near East, ancient Greece and ancient Rome, its incidents worked out in conversations with Villot. It would be the same history as had been known to Michelangelo when he painted the Sistine chapel ceiling and to Raphael when he painted the Vatican Stanze. There would be, however, this crucial difference. Michelangelo and Raphael had painted for popes at prayer and popes at work. Their pictures had shown how all human history leads to and from the coming of Christ. He was painting for a parliamentary library: his scheme was centred on the very parliamentary concerns of oratory and law-making; and his ultimate point of reference was not God's revelation but the clash between civilisation and barbarism or, as Matthew Arnold would put it, between culture and anarchy. At one end of the room one hemicycle shows Orpheus teaching the arts of peace to the still savage Greeks. At the other end Attila, heading his barbarian hordes, tramples on the Italians and their arts. Within this context Delacroix paints other episodes of gentle harmony, like the scene where the poet Hesiod is visited

by his muse in his sleep, and of brutal force, such as the wanton murder of Archimedes by an ignorant soldier. He varies moments of enlightenment and moments of futility with something like detached dramatic sympathy. The events depicted, actual, legendary or mythological, come from the history of science, philosophy, law, theology and poetry – or as he put it, the topics which may be studied in a library.

Delacroix responded warmly to vigour; and for this reason some critics have preferred Attila to Orpheus. Others have preferred to all other scenes one which is equally vigorous but much less cruel: the scene where young naked Achilles shoots arrows while riding on the centaur's back. The boy-hero excels the beast-man in physical beauty as in intellect. There is no need for a civilised man to be effete. There is no need for an athletic man to be destructive.

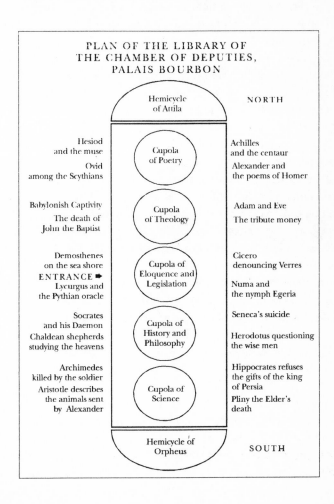

PLAN OF THE LIBRARY OF
THE CHAMBER OF DEPUTIES,
PALAIS BOURBON

Hemicycle of Attila — NORTH

Hesiod and the muse
Ovid among the Scythians

Cupola of Poetry

Achilles and the centaur
Alexander and the poems of Homer

Babylonish Captivity
The death of John the Baptist

Cupola of Theology

Adam and Eve
The tribute money

Demosthenes on the sea shore
ENTRANCE ➡
Lycurgus and the Pythian oracle

Cupola of Eloquence and Legislation

Cicero denouncing Verres
Numa and the nymph Egeria

Socrates and his Daemon
Chaldean shepherds studying the heavens

Cupola of History and Philosophy

Seneca's suicide
Herodotus questioning the wise men

Archimedes killed by the soldier
Aristotle describes the animals sent by Alexander

Cupola of Science

Hippocrates refuses the gifts of the king of Persia
Pliny the Elder's death

Hemicycle of Orpheus — SOUTH

Delacroix's focus is on the body, not the destiny of man, the body in all its expressive range, most triumphantly physical in youth and most tragically powerless in age. Achilles will grow up to become Homer's sulky warrior, to slay Hector and to be slain by an arrow shot from a bow – the self-same weapon which he wields here – in his heel. Michelangelo's Adam is a pre-Christian saint: the Achilles of Delacroix is a Romantic hero.

In no other of his major murals of the period did Delacroix come so close to expressing his personal ideals. The ceiling of the Palais Bourbon library had given him the chance to express his deepest feelings and to create a work of art which was truly his own. While he was working on his preliminary ideas for it, he received yet another commission for yet another library ceiling, this time for the cupola and hemicycle in the Palais du Luxembourg, the seat of the French upper house or Senate. For the hemicycle he used a story which appears on the Palais Bourbon ceiling, the story of how Alexander the Great had the works of Homer enclosed in a golden casket. For the cupola he had recourse to one of his favourite texts, Dante's *Inferno*, which had inspired his first notable painting almost twenty years earlier. He chose the moment when in the Elysian Fields Dante is greeted by the ancient pagan poets, Horace, Ovid, Lucan and Homer. The first scene stressed the value of art and the second scene the limitations of art. Once more Delacroix would show what the classical tradition meant to him. Once more he was indebted to Thiers, then Prime Minister, for a chance to work out his principal concerns on a mural.

Similar ideas inform his major easel paintings of the late 1830s and the 1840s. His *Medea*, about to slay her children, is enfolded in humanity's tragic destiny. A medieval response to the noble behaviour of a good pagan, from Dante again, came in *The Justice of Trajan*. One more classical scene, *The Death of Marcus Aurelius*, shows the philosopher-king dying stoically aware that his profligate heir will mar his work, a Davidian subject but treated with a freedom that none of David's followers could have shown. Delacroix's classicism had in it nothing that was hard, cold or correct. In Morocco he had seen the antique world come to life; and it was that world, not the world of the statuesque reproduction, that he wished to inspire his art, just as it was that same world which had made him question the relative merits of barbarism and civilisation.

To move from inspiration to execution was no easy matter. Delacroix's over-ambition irritated the civil servants whom he pestered for money while seemingly being slow to finish what he had promised. For the murals he relied on assistants, the first of whom, Lassalle-Bordes, came to dislike him and to denigrate his part in the paintings he claimed as his own. At one stage the wall

behind the hemicycle of Orpheus began to crack. At another stage the canvas in the Palais du Luxembourg came unstuck.

In the end all went well. The Senate decorations were finished before the end of 1845 and the Chamber of Deputies decorations by the end of 1847. With these works Delacroix knew there was a sound basis for the fame which he wanted. Unfortunately, the public was not generally admitted to either palace; his grandest works were not then and are not now well known; he would have to rely for public recognition partly on the State, but partly too on the judgment of his peers.

His recent works had established his position as the most important painter in the service of the State. Official recognition had to come soon. In 1846 he was made an officer in the Legion of Honour. Precious though this Napoleonic reward was to him, there was a position he rated even more highly. During the Revolution the French Institute had been set up with five academies, as a new version of Louis XIV's system for controlling the sciences and the arts; and of these five the Academy of Fine Arts was the fifth. It was the desire of all successful French artists or poets or musicians to become academicians. In 1837, on the death of his old friend Baron Gérard, Delacroix applied for the first time to be admitted into the select, self-selecting, inner group of French artists. He was rejected. He would go on trying for twenty years, until at last, thanks especially to the musicians, he was accepted.

Later Berlioz would note how many others among the leading Romantics had fared equally badly, himself included. 'So far I have applied only twice. Hugo had to knock at the door five times, De Vigny four. Eugène De Lacroix has still not been able to gain admission after six successive attempts. De Balzac never got in. And the fools who are admitted! You simply have to resign yourself to regarding it like a strict question of money, a sort of lottery, and wait patiently till your number comes up.'[5]

It was unfair of Berlioz to imply, if he did, that everyone who was admitted to the academy was without talent. In 1832 the competent Delaroche, a well-known painter of historical pictures, to whose seat Delacroix would succeed, was voted into the Fine Arts division of the Institute and in 1833 Thiers joined the literary section. If Delacroix did not finally become one of the 'immortals' till 1857, that was above all because Ingres had been one since 1825. Ingres had been a great painter, the most graceful and talented of David's pupils; and in recent times he has been seen, as he was seen in the Universal Exhibition of 1855, as the other great French painter of the first half of the nineteenth century. By temperament a dictator, in lifestyle utterly conventional as a bourgeois, married, childless man, by conviction the most puritanical of aesthetes, Ingres wished to know nothing about life that was not beautiful and nothing about art

that was not dead. What he chose to resurrect for the modern world was the art he thought of as classical, the art of Periclean Athens and Augustan Rome, the art which he believed had been revived by Raphael, by Poussin and by David. It did not matter to him that such a restricted canon ignored much of antiquity, much of the Renaissance and much of the age of the Baroque. He saw no irony in the fact that he made his money from painting society beauties and dandies, that he pandered with exquisitely unlikely nudes to a Romantic taste for the Orient and that he clung obsessively to certain tried formulae which he had worked out in his youth. He made his opposition to Gros, Géricault and above all Delacroix a crusade. If Delacroix came to the Louvre, he would open the windows to let out the sulphur. If he found himself dining at the same table, he would be apopleptic with rage. In the seventeenth century, French art theorists had been split between the Poussinistes who venerated line and the Rubénistes who venerated colour. Delacroix passionately loved Rubens, but he could appreciate Poussin too. Ingres allowed no such spirit of compromise. Those who desecrated art must be kept from the temple; and any nonentity, provided he believed as Ingres did, might be chosen for the Institute. Unlike Delacroix, who, contrary to popular belief, had no school, Ingres had many pupils, whose lack of talent made them subordinate to the master. With their help for twenty years it was possible to keep Delacroix outside the portals of the Institute.

The marvel is that Delacroix persisted in going on trying. It was not just a desire for social status that made him so persistent. Delacroix wanted to be an academician so that he could teach. Ingres could not dictate to his fellow academicians but they suspected the freedom from approved methods which was the hallmark of Delacroix's art: their aesthetic timidity was given fire by Ingres's unshakeable convictions of his own rectitude. Ingres tried to insure that his own ideals would become the norm for the painting of the latter part of the nineteenth century. One young artist who learnt from him, Edgar Degas, became a great artist. But almost all the younger artists now thought of as important, especially the Impressionists, learnt from Delacroix. Delacroix was not accepted till he was too frail to be more than an honorific member of the Institute. His exclusion for so long from the Institute had the reverse effect of what Ingres and his allies wanted: it helped to create the modern excessive respect for the avant-garde.

His exclusion during the years of his greatest productivity had this further consequence: it furthered the cult of mediocrity at the official annual exhibition, the Salon. Writing to a friend about the Salon of 1839, Stendhal concluded:

On the whole these painters seem to me like good technicians, but lacking intellect and with even less feeling. . . . I naturally don't include Delacroix, three of whose paintings have been turned down by those brutes at the Institute.[6]

Delacroix, though patronised by the State, had to suffer official disapproval by the artistic establishment. To compensate for this he had the friendship of many of the most talented people of the age.

Trio (1836–49) and coda (1849–63)

EW painters have been so sensitive to beauty of sound as Eugène Delacroix. Leonardo and Giorgione sang songs to the lute; and Delacroix's principal rival was so skilful a performer that the French came to use the expression *violon d'Ingres* to describe a great gift which was almost a chief talent. Delacroix, who played at various times the violin, the guitar and the piano, wrote about music with a discernment and passion that is exceptional in a musical amateur. He made friends with composers. The Halévys, who had a country house near him at Champrosay, would invite him to call on them. In Paris he was a near neighbour of Auber's. He was often at the opera or at concerts in private rooms or at the Conservatoire. When late in life he was elected to the Institute, he owed his belated triumph partly to the respect in which France's approved musicians held him. In his middle years, however, he valued one musician above all others: Fryderyk Chopin.

Chopin had come to Paris at the moment when the liberal monarchy seemed to open France to the free spirits of the world. The prototype of the uprooted intellectual, Heine – a Jew among Germans and a German among Frenchmen, a rebel among the bourgeoisie and a conservative among revolutionaries – was one of the first to arrive. Another poet, Adam Mickiewicz, came with a different tale to tell. Being a Pole, he had to write of the sufferings of his people; and in *Pan Tadeusz* (1834) he was to write the epic of his race. In literary circles he was easily the most famous of the Poles. The Polish rebellion of 1830 and its brutal suppression by the Russians the following year had ensured that he would be part of a numerous expatriate community. The Poles who fled to Paris were clannish and sentimental and refined. As with all Polish rebellions between partition in the eighteenth century and independence in the twentieth century, theirs had been led by students and aristocrats; and so it was the intelligentsia and the nobility who set the tone among Parisian Poles. By chance, they were able to count among their number a composer-pianist of genius.

Fryderyk Chopin was ideally suited to be an ambassador of Polish culture in France. He had a French name, for his father had been born in Lorraine where an ex-King of Poland had ruled as duke. In Lorraine the elder Chopin had entered the service of the agent to a Polish count who owned land there as well as in Poland; and so in 1787 he had come to Warsaw at a time when Poland was still independent. In 1794 he had supported the fruitless insurrection of Kósciuszko and after its failure he stayed on in Russian-occupied Poland. He took service in another noble household as a tutor, met Justyna Krzyzanowska, an impoverished relative of his employers, and married her in 1806. They had four children: Ludwika, born in 1807, Fryderyk, born in 1810, Isabella, born in 1811, and Emilia, born in 1812. Some months after Fryderyk's birth his father accepted a post at the Warsaw High School. During that period it was a good time for a Frenchman to be in Poland. Not only did Napoleon have a Polish mistress, who convinced him that he was not impotent, but he also sought to favour the Poles politically. He set up the Grand Duchy of Warsaw as a distinct unit within his empire. The good times did not last long. They came to an end in 1814 when the Grand Duchy of Warsaw was incorporated into Russia.

Luckily for Fryderyk, his family stayed on in the Polish capital. There his precocious talent was noticed early and he had the opportunity to play before the tsar in 1825 and to receive the best piano teaching that Poland could provide in the person of Joseph Elsner. By the end of the decade he was already a notable composer, who had written variations on Mozart's *Là ci darem* and the first set of *Etudes*, and a pianist who had played in Berlin and in Vienna and who had spent a week at the country house of Prince Radziwill. His motive in leaving Poland in 1830 was purely personal. He and his closest friend, Titus Woyciechowski, were thinking only of music when they left for Vienna. News of the revolt drew Titus home to fight. At his family's urgent request Fryderyk stayed abroad to play.

Vienna proved to be musically philistine. Everybody was dancing to the waltzes of Lanner and the elder Strauss and few realised that Chopin's technical brilliance, for at this stage only he could play his *Etudes*, was concealed by his artistic reticence. His two solo concerts were not successful and he left for Germany. In Stuttgart he heard of the fall of Warsaw and he prepared to take refuge in France. As legally he was a Russian subject and as Louis-Philippe's France was not on good terms with Tsar Nicholas, who disapproved of all revolutions, whether Polish or French, Chopin had to pretend that he was going to London via Paris. It would be many years before he went on to London. The stop-off in Paris would last most of the rest of his life.

Once in Paris he soon got known among the musicians and the Poles. He met Camille Pleyel, whose pianos he would henceforth prefer to all others. He met

the cellist Franchomme, the composers Mendelssohn and Berlioz and the pianists Kalkbrenner, whom he thought the best, and Hiller and Liszt. He saw the Radziwills again and became friendly with the Wodziński brothers and the Brykczyńskis. All this was more pleasant than being lonely and neglected in Vienna. Unfortunately fame alone did not pay the bills.

It was his introduction to the Rothschilds that changed his fortune for the better. Once it was known that he was giving piano lessons to the Rothschild wife and daughters, he became a social catch. No other pianist was so naturally courteous as Chopin. Unlike Liszt, over whom women fainted at his hysterical concerts, Chopin broke select hearts with a good grace. His failure to make a career as a virtuoso concert pianist helped to make him the darling of the discreet *soirées* of the best people. Unlike Rossini, who came into exclusive households by the servants' entrance, Chopin arrived at the front door. He was acceptable anywhere. He charged twenty francs a lesson, he dressed as elegantly as he played, he had a manservant and he rented a luxuriously furnished apartment in chaussée d'Antin. He met Heine, Mickiewicz and Delacroix.

In January 1831, a few months before Chopin, there had arrived in Paris a young Berrichon heiress, Aurore Dudevant (née Dupin). Twenty-six years old, mother of two small children, she had come to the capital first to get away from her insupportable husband and secondly to join her little lover, Jules Sandeau. She had written a novel or two to pass away the hours of boredom she had spent in the family home, her home, at Nohant. She also painted and played the piano. She read more than most women of her class, but writing was merely one accomplishment among many; and, if she already wrote letters with greater fluency and at greater length than most other well-brought-up young ladies, that did not make her a professional writer. Once in Paris, however, she stopped behaving as though she was well brought up. She dressed in men's clothes, she smoked and the unfortunate Sandeau soon found that he was just the first of a series of lovers. He is memorable only because she took his name, removed the second syllable, added a masculine first name and so became for most of the world George Sand.

In 1832 her novel *Indiana*, a plea for women's equal rights in the matter of extra-marital affairs, was received with acclaim by Balzac and by the reviewer of the *Revue des deux mondes*. She was famous, even notorious, and in 1833 she embarked on a relationship with Alfred de Musset, which took them to Italy, where he was ill and she found a new, Italian lover, thus provoking a break-up with Musset and giving both Musset and Sand exciting material for their books.

For a little while there was hope of reconciliation; and after a tiff George Sand would wander round from friend to friend, declaring that she would write her memoirs to make her children's future secure and then commit suicide. She asked advice from her editor, Buloz, from the eminent critic Saint-Beuve, from Liszt and from a recent acquaintance, Delacroix.

Outside her own literary world at this time her friendship with Liszt must have seemed more important to her than her relationship with Delacroix. Musset had introduced Sand to Liszt and then quickly regretted the introduction. Liszt admired her novels, to which his mistress the comtesse Marie d'Agoult had drawn his attention; like everyone else, George Sand found his playing intoxicating; they seemed ideally suited, being alike demanding, idealistic and extravagant. Rumour had it that they became lovers, but for some years George Sand and Marie d'Agoult tried very hard to be sisterly. As for Liszt, he insisted that he was instrumental in bringing her into contact with Chopin.

It was in 1836, the year in which her separation from her husband became absolute, that the first meeting occurred. Liszt, with his sense of drama, tells of an occasion when there was a soirée *chez* Chopin. Besides himself and Chopin and George Sand there were among the company Meyerbeer and Hiller, the musicians, and Heine and Mickiewicz, the poets, and Delacroix. Chopin's apartment was dimly lit 'by some wax candles grouped round one of Pleyel's pianos, which he very much liked on account of their slightly veiled but silvery sonority and easy touch'. While most of the distinguished audience stood, George Sand, 'buried in an armchair, her arms resting on a table, sat curiously attentive and gracefully subdued'.[1]

Was Liszt correct to maintain that this was the first occasion when the future lovers met? If so, Delacroix was present at the beginning of the story as he would be at the end. In time he would matter to both George Sand and to Chopin as Liszt never would. In the dimly lit room there began not only the most important relationship in the lives of George Sand and Chopin – that between the two of them – but also a very unusual triangular relationship between writer, composer and artist.

Already in 1832 Delacroix had painted a great musician, Paganini, bony, rapt and consumptive. In 1834 Buloz, editor of the *Revue des deux mondes*, had commissioned from him a portrait of the newly famous George Sand to coincide with the publication of her new novel *Lélia*; and Delacroix painted what he saw, the vulnerable young woman, disappointed in her love for Musset. In 1838 he brought music and letters together when he painted a double portrait of George

Sand with another consumptive composer, Chopin. The painting as originally conceived showed Chopin seated at the piano while a 'curiously attentive and gracefully subdued' George Sand stands behind him. At some date the painting was cut in two, so that the consumptive Chopin is familiar to visitors to the Louvre and the pensive Sand is to be found in Copenhagen.

Delacroix had known both Chopin and Sand before either knew each other, but for the first year or two after they met he was a detached observer, while between 1836 and 1838 their fresh acquaintance turned to love. In 1836 Chopin had been courting Maria, younger sister of the Wodziński brothers, but her family had been concerned about his health and resisted his romantic intentions; and by early 1838 he knew that he would never marry her. As for George Sand, she had forgotten about Musset and had had time for two more lovers and one passionate admirer before she was free to concentrate on Chopin. She may have thought briefly of some romantic involvement with Delacroix. If so, he rejected the invitation, because he was in love with Joséphine de Forget. In 1837 George Sand had invited Chopin, through Liszt, to come to Nohant, but Chopin, still pining for Maria Wodzińska, had refused. He was conscious of George Sand's intentions. To his diary he confided his memory of an occasion when he was playing sad music, 'legends of the Danube', and how she looked deep into his eyes and his heart danced with hers and how her eyes held his and his heart was captured. By April 1838 they were approaching intimacy, for George Sand wrote to Delacroix to ask him to an evening recital. 'Come at midnight if you are not too sleepy, and if you meet anyone I know don't tell them a thing, for Chopin is terrified of barbarians.'[2]

In the summer George Sand had still not got her way, for from Nohant she wrote one of her longest and frankest letters to Count Wojciech Grzymala, a Polish friend of both Chopin and Delacroix, pleading her case, which Chopin seemed to have rejected. 'He seemed to despise (in the manner of a puritan) the coarser side of human nature and to blush over temptations he had had, and to fear to pollute our love by a further ecstasy. I have always detested this way of looking at the final embrace of love. If this last embrace is not something as holy, as pure and as devout as the rest, no virtue lies in abstaining from it.'[3] Her letter, she explained, was her ultimatum. She followed it up by coming to Paris in July. By September Chopin must have given in, for Delacroix wrote to her in terms that take for granted that the two were lovers. From Valmont, 'an ancient abbey of rich monks with a superb ruined church and water and marvellous gardens', he grumbled cheerfully about 'many intolerable provincial faces, a lot of dinner tables and wits, a lot of inns and very few lavatories in the English style (forgive my vulgarity, but it's a very important detail).' His tone gradually becomes more serious, for he wrote to encourage her. 'You deserve so much to be loved!

You are neither a blue-stocking nor a flirt. You are a good judge of the foolish tactics of my sex and of your own in the war called love.'[4] He sent all his love to Chopin. By this time she was no longer *'chère madame'* but had become *'chère dame'* or *'chère femme'* and she could refer to herself, playfully, as his *'vieille soeur'*. Intimacy with Chopin had brought her friendship with Delacroix. She was able to write coquettishly, 'I would be mad about you if I wasn't about someone else,'[5] but it was the someone else who must come first. To avoid scandal and to improve Chopin's health, George Sand and her children and Chopin set out for Majorca, to enjoy what Delacroix called elsewhere in his letter 'those precious drops of honey'.

The honeymoon from which so much was expected turned into an ordeal, a trial of strength against a hostile environment. The Majorcans were shocked, Chopin began to spit blood and the lovers had to move to a devoted monastery. By the time that a Pleyel piano reached him, after a three-week delay at the customs, Chopin was too weak to compose. Only the devoted nursing of George Sand, who trudged through mud to buy him food, and the gradual return of fine weather gave him back the will to work. He completed the *Preludes* and sent them off to Pleyel. He had the energy to haggle with his publishers. In the spring he was well enough to move and the party went back to France, to Nohant, which Chopin had not yet visited. Knowing that their liaison was accepted, they felt no need to avoid Paris any longer, and during the next seven years most of their life together would be spent either there or in Nohant. What was over was the first careless rapture and possibly even sexual intimacy. They had more time for their friends and therefore for Delacroix.

In March 1839 Delacroix sent Chopin two books from an obscure poet, apologised that he could not use a concert ticket Chopin had sent him – he was not well – and said that he would have liked to have news of the inhabitants of Nohant.[6]

Chopin was the most respectable lover George Sand had ever had and he was determined that she would not disgrace him. He insisted on calling her Aurore, he would not have her wearing men's clothes and in Berry he made her local friends behave more decorously. He also refused to live openly with a married woman. At Nohant he was just a house-guest and in Paris they rented apartments close to one another, first in rue Pigalle and later in place or square d'Orléans. Sometimes, because of his teaching and his concerts, Chopin had to be in Paris without her, but usually they lived a quiet domestic life. This stability suited them both well. He was free to compose and she was free to mother him as the third of her children. Taking each other for granted, they drew closer to Delacroix.

The evidence of their letters would suggest that Delacroix was closer to George Sand and she to him, for he wrote to her regularly, affectionately and revealingly and she replied in kind, if also at greater length. By contrast there are many fewer letters to and from Chopin, in her case because there was little need, as long as they were near one another and happy with one another. In Delacroix's case the explanation must be that in Paris he and Chopin saw each other too much to bother to write; and when they were separated they used George Sand as intermediary.

On 1 January 1841 Delacroix wrote to Chopin to apologise for a delay in sending Chopin some prints. 'Accept lots of good wishes,' he added, 'not as everybody sends them, but the wishes of a heart that loves you dearly, dearly, dearly.'[7] Two letters date from the winter of 1844–5. In the first he begged Chopin to ask Mr Brown the bootmaker to call around nine o'clock one morning. He had asked Mr Brown to make him some boots without success and hoped that Chopin's word would be more effective. In the second letter he gave the bootmaker's address and stated his preference for boots like Chopin's, rounded in the English style, and for winter shoes like those of Mr Arrowsmith the art dealer with very thick, light soles. These two notes explain one reason for the friendship between the two men – their dandyism – but only two sentences indicate anything more. 'How sad to spend our lives without meeting! I truly love you and admire you as one of the people who most honour our unhappy species.'[8] Even the date of this letter is not certain and so why they could not meet is not clear. In the course of 1844 Delacroix moved to rue Notre-Dame-de-Lorette and so became a neighbour.

Fortunately there is other evidence of their relationship. In Paris Delacroix seems to have been a regular visitor even before his move. It was, however, as a house-guest at Nohant, technically a fellow house-guest with Chopin, that he had the opportunity to know Chopin better. Once George Sand had felt herself established in the Paris literary world, she took to inviting Parisian friends down to her country estate. In 1838 Balzac had spent six days there, talking about himself most of the time but pausing to listen to what she would say about him while he drew breath. In 1841 for the first of many times the famous diva, Pauline Garcia-Viardot, was a visitor. The beauty of her singing and the cool dignity of her personality had so entranced George Sand that Pauline became the idealised object of her overwhelming devotion. It was George Sand who had helped arrange Pauline's marriage to an operatic impresario; and she greedily took on the role of surrogate grandmother to Pauline's children. In 1843 Pauline left her baby daughter at Nohant while she and her husband went off to Vienna alone for one of her engagements. It was a pattern of behaviour which she would often repeat. Meanwhile among male guests the favourite had become

Delacroix. He was at Nohant in 1842, in 1843 and in 1846. Nohant became for him a home from home, a refuge from the strains of Paris, from his public commissions and from the social calendar.

Just before he went in 1842, he wrote to beg his hostess not to make too much fuss. 'Tell my dear little Chopin that the entertainment I like involves ambling along garden walks talking about music and spending the evening on a sofa listening to music when God takes over his divine fingers.'[9] Once there he adjusted to a routine of billiards, reading, walking and eating. 'From time to time,' he assured Pierret, 'you hear through the window which opens on to the garden strains of Chopin's music while he is working; this blends with the song of the nightingales and the scent of the rose-bushes.'[10] His one regret was that he could not help thinking about work, so he told Villot, and he had undertaken to paint a *Saint Anne* for the parish church.[11] His chief pleasure was the endless tête-à-têtes with Chopin, whom he described to Pierret as 'a man of great distinction' and 'the truest artist I have ever met'.[12] Once back in Paris, he assured George Sand that he was overcome by depression whenever he thought of the kindness and peace he had met in Berry.

He was invited to Nohant in the following summer; and when he had to return to Paris, he was soon teasing George Sand with the observation that he was born for air, the countryside and oxen, in other words for her. He wrote again on 15 November, the feast of Saint Eugenius and so his name day, to thank her for remembering him kindly. In his daydreams he saw their relationship in Byronic terms, himself as a Sultan and she as Zuleika, Zetusbe or Gromufila. 'You plant, you sow lucky flowers.'[13]

In 1844 he could not appreciate them, for though he carried on discussing his ideas with Chopin in September, when the composer made a brief sortie to the capital, he was preoccupied with his new house in Champrosay; and Chopin and George Sand were coping with news of the death of Chopin's father and the visit to Nohant of his sister Ludwika and her husband. By contrast, 1845 was a bad year for Delacroix. He suffered from ill health and had to spend July and August in the Pyrenees. As late as September he was writing to apologise to George Sand that in his mountain retreat he had no energy to write to her. He finished the year with a sad little note to her. His brother's health was deteriorating and he was off to Bordeaux at seven next morning. He would arrive too late.[14]

His last visit to Nohant was in the late summer of 1846. Delacroix came there looking for a rest from the heat, dirt and sweat of Paris, but the holiday was not idyllic. He could hear Chopin play Beethoven divinely well. He could envy the people of Berry their lack of ideas. But he found it was impossible to escape the excessive heat even in the provinces, he welcomed the onset of thunderstorms and he was eaten alive by little red insects which he could feel but could not

see.[15] At the end of the month he left, taking with him the manuscripts of the Barcarolle in F sharp major, the Polonaise-Fantasie in A flat major and two Nocturnes. Three months later Chopin left Nohant for the last time. Stormclouds were gathering that would break up the three-sided relationship for ever.

Posterity has valued the achievements of Chopin and Delacroix above those of George Sand, but to her both men owed a great debt. Between 1839 and 1846 Chopin composed some of his best loved pieces: the B flat minor Sonata, the Polonaise in A flat minor and the Berceuse. Only in Nohant could he have peace to rest and concentrate. Delacroix, it is true, was mainly concerned during these years with his grand official paintings. At Nohant he found a much needed antidote to solemnity – he began to paint flowers. It was a considerate hostess who provided for each just the conditions each needed for his art, including a studio for Delacroix and the living room for Chopin's composing and playing. It was the same hostess who had watched the two men learn from each other. 'Chopin and Delacroix love one another dearly. They have many affinities of character and the same great qualities of heart and head. But, in matters of art, Delacroix understands and adores Chopin, Chopin does not understand Delacroix. He values, cherishes and respects the man, but he detests the painter. Delacroix, more versatile in his faculties, appreciates music, knows and understands it and has a sure, refined taste. He never gets tired of listening to Chopin; he savours his music, knows it by heart. Chopin accepts this adoration and is touched by it; but when he looks at a picture by his friend, he is hurt and does not know what to say. He is a musician and nothing but a musician. He has great intelligence, elegance and irony, but he understands nothing about painting or sculpture.'[16]

This verdict, if just to Delacroix, may have been harsh on Chopin. Four years after George Sand wrote these words, Chopin in 1845 told the cellist Franchomme that Delacroix was the most admirable artist anyone could meet. 'I have spent delightful times with him. He adores Mozart and knows all his operas by heart.'[17] From Chopin that was high praise.

The château of Nohant, large, rambling and comfortable, was described by Matthew Arnold as 'a plain house by the roadside, with a walled garden'. When it echoed to the advanced harmonies of Chopin's music or was stilled by the marvellous *pianissimi* for which his playing was renowned, life there must have seemed like a return to the golden age. If so, the impression was false. It was not just that George Sand was bossy. Her children were impossible.

By 1846 Maurice was twenty-three and Solange eighteen. Both had been brought up erratically, sometimes with their father, sometimes with their

mother, often away at boarding-school, educated with little sense of plan and subject always to George Sand's overwhelming personality. He was clinging, not very robust, an idle artist vaguely attached to Delacroix. She was rebellious and petulant. He resented Chopin. She expected that Chopin would obey her every whim.

One year earlier another young person, Augustine Brault, had entered the household. She was a poor relation and pretty. Solange treated her as a social inferior, Maurice found her attractive. Chopin suggested that she should leave – he believed that Maurice had seduced her and said so – and Maurice retorted that Chopin was not wanted at Nohant. To protect her son Sand had a row with Chopin. Briefly calm was restored. It was then that Delacroix had come down. He had cheered up Chopin. He was on good terms with his lazy pupil. He liked Solange.

After his return to Paris, in the autumn Solange announced that she wished to marry a handsome young landowner, Fernand de Préaulx. George Sand was pleased and so was Chopin, who returned to Paris in November. He wrote to George Sand regularly, a little formally, and she wrote back to him, formally, to ask him to run errands to the dressmaker's. Grzymala, he told her, was getting better, Pleyel had fever again, Delacroix was unwell but continued working and sent warm greetings. As late as 10 April 1847 he was thanking her for good news – she was planning to come back to Paris soon – and telling her that he had passed it on to Maurice, who would write. Both he and Maurice were well.

At Nohant all was not well. In February George Sand had come to Paris to buy Solange's trousseau and at intervals in the shopping expeditions had sat for a sculptor called Clésinger, whom Chopin described to his family as a genuine new talent. Suddenly Solange announced that she wanted to marry Clésinger. She was whisked off to Berry, with Clésinger in pursuit, and in Berry he persuaded both parents that the marriage should go ahead. George Sand wished to conceal the news from Chopin and for a time Chopin was puzzled as to why she had not returned to Paris. He was far from well – on 12 May Delacroix wrote to tell her that Chopin had had a violent attack of asthma[18] – and, though she told her domestic problems to Grzymala while begging him to tell Chopin nothing, she also told another friend of Chopin's, Adolf Gutmann, how she was worried about his health. Her ruse failed, for Chopin found out what was happening and wished both George Sand and Solange all the best for the great day on 20 May.

By that date, however, Chopin and Delacroix had found out more about Clésinger's character. They were horrified to learn that he was heavily in debt, that he had beaten his pregnant mistress and then abandoned her in order to get married and that he was a drunkard. Delacroix was also without illusions about

his art. He thought his sculptures looked like so many daguerrotypes. Neither he nor Chopin went down to Nohant.

There was good reason for the lack of guests that summer, for the family was quite enough. In one letter to an intimate George Sand told how there had nearly been murder at Nohant. 'My son-in-law took a hammer and maybe would have killed Maurice had I not thrown myself between them, punching Clésinger in the face and getting from him a blow to the chest. . . . And there stood Solange, stirring the flames with icy ferocity, after having caused these terrible outbreaks by her stories, lies and unbelievably nasty tales.' She added that Chopin would be told only a partial version of what had happened and she ended by asking for the keys of the apartment to be taken while he was out.[19] Unfortunately soon after this, Solange wrote to Chopin to mention that she had had to leave Nohant for ever because of dreadful scenes with her mother. She also asked his permission to use his carriage. He gave it; and by that action, in George Sand's eyes, he broke the last link of friendship with his former lover.

All this while, Delacroix's relationship with George Sand had been correct, if somewhat distant. In March he had dined with her twice and on 1 April all three of them had gone to look at his paintings in the Luxembourg. In the following week he saw her twice more before she went back to Nohant; and good advice followed her there about Solange's need for financial independence from her husband – a major problem in French marriages at the time – along with his ritual anticipation of his next visit to Nohant. He was also in frequent contact with Chopin; and it was not till 20 July that he learnt how drastic the breach between George Sand and Chopin had become. On that day it seems that Chopin told him about a letter, now lost, from George Sand. He was sufficiently agitated to read out most of it – and there must have been much of it – to Delacroix. He was appalled. 'It is atrocious. Cruel passions and impatience that has been repressed for a long time have become apparent in it; and, by way of a contrast which would be funny if it were not so sad, the authoress sometimes takes over from the woman and embarks on tirades which would be appropriate in a novel or a philosophical lecture.'[20] Delacroix, so cautious, so courteous and so non-committal, had been drawn into a bitter quarrel between two of his dearest friends.

Forced to choose between the two of them, Delacroix sided with his own sex. Of all Chopin's male friends, he seems to have remained the one non-Pole who stayed close to him. They still wrote to one another rarely – or else their letters are mostly lost – but then they were neighbours as long as Chopin continued to live in square d'Orléans. Delacroix had resumed his *Journal* and up to

September his contacts with Chopin can be traced. In October he spent a fortnight in Champrosay and for November and December there are almost no notes on his daily life. How much he saw Chopin that autumn cannot be known.

He did not stop writing to George Sand, but he could ill conceal his embarrassment. In August 1847, from Champrosay he turned down an invitation to Nohant, making an excuse of his lack of money. Another passage in the letter shows that there were other reasons for avoiding a stay. 'What sad happenings; and how can I say anything more to you about them? I feel I was wrong not to reply to you at once. . . . Let's therefore just do nothing, let's run away from ties and emotions, since both almost inevitably lead to one torment after another.' He was silent till November. Then something of the old confidentiality returned. He was saddened by the death of his adored aunt Riesener. 'All the people necessary for our existence who disappear take away with them a world of feelings that cannot live again in anyone else.' These days there was small compensation in the arts. Referring to the horrible music by Verdi, or Merdi, which Pauline Viardot had to sing for a living, he added a familiar lament: 'Where is Chopin, where is Mozart, where are the priests of the living God, where are you?' He concluded with these words: 'Prepare poor Chopin for the harsh music he's going to find here.'[21] Was he being tactless? Chopin's letters to Solange mention Delacroix in October, November and December. What did Delacroix know? Not everything, it seems, if he thought that Chopin was still at Nohant. Chopin must not have been completely frank. He hated scenes and was likely to pretend that, if they had occurred, they had been less tempestuous than in reality. Besides, in December he was encouraging Solange to be reconciled with her mother.

The year 1848 reveals nothing to us of the relationship between Delacroix and Chopin. Delacroix lost his *Journal* for the year and from April to November Chopin was in England and Scotland. When Chopin heard of the riots in Paris in June, he was anxious about Gutmann, to whom he had written, and about Grzymala and Pleyel and Delacroix. In October, through Grzymala, he sent Delacroix his best wishes from Edinburgh.[22] There is no evidence that Chopin ever talked to Delacroix about his last meeting with George Sand, which occurred in March 1848 at a friend's apartment, when he told her of the birth of her first grandchild and she enquired after his health.

Delacroix's dealings with George Sand were a little happier, for he wrote to her in affectionate terms. Politically he was much more conservative than her, but he joked that his letter took longer to reach her than it took for the Second Republic to be formed. He said that Maurice would have the chance to paint soldiers, whom he had never seen before, that the young people had become men in a few days and that he was afraid that many men would soon become

decrepit. About her politics there was some gentle teasing. She had come to Paris to further the republican cause – it was then that she had met Chopin – but she soon returned to Nohant. 'You were right,' he wrote, 'people would perhaps have accused you of raising barricades.' More seriously, he told her that he no longer preferred liberty to subjection, if liberty meant fighting.[23]

By the end of 1848 stability and Chopin had come back to France; and once more Delacroix's life can be traced through entries in his *Journal*. On 29 January the two men discussed George Sand, her qualities and her vices, her proposed memoirs. Chopin was sceptical about her ability to write them, since she forgot so quickly. Delacroix forecast for her an unhappy old age, but Chopin disagreed, for she would be affected only by a misfortune involving Maurice. They went on to discuss suffering, a subject which naturally preoccupied the ailing Chopin and which would preoccupy Delacroix increasingly as he watched his friend dying.[24]

He saw Chopin regularly in the early summer until Chopin moved to the suburban district of Chaillot, where his sister joined him. Sometimes he reported just a call and on other occasions he betrays his emotions, as when another pianist's style makes him think of Chopin, 'my poor dying great man'. On one visit he met a quack from Quimper whose pompous declarations on music annoyed him and on another he met the enchanting Countess Potocka, whose beautiful voice would give pleasure to Chopin near the time of his death.[25] In April they took a carriage ride up the Champs Elysées while Chopin explained to him the logic of the fugue and Mozart's constant fidelity to the eternal principles of music. A few days later he heard the countess sing to Chopin snatches of his Nocturnes and his setting of *The Mill of Nohant*. He saw Chopin once more that month – 'a man of refined feeling' – and in May he went to see him in Chaillot.[26]

Sensing the end was near, Chopin returned to Paris to an apartment in place Vendôme. George Sand, by now alarmed, wrote to Ludwika to ask how her 'child' was. Chopin himself was deeply touched that the best friend of his youth, Titus Woychiechowski, was coming to the west, but he was too unwell to arrange a permit for him to cross France. He was too weak to see anyone for more than a few moments; and at the end of his life what mattered most to him was his Polish past – his sister and Grzymala and the countess and Titus, whom he never saw, and the Catholic religion. He died on 17 October 1849.

Three days later, at Valmont, Delacroix heard the sad news. He had a presentiment of it before getting up that morning. Rascals were left alive and that fine soul was extinguished.[27]

He went back to Paris for the Mass at the Madeleine on 30 October; and there, along with Franchomme, Gutmann and Prince Alexander Czartoryski he was a

pallbearer. Among the solo singers were Pauline Viardot and Lablache, who had sung in 1827 at Beethoven's funeral. At his own request Chopin's soul was sung to rest to the accompaniment of Mozart's *Requiem*.

Delacroix remained faithful to the memory of Chopin for the rest of his life and yet still managed to number George Sand among his dearest friends.

An undated entry that comes in the *Journal* after 24 October 1849 shows how much he was concerned with both of them. Madame Marliani had told him that George Sand, then at Nohant, was sad and bored. Afterwards Solange had come to take him to see the statue which her husband was making for Chopin's tomb, which was to be unveiled in the cemetery of Père Lachaise on the first anniversary of Chopin's death; and Delacroix was surprised that he liked it.[28]

Others of Chopin's friends were not so impartial. Grzymala, to whom George Sand had confided her views on physical love ten years earlier, wrote soon after Chopin's death that 'if he had not had the ill luck to know G. Sand, who poisoned his whole life, he might have lived to have been as old as Cherubini'.[29]

Delacroix did sometimes allow himself to be critical of their relationship. Madame Jaubert, whom he knew from his stays at Augerville with his cousin Berryer, had a strange story she had heard from Delacroix. He recalled an incident, which must have dated from 1845, when his hostess read aloud to himself and to Chopin from the manuscript of her most recent novel *Lucrezia Floriani*, whose hero was exactly like Chopin, exquisitely well mannered, yet despotic in his treatment of the woman he loved. While Delacroix was acutely embarrassed, he realised that Chopin was so unaware of the parallel that he listened to the reading with enthusiasm, while George Sand read on and on without any sense of awkwardness.

It was more common for Delacroix to remember Chopin with affection and admiration. When he listened to Princess Marcellina Czartoryska playing his music – she was born a Radziwill and so had known Chopin from childhood – Delacroix thought how perfect was Chopin's art, how like Mozart in the seeming inevitability of his subjects. When he was in a Brussels church, he recognised the psalm Chopin loved best. Even George Sand's asthma reminded him of Chopin's. When Liszt wrote a tribute to Chopin, he copied it out page after page. If he got up to leave one of the Princess's concerts to avoid the all too familiar *Polonaise*, he was moved by the artistry of Pauline Viardot's rendering of singing versions of the mazurkas. Chopin, he was convinced, was so like Mozart, if a lesser talent, for he combined modern melancholy with old-fashioned elegance. When he came across Grzymala, whether in 1853 or 1857, the conversation turned naturally to their common friend.[30] He wrote to him in

1861, asking him to pass on his respects to the princess, who is 'another link with the angel whom we have lost and who, now, delights the heavenly spheres'.[31] Among his dead, Chopin was one of the most precious. When he visited his mother's grave in the cemetery of Père Lachaise, he regretted that he had no time to visit Chopin's grave too.[32] Years before he had made a drawing of Chopin as Dante, the most flattering comparison he could make with any artist of any kind. He inscribed it '*Cher Chopin*' and kept it till he died.

With the living, relations are always harder. It was impossible for Delacroix to think that George Sand was an angel after what had happened. Privately he was critical of her literary skill. Like Dumas – it was a point he often made – she had had to write too much for money, so that she was even prepared to praise the composer Meyerbeer. He faithfully accepted invitations to her plays without the least illusion that they were good. She could not develop an interesting situation and she was too idealistic to be true. In one play, *Mauprat*, there were two virtuous peasants – one would have been boring enough – and an equally boring seigneur, an irreproachable heroine, a rival to the hero who was himself the soul of moderation and finally a hot-headed hero who was basically excellent. 'She does not write for the French people, though in excellent French.'[33]

There were also defects in her personality. He was conscious that she could make herself ridiculous surrounded at dinner by young men, that she was not truly happy; and yet . . . she had the discernment to invite him to hear Pauline Viardot in Gluck's *Orfeo*, she had the humour to enjoy his description of the famous actress Rachel waggling her bottom like a woodcock; and she was always glad to see him. Though he thought the publication of her memoirs was misjudged, since she would insist on praising Balzac and could not say interesting things about living people, she was still his '*chère amie*', to whom he could confide his secrets as to nobody else. It was to her that in 1860 he wrote his terrible, candid comment: 'Let us keep well, my dear friend. There are horrid things in this world, but after all what shall we find beyond it? Night, dreadful night.'

Only two months later, in January 1861 he had changed his tone, to tell her how hard he was working and how much he was enjoying it, behaving like Newton 'in his famous discovery of the law of gravity' and then adding: 'My thoughts gravitate towards you, my dear, kind, faithful friend.'[34] Even as late as 1863 he continued with his dual attitude to her: disapproving of the writer, loving the person. In May he confided to his *Journal* his criticisms of her novels;[35] and in July, when he was very ill, he wrote a last, brief note to thank her for letting him know of the birth of Maurice's son Marc. 'Long life to Marc, may he be as good as you all are.'[36]

For her part George Sand valued Delacroix with a special place in her heart. Possibly she sensed that their relationship was that most unusual one: a friendship between a man and a woman which was flirtatious at times, almost but never quite intimate, and all the more successful because they were both not very good at sustaining romantic entanglements, for neither of them ever found that ideal partner which she for one went on and on seeking and which he knew was not to be recognised in Joséphine de Forget.

Our relationship has no history. It can be described in one phrase as an unclouded friendship. That is very rare and very sweet and, as far as I am concerned, quite true. Delacroix's character may have its failings, but I have lived with him in the depths of the country for long periods on end, without being able to find any fault in him, even in the least degree. And yet no one could be more affable or more open or more giving towards his friends. His manner is so charming that near him your own faults tend to seem less conspicuous ... I have never met a comparable artist or one so easy to understand when he sets out to communicate his enthusiasms. The masterpieces you read or look at or listen to are appreciated with redoubled force when there is a genius by you to share his reactions. Whether we discussed music or poetry or painting, Delacroix spoke with equal assurance; and he was always arresting or impressive without any sense of self-consciousness.[37]

When Delacroix died, he left instructions that the paintings he owned should be sold off. George Sand, always short of money to live in the style to which Nohant accustomed her, took the opportunity to sell off most of her paintings by her friend. In time the double portrait of Chopin and George Sand was cut in two; and the last links between composer and writer and painter were severed.

— 14 —

Joséphine (1847–63)

THE friendship between Eugène and Joséphine was given a new political point by the turn events took between 1847 and 1852. It was in 1847 that the republican opposition to Louis-Philippe found a peculiarly French way of voicing its feelings without defying the laws on association which had virtually banned trade unions. The habit of giving political banquets caught on. It was a habit that made conservatives nervous, so that the government tried to stop a banquet in February 1848, caused a riot, shot some demonstrators and then quickly and ignominiously collapsed. By royalist default France became for the second time a republic. The privilege of choosing a president was suddenly offered to all French men.

With a comic irony, the comedy of which at the time escaped the earnest idealists of the left, it was this essentially democratic act which for a generation destroyed the possibility of democracy in France. Besides Bourbon, a name that had just gone out of fashion, the one name all French men knew was Bonaparte. In the presidential election most of them voted for it; and by so doing they put Prince Louis-Napoleon into office. He was to show that he had a personality of his own, but it was the Napoleonic aura attached to him which was initially his best asset. On 2 December 1851, the anniversary alike of Austerlitz and of the imperial consecration, he seized the presidency for life, in a plebiscite he gained popular approval for doing so; and exactly one year later he was proclaimed the Emperor of the French, being careful to honour his dead, younger cousin the 'Eaglet' King of Rome by taking the title of Napoleon III.

Napoleon III was the grandson of the Empress Joséphine de Beauharnais, the godmother of Delacroix's Joséphine, and therefore he was cousin to *la consolatrice*. In the reign of Louis-Philippe twice he had tried to stage a coup. On the second occasion, in 1840, he had been imprisoned in the château of Ham and had been visited there by Madame de Forget, before in workman's clothes and

with a decorator's ladder he had effected an escape that was like an incident from operetta compared to the grand operatic escape which she had helped with some thirty years earlier. In late 1848 he felt it safe to return to France. Madame de Forget received him into her home. Had she so wished, she could have become an important lady when he set up first a presidential, later an imperial court. It seems, however, that she had no such pretentions. She was willing to use family influence only to favour her friends; and chief among them was Delacroix.

She wanted him to be recognised. In July 1849 he could write to tell her: 'I would have less to do with people at the Gobelins' – the tapestry works – 'and consequently more independence . . . all you say about this matter suggests to me that we should give up the idea of the Museum, at least for the time being.'[1] Evidently the two of them were planning to have him put in charge of either the Gobelins or the Louvre and she was the principal planner. The scheme came to nothing. There were limits to what she could do. In October he commented: 'Your poor president is scarcely kind to you, who have shown such rare devotion to him. You are asking such a little favour that I cannot see why he would not take this easy opportunity of pleasing you.'[2]

Whatever the president was failing to do for her, she went on trying to do something for Delacroix. In November 1850 he was touched at the thought of her assiduity. 'I have it in my heart to thank you for what you have done, although I think that, in spite of all our intrigues, we will not get our way. These people push forward only their own clique.'[3] Yet once more he was trying to become a member of the Institute and this time she was trying to help him. He was grateful to her. He needed to know that somebody manipulative like her was backing him. It was to her, then, that he confided in 1853 his fears that he was in some kind of disgrace at court[4] and the news of yet another failure to be an academician. She had already gone on holiday when he grimly remarked: 'You did not wait, I hope, any more than I did, to be chosen this time.'[5]

Was he worried and was she worried at his lack of worldly success? When in 1857 he was at length elected, he owed more to his musician friends than to his friendly mistress. There is no trace of a Beauharnais hand in his election and not one letter from him acknowledging her congratulations. When he wrote to her that spring, it was to apologise for forgetting the feast of St Joseph, her name day.[6] Theirs was not a political partnership; and by 1857 their quarrels were the tiffs of a pair of former lovers.

By 1857 their romance was long over. He no longer said '*tu*' to her. At the end of that year they ceased even to be neighbours. He made the final house move of

his life when he recrossed the Seine to go to place Furstenberg on the left bank. There, off a quiet square in the Latin quarter, he had found a large apartment with a secluded garden and a larger sunlit studio. Like an artistic hermit he could retreat into an inner sanctum, untroubled by the gyrations of the social whirl, while within reach of their destination, the chapel of the Holy Angels in the church of Saint-Sulpice, he worked away at his last grand murals. To Joséphine he confided his anxieties over the coming upheaval. 'The phantom of the move that is to become a reality appears before me. You understand how complicated it is for me, because of my pictures and my drawings . . . Come back then to give me courage.'[7] She was also his first caller at his new address at the start of the New Year. 'Dear friend, I was very sadly disappointed to see your card yesterday [January 1] . . . I was so brusquely installed that I had not managed to get a workman to put in a bell, so that, as the apartment is sizeable, when nobody is by the door, you cannot hear anyone knock.'[8] He asked her to call another time and promised her that she would love the air of faubourg Saint-Germain. She did come, if only just before his death, just as he still called at the house in rue de la Rochefoucauld, but the easy comings and goings of the previous ten years were over. They still loved each other, but they were not any more in love.

The new distance between them suited them both. Because they continued to write, they kept up with each other's news. In July 1858 Delacroix went to take the waters at Plombières in eastern France at the same time as the emperor. He did not realise that the emperor was having a series of secret meetings with an envoy of the prime minister of Piedmont, meetings which would lead the very next year to French intervention in Italy and thus, by a circuitous route, to the unification of Italy. He was intent on enjoying a private joke with Joséphine. One day he met his former friend Cuvillier-Fleury, who had been her lover and the father of her daughter before Delacroix had supplanted him in her affections and her bed. Late in life Cuvillier-Fleury had married and at Plombières Delacroix had met him with his wife and his legitimate daughter. Unfortunately Delacroix's throat trouble had curtailed the conversation, especially as it occurred out of doors. 'The poor man looks as bad as I do and, besides, he has a still quite young wife who's attractive enough to keep him awake when he wants to rest.'[9]

Back home, he was soon in his beloved Champrosay and eager to tell her that he had bought his little house there, the only property he ever owned. By then he was regretting that he had spent the boring month in Plombières. He would have done better to have stayed in his own village. There he could see his friends when he wanted to and be alone when he wanted to be. He liked the combination of solitude and society, his health was better in the countryside

and he appreciated the deep tranquillity he could find there.[10] He was soon writing to tell her proudly about the building projects that now preoccupied a property-holder.

Health had become, next to his work, his major obsession. He could go out only for the short walk to the Institute, he had not been able to see her because he had problems with his stomach, he had unwisely gone out to dinner and so he had brought back his cold, he was having bouts of gout and rheumatism and he was always having trouble with his throat. When he felt better he was back to the studio or he was off to the chapel of the Holy Angels or he was off on his travels. He would write to her from Strasbourg, where he had gone to see cousin Lamey, he would write to her from Augerville where he was with cousin Berryer, he would write to her from Dieppe where he had gone to be near Valmont without seeing cousin Bornot and he would tell her that in Champagne, where he had been staying with cousin Delacroix, he had discovered that he had many many cousins called Delacroix to the umteenth degree whose existence he had never heard of before. She was the only cousin, however, whom he ever called his '*chère amie*'.

Did they still pause to wonder why they had never married? Had they done so, they would not have been the only nineteenth century couple who were lovers before they were man and wife. Long ago, in 1820, he had advised Pierret to marry the mother of his son; and in the Impressionist circle such behaviour was to become normal. But Cuvillier-Fleury, by whom Joséphine had had a daughter, had been discarded for Delacroix; and she and Delacroix had avoided having children. It is hard to imagine that in the years 1834–44 they had not thought about their relationship often. It was then that she had given up Cuvillier-Fleury and had lost her husband, and that he had given up Eugénie Dalton and flirted vainly with Elise Boulanger. They became free to be together, free to live for one another, yet both chose to keep their freedom for themselves; and after a decade it had become a habit. Delacroix might care for her sons, particularly his own namesake. She might admire his art and his writing. He was not too detached to relish the advantages of an aristocratic connection, nor was she foolish enough to deny the attractions of having a man so cultivated, so distinguished and so charming as a lover. They would have made an elegant couple, but probably neither was quite generous enough to devote their selves to the other. She demanded entertainment, while he wanted to work. She lived for Paris: he sought refuge away from the city. She presumed that she had a position in the world that she had merely to maintain. He, on the other hand, sought status as an 'immortal' academician so as to be recognised as truly one of the great masters.

The biographer can never be sure, since by her instructions to her executors

Joséphine destroyed the evidence which would have elucidated Delacroix's inner feelings about her during the critical decade. By the time it had ended he had begun to move away from the possibility of a joint existence by finding his country refuge in Champrosay; and her move to rue de la Rochefoucauld, though it made her live near him, had the same effect. Their lives were in essence separate long before he decided to return to the left bank. In such conditions what they could preserve was a sentimental friendship, an *amitié amoureuse*. Delacroix, who had been sexually promiscuous in his youth, turned in middle and old age into an attentive friend to women and a man who himself readily attracted female sympathy; and in no case was this truer than in that of his relationship with Joséphine de Forget.

They had many interests to share. There was music, there were books, there were flowers. In the early part of 1847 alone, they went together to performances of Rossini's *Robert Bruce* and of Bellini's *I Puritani* and an evening when they heard extracts from Cimarosa's *Secret Marriage*, Verdi's *Nabucco* and Rossini's *Otello*.[11] It was the golden age of *bel canto* operas and Delacroix loved them as much as he loathed early Verdi.

He showed the same fastidious taste for graceful art in literature. Lovingly she copied out for him long passages from his favourite Voltaire. She had a taste for the two untidy novelists of the age who rambled all over the social life of the times. She sent him a copy of Balzac's *Cousine Bette* – he found its remorseless analysis of the betrayal of family values tough to take – and she advised him: 'Read the memoirs of Dickens, or of Thomas Coperfill (it's the same thing), you will, I think, be charmed by them.'[12] He recommended Dumas for a good read, but not from a sense of critical approval. Just as he loved purity of sound, so he loved the precise use of language.

George Sand liked to think that it was she who taught Delacroix to love flowers. Joséphine de Forget might have claimed with equal justice that it was she who first aroused his enthusiasm. She was quick to make recommendations for his garden in Champrosay; and he would send her flowers for the feast of Saint Joseph and he would admire her flowers in the garden in rue de la Rochefoucauld. He counted himself luckier than her, however, since he had at Champrosay fresh air and peace. A note for 1857 shows what kinds he wanted his gardener to plant: hollyhocks, syringas, lilies, zinnias, honeysuckle, nasturtiums, heliotropes, hyacinths, narcissi, tulips, buttercups, Marvels of Peru. He had the delight of a great colourist in the profusion of nature. As an artist he never became as enamoured of flowers as Manet or Monet or a specialist like Fantin-Latour. It was, however, a symbol of his response to the feminine principle in creation that he should associate with his dear friend the love of flowers.

The last time she came to see him, he was too weak to receive her. By way of thanks he penned a short note. 'I do not need to tell you, dear friend, how charmed I have been with your flowers.' He added a postscript: 'Thank you for the books.'[13]

That note was written in July 1863. Delacroix died on 13 August and was buried in the cemetery of Père Lachaise. Joséphine lived on till 13 October 1886, when she left her two Delacroix paintings to the princesse de La Tour d'Auvergne. She was buried in the same cemetery as her former lover, alongside her father and her mother, whose marriage had been happy, if it ever had been, only in the reign of Napoleon I, before that moment when the young Joséphine had helped her father escape from prison. Joséphine de Forget and Eugène Delacroix had lived and died within the confines of a small, Bonapartist world.

— 15 —

A new revolution and a new Napoleon (1848–57)

IGHTEEN FORTY EIGHT was the year of revolutions. Not only did the king of France and the emperor of Austria abdicate but the Pope and princes and grand dukes hurried away into exile; agitated crowds gathered in capital cities, and there were national liberal assemblies in Palermo and in Naples, in Vienna, in Pest and in Frankfurt, while the flags of new or old republics fluttered in Paris and in Venice and in Rome. By 1852 at the latest almost all the old régimes were back. In France, the home of revolution, the Second Republic had given way to the Second Empire.

For Delacroix 1848 was an irritating year, because it was the year for which he lost his diary in a hackney-coach. He had lost his youthful commitment to politics. He was not so concerned with political systems as either George Sand or Joséphine de Forget. George Sand was a sentimental socialist who wanted to do something for the people. Joséphine de Forget opened her Paris home to her cousin Louis-Napoleon Bonaparte, when he came back to France; and her social distinction was confirmed when he became first president of the Republic and then Emperor.

Delacroix found it no problem to keep on cordial terms with both his lady friends. In March 1848, after the first gusts of change had blown Louis-Philippe away across the Channel, he told George Sand that the people of Paris had lived fifty years in a few days. He was relieved that the city was calm again, for he was preparing for the Salon; and the muses 'are friends of peace'.[1] Two months later he was telling her that 'your friend' Rousseau quoted with approval the saying 'I prefer dangerous liberty to servile tranquillity', only to add with a shrug: 'I have come to the opposite opinion in holding that this liberty snatched by warlike blows is not true liberty, which consists of coming and going in peace,

reflecting and above all dining at usual times and having lots of other advantages which political agitation makes no allowance for.'[2] He begged pardon for his reactionary thoughts and asked her to love him in spite of his mistrust of his fellow men.

He did not feel what an artist of revolution ought to have felt. At the first sign of violence, in February 1848, Louis-Philippe had left and for a time republicans and socialists had the upper hand. In May the violence in Paris mounted, the Assembly was invaded by a mob and severe reprisals were taken against the invaders and their friends. Early in June Delacroix was at Champrosay when he wrote to Joséphine de Forget in rue Matignon to let her know how depressed he was by the terrible news from the capital which he had read in the papers. In Champrosay bourgeois and peasants had taken joint action to arrest any of those passing through the countryside who had come from the notorious Parisian district of faubourg Saint-Antoine. 'False reformers' are 'so clever at criticising and so feeble when it is time to act. . . . This unhappy nation [of ours will have] to save itself and at the same time save the unworthy men who have made themselves its leaders. . . . Don't worry any more about me . . . everything is calm for the moment. . . . I'll soon come to hold you tight, content to be with you again after these dreadful ordeals.'[3]

By August, when he next wrote to her (once more from Champrosay), he was more relaxed. He was working hard, up to seven or eight hours a day, writing his article for the *Revue des deux mondes* on the Napoleonic master Baron Gros. There was no news and he wanted to read Thiers's refutation of the arguments of Proud'hon.[4] A far more important Left-wing thinker than Proud'hon had published *The Communist Manifesto* as recently as February 1848, but there is no indication that Delacroix ever knew of the existence of Karl Marx; and his hatred of Socialist ideas was focused on Proud'hon, who had dared to maintain the case for free credit for all. In one sense Delacroix was right to concern himself with Proud'hon, for he is more important than Marx in art history if only because there is a fine Realist portrait of him with his two little girls by his friend Gustave Courbet. Bespectacled, bearded and dressed in his farmer's smock, looking out at the spectator with kindly eyes while he prepares to write, he has the air of a secular saint (being already dead, he was ripe for canonisation). Delacroix disapproved not only of him. The following month he turned his attention to possibly the foremost among Socialist politicians, Louis Blanc, who was under attack for having been involved in the May riots. Louis Blanc had tried to set up national workshops to cope with unemployment, but as far as Delacroix was concerned 'the Communist gentlemen find work disagreeable'. Before politics he placed art and love. Just as he had told the sculptor Préault that 'we fight for our *patrie*'[5] and explained that he meant the

'country' of Titian and Rubens, so he insisted to Joséphine: 'you are my Republic and I vote for you'. He wanted to forget about politics and never hear the names of Louis Blanc or Proud'hon and go back to the Austria of the *ancient régime* where discussion of such matters was forbidden on pain of death.[6] When Louis-Napoleon took his seat in the new Assembly, Delacroix was glad that the prince's arrival there had caused no disorder.[7] No letter survives which shows how he reacted to Louis-Napoleon's speedy elevation to the office of president, but there is every reason to believe that, in so far as he noticed it, the news satisfied Delacroix because he was happy that Joséphine's cousin had become the head of State. Louis-Napoleon had provided her with some pleasant distraction.

The attitude of Delacroix to the events of 1848 had shown scant enthusiasm for the ideals of his own *Liberty on the barricades*, that most famous evocation of France's previous revolutionary year, 1830. He had had no special love for the rule of the one and only king of the French, but in 1847 his diary shows that he had courted Guizot,[8] the principal minister in Louis-Philippe's government, as well as his friend Thiers, who hoped to replace Guizot and did so only when it was too late to save the throne. Briefly he may have been thinking of painting an *Equality on the Barricades*, but he never carried through the scheme. For a time he was involved in artistic politics and attached his signature to a petition for more democracy in the assignment of State commissions. The idea got nowhere; and the first ever democratic election for a president anywhere in Europe gave France no lay radical as its leader, but a Bonaparte whose first government would be Catholic and conservative and who would despatch troops to put the Pope back in Rome. Delacroix made no recorded comment. He had no illusions about the illusion of the epoch, the notion of irresistible human improvement. When Baudelaire revealed his Left-wing sympathies in February 1849, Delacroix's comments in his diary were caustic. 'Monsieur Baudelaire came. . . . He told me of the problems Daumier has in finishing [his illustrations]. He leapt to the subject of Proud'hon whom he admires and whom he says is the idol of the people. His views seem to me the most modern and utterly progressive.'[9] Delacroix was in a sad mood and did not know how to banish his bitter thoughts. He consoled himself by retreating to Champrosay, by painting flowers and by writing to his *consolatrice*. Joséphine was busy with ideas for his future status. He tried out other ideas. For much of 1848 and even into 1849 he was concerned with attempts to bring *Liberty leading the People* back into the consciousness of the people at a profit to its author; and while he had no time for Louis Blanc, he began to pay attention to his brother Charles, who was a critic, editor, engraver and now from 1848 to 1852 Director of the Beaux-Arts. It was Charles Blanc whom he thanked in 1849 for the commission to paint a chapel in

the church of Saint-Sulpice.[10] Rulers had gone and come. He would be back working at his beloved walls.

A more prominent task in art soon came his way, when in 1850 he was asked to decorate part of the ceiling in the Galerie d'Apollon in the Louvre. He temporarily abandoned his church walls. In 1852 he was invited to paint the ceiling of the Salon de la Paix in the Hôtel de Ville and his church walls were forgotten again. By then he had realised that his vocation was not to be an artistic autocrat. In the reign of Louis XIV the great Le Brun had managed the Gobelins and had been the Director of the Academy of Painting while taking responsibility for the décor of Versailles and the Louvre. In the mid-nineteenth century, even when in 1851 by a *coup d'état* the Prince-President Louis-Napoleon was transformed into a dictator and in 1852 by proclamation into Emperor Napoleon III, France was no longer an absolute monarchy; and Delacroix was too much of an individualist to take on the public position of a Le Brun. As a mural painter, however, he would be a more than adequate successor of Le Brun, as the last and perhaps the best of all France's public painters.

His diary contains no contemporary references to the *coup d'état* or the proclamation, which both occurred on 2 December. One letter of December 1851 notes that recent political events may hold up elections to the Academy[11] and soon after he wrote to congratulate his old flame Madame Cavé (the former Elise Boulanger) on the appointment of her husband to be Director of the Tuileries Palace, an obvious reward it seems for having lost the control of the Beaux-Arts in 1848. He hoped it would be a medicine to Monsieur Cavé, who he knew was seriously ill (he died soon afterwards).[12] George Sand came to Paris early in 1852 and he was sorry to have missed her, but he did not mention that the reason why she had come to Paris was to intercede for those who had been arbitrarily arrested during the coup.[13] His first letter to her after the proclamation made no mention of national affairs, but promised her that she would soon receive a scene from her novel *Lélia*. 'The sight of a letter from you is always a ray of sunshine.'[14] His last advice to her that year was the same he had given Elise Cavé when her husband had died.[15] Work. 'As long as the eyes can see and the hand hold a pen or a brush, the great enemies, boredom and depression, are held in check. With that you need a little money and a little health and perhaps not too much of either or the beast in us dominates the rational part. My beast is quite well behaved at present because my little bit of reason and spirit is satisfied.'[16]

During France's next period of revolution, when the Second Empire collapsed and in Paris a Socialist Commune took over in 1870–71, the Hôtel de Ville was burnt down and Delacroix's paintings were destroyed. The visitor to the Louvre

may have better luck. On the ceiling of the Galerie d'Apollon is Delacroix's *Apollo, conqueror of the Python*. At the top of the picture, while driving his prancing horses across the sky, Apollo stands up in his chariot to shoot his arrows far below at the furious bleeding snake who writhes with pain amid waters that have gone eerily calm. Other Olympian divinities join him in his fight against monsters to bring back order to the chaos of the world beneath them. As the primeval flood recedes, the corpses of men and animals are revealed.

From his detailed notes on colour it is clear that Delacroix used subtle combinations of Prussian blue and vermilion and white in the shadows, and that he put Naples yellow in the clouds and burnt sienna and yellow lake in the shadow of Apollo's golden chariot.[17] But it was not his great range of colours that pleased him most. 'The way the dead bodies in the picture of the *Python* are done, that's my true way of doing things, it shows my natural inclination. They were not done from nature, and the sense of freedom in the painting then came from not using models. Remember this characteristic difference between this part of my picture and the other parts.'[18]

It was not just his passionate handling of flaming paints that made Delacroix outside the current fashion: it was also his lack of literalism. It was this quality in his art which Baudelaire above all other critics understood, whatever his political misunderstandings of the master. Delacroix did not think as much about the contemporary world as about the eternal world which myth tried to express. A sound knowledge of the classics gave access to tales which his contemporaries knew, but he was not interested in using the classical stories to provide excuses to paint titillating nudes or to appeal to pedants by showing he knew correct antique costume. He did not use classical settings to satirise contemporary behaviour, as when Couture painted *The Romans of the decadence* to show what he thought of the rich in the last years of Louis-Philippe. Still less did he make fun of classical pretensions, as Daumier did. He saw the classics as classic, as the European expression of what is permanent in human life. He did not need to be reminded that human life is fleeting. He was only too aware of the fact.

The artists of 1848 had a different point of view, with which for a time Baudelaire also sympathised (and that is why he seemed tedious to Delacroix with his admiration for Proud'hon). One of the best technicians among the younger artists was Meissonier, who was a young captain of artillery when the National Guard took the barricade in rue de la Mortellerie in the bloody suppression of a Left-wing uprising in June 1848. With his own eyes he saw the horror of the moment when he confronted a pile of corpses slumped together in the road. A year later Meissonier had an oil painting of the scene ready for the

Salon, only to withdraw it. (It was finally exhibited two years later.) Perhaps the gore was too fresh in public memory to be palatable for refined tastes. In June 1848 Delacroix was in Champrosay and he missed the worst carnage of the revolution. Back in Paris, he came to know and admire Meissonier's work and the grateful painter gave him his watercolour sketch. Meissonier was a fellow supporter of order under the Republic and of Napoleon III under the Second Empire. In his art, however, Delacroix sensed a concern with humane values which he could share. Like Salvador Dali in more recent times, he thought highly of Meissonier's skill. He dined with him occasionally and excepted him at the Great Exhibition of 1855 from his generally low opinion of the modern French School.

Meissonier's painting was a piece of artistic journalism. As a journalistic painter he lacked the gift for inventive caricature of the middle-aged Republican Honoré Daumier. Other young artists touched on deeper levels of experience. One of them, Jean-François Millet, moved on from the depiction of famous moments from classical legend to a brief concern with the politics of the day before finding his true subject: traditional peasant life. He saw the everyday activities of sowing and digging and gleaning and harvesting as perennial. When he boasted to Delacroix that he studied nothing but the Bible and Michelangelo, Delacroix felt that remark accounted for the pretentiousness of his art.[19] Millet's lumpy forms are drawn with a tender loving care which he did not often show his ill-educated neighbours in the forest of Fontainebleau; and did Delacroix miss the delicate pastel shades which he placed at the back of his pictures behind the powerful earthy colours he used on his subjects?

Delacroix attended much more closely to another of the younger artists, Gustave Courbet, for Courbet had or told everyone he had a whole philosophy of life and art as the quintessential Realist. He eventually shared a patron with Delacroix, for both painted masterpieces for the fastidious collector Alfred Bruyas. Courbet first came to prominence in the Salon of 1848, where by chance Ingres and Delacroix met in front of one of his exhibits. 'There's an innovator for you,' said Delacroix. Ingres remarked with some reserve, 'The fellow had an eye.' Ingres saw that Courbet was artistic: Delacroix found his work a challenge.

Delacroix had the chance to work out his considered reaction to Courbet when Courbet showed his pictures in the Pavillon du Réalisme set up beside the official 1855 exhibition. He spent an hour and a half there one August day, unable to take his eyes off the gigantic painting of *The studio*, which convinced Delacroix that Courbet had made enormous progress. In his earlier huge picture, *Funeral at Ornans*, there had been superb details but the composition was badly arranged, so that the figures of the mourners seemed to be on top of one another.[20] Now Courbet had achieved a much greater sense of ease and

atmosphere; and parts of the work, especially the central nude, were superb. Delacroix had not always liked Courbet's women. He had heartily disliked the vulgar rump half naked in *The Bathers.*

Nor was Courbet always good at harmonising the accessories – in this case the landscape – with the main subject – in this case the bare-backed and broad-bottomed woman and the woman beside her just starting to undress.[21]

It was Courbet more than any other artist who forced Delacroix as well as Baudelaire, Courbet's one-time friend and admirer, to work out a response to Realism. The Realists were not just artists whose subjects were modern and whose eyes were trained by photographs. They were in politics men of the Left. For Baudelaire an addiction to Proud'hon, which had such an unhappy effect during one conversation with Delacroix, was but a passing phase. The involvement of Courbet with him lasted till his mentor's death. Such a passionate concern with politics had become beyond the comprehension of Delacroix. It was in beauty that he found such salvation as mankind could have. 'Oh Rossini, oh Mozart, oh inspired geniuses in all the arts, who draw out of things only what must be shown to the mind! What would you say confronted with these pictures?'[22]

That other people were preoccupied with political action had advantages for Delacroix. In the course of 1851 he was made a municipal councillor in Paris and kept his post undisturbed by the *coup d'état.* He was given the agreeable job of giving advice on the restoration of certain churches. The coup involved not only some deaths but also a large number of arrests and deportations. One of those driven into exile had been Thiers. As long ago as 1849 Delacroix had noticed that Thiers treated him coldly; and even though Thiers' exile lasted only a short time, their relations were never as cordial as in the days of old Louis-Philippe. Delacroix got to know the new men, the emperor's half-brother the comte de Morny, his cousin Prince Napoleon and the brilliant financier Achille Fould. He was a habitué of receptions at the Tuileries and he dispensed tickets for balls at the Hôtel de Ville.

Of all the servants of the Second Empire none was more remarkable than Georges Eugène Haussmann, who was appointed the prefect of the department of the Seine in June 1853. Grandson of a Napoleonic general on the staff of Prince Eugène de Beauharnais, who had been also served by several members of the painter's family, Haussmann came from the same class of military men and bureaucrats as Delacroix. Like Delacroix, he believed in working on the grand scale. He too had the ability to make dreams come true, in this case the dreams of

Napoleon III, who in prison had wanted to be a second Augustus 'because Augustus ... made Rome a city of marble.'[23]

Despite the buildings of the Bourbons and Napoleon I, Paris in 1850 was still basically a medieval city, with winding streets and crowded tenements on either side of an open sewer, the Seine. The Paris which was transformed by Napoleon III and Haussmann became the city of broad boulevards and grand apartments, of gardens, parks and *bois* above an elaborate system of water pipes and drains, all of which stayed almost unchanged till relatively recently.

The work of clearance had begun tentatively under the Second Republic. It was, however, the arrival of Haussmann which turned much of Paris into a permanent building site. Delacroix passed the last ten years of his life surrounded by evidence of constant change and he died more than ten years before the new Opera House was finished. He knew Baltard, the architect of Paris, and Visconti, the architect who proposed the junction of the Tuileries and Louvre palaces, and Viollet-le-Duc, the architect who restored Notre-Dame, and Hittorf, the architect who was responsible for the work on place de la Concorde, the Champs Elysées, place de l'Etoile and the Bois de Boulogne. He liked them personally, but showed only slight enthusiasm for much of what they achieved.

In December 1853 he and Pierret were walking back from dinner at cousin Riesener's in rue Bayard, just off the Champs Elysées. Under the clear, moonlit sky it was bitterly cold and Delacroix felt that his friendship with Pierret had turned icy too. Pierret gave him an account of the magnificent plans for the area. Trees would be cut down to make way for English lawns, the balustrades in the *place* had gone already and the obelisk was to go somewhere else. 'Man, who is so ephemeral, simply has to leave this earth so as not to witness the passing of everything contemporary with the split second of his own existence.'[24] He even sneered at the 'idiotic' ideas for the Bois de Boulogne. The older he got, the fonder he became of old Paris, the Paris of his youth; and it is possible to see his decision in 1857 to move back to a quiet corner of the Left Bank as in part a sentimental move. Walking through his beloved city filled him with melancholy. His relations with Haussmann never went beyond correctness. When he politely apologised for not being able to come to a meeting, Haussmann tersely scribbled one word: '*Vu*'.[25] There was no gracious reply. When he invited Haussmann to come and see his pictures, there was no response. But he would do what he was asked. He would sit on a commission to discuss the enlargement of the city boundaries and he would sit on the commission to plan the 1855 exhibition.

In 1851 the British had put on the Great Exhibition, the first display of modern technical achievement to be truly international. For the French, who had pioneered the idea of national industrial exhibitions as long ago as 1798, the year Delacroix had been born, and who had often talked of going international, it was humiliating. Their reply was the exhibition of 1855.

The project was first announced in 1853. Like the London exhibition, the Paris one would include the arts as well as the sciences; and so it was that Delacroix was one of five artists who were nominated to be members of the thirty-seven-strong Imperial Commission to plan the organisation. Prince Napoleon was made President of the whole Exhibition, the comte de Morny was President of the Fine Arts Section, Achille Fould as Minister of State was ultimately responsible for the direction of the Arts in France, the comte de Nieuwerkerke was the most powerful figure in the realm of the Arts as Director-general of museums, Intendant des Beaux-Arts de l'Empereur, President of the Admissions Jury and Vice-President of the Awards Jury of the Exhibition, and finally Mercey was the leading civil servant to help run the Exhibition. All five were important to Delacroix. Their names recur in the pages of his *Journal* and his correspondence. Mercey was sympathetic and efficient, Nieuwerkerke was ambitious, overbearing and ruthless and Fould lived in a luxury which Delacroix refused to envy. It was, however, the views of the members of the imperial family which mattered most. Prince Napoleon, supported by Ingres, another member of the commission, wished to confine the exhibition to the artists of the recent past. Mérimée, supported by Delacroix, insisted that the artists should have been living at least as recently as 1853; and their argument, backed by the comte de Morny, prevailed. The disagreement between the prince and the count was not just a family quarrel between the emperor's cousin and his half-brother. The prince's taste was rigidly Neo-Classical: the count had pictures of every school except that of David. In gaining his victory, Morny had gained a victory for variety; and if variety was the salient feature of the modern French school, then Delacroix was an artist not so much opposed to Ingres as complementary to him.

Another idea of Morny's brought Delacroix to even greater prominence. He suggested that the leading artists should be allowed to have retrospective shows of their own. Two masters, Ingres and Vernet, were granted galleries of their own, Décamps was lured only with a special letter from Nieuwerkerke, but Delacroix was delighted at the opportunity to show off his *œuvre*. Typically he became more pessimistic as he met the practical diffulties of getting the pictures which he wanted. To have *Liberty Leading the People*, he had to appeal via Nieuwerkerke to the emperor himself. He got his way. In the end he was able to give a good sense of what he had done by putting together thirty-five of his

masterpieces, piled on top of one another in the manner of the day. The pictures which had first made his name in the 1820s were there: *The Barque of Dante* and *Scenes from the Chios Massacres* but not *The Death of Sardanapalus*. There were some scenes from Shakespeare and Goethe and Scott and Byron as well as scenes from the Bible and the classics. There were scenes from French medieval and modern history. *The Women of Algiers* and *The Jewish Wedding* were the most famous of the North African pictures. One lion attacked an Arab and another a goat and there was a *Lion Hunt* painted specially for the occasion. He was solemn when representing Justinian drafting his laws and delicate when depicting flowers. Nobody else anywhere in the Palais des Beaux-Arts had his diversity, his grandeur or his strength of feeling. As the official critic, Théophile Gautier, stressed, he had been traduced for a quarter of a century and yet 'never has an artist more fiery, more savage, more passionate, depicted the anxieties and aspirations of our period'.[26] Prince Napoleon made clear that Delacroix, who was popularly considered revolutionary, was more accurately Delacroix the colourist. As far as the régime was concerned, he was a genius who was also safe.

When it came to the prizes, there could be no doubt that Delacroix would be bound to obtain a Grand Medal of Honour along with Ingres, Horace Vernet, Décamps, Meissonnier (principally because Prince Albert liked him) and some foreigners, such as Landseer. Delacroix was told by Vernet that Ingres was so appalled when he learnt that he had had less votes than Vernet himself that he was thinking of declining his medal. The prince found the solution. Only Ingres would be given the rank of Grand Officier de la Légion d'Honneur, while Delacroix would be a Commandeur, a rank which Vernet already had. Vernet was angry, but Delacroix was pleased. He had the status of a great man.

More was involved in the 1855 Exhibition than the high politics of French art. It was also a chance to demonstrate to the world and above all to Britain that under its new emperor France was a centre of world civilisation as well as a great power. In the early 1850s the British had viewed with alarm the return of a Napoleon to the French throne. By the mid-1850s France was a firm ally of Britain in the Crimean war to protect Turkey against Russia; and the emperor, now safely married, used his famous way with the ladies to beguile Queen Victoria into being an enthusiast for the entente. In April 1855 he and Empress Eugénie visited England. After a reception at Windsor Castle in the Waterloo Chamber – tactfully renamed the Picture Gallery – the Queen noted with approval the perfect courtesy of the young empress. It was, however, the emperor who captivated her. He is, she wrote, 'endowed with a wonderful *self-control, great calmness,* even *gentleness* and with a power of *fascination,* the effect

of which upon those who become intimately acquainted with him is most sensibly felt'.[27] If she felt that she had been unguarded in succumbing to the charms of a middle-aged roué, she may have been relieved to notice that Prince Albert was much taken with the beautiful Eugénie. Their return visit to Paris would be a great success.

Delacroix had been enough of a *personnage* to have been invited to the celebration of the emperor's marriage in January 1853 – he had been irritated that the occasion had held up his work in the Hôtel de Ville – but he had been too unwell to go. Now he would be asked to help entertain the English. That summer Paris had gone Anglophile. The *maire* invited the Lord Mayor and aldermen of London to visit Paris. By mistake Delacroix missed the ceremony in the morning and therefore did not have the chance to see the robes of the English dignitaries, which he learnt were well worth seeing. He had better luck in the evening. The banquet at the Hôtel de Ville under the sparkling chandeliers of the Salle des Fêtes was superb. Delacroix found himself sitting next to an Englishman and was mortified to find how much of his English he had forgotten. The words came to him with difficulty and he had to spend most of the meal in silence.[28] That year he was in a mood to appreciate all that was best in the English arts. A chance stroll in the Palais-Royal reminded him of his cherished Bonington;[29] and the sight of English pictures at the Exhibition reinforced his conviction of the special charm of the English school. In Leslie and Grant he found the successors to Wilkie and Hogarth and the light and elegant touch of Lawrence, and in Hunt's sheep and Millais's *Order of Release* he found far more promise than among the French 'primitives'.[30] There was also always Shakespeare. At the Théâtre Anglais he loved the performance of *Othello*, which gave him 'noble and complete pleasure', and he saw again the Anglo-American actor James William Wallack, whom he had applauded thirty years before in London playing the part of Faust.[31] During the summer heat he slipped out of Paris to stay at Champrosay and Augerville but in late August he came back to greet Queen Victoria.

She arrived on 18 August. Delacroix had to leave his cool chapel in Saint-Sulpice to go home at three o'clock. 'Not a carriage free! Paris has gone mad today. Everywhere you meet only groups of workmen and market women and girls all in white with banners jostling each other to give the Queen a good reception. In fact nobody saw anything because the Queen came at night.' He felt sorry for all the people who were there to give her a heartfelt welcome. The marquis de Pastoret invited him to watch the procession from his house.[32]

Delacroix is unfortunately silent about much of the nine days' visit – two days of his diary were torn out – as the emperor accomplished the emotional seduction of the queen. He was present at at least two receptions and may have

been present at more. Once the British royal couple were taken into his world when they went to see the sights at the Exhibition. Prince Albert was a man of taste, but the painter whom he admired was Meissonier; and so it was that *The Brawl* was given him by the emperor. The queen would later buy French paintings by artists she now knew, by Vernet and by Delaroche, but not by Delacroix.

On 23 August Delacroix was at the Hôtel de Ville for a civic ball for the queen. In the overwhelming heat he walked three times round the building to get hold of a glass of punch. He was so cold because he was bathed in sweat. Two evenings later he was at Versailles for a ball and fireworks in front of the Hall of Mirrors. He was on the look-out for Baron Gros's great canvas of *The Battle of Aboukir*. He was disappointed. He went home alone by the Saint-Cloud route in magnificent moonlight, recalling with pleasure those delectable models of the period of *Sardanapalus*. He was still susceptible to pretty women.[33]

Despite the sad death of the senile mother of Joséphine de Forget, 1855 was a splendid year for Delacroix. A sense of his own fame had for some time begun to buttress his self-esteem. In 1850 Jenny had lamented to him that he was unrecognised. She was sure he was a great man, but he did not live like a great man.[34] Very gradually, however, his work had started to sell well. His pictures disappeared into provincial museums as well as into the drawing rooms of his admirers. He began to be able to travel.

The Exhibition made clear to the French establishment that he was one of France's greatest painters. The only recognition denied him was recognition by the Institute. On 3 November 1856 he called in on Paul Delaroche, who was ill. Three days later he was present at the academician's funeral.[35] For an hour he stood at the church porch in the freezing weather till he was forced by the cold to go away before the service was finished.

Delaroche had been elected to the Institute in 1832, five years before Delacroix had first had even the temerity to apply. Delacroix's seven applications had all been rejected. Once he had found so little support that he had withdrawn his own candidature. It had been galling to watch as nonentity after nonentity was admitted to the ranks of France's leading contributors to the arts. But now that Delaroche was dead, he resolved to try yet one more time. In the depth of winter he felt so ill that he could not go out to make the customary courtesy calls. From his sick room he wrote a series of letters: to the President of the Academy, to Ingres and to Abel de Pujol and Heim, who both belonged to an alternative conservative tradition, and to Lefuel the architect and to Auber the composer, his friend, and to Clapisson, a forgotten musician who had just been

elected in preference to Berlioz.[36] The vote took place on 10 January 1857. He was elected without opposition. Probably the influence of the court had secured the decisive result. Ingres shuddered at the news. The enemy was inside the gate.

Delacroix was too feeble and perhaps too discreet to come to the Institute till the furore was over. When he made his first appearance in March, Ingres had the magnanimity to shake him by the hand. In the course of 1855 Delacroix had had second thoughts about his rival's art and had realised that at least the early pictures were works of great distinction. It is unlikely that Ingres ever came to so tolerant a view of the art of Delacroix, but he was not so stubborn as to fail to allow that there might be other muses on Mount Parnassus besides his own. As for Delacroix, he knew that he had found his rightful place, a seat among the immortals.

The fervour of a sceptic (1849–61)

L'INSTITUT de France is housed in one of the finest and most Italianate of French Baroque buildings. It was on the Left bank, just opposite the original square palais du Louvre, that Cardinal Mazarin commissioned Le Vau to build the Collège des Quatre Nations with a façade whose alternating convex and concave surfaces would recall façades he knew from Rome. The cardinal's name is commemorated in the narrow rue Mazarine which runs round the back of the Institute. The large building next to it on quai Malaquais is the Ecole des Beaux-Arts, put up in the lifetime of Delacroix in a dull Neo-Classical style. Between the two buildings the thin line of rue Bonaparte leads past place Saint-Germain-des-Prés and place Saint-Sulpice towards the gardens of the palais du Luxembourg. This charming part of the Latin quarter is bounded by the handiwork of Haussmann, who drove rue de Rennes and boulevard Saint-Michel up from boulevard Montparnasse to boulevard Saint-Germain in near parallel lines. But once rue de Rennes reached place Saint-Germain-des-Prés it mysteriously stopped. To the north lay an area of old Paris with little shops and quiet cafés and peaceful squares. In the days of Louis XIV the abbey of Saint-Germain-des-Prés had been famous for its learned monks. To Mazarin's Collège, which dated from the early years of Louis's personal rule, Napoleon had moved the Institute in 1806; and it was after him that nearby rue Bonaparte was named. It was wholly fitting that Delacroix, with his love for the culture of the *grand siècle* and his admiration for Napoleon, should pass his last years in this tranquil corner of the city.

The apartment he chose is to one side of place Furstenberg, just off rue Jacob, one of the more important side streets leading into rue Bonaparte. During the thirteen years he had lived in rue Notre-Dame-de-Lorette Delacroix had had an enormous studio. Before he moved into his final home he now had to arrange for a new studio to be built in his small garden. He showed all an invalid's

querulousness at the prospect of moving in the depths of the winter. Once there, however, he was happy. When required he could walk to the Institute. In the other direction he could walk to the church of Saint-Sulpice. His life had become compact.

Some seven years had elapsed since 1849 when Delacroix had first been offered the commission to paint part of the church of Saint-Sulpice. A great number of Paris churches were being decorated at this time. For Saint-Denis-du-Saint-Sacrement in the Marais, Delacroix himself had already done a *Pietà*. In Saint-Germain-des-Prés, now no longer a monastic church, and in several other Parisian churches Hippolyte Flandrin, a pupil of Ingres, was in charge. Under Napoleon III over one third of the State budget for the arts was spent on religious paintings. This was partly a consequence of the Concordat which the great Napoleon had made with the Pope, according to which the State had been given control of the financial needs of the Church in return for conceding to the Church its spiritual independence. It was partly deliberate government policy, for Napoleon III, like Napoleon I and Louis-Philippe before him, had found it politic to court Catholic opinion in France. A hint of generosity towards the Church might appease the pious: a question of art might not offend the unbelievers.

The church of Saint-Sulpice is the grandest church in the Latin quarter. Begun in the mid-seventeenth century, for some time in the charge of Le Vau but not finished for over a century, it had seemed to Gibbon 'one of the noblest structures in Paris'. Gauntly Classical, it became in the Revolution the Temple of Victory, but in the nineteenth century, as in the seventeenth, it was associated with the victories of faith rather than reason. It was the mother church of the society of Saint-Sulpice, which had been founded to raise the standard of clerical piety and instruction. At the time of the revolution the Sulpicians had refused to accept the revolutionary or 'constitutional' Church. Some were martyred, others took refuge in exile and the seminary which was their headquarters was shut. After Napoleon I had signed the Concordat, the seminary of Saint-Sulpice was reopened and gradually became the most celebrated centre in France for the training of parish priests.

At first there was some doubt as to which chapel would be Delacroix's concern, but on 2 October 1849 he agreed with Monsieur le curé that he should have the chapel of the Holy Angels. When he came to record this event, he noticed that the feast of the guardian angels had occurred that day.[1] 'I have to paint two large subjects facing one another in the chapel, as well as a ceiling and a number of ornaments.' Delacroix wrote to his painter friend Camille Dutilleux,

'One of the subjects is *Heliodorus being Driven from the Temple* and the other *Jacob Wrestling with the Angel* and finally the ceiling, *Saint Michael the Archangel Vanquishing the Demon*. As you see, in these various subjects I tread very close to certain impressive great masters. But religious subjects, among all the various attractions they offer, have the advantage of leaving one's imagination free rein, so that each artist can express his individual feeling in them.'[2] Dutilleux would have understood whom he meant by 'certain impressive great masters': probably Titian and Rubens and certainly Raphael, adored master of Ingres and his school. His imagination, however, would be free, his feelings his own and he would interpret the Bible in his own way.

Despite his involvement with committees and other commissions, Delacroix did not forget his chapel. He worked out his ideas in sketches in 1850, he took careful measurements of the ceiling and made notes on subjects for the pendentives in 1851, he roughed out the pendentives in 1852 and the ceiling in 1853. Desultory attention to the scheme came to an end only in the spring of 1854, when he wrote to Dutilleux: 'I plan at last to apply myself this summer to the work at Saint-Sulpice, which has always been put off because of rushed jobs like the Louvre ceiling and this recent one at the Hôtel de Ville.'[3] He had not forgotten his interest in church decoration. He had looked at Flandrin's murals at Saint-Germain-des-Prés and decided that they were 'Gothic smears' and 'fraudulent imitations'[4] – a pious critic would later say that Flandrin 'interprets ideas which he loves' – and he had gone to midnight Mass at Saint-Roch in rue Saint-Honoré on his way home from dinner with his friend Buloz. As his eyes glanced about at the various modern paintings he could observe their lack of the power to move the spectator. 'I do not know whether it was this crowd all packed in together or the lights or the solemnity of the scene that made the murals seem colder and more insipid than they usually do. How rare talent is! What effort is made to mess up a canvas and what wonderful opportunities religious subjects give. I was asking of all these paintings so painstakingly or even so skilfully worked by so many different artists of so many differing schools just a hint, just a glimmer of feeling and even profound emotion which I would have inserted almost in spite of myself.'[5] He went on to recall the way that on a solemn occasion a beautiful painting, such as a Prud'hon, even just a copy, would have affected him, especially while he listened to religious music. He himself had worked with redoubled enthusiasm when he had painted in Saint-Denis-du-Saint-Sacrement to the sound of the chanting of the offices of the Church and when he had painted *The Barque of Dante* while his Corsican friend Pietri had recited to him a canto from the *Commedia*. It was again the beauty of the sound that had inspired him.

At long last, in June 1854, once the walls had been primed, his favourite

collaborator, Pierre Andrieu, was able to begin.[6] The start was excellent[7] and he was soon writing that his heart beat faster now that he was back at his beloved walls.[8] In August he asked permission to work on Sundays to the sound of the music. Permission was refused him and he commented, perhaps with a conscious touch of irony: 'The Emperor, the Empress and Monseigneur conspire so that a poor painter like me cannot commit the sacrilege of giving free play on Sunday to the ideas he draws from his head to glorify the Lord.'[9] Concern with the 1855 Exhibition forced him to stop work for almost a whole year, but when he started work again the argument of the previous year seemed to have been forgotten. Because of the overpowering heat which attended the visit of the English royal couple to Paris he had to work in the early hours of the morning. Once he was in luck. On 30 August, 1855, there was a special office at eight o'clock in the morning and the music of the organ and the choir transported him. 'This music puts me in a state of exaltation favourable to painting.'[10] A year later friend Adolphe Moreau, a wealthy stockbroker and keen collector of his pictures, was able to see how far Delacroix had progressed. He admired the angel who swoops down to scourge Heliodorus and wrote that Delacroix attributed its success to the mental state induced by the playing of the *Dies Irae* on the organ.[11]

By then he needed more aid. Louis Boulangé, who had helped with the background of *The Justice of Trajan* and *The Entry of the Crusaders into Constantinople* had already been called in. Still progress was slow. Inevitably winter would cause an interruption. All through 1856 Delacroix had had a hectic social life, being present at soirées given by Prince Napoleon or the prefect, spending the weekend at Achille Fould's, calling in on Thiers or Mérimée, going to concerts and operas and plays, dining with Auber, having a series of meals with his old friend Louis Guillemardet, elder brother of his beloved Félix, entertaining his elderly cousin Lamey, travelling off to Champagne to visit the Delacroix cousins or to Augerville to stay with cousin Berryer or, back in Paris, going to the wedding of cousin Bornot's daughters and, as if none of this was enough, drawing up his will. During late August he took to solitude. 'I live the life of a monk and any day is like any other day. I work every day at Saint-Sulpice, except Sundays, and I see nobody.'[12]

In the end it proved too much and he became seriously ill. While he would have liked to be paying calls on those who might vote him into the Institute, he was compelled to sit up indoors working out his theory of art. Only on Tuesday, 17 March could he write in his diary: 'Yesterday I went out with Jenny for the first time. It was sunny. I gave up going towards place de l'Europe. The wind was coming from that direction. I walked down and came back by the roads, feeling tired, but this walk gave me some strength.'[13]

The illness had shaken him. It made him realise that he must simplify his life. He should preserve his returning health with greater care. He consulted Haro, his long-time *marchand de couleurs*, who lived in rue Bonaparte. As early as 1 April he was thinking of renting the apartment in rue Furstenberg, which Haro had found for him.[14] Once his mind was made up, it was Haro who supervised the construction of a studio – as always Delacroix was good at getting people to work for him – and on 28 December he moved.

A week before, in his bare studio in rue Notre-Dame-de-Lorette he had ruminated on the passage of the years. 'As soon as I got up, I quickly climbed the stairs, scarcely stopping to comb my hair. I stayed there till night-time, without passing one moment of emptiness or regret for missing the distractions which visits, or what one can call pleasures, can give. My ambition is enclosed within these walls. I have been spending the last moments still left to me in this place which has seen me for so many years and in which has been passed the greater part of the last period of my late youth. I speak in this way of myself, because, though at an advanced stage of life, my imagination and some quality I cannot define make me feel the spirit and energy and impulses I felt at the best time of life. . . . I cannot leave this humble place without strong feelings, for here I have been both sad and happy over so many years.'[15] On 28 December, however, when the move was over, he soon recovered. 'My apartment is decidedly charming. I felt a moment of sadness after dinner at the thought of the move. Little by little I am getting reconciled to it and I went to bed delighted. Woke up this morning and saw the most gracious sun on the houses in front of my window. The view of my little garden and the cheerful appearance of my studio give me continual feelings of pleasure.'[16]

The following day he walked to the Luxembourg gardens and he felt healed by the most beautiful weather possible. He had come home.

For the remaining three and a half years before the chapel was open Delacroix could only work in fits and starts. There were other preoccupations. In August 1858 he finally bought the modest house he had previously rented at Champrosay and the following year he showed at the Salon for the last time, but holidays and relaxation and writing and painting easel pictures were only diversions. Saint-Sulpice had become the mainspring of his life.

At his best he accomplished a lot in one day, as he noted on 11 September 1858, but the following day he simply wrote 'incapacity'.[17] Slowly it was becoming clear that the long task was nearly at an end. In 1850 he received an advance of 5,000 francs from the State and in 1860 the balance of 10,000 francs.

After holidays in Strasbourg with cousin Lamey and in Champagne with

cousin Delacroix and at Augerville with cousin Berryer he decided to work on through the winter of 1859–60. In March 1860 he got permission for Boulangé to work on the ornaments between the painting on the ceiling and the angels which frame the lower paintings. When he came to see what Boulangé had done, he was furious with his clumsy assistant. 'He had not understood a word of what I wanted.' When he got home, he was glad to see that his explosion had left him tired but not exhausted. It is understandable that next day Boulangé did not turn up, but Delacroix was very much put out and hurriedly wrote off to tell him exactly how he felt. This time his anger had the intended effect and Boulangé returned in a chastened mood, ready to paint alongside his master, who busied himself with the border of fruit that surrounds the *Saint Michael*.[18] By November 1860 he could claim triumphantly that only a few weeks' work remained[19] and he greeted the New Year with a paean of joy for all that painting meant to him.

> I began this year continuing my labours in the church as normal. I have paid no visits except by leaving cards, which scarcely put me out at all, and I have been working the whole day long. What a happy life! Heaven sent compensation for my so-called solitary state! Brothers, fathers, relations of every degree, friends living together quarrel and dislike one another more or less without saying anything but lies. Painting indeed harasses and torments me in thousands of ways, like the most exacting mistress. For four months I have been hurrying away at the earliest light and racing to this enchanting work, as if to the feet of the best loved mistress. What seemed from a long way off to be easy to cope with has presented me with dreadful, continuous difficulties. But how is it that this eternal combat, instead of crushing me, bears me up and, instead of depressing me, consoles me and preoccupies my time when I am no longer directly concerned with it? A happy compensation for the youth I have lost and a noble activity for the old age which presses in on me in so many ways, but which still leaves me enough strength to get over the sufferings of the body and the afflictions of the soul![20]

On 29 June Delacroix issued a formal invitation to view the paintings complete with a brief description of them. He invited Achille Fould and Haussmann from the world of public life. From the world of artistic patronage he invited Charles Blanc, who had granted him this commission twelve years before, and Thiers, who had secured commissions for him long ago, and from the world of the arts critics like Thoré and Gautier. He also invited those who had been close to him like Joséphine de Forget.[21] None of the important political figures appeared, but critics and friends were appreciative and appreciated. He

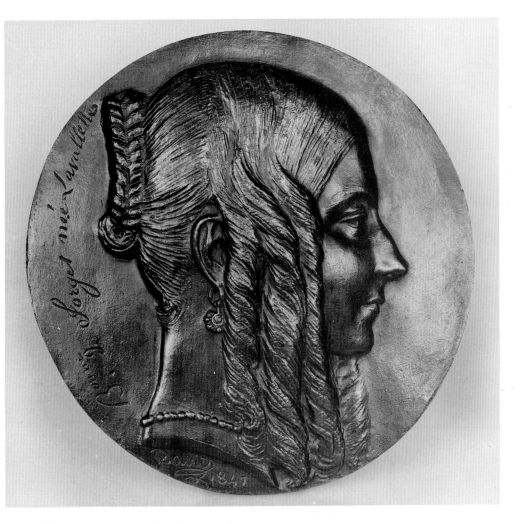

Josephine, baronne de Forget, by David d'Angers

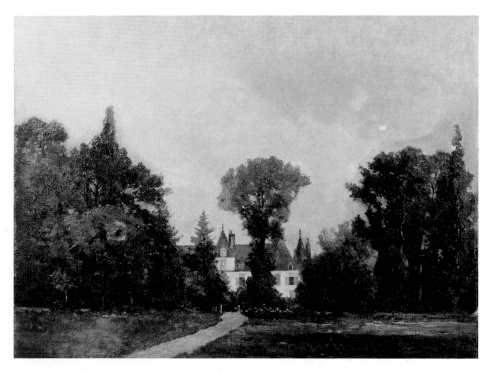

The château d'Augerville

Bacchus and the leopard

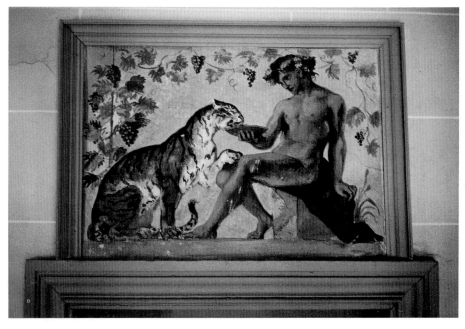

The education of Achilles

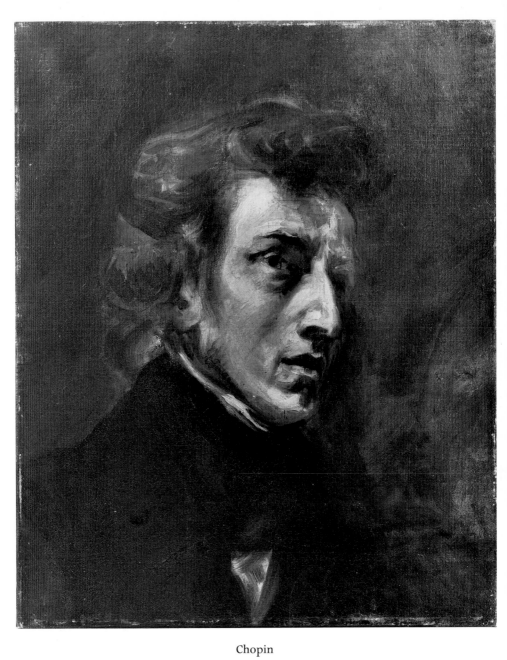

Chopin

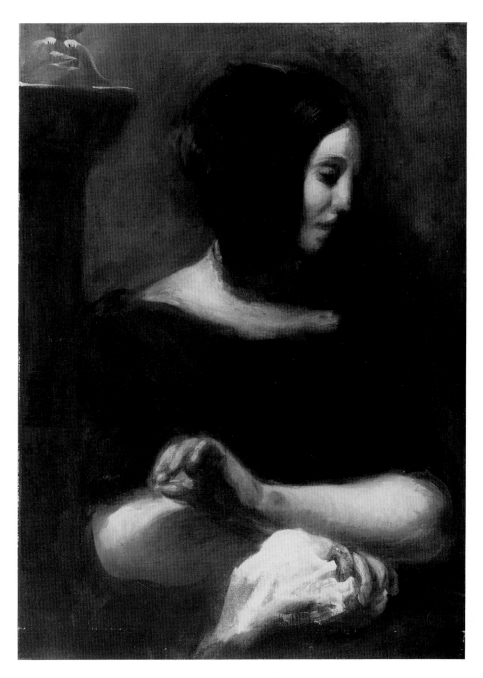

George Sand

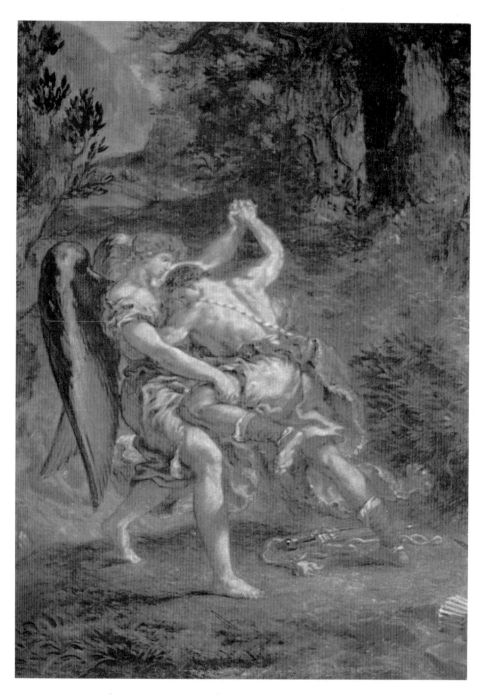

Jacob and the angel

Delacroix's house at Champrosay

The studio at place Furstenberg

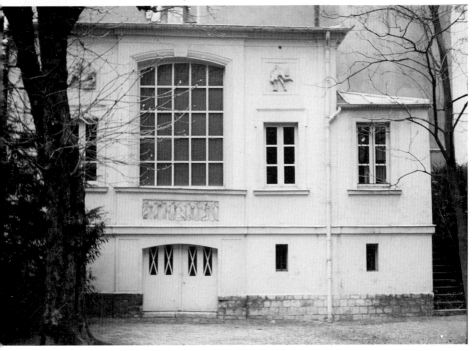

Delacroix en académicien,
1858, drawing by Heim

Delacroix's tomb in the
cemetery of Père Lachaise

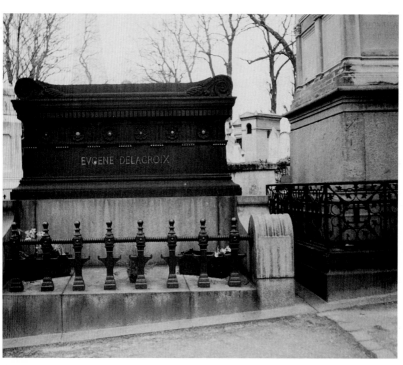

was less detached from other people than he had pretended to himself in his New Year meditation. He told Léon Riesener: 'On the whole I am pleased; I was assured by everybody that I am not yet dead.'[22]

Delacroix did not invite any cleric to the public showing and the Catholic press was hostile to his paintings.

When Delacroix was born, the Catholic church was no longer the religion of most Frenchmen. In the 1790s Robespierre had tried to substitute for the old faith the anaemic cult of the Supreme Being, but what had a far more lasting influence on France as a whole was the policy of dechristianisation which some revolutionary zealots had pursued with great effect in certain areas. In such areas there developed an ignorance and hatred of Christianity alongside the much older national tradition of anticlericalism. When Louis-Napoleon appealed in plebiscites beyond the politicians to the people of France, he never got many votes in such districts, whether in town or country.

Delacroix himself had not been baptised. In 1798 the Catholic church was proscribed and the only nominally Christian church was the official or 'constitutional' church which had been created by the State in 1791 and which was destroyed by the State in 1801. Delacroix's own father had been at one stage a fanatical dechristianiser and, even though Delacroix himself had been educated in a lycée where the Catholic religion, with a distinct Napoleonic flavour, was the belief served up to the pupils, he showed no signs as a young man of any interest in Christianity of any kind. When he began to paint, the Bourbons stood for the union of throne and altar, but Delacroix felt no loyalty to either. Some of his earliest paintings were of religious subjects, but though occasionally they were beautiful – he was rightly proud of *The Agony in the Garden*, which was shown in the Salon of 1827–8 and the Exhibition of 1855 – their appeal is largely aesthetic. High up where it is on the wall of the Baroque church of Saint-Paul-et-Saint-Louis, *The Agony in the Garden* is distinguished by the graceful movements of Jesus and three – why three? – attendant and very feminine angels. It is tranquil, even serene; the use of light and shadow is poetic; the russet-coloured robe of Jesus and the halo round his head are arresting. It is not frigid, like most of the religious pictures of Ingres, but it is also merely lyrical.

By the mid-1840s, when he painted his fine mural of the *pietà* for Saint-Denis-du-Saint-Sacrement, close to the church of the earlier painting, Delacroix was striking a profounder note. As Baudelaire would claim. 'This masterpiece digs a deep furrow of human melancholy.'[23] By then Delacroix was engrossed in his great scheme for the Palais Bourbon, where all the ennobling occupations of man

– science, philosophy, law, religion and poetry – are poised between barbarism and civilisation. The death of Jesus could be seen as typical of the tragic fate of mankind and the swooning Mary as an example of any mother desolate at the loss of her son. At this level Delacroix had achieved far greater insight into a traditional Christian theme.

By this time the lines were already well drawn which divided Christianity from unbelief. Atheism was rare. Christianity, however, belonged to the past and something had to be put in its place. There was a vogue for inventing new religions. Comte, an exact contemporary, preached a religion of humanity. The former priest Lamennais believed in a religion of 'the people' and converted George Sand to it. Some, like the once-fervent Catholic poet, Lamartine, rediscovered eighteenth-century Deism. Others, probably indebted to German higher thought, had a craze for explaining the dying of traditional religion as part of the scheme of universal history.

Delacroix put on canvas his own grand vision of the past in the Palais Bourbon. In so far as he had some knowledge of contemporary secular philosophy, it may have come from conversations with Victor Cousin, the most influential philosopher at the Sorbonne,[24] and it certainly came from conversations with a painter who had a mission, Paul Chenavard. Cousin he described as a 'poet who forced himself to be a man of learning':[25] Chenavard was prose incarnate. In 1848 the unknown Chenavard had united most of his fellow painters against him when the then Socialist government of the Second Republic invited him to decorate the interior of the Panthéon. Maybe he had been chosen because he could work out a programme. The only trouble would come from painting it – he was a dull artist. The *coup d'état* rescued the cause of the other painters as the Panthéon was quickly converted into a church again. Chenavard went on with his programmes. Delacroix knew something about them because he ran into Chenavard when on holiday in Dieppe. Finding in Delacroix a polite listener, Chenavard poured out to him a torrent of ideas.[26] Even had Delacroix nodded off from time to time on the promenade in 1854, he could see the ideas set out the following year in diagrammatic form in Théophile Silvestre's *Histoires des Artistes vivants*, which contained a life of himself as well as of Chenavard. On the wheel of life there had been progress up to the time of Jesus Christ, the zenith of human life. Then there had been a period up to A.D. 1400 – Chenavard's history was divisible into multiples of 700 years – when one religion had dominated. From 1400 to 2100 was the period of the apogee of the sciences. By 4200 it would be all over.

Chenavard may have appealed to Delacroix not just because he was an interesting companion for a few days beside the seaside, but also because he did not assume all human life was on an upward curve of inevitable progress and

that the nineteenth century was better than all previous ages. His dogmatic temperament, however, irritated Delacroix. Delacroix saw life in terms of nuances rather than of systems. To treatises he preferred the essay and to all other anticlerical writers he preferred Voltaire. He read Voltaire with pleasure all his life. He wrote in 1814 with respect of a school companion who loved Voltaire[27] and he was reflecting on Voltaire's observance of the principle of stylistic decorum just months before he died in 1863.[28] He carried extracts of Voltaire around with him on his travels. And yet there is no hint of Voltaire's antipathy to the Catholic church, nor any overt discussion of Voltaire's own religious beliefs. He was content to be Voltairean by instinct, a sceptic.

For people of his generation the Catholic church was less of a threat than a relic. He had grown up knowing the abbey of Valmont, but not monks; and he did not know that Dom Guéranger was introducing monks again into France. He was moved by eloquence in the theatre, yet never seems to have heard Lacordaire preaching to a rapt congregation in Notre-Dame. He knew something of the Catholic revival through his reading of Chateaubriand, but of the leading Catholics of his own generation he was almost completely ignorant. He lamented the division of Frenchmen into those who favoured the Jesuits and those who had supported the September massacres of royalists and Catholics in 1792. Though of course his sympathies were republican there was one royalist and Catholic who was part of his circle; and that was a friend and relation who was very dear to him, his distant cousin and persistent host, Antoine Berryer. Only through Berryer that he was able to learn that the Catholic faith was alive.

In May 1854 he was staying at Augerville when the bishop of Orléans came for a Mass of confirmation. The bishop, Monseigneur Dupanloup, was the most distinguished Christian apologist on the episcopal bench, an academician and one who was perceptive enough to remark of *Madame Bovary*, at a time when all *bienpensant* opinion was outraged with Flaubert, that it was an admirable book whose merit could be grasped only by one who, like himself, had heard confessions in the provinces for twenty years. Delacroix did not go to the Mass, but afterwards he regretted it. 'I like this bishop very much. I have a nature like wax. I am easily impressed by a spectacle or by the presence of somebody who has an air of importance. . . . I spoke about original sin in such a way as to give these gentlemen a grand idea of my beliefs.' Next day Berryer took Delacroix aside and told him about his own father's memories of Delacroix senior and how during the Revolution Delacroix senior had intervened to protect his father. Delacroix was flattered and touched. Afterwards, about ten o'clock, the bishop was met in procession. 'This ceremony moved me deeply.' As Berryer's parents were buried in the church, Delacroix thought of painting a *Saint Peter* for them, as Saint Peter was the patron both of the parish and of his father. 'This project

[which was never fulfilled] will fit perhaps my Catholic feelings of the moment.' After the ceremony and the bishop's sermon they went into the cemetery, where the tombs were blessed. 'Religion is beautiful in this way. The consolations and advice the bishop gave in the church to these simple folk, sunburnt from working in the countryside and bound to a life of harsh necessity, were truly helpful to them.' Before returning, the bishop blessed the children presented to him. Delacroix had been struck; and, when Monseigneur Dupanloup left, he commented: 'His reign was over.'[29]

Delacroix, for all his mask of detachment, was more impressionable than he liked to appear. In Dieppe that September he strayed into the church of St Jacques for a Mass that was sung by a choir from the Pyrenees. The singers all had excellent voices, but it was the small boys who had the greatest effect on him. 'In this naïve artist of eight or nine years there is something almost sacred. These pure voices raised up to God, from a body that is scarcely yet a body, and from a soul that has not yet been polluted, must be carried straight to the foot of his throne and speak to his all goodness of our feebleness and sad passions.'[30]

This could have been the sentimental reaction of a moment. Back in Augerville that autumn, he came closer to the heart of Christianity. On 2 November he attended the Mass of All Souls. He was very taken 'with all there is in religion for the imagination and at the same time the way it is directed at the inner being of man. *Beati mites, beati pacifici*: what doctrine has ever so made gentleness or resignation or simple virtue the sole object of man on earth? *Beati pauperes spiritu*: Christ promises heaven to the poor in spirit. This saying is meant not so much to depress self-satisfied pride as to show that a simple heart is preferred to a dazzling mind.'[31]

None of this shows that Delacroix had become a cryptic Catholic. He did not hold to distinctive Christian convictions. He may not have believed in an afterlife. He asked George Sand what awaited man after this world and answered the question with the words: 'night, dreadful night'.[32] He seems to have seen Christ just as *a* religious teacher. His God was within. At Augerville once more, in 1862, he declared his personal creed. 'God is within us. It is this interior presence which makes us admire beauty, which makes us glad when we have done well and consoles us for not sharing the satisfaction of the wicked. It is doubtless he who inspires men of genius and encourages them with the spectacle of their own creations. There are men of virtue as well as men of genius. Both are favoured by God. The opposite is also true. There are people in whom God does not act, who commit crime without remorse and who never rejoice at the sight of anything honest or beautiful. There are therefore favourites of the Eternal being. The unhappiness which often, too often seems to be attached to these great spirits fortunately does not make them fail in their

short passage through life. . . . Their interior peace of mind from obeying God's inspiration is a sufficient reward in itself. . . . '33 He falls naturally into the language of a disciple of Voltaire.

As he confided to Charles Soulier, 'I keep reverting to Candide's conclusion: That's all very fine, but one must cultivate one's own garden, and to that axiom of this truest of all books [he means *Candide*]: Man spends his life convulsed with anxiety or lethargic with boredom. That is his dilemma.'34 Like Voltaire's hero, he found that he had no intellectual solution to life's problems. Only work would give meaning to what he did.

It was in religious subjects that he could best express his creedless creed. In the dead Saint Stephen or the dead Saint Sebastian, still more in the events of Christ's passion he confronted the cause of human anguish: the inevitability of suffering and death. In Christ sleeping in the boat on the lake of Genesareth – a subject that he treated over and over again in the mid-1850s – he dramatised man's thirst for peace and the consoling power that he himself had observed in faith.

Like any artist of the time, for inspiration for the chapel of the Holy Angels in Saint-Sulpice Delacroix looked to the Christian cultural tradition. When he painted his murals, he studied the Bible assiduously: his principal study was the art of the great masters.

Two of the paintings took subjects from Raphael. In the Louvre there is a painting of *Saint Michael Subduing Satan* which shows the archangel swooping down on a devil who is prostrate on the ground. Delacroix is less polished but more powerful. His saint comes out of a brilliant sky to push down the squirming serpent on to the spectator below. The second subject – *The Expulsion of Heliodorus from the Temple* – elicited finer art from both Raphael and Delacroix. Both treated an awesome incident not from Jewish mythology like the *Saint Michael* but from Jewish history. Heliodorus had come to grab the Temple treasures. At the prayers of the high priest Onias a heavenly horseman set upon him, followed by two young men with whips. Raphael's famous fresco in the Vatican Stanze is carefully balanced. To the left Pope Julius II, who commissioned the painting, looks on; in the centre the high priest, with the Pope's features, prays; to the right the horseman is poised to strike at the cringing Heliodorus and the two young men are racing to catch up with him. As a composition, the fresco manages to be both serene and dynamic. Delacroix gives to the subject a greater feel of space and tension. In a huge Temple, which was based on his knowledge of Persian and Moroccan architecture, a small despairing group gesture in agitation from an upper floor, while at the base of a

giant staircase a majestic horseman rides over the recumbent Heliodorus and the two young men bend over him with their scourges, neither of them quite on the ground, one of them flying down through the air. The Romantic interest in Oriental authenticity is typical of the nineteenth century. The sense of scale and the fluttering draperies derive from Rubens.

The third subject had been painted by Rembrandt, whom Delacroix admired, but the principal influence was from Titian and the detailed touches from observation. Delacroix had seen Titian's renowned painting of *The Death of St Peter Martyr*, which was to be destroyed in 1867, and he was impressed by the way in which the murder of the saint was given grandeur and emotion by the enormous trees which enveloped the action. So Jacob's fight with the angel is carried on under overmastering foliage, some sections of which are based on favourite trees which Delacroix had sketched in the forêt de Sénart on his walks near Champrosay. Once again Renaissance art was updated by Romantic awareness of actuality.

Some of these debts to other artists were noticed by the critics and he was praised or blamed by comparison. One of the greatest, Baudelaire, chose rather to be enthusiastic about Delacroix's handling of colour: that was indeed remarkable, for Delacroix used a palette of 27 different colours and 23 combinations of them; and another critic, Thoré, who was also favourable to Delacroix, went so far as to assert that 'the subject is absolutely unimportant in the arts'.

Such aestheticism was not acceptable to the proponents of 'Catholic' art. For Merson, a professional religious painter, the subject was all-important, so that he condemned Delacroix for being too human.[35] Delacroix had failed to paint religious paintings at Saint-Sulpice, since he could not embrace 'the cult against which his whole life has been one long combat'.

Faith alone does not produce good works of art. The walls and ceilings of many Parisian churches testify to the failure of the Catholic revival to find an adequate artistic expression of its convictions. In music, in the dull Neo-Gothic church of Sainte-Clotilde, the Belgian César Franck managed to keep alive the French tradition of devout organist composers. In the arts there was no Fra Angelico and no Michelangelo. Instead there was Delacroix, a religious sceptic drawn to religious subjects.

Delacroix fought against the faith, as Merson said, but the battle did not leave him unscarred, just as Jacob was wounded in the thigh after his combat with the angel. To some the message of such a picture would have seemed pointless. Courbet blandly remarked that he could not paint angels because he had never

seen any. Some Catholic critics objected to the lack of serenity in the treatment: the emotions must be calmed, not stirred. By a strange irony it was this view of religion which the former Sulpician Ernest Renan reaffirmed in his *Life of Jesus*. Jesus came from a people given to 'ethereal dreams and poetic mysticism'; he was a 'delicious' moralist: and, gifted with 'pure and sweet' beauty, he taught 'the delicious theology of love'. Renan's cloying religiosity was merely a refined, literary equivalent of the 'art de Saint-Sulpice', the sentimental religious art for which the square became notorious.

Delacroix bore witness to a tougher attitude to the relationship between God and man. Because he was sceptical, he could put much of himself into the struggle between Jacob and the angel. In the Bible Jacob was rewarded after the fight, when he was given the name of Israel because he had fought with God and with men and had prevailed. Delacroix interprets the central action of the story differently: 'A stranger appears, who stops him [Jacob] and closes with him in a stubborn wrestling match that ends only when Jacob, wounded in the sinew of his thigh by his adversary, is rendered powerless.'[36] Delacroix was a modern doubter, facing life and death without the comforting certainties of a traditional believer. He was a man who had wrestled with a stranger and he knew that the stranger may have been God.

The search for
an inner life (1847–63)

As records of the story of the arts in nineteenth-century France there are three autobiographical documents that have unique importance. For literary life there are the monumental *Journals* of the brothers Goncourt; for musical life there is the memoir of Hector Berlioz; and for artistic life there is the *Journal* of Eugène Delacroix.

Compared to the other works, the *Journal* of Delacroix is less entertaining. He did not have the love of anecdote that enlivens the *Journals* of the brothers Goncourt, nor did he make himself the hero of his own tale in the manner of Berlioz. He wrote in many moods, sometimes content to record his official engagements or his social round or the hours he passed in the studio or in front of his beloved walls, sometimes giving lengthy descriptions of sightseeing trips on holiday, sometimes analysing his feelings towards friends or acquaintances, sometimes trying out opinions on music and literature and above all painting that he planned to elaborate later in print, sometimes jotting down the first draft of a letter, sometimes copying out an extract from a book he was reading, but in all circumstances keeping firmly in mind his conviction that it is only memory that unifies human life. A man is what he recalls.

Viewed in any other way the *Journal* of Delacroix is just a collection of fragments. It seldom repays the reader who wants to read continuously. But if it has been thought second only to the letters of Van Gogh as a source for understanding any artist of the last century, then it is easy to see why Monet treated this as his favourite book.

Delacroix had always wanted to write. As we have seen he had tried his hand at novels and poems and translations as a young man. He had started to write

extensive letters to his friends. From 1822 to 1824 he had kept a diary; and when he went to Morocco, Spain and Algeria in 1832, he had accompanied his watercolour sketches with an explanatory text. In 1829 and 1830 he had begun to publish articles on matters artistic in the *Revue de Paris* and from the mid-1840s this became a regular feature of his life as he wrote for *Plutarque français*, the *Moniteur universel* and the *Revue des deux mondes*. All the while he carried on his large correspondence and, if the survival of his letters is a reliable guide, then it seems that he wrote more as he grew older.

For fifteen years after his North African trip there was no record of everyday life or even of his ideas, apart from occasional note-taking, till in 1847 he began once again the habit of keeping a diary. This time he would continue to make entries up to the time when his final illness in 1863 ended everything. But the diary is itself not exactly an affair of day-to-day happenings.

Accounts of his manner of painting make clear that Delacroix painted with passion – as the finished works testify – and would often work without bothering to shave or pausing to eat. When he came to write, he was a different man. Instead of suggesting, he wanted to explain. Instead of assaulting the eye with a riot of colour, he aimed to clear the mind with the precise use of words. The fire that was released by the brush was damped down by the pen. One description he disliked, that he was the 'Victor Hugo' of painting, is understandable to anyone who knows only his grand overblown masterpieces in the Louvre. He insisted that he was a pure classic; and the reason for that is obvious to whoever peruses his prose. He was at heart a Romantic – and painting was at the heart of him – but his mind had been trained by pre-Romantic values. As he grew older, his reason became as important as his emotions and his writing took up more and more of his time.

For Neo-Classical artists Rome was the eternal city to which all roads in art led. Had he won the Prix de Rome and gone to live in the Villa Medici, Delacroix would have developed a love for the statues of antiquity and gained a knowledge of the Italian Renaissance art that could have fixed him in the Neo-Classical tradition of French painting, like David. He went to England, however, at a time when his thoughts ran on Shakespeare and Scott and Byron, and far more of the subjects for his easel paintings would be taken from English than from classical stories. Then his 1832 trip had been even more decisive, for North African themes would free him from the over literary manner in which he had been trained. He would never lose his fascination with the thought of Italy and as late as 1862 he was toying with the idea of a trip with his old friend Louis Schwiter, but he only half meant it and he quickly backed out when he found

that Schwiter was serious. He knew Rome and Greece and the Holy Land with his mind's eye. Had he been told of it, he would have deplored the literalistic spirit that led Holman Hunt to travel to the Levant, on the theory that only by being at the Dead Sea in front of a dying Sinaitic ibex could he paint *The scapegoat*. Delacroix travelled in imagination, and that was usually enough.

As he grew older, he found it easier to move around inside and just outside France. In part this was the result of his increasing prosperity and in part it was the result of better communications. His youthful journeys had all been major adventures in disagreeable coaches along rutted roads. After 1840, however, a Parisian might find it possible to use the new method of transport: he could go by train. At that stage the French had lagged behind the British and Belgians, but in the following decade there was a great increase in the kilometres of rail lines laid in France, radiating out in all directions from Paris. Delacroix found he could take himself further more often.

The 1850s therefore inaugurated a new stage in his pattern of travel which lasted right down to 1862. He divided his free time between occasional trips to places of artistic interest or to holiday resorts and more frequent journeys to stay with cousins other than Riesener or Bornot.

His journey to Ems in 1850 was typical of the older Delacroix. In 1838 he had raced away to Belgium and the Netherlands with Elise Boulanger, later Madame Cavé. This time he was off to Ems for his health and his female companion was Jenny, who was there to look after him. It took just under nine hours to reach Brussels from Paris – that really made travelling tempting, he noted – but he was in a grumpy mood. The hotel was uncomfortable, the statues in the park were in poor taste; indeed he could not help reflecting how little taste there was in any country compared to France. But then next day he saw the magnificent stained glass in the church of Sainte-Gudule and he was enchanted by the plain-chant – a children's choir was singing Chopin's favourite psalm to organ accompaniment – and in the late afternoon at the museum there were the magnificent Rubenses, even better than those he had seen in Antwerp, and in the evening he went to a little theatre and laughed a lot. Next day they went on to Antwerp. The museum was not so well arranged as it had been on his last visit and the Rubenses were dispersed, and yet he had never felt so keenly their crushing superiority to everything else. There were some remarkable primitives, but his favourite picture this time was *The last communion of St Francis*. None of the pictures in the museum were in the dreadful state in which he found some pictures in the churches, where damp and decay were doing their worst. They

had to go back to Brussels, so this time he allowed himself a long session in the museum. Although it was early July, he shivered with cold. Again it was Rubens who overwhelmed him, but he was also struck with one Rembrandt. It was a liking that would grow stronger in his last years, as he himself became less flamboyant and more reflective.

They left Brussels next day and passed through beautiful countryside between Liège and Verviers before quitting Belgium and getting into the narrower and less comfortable Prussian carriages. There was a downpour when they reached Cologne and the customs had taken an eternity, but at 5.30 next morning they were off by boat and after Bonn the scenery was fine. Once at Ems he had problems with lodgings, he and Jenny had to spend their first night in what seemed a barn, he had a migraine so he did not eat, and the doctor kept on addressing him as Monsieur Sainte-Croix.

Ems was one of the many spas where the European aristocracy and *haute bourgeoisie* met to while away their time in talking and parading and dancing and flirting and gambling. Delacroix would later get to know similar resorts like Baden and Plombières. He would be in 1858 at Plombières when the emperor had secret meetings with the Piedmontese premier Cavour and plotted to eject Austria from northern Italy; and Cavour then went on to Baden to sound out the views of other European politicians. Even though he saw the emperor and watched him leave, Delacroix would have no idea of what was going on. As for Ems, twenty years after that too would have its famous moment in the history of the Second Empire. It was to that spa that Bismarck would send his edited version of a French telegram intended for Kaiser Wilhelm and so provoke the Franco-Prussian war, but happily long before that catastrophe Delacroix would be dead. In 1850, because he had no intrigues, even amatory ones, to amuse himself with, his main problem was simply how to fill his day. He needed time to feel at ease. He began recording his reflections. 'For me the secret of avoiding boredom,' he wrote, 'is to have ideas'. Early on he was fretting about finding suitable lodgings and arranging dinner and running after the doctor and drinking his glass of mineral water and being angry with Germans for being wrong not to be French. In that mood he was, like most human beings, a mere machine for living. 'What a disgrace for *my immortal soul*!' That was why he needed to read. He was soon into Medwin's *Journal of the Conversations of Lord Byron* and Elise Cavé's treatise on drawing and a novel of Balzac's. He made the great decision to drink his water before dinner. He enjoyed writing, but he did not feel the same enthusiasm at the sight of his pen as he experienced in front of his palette freshly laid out and gleaming with contrasting colours. He was reading another Balzac and was discovering where the best walks went. He loved the woods of fir trees and found a river-bed with a deep ravine where

there must be a torrent in winter. He drew the church tower. Two days later he was on his way, back past Coblentz and Mainz and Cologne, where he thought about the damage modern restoration could do to a Gothic building, and Malines, where there was yet more of Rubens to admire and a chance meeting with his childhood friend Horace Raisson, and on to Antwerp, where he made a special study of Rubens's *Coup de lance* and *Elevation of the cross*, and so on to Brussels, where he remembered how he had been in the city eleven years before with Elise Cavé when she was still Elise Boulanger. A long tiring journey took them home to Paris. He and Jenny had been away almost six weeks and yet it seemed like three months.[2]

He was next in the Rhineland in 1855, when he went to stay with his cousine Lamey and her husband at Strasbourg and went on to Baden, where he discussed the dreadful Wagner, who not only wanted to break all the laws of music but was also a democrat.[3] In 1857 he combined a further visit to Strasbourg with a stop-off at Nancy and a stay at Plombières; and in 1858 he went again via Nancy to Plombières. Guarding his health, whether at home or in spa towns, was now a major concern, which both he and Jenny took very seriously. Aesthetic pleasure was light relief; and there was much of that to be found in the wonderfully spacious and elegant place Stanislas at Nancy, which was the masterpiece of the epicurean who was last ruler of an independent Lorraine, and in the Dominican church built by duc René to commemorate his victory over Charles the Rash, last duke of independent Burgundy. In the museum he saw his own painting of *The Battle of Nancy*, which showed the moment when Charles the Rash had been killed in 1477. It was placed too high and without adequate light. All the same, it did not displease him.[4]

Neither eastern France nor the Rhenish states of Germany, not even Belgium drew him so much as the Normandy coast. It was then that *le beau monde* first noticed the watering places on the Normandy *corniche*: Deauville with its racecourse and Trouville, where Boudin painted the empress and her ladies struggling against the breeze, and Honfleur, where Boudin first encouraged young Monet to turn aside from caricature to look out to the sea and up to the sky. For forty years Delacroix had loved Valmont, to the other side of the Seine, and so it was natural that he should choose the seaside resort near by, Dieppe. He stayed in Dieppe in 1852, 1854, 1855 and 1860. It was probably during the first of his holidays that he painted the seascape, technically pre-Impressionist, where on the crest of gentle waves the sailing boats bob up and down under the enveloping sky. 'I made my last visit to the sea about three o'clock. It was beautifully calm and one of the loveliest I have ever seen. I could not drag myself away from it. I was on the beach and had not been on the jetty the whole day long. The soul is passionately attached to objects it is on the point of leaving.

It was based on this sea that I made a study from memory: golden sky, boats waiting for the tide to come in.'[5]

Not every moment was so precious. Indeed on this occasion he was suffering from a sore throat, because he had talked too much the day before. At Dieppe he got into the way of enjoying a tranquil social life. There was always someone he knew from Paris come to Dieppe to spend like him the last days of autumn before the winter storms made a retreat to the capital imperative. In 1854 he was so bombarded with the opinions of Chenavard on everything that he did not have much time to enjoy the American clipper in harbour or the fine view from the château or even Dumas's *Vicomte de Bragelonne*, of which the last two volumes of twenty-six were missing. But Chenavard at least drove him to work out his own, more flexible views on art and to realise that he was a happier person than his philosophical friend. 'A man lives in his century and does well to speak to his contemporaries in a language which they can understand and which can touch them. . . . I told Chenavard on the day when we were talking on the jetty that what distinguished talents was taste. It was taste that made La Fontaine or Molière or Racine or Ariosto the superior of Corneille or Shakespeare or Michelangelo. . . . My devil of a companion always praises what is beyond our reach. Kant or Plato, they are the true gods.'[6]

Fortunately he was less stimulated in 1855 and he was glad enough to pass days reading or even going out. He could remember with delight the poor little maid with the turned-up nose and the angelic face and the bad-tempered mistress who had left the train at Rouen; and there was an English family to chatter with on the way to Dieppe and on the beach next morning; and when a cold confined him to his room, there were his last year's drawings to look at and he could go on travelling in his imagination. The churches of St Jacques and St Rémy, the château, the harbour, the beach, the walk to Le Pollet, he enjoyed them all.[7]

In Ems or Plombières or Dieppe he could have a holiday on his own terms. But he was also fond of visiting his relations; and he proved himself over and over again a courteous guest whom it was a pleasure to invite, charming to the ladies, interesting to the men, a good talker – when he was not troubled by his throat – and an attentive listener. Behind the slightly ceremonious manner he had an affectionate heart. He was at ease with young adults as well as old people, and, if he did not find it easy to join in children's games, at least one child who met him, the oldest of Léon Riesener's daughters, claimed as an elderly lady that she had never forgotten him.

That he would go far to see members of the family was shown in a most

spectacular way in September 1855, when he journeyed all the way down to the château de Croze in the department of Lot. Croze was the home of the Verninacs, the family of his brother-in-law, and remote. He set out by express train to Argenton, where he had to wait for his luggage one long hour in the mud and the rain before transferring to a dreadful little coach, where he found himself hemmed in between a child who pissed and three women who vomited. Once in Limoges he had half a mind to call the whole adventure off. The whole day lay before him. He decided to base himself on the Grand Périgord Hôtel for the day. Rarely for him, he breakfasted and felt much better. He began sightseeing, fell asleep in the cathedral and again in the church of Saint-Michel, had himself shaved and for dinner at 4.30 had mushrooms that were better than any he had had in Paris. At six o'clock he got into a brougham for Brive.

He slept part of the journey and when awake could just make out the bizarre countryside through which he was passing. He reached Brive at ten o'clock next morning and was met by François de Verninac, the son of his sister's sister-in-law. They walked round the pretty little town and he admired the Romanesque church and the Renaissance college. At three they were at Croze and there was the mother of François calling him 'tu' and there was François's attractive wife. He walked along alleys of fruit trees, among them some fig-trees. He spent just three happy days at Croze, thinking back to his youth and to his dear friends, his good brother and sister and his dear nephew Charles. He loved to draw the mountains he could see from his window and he even came to enjoy the ramshackle appearance of the château. He was very struck by the sight of Turenne perched up on top of its crag and he was on good terms with Dussol, an amiable young man who was at dinner most days and went with them on their excursions.

On the way home his senses were much sharper than on the journey out. He admired the coquettish sister of François's maid, who was to be married in a week, and in the coach he was amused by a jolly fat Limousin who was also to marry in a week and who talked on with great pleasure about the beautiful house and excellent land which would be his, without once saying a word about the marvellous lady who would be part of the deal. This time the journey put him into an expansive mood. At Périgueux he appreciated the style of Madame l'hôtesse as he paid his bill of three francs 50 for dinner. He made for the little town of Ribérac, where he arrived at 2 a.m. and fell on a bed in the auberge and slept fully clad till 5. He caught the early morning train and watched the rising sun lighting up the beautiful landscape, with vines clustering round trees in the Italian manner, while a young soldier grumbled on about the frostbite he had endured in the Crimea and about the English, who he said were 'parade-soldiers who give up much too quickly' in spite of their reputation for perseverance. At

Montmoreau Delacroix changed trains and at Angoulême he helped Madame Duriez and her daughter and son-in-law and grandson to get on. Madame Duriez he had met when staying with his cousin Philogène Delacroix in Champagne. It was a lucky meeting, and yet he would have liked some rest and some solitude while the train sped on through the *pays* he had known in his youth. Instead he noticed the stifling heat and the uninterrupted conversation and the scramble for food at Orléans. He arrived back in Paris exhausted, only to be off to Strasbourg next day.[8]

None of his holidays ever had this epic quality, because fortunately his hosts were usually more accessible. His first cousin, Philogène Delacroix, was a retired soldier who still lived in the Delacroix area of the Argonne, in the village of Ante. He would sometimes come to Paris for a week or so and call in on Eugène, occasionally with another soldier cousin, cousin Jacob. Eugène loved to listen to their tales of military life. In 1856 this friendship gave him the opportunity to unearth his father's roots and he made for a quiet area of Champagne, there to discover that in Givry-en-Argonne, his father's birthplace, there was one old Delacroix still living of whom he had never heard. That same day he saw La Neuville-au-Bois, from which Joséphine de Forget's father had come, and Le Châtelier, from which the Berryers had come and where the Vauréals had lived – grandfather Claude had earned his living as their bailiff.[9]

He enjoyed life with the provincial gentry and *haute bourgeoisie* and he was back to Delacroix country again in 1859 and in 1862, but he did not have many links with these people other than ties of blood. He had more in common with cousin Lamey, who was strictly speaking not even a relation but the husband of his first cousin Alexandrine Pascot, and with a more distant cousin, Antoine Berryer, the cousin whose family came from Châtelier. Both men had legal careers, but both also had literary interests – and that he could understand better than shooting and fishing. Being a closer friend to the Lameys and to Berryer had this extra advantage: it was easier to reach them. Strasbourg, if the further away, could be reached within a day from the gare de l'Est and Augerville lay just off the Paris-Orléans road by Malesherbes.

For much of his life Delacroix was in search of substitute parents. He was only seven when his father died and only sixteen when his mother died. For a time his elder brother and sister had filled those roles, but his brother was debauched, so the family said, and his sister was harsh. He was fond of his mother's niece Alexandrine Pascot, but she married Auguste Lamey in 1824 and moved away to Colmar in Alsace, so he turned more to Léon Riesener's lively and beautiful mother even before his sister died in 1827. Félicité Riesener lived

another twenty years, but the double blow of her death in 1847 so soon after his brother's death in 1845 left Delacroix once again feeling emotionally deprived. It was then, probably in the late 1840s, that he rediscovered the Lameys. Thus began for all three an autumnal friendship which would last till Alexandrine and Auguste were both dead.

From the first surviving letter he wrote to his *chère cousine* dated July 1850, it is clear that he would see them when they came to Paris – there was to be no question of his going to Strasbourg till 1855. It was to her that he could open his heart. 'You are for me,' he told her just after his first visit to their house, 'mother, aunt, sister, and, what makes me very happy, you also remember the people you have loved'.[10] His first surviving letter to his *cher cousin*, from May 1851, has a different tone.[11] *Monsieur le juge* still cherished ambitions as a writer. Half a century ago he had put on classical plays in Paris, such as *Romulus* or *The Foundation of Rome*, and he wished his young fifty-three-year-old cousin to use whatever influence he had in the theatrical world to help him put on another. Auguste was not aware that there had been a Romantic movement, and nothing came of it. Delacroix wrote an affectionate letter for the New Year of 1856 to Alexandrine[12] and was devastated to have to write his next letter to Strasbourg in February to offer Auguste his condolences on her sudden death.[13]

For the remaining five years of the aged judge's life a constant flow of letters passed between Strasbourg and Paris or Champrosay or wherever Delacroix was. The old man carried on with his writing. Delacroix would try to interest Buloz, editor of the *Revue des deux mondes*, in an article on Lamey's German poems – unfortunately the magazine had had a long recent essay on modern German literature. In the end the poems were mentioned in the *Revue française*. Delacroix was also deputed to get financial advice about Lamey's investments. In 1859 Lamey raised the question of one of his verse dramas – Delacroix gently hinted that modern plays were different. But he was not just the kindly helper. The two shared the topic of their health, which was raised in almost every letter. Delacroix wrote about Louis Guillemardet, whom the Lameys had known from long ago. He went twice from Paris to Strasbourg and Lamey came twice from Strasbourg to Paris. He would ask Delacroix to entertain his nephew and Delacroix would call on Lamey's sister-in-law; and Delacroix gave him details of his 'hermitage' off place Furstenberg and of his purchase at Champrosay and of how he was getting on at Saint-Sulpice. The murals were almost done when he learnt in early 1861 that Lamey had gone – he was eighty-eight.[14]

The cousin he visited most often was Berryer and on average he was at Augerville almost once a year. Himself widowed young, Berryer loved to have

an excuse to have pretty and intelligent women around him; and to accompany them he needed fascinating men. The atmosphere was relaxed – Berryer never made his Catholic piety or his Bourbon politics oppressive – and there was music and talk about Racine and walks by the lake and under the trees and fine views in every direction. Delacroix admired Berryer's great energy, which enabled him to race up to Paris to defend a client with his customary eloquence – he was reputedly the finest advocate in France – and then to come back to Augerville by nightfall. He himself preferred a gentler pace. It was that preference which drew him to Champrosay.

The train made it all so easy. There was a small station at Ris Orangis on the Lyon line; and from there it was just a short walk across the bridge over the Seine and up the hill to his little house, which he liked to consider a cottage. Champrosay gave him a garden, long walks in the forêt de Sénart, with its massive oaks, and a social life that was at a slower pace than Paris. He had come to Champrosay in the 1840s at the invitation of Frédéric Villot, who made engravings from his paintings and who was conservator of painting at the Louvre in 1848, only to lose his job when he was attacked for the way he had restored the enormous Rubens canvases which Marie de Médicis had commissioned for the palais du Luxembourg to glorify herself and her dead husband Henri IV. For several years Delacroix was on good terms with Villot and was delighted to see him in the country, but at some stage their friendship cooled. Biographers have asserted that perhaps it was not Rubens but the flirtatious Pauline Villot who provoked the ill-feeling that developed between the men. Fortunately he made other friends in the district. Halévy, the distinguished composer member of a distinguished Jewish family, had a country house in a nearby village; and there were General Parchappe and his wife and the Quantinets and Bontemps, all neighbours whose houses were open to him when he was there. But he valued Champrosay chiefly for the chance to be alone.[15] There he could draw or work at small easel paintings or read or write his articles with little fear of interruption. He could have all the exercise he felt like. In hot weather he could take the train up to Paris for business during the day and return on the train in the afternoon. It was good for his health; and Jenny could run the practical affairs of his life as smoothly as in rue Notre-Dame-de-Lorette or place Furstenberg. It was not just a question of his being a bachelor, a man who expected to be entertained and who was a little chary of entertaining: he was in danger of becoming isolated.

As he grew older, he became more critical of those who had been his best friends. When he saw the struggle his married friends had to make ends meet, he could be unsympathetic. One Saturday in May 1853 the two men who had mattered to him more than any others came to spend the afternoon with him at

Champrosay: Jean-Baptiste Pierret and Léon Riesener. 'Why does the sight of these two old old friends . . . here . . . and in the midst of the beauties of spring not give me the great happiness I would not have failed to feel in the past? I felt . . . in front of witnesses and not with friends.' A week later the painful experience still rankled. 'When I think about Pierret and Riesener and I realise I don't see them, I am like metal, without any feeling. When I am with them, after the first moments have broken the ice, I slowly recover the emotions I used to feel.'[16]

His cottage at Champrosay was supposed to be a retreat where he could have peace of mind, a refuge from the busy, dirty, hurried life of Paris. All too easily it could be treated as his defence against the unwanted intrusion of other people's worlds into his own. It could be a castle where he could pull up the drawbridge; and Jenny had become the portress and perhaps his gaoler.

He was ever sensitive to criticism. During their visit Riesener and Pierret had discussed his artistic practice and his artistic theories with him and he did not like them not praising both[17] – Jenny would surely have pandered to his need for reassurance. About Riesener there were special reasons for concern. He saw a man fighting to maintain home and family and sacrificing artistic integrity to do so.[18] Delacroix himself was not just a bachelor, a man who had not married. He had also become celibate, a dedicated soul. Painting was his lifelong mistress, a passion that would endure longer than his affection for Joséphine de Forget, as she herself had seen long ago. Either he would paint or he would write about painting; and, since he had some mastery of two arts and enjoyed others like architecture and music, he would write about art as such.

He loved Riesener enough to will him the house.

On that Saturday he remembered the conversation and his reflections arising from it.

Riesener carried on with his criticism of my search for a certain degree of finish in my small pictures which he thinks lose a lot in comparison to what I achieve in my initial sketches or what I would achieve if I worked more quickly and spontaneously. I am not sure if he is right or wrong. Probably to contradict him, Pierret said that the painter should do what the painter feels inclined to do and that what is arresting about a picture matters more than technical matters of touch and freedom of brushwork. I answered him by pointing out what I put in my notebook a few days ago on the unfailing effect of the sketch as opposed to the finished painting, which is always a little spoilt by the lack of freshness but compensates with greater harmony and depth of expressiveness.

At the Prieur oaktree, I showed them how, taken on their own, isolated branches looked more striking, and so on – the story of Racine and Shakespeare. They reminded me of my warmth a few months back, when I set myself to re-read and see again in the theatre *Cinna* [by Corneille] and Racine. They admitted how powerful had been my emotion when speaking to them on the topic.

After dinner, they looked at the daguerrotypes Durieu has kindly sent me. I contrived to have them try the same experiment I tried out by accident two days ago. When they had studied daguerrotypes of nude models, some of whom were weedy specimens who were overdeveloped in some parts of their bodies and disagreeable to look at, I then showed them Marcantonio's engravings. We felt put off, indeed almost disgusted by their mistakes, affected and unnatural manner, in spite of the excellence of their style, which now we no longer admired. I really think that if a genius uses daguerrotype as it should be used, he may reach heights we have no idea of. Above all, when you study these engravings, which have exhausted every painter's admiration for them, you feel how right Poussin was to say: 'set beside the classical artists Raphael is an ass.' Up till now this mechanical art has done us a bad turn. It spoils masterpieces without satisfying us completely.[19]

This long diary entry is remarkable because in it Delacroix touches on most of his central aesthetic concerns: the relation of preliminary work to the finished object; the relation of the parts to the whole; the interrelation of the arts; and the relative importance of realistic and idealistic elements in the arts of painting and literature. He published some of his thoughts in his articles, but it is in his diary that they are found in their purest form. He confessed that he found working up an article a chore. A brief analysis, a short note, even a sentence was more compatible with his way of working things out. In the French literary tradition he looked back to Voltaire's *Philosophical Dictionary*, La Rochefoucauld's *Maxims* or Montaigne's *Essays*. His own *Dictionary of the Arts*, which occupies so much of his journal, especially from 1857 onwards, was to be his attempt – his *essai* – to suggest an answer to what was for him the most pressing of questions: what is an artist? – which for him meant, what am I? – or in other words, who is Delacroix?

Surviving portrayals give some hints of what he was like. From 1847, the first year of the mature Journal, there dates a fine engraving of him by Frédéric Villot, whose subtle shading emphasises his brooding, magnetic face. From the later years around 1860 there are a number of photographs, inevitably less personal, by Nadar, Carjat, Legé and Bergeron, and Pierre Petit. In each case his bearing is majestic, his jaw strong and his eyes deep-set and pensive. During the

last years of his life he remained faithful to a Romantic world-weary view of art and the world.

So far as modern taste is concerned, the most important question Delacroix discusses may well be the relative value of the sketch and the finished work. Modern taste has come to prefer Constable's sketches to his exhibited paintings; and the knowledge that Monet was devoted to the diary of Delacroix may suggest that the older master was a proto-Impressionist, a painter more intelligent than Constable in that he at least recognised where his real talent lay. The issue is more complex than it seems. Recent research has made clear that the French painted *impressions* long before Monet showed *Impression Sunrise* in 1874. What was eccentric in Monet's behaviour was that he showed the public what other painters kept in their studios. It is also clear that many so-called Impressionist paintings were carefully worked.

Delacroix had been trained in Guérin's Neo-Classical studio to copy earlier works, to sketch statues and models, to make preliminary studies and so to construct the idea of a composition which he would realise after many many hours of painting and repainting. It was such a method that he had followed even in a picture which seemed to offend against all the canons of Neo-Classical decorum: *The Death of Sardanapalus*.

Two years before, in 1826, he had exhibited another Byronic subject, *The Execution of the Doge Marino Faliero*, which the Neo-Classical critic Delécluze had called a 'brilliant sketch'. The modern visitor to the Wallace Collection in London will find the description puzzling, for the forms are strongly defined; and, even if Delacroix always regarded this as one of his favourite paintings, that was not because it anticipated the freedom with which he painted some of his later works. Maybe he was proud of his economy of effort: he had achieved his effect without sliding into the grandiloquence which marred *Sardanapalus*. Despite the view of Delécluze he never blurred the distinction between a sketch and a painting. The large *Lion Hunt* which was done specially for the 1855 Exhibition has a Rubensian fluency and dash, so far as can be judged from the wreck left after part of the picture was destroyed by fire, but there is in it nothing like the swirling movement and frantic streaks of paint that make the sketch, now happily in the possession of the Louvre, look proto-Expressionist. He stuck to the traditional vocabulary. A sketch (*une esquisse*) or a study (*une étude*) or even an outline (*une ébauche*) could never be a picture. They were preliminary and necessary stages in the production of a picture. Delacroix quarrelled with academic training in so far as he never sought the high finish which the professors taught their students to admire and which he knew

destroyed all sense of life. His problem then became how to preserve vitality throughout the process of constructing a painting.

Sometimes he probably failed, as Riesener sharply pointed out. He would have agreed with the critics of Impressionism, like Cézanne, that 'harmony' and a profounder 'expressiveness' within a picture were some compensation for any loss of the spontaneity of the sketch. Flair is not everything; art also involves thought; or, in Wordsworthian terms, emotion needs to be recollected in tranquillity.

The relationship between an outline and a finished work led him on to consider exactly what was perfection in art. Twelve days before he had heard Riesener's comments, he had been meditating on the oak of Antin, one of the great trees of the forêt de Sénart. 'In the presence of this beautiful tree, which is so finely proportioned, I find a new confirmation of these ideas. At the distance necessary to grasp the whole of it, it seems to have an ordinary grandeur. If I go underneath the branches, the impression changes completely. As I see only the trunk which I am almost touching and the way the great branches spring from it and extend above my head like the enormous arms of this forest giant, I am astonished at the grandeur of its details. To put it briefly, I find it great and even alarming in its grandeur. Is lack of proportion what induces admiration?'[20]

From the time when Vasari had written his *Lives of the artists* in the sixteenth century, it had been a commonplace of art theory to contrast the regularity or correctness of Raphael with the power and nobility of Michelangelo. This contrast was familiar to Delacroix probably through the *Discourses* of the Englishman Sir Joshua Reynolds; and even though he had never compared their finest works in Rome, it is presupposed in the two very early critical essays on these two masters which came out in 1830. So of Raphael he wrote: 'In his simplest arrangements, as in his vast majestic compositions, his spirit introduces everywhere, together with life and movement, the most perfect order and an enchanting harmony.'[21] As a corollary he maintained that in Michelangelo's *Last Judgment* there is 'something confused which at first is shocking'.[22] In 1854, twenty-four years after he had published this article, he told Chenavard that in *The Last Judgment* there are some striking details, as striking as a punch on the face, but there is no compensating sense of unity.[23] He was also sure that Raphael, beloved of Ingres, too often sacrificed naturalness to elegance.[24] By contrast Michelangelo, Shakespeare, Corneille[25] and Beethoven[26] were wonderfully inventive, surprising and strong, even sublime. But they risked banality. They did not have that sense of exquisite balance, of restraint, of near perfection which was the hallmark of Racine or Mozart. He no longer put Raphael quite into that supreme class and, under his breath, muttered that he ranked below Rembrandt[27] – but that was a view he did not much publicise. The fashion in

France for the Dutch seventeenth century, for Rembrandt first and then for Hals and Vermeer, was yet to be established.

There was another way of relating the parts to the whole. If from the French seventeenth century Delacroix inherited an old quarrel, between the masters of line, like Poussin, and the masters of colour, like Rubens, he found a new way of discussing it. At Champrosay in the summer of 1853 Delacroix worked away at an article on Poussin. 'Every so often I want to throw *Poussin* out of the window and every so often I get back to him either with frenzy or else in a reasonable state of mind.'[28] But if he had strong feelings about Poussin, he adored Rubens. While a sense of shape was natural to the human eye, painting as such was the art of handling colour. If forced to choose, he had to opt for Rubens. He criticised Poussin for a certain lack of unity, as 'harmony of lines, of effect, of colour is . . . a quality or reunion of the most precious qualities denied to him completely.'[29] Rubens's great strength was his fluency;[30] and it was that gift which enabled him to subordinate the parts to the whole. In Rubens, whatever his failings, there was no danger that attention to finish would quench the fires of his imagination; and imagination is 'the first quality of the artist'.[31]

Anyone prominent in any of the arts in the early nineteenth century knew the importance of the imagination. For Delacroix, who was familiar with most of the great painters since 1500 and who wrote about a sculptor, Puget, and who had strong opinions about music and literature, it was to the imagination that all the arts were addressed and from the imagination that all the arts came. The arts, however, acted in different ways. It was the ear which grasped music, the eye which grasped painting. Music, like literature, was grasped successively, painting in a moment. On these grounds Delacroix rejected the common Romantic notion that all art tends towards music. For him it was painting, the most approachable of the arts, that had the natural priority among the products of the creative imagination.

Instead of harping on the superiority of his own favourite medium, he was more interested in seeing analogies between the arts. Comparisons between Shakespeare and Racine or Beethoven and Mozart came readily to mind. When he read Edgar Alan Poe, whom Baudelaire lauded, he attacked his attention to horror for its own sake. 'You recognise there the bad taste of foreigners. The English, the Germans, all these anti-Latin people have no literature because they have no idea of taste and measure.' For an admirer of Shakespeare and for one who had been influenced, along with so many of his generation, by Madame de Staël's enthusiasm for all things German, it was an astonishing statement, if not seen in the context of his comments a few lines further down: 'Shakespeare alone knew how to make spirits speak' (a comment he added later) and 'put this beside what I said about the coldness of the French schools and of their

excessively timid imitation of nature.'[32] Here again he moved from literature to painting, for 'the French schools' were the French academic painters. The one unifying idea was the 'imitation of nature', which he believed to be the aim of all art.

Imitation was the essence of art. This was an ancient Greek idea; and he agreed with the Neo-Classicists, that 'the ancients are perfect in their sculpture' and that 'the antique is always even, serene, complete in its details and the whole in some way beyond criticism'. But he himself was a modern, and, just as he recognised that Beethoven was more modern than his beloved Mozart, so Christianity and the discoveries of the sciences 'which have encouraged the boldness of the imagination' have meant that no 'period may be like the ones that have preceded it'.[33] There was no point in trying to go back. The problem was how to go forward. He was not in favour, then, of the imitation of imitations. The problem was how to be original.

When he was young, he found himself protesting against excessive idealism, as in the art of David and Ingres, which departed too far from nature. He had found out in Morocco that the people had a kind of antique gravity without the pallid flesh of a Davidian hero; and his *Women of Algiers* had none of the mannered grace of Ingres's *Odalisque* of 1816 with her extra vertebrae. His sick men of Chios would rot, his *Liberty* led the people with hair under her armpits and he would prefer Rembrandt to Raphael because he was truer. Thus far he was on the side of the Realists who emerged when he was getting old. Like them he wished to be more scientific. He was fascinated by photography, as he made clear to Riesener, and late in life he learnt the modern science of colour. But he agreed with a remark of Jenny's as they were walking through the forêt de Sénart, that 'an exact imitation is always colder than what it imitates'. If everyone tried to follow the ideas of Courbet, then art would be without poetry. As he wrote to a painter friend, Alexis Pérignon: 'If you observe nature well, which makes no effort to produce its effects, you see that you should follow it step by step rather than add to it or correct it. There is one man who makes things clear without violent contrasts and who makes the air seem fresh, which we have always been told is impossible; and that is Paolo Veronese. In my view he is the only man who has penetrated the whole secret of nature.'[34] It was therefore Veronese's colossal *Marriage Feast at Cana*, which dominates the Italian room in the Louvre, rather than Courbet's *Funeral at Ornans* which should be the best guide to a modern artist. Atmosphere counted before accuracy.

When he painted his mistress Camille in *Ladies in the Garden*, Monet without knowing it would take the advice of Delacroix, for he studied the way Veronese painted shadows. He also greatly admired the pictorial skill of Delacroix's *Jacob*

and the Angel in Saint-Sulpice and above all his handling of complementary colours. Monet may have had the Realist obsession with modern life. His own picture of his friends – Courbet among them – having a picnic in the forest of Fontainebleau had none of the learned debts of Manet's *Déjeuner sur l'herbe* to Renaissance compositions, and yet a sense that an event of everyday life is transfigured by beauty.

Delacroix had an imagination that stuck to the world around him only when he painted portraits, which he did less and less in later years, or when he had recorded what he saw in Morocco and in the zoo at the Jardin des Plantes or when he painted flowers or sketched the landscape on his travels and at Champrosay. For him this procedure was a starting point, but not the end of his art. His themes were grander, not everyday life but life, not the civilisation of the time but civilisation. He was ambiguous. In one mood he could sound like the perfect disciple of Rousseau: 'The true man is the savage; he accords with nature as it is.'[35] In another mood he castigated Rousseau. 'Man is born free,' a friend of George Sand had said, quoting Rousseau. 'Never', commented Delacroix, 'has anyone said anything so idiotic, however philosophical he may be'.[36] His life was poised like his own ceiling of the library of the Palais Bourbon between barbarism and culture, between Attila destroying the arts of Italy and Orpheus bringing the arts of peace to Greece.

Finally – and this was a point he had not elaborated to Riesener that May afternoon in Champrosay – his last word was that art must be personal. Writing in 1855 to Elise Cavé, he explained his objection to all kinds of schools, not least the so-called Romantic school. 'Truth in the arts is relative only to the person who writes, paints, composes in whatever medium it may be. The truth I extract from nature is not exactly what would strike another painter, whether my pupil or not. Consequently you cannot transmit the feeling for beauty or truth; and the expression "to create a school" is an absurdity ... Schools or côteries are nothing other than associations of mediocrities, to guarantee each other an appearance of fame which truly lasts only a short while but which enables them to pass through life in a comfortable way.'[37]

Just as much as Berlioz or the Goncourts, Delacroix knew his art was his own. In the strictest sense his art was autobiographical; and that means that his life is the clue to his art. It is a point of view that made him try to give meaning to that life in his writing as in his painting. He has left some clues for anyone to try to follow the chase to the heart of him, but the essential clue is found in what he made of his self. That was his life-long task, which would occupy him till illness, old age and death supervened and there was nothing more to do.

Death (1863)

THE paintings of the chapel of the Holy Angels at Saint-Sulpice, officially open on 21 July 1861, were the last major achievements in the painting career of Delacroix. They had taken him so many years to complete that he lacked the courage to attempt anything that would involve much of an effort. He never retired, but he thought little about the future and he took an old man's interest in the past. Social life was restricted. He did not go out much. In both 1861 and 1862 he took his two habitual brief holidays, at Augerville, where 'I do nothing except appear at mealtimes, go out, walk, reappear at table and then go to bed to begin again next day,' and in Champagne, 'the cradle of my family', where 'my good cousin, with whom I am staying, is the last relation who bears my name and who can talk to me still about all that has gone'.[1] More and more of his time was spent at Champrosay, which seemed to him quite suburban after the rusticity of Champagne, where he had seen only men and women and cows. Thanks to Louis Guillemardet he now had a new manservant, Jean, who was clean and conscientious, everything that was rare in fact, and he fretted that the wealth of his neighbours might tempt Jean to leave him.[2] As late as summer 1862 he was writing to Louis Schwiter about their projected journey to Italy, but first it was Garibaldi and then it was the heat, which was bad enough at Champrosay, and then there was his stomach. He liked what was simple and old. He was in his element lamenting to Soulier, whose time in Italy he had envied so many years ago, about the infirmities of age.[3]

He became animated when younger men asked him his memories. He wrote at length to Thoré about Bonington for his book entitled *Treasures of Art*[4] and he gave Philippe Burty details of his various uncommercial ventures into engraving. He was keen to find out about the fate of his pictures in provincial galleries or to exhibit his pictures again in Paris. *The Death of Sardanapalus* was on show in boulevard des Italiens; and though he could not get to see it, he was

glad Burty had liked it and told how in 1828 'it had infuriated everyone and alarmed even my friends'.[5]

His status involved him in unavoidable tasks: an occasional visit to the Institute; fruitless attempts to further the painting career of the son of his old friend Colin; and a campaign, which also came to nothing, in which he and Ingres and the architect Hittorf tried to prevent the dispersal of the valuable Campana collection, which had been acquired by the emperor in 1861.[6] He had pleasure in accepting an invitation from Prince Napoleon.[7]

He was still not forgotten by his lady friends. His pupil Madame Babut sent him oysters from La Rochelle[8] and Elise Cavé gave him a dressing-gown[9] and there was always the faithful Joséphine de Forget, Joséphine to thank for her note for his nameday and Joséphine to call on when he felt up to a little Paris social life – and he would be delighted to see her son Eugène again – and Joséphine to tell about his time in the countryside and how at Augerville he wished he played cards and kept on falling asleep over books.[10]

He spent much of 1862 writing an article on the charming French painter Charlet, a friend of Géricault's.

Delacroix still worked at his main craft. One day two young artists, Monet and his friend Bazille found a window which overlooked the garden studio at 6 place Furstenberg. There they could secretly watch him drawing from a model, who was asked to walk around the room – from 1862 there have survived drawings of some such model. He had been commissioned to paint four pictures of *The Seasons*, but once he had learnt that there would be no room for them at next year's Salon, he had taken them little beyond the preliminary stages. He was involved with other schemes. He worked on a subject which took him back to the days of the Greek War of Independence: *Botzaris Surprising a Turkish Camp at Dawn*. For a dealer he produced two pictures, *The Collection of Arab Taxes* and *Arab Camp at Night*, and for his friend Dutilleux a *Small Lion* and a *Tobias and the Angel*. The last picture, perhaps the last he ever did, is a sketch.

For some years he had feared the onset of winter. Unless he stayed at home all the time, he was liable to get flu or a cold. His point of weakness was his throat. A severe dose of laryngitis had afflicted him early in 1862; and quite recently, when he had met again an old acquaintance after many years, the acquaintance had remarked how much his voice had changed.[11]

In February he complained to a pupil of his, Adolphe-André Waquez,[12] that he was ill and in May he told his assistant Pierre Andrieu that the cold he had had for three months was still a heavy one.[13] He had fallen over and hit himself against the side of a table and his eyes were strained from having read too much and he could not work. Between these two letters he had carried on with a

routine of receptions and visits, though he had confessed to one of his hostesses that the state of his health was such that he would not give a favourable impression to her sister-in-law when they met.

At the end of May he decided to go to Champrosay to rest. On the way there he met someone he knew and talked with too much animation. By the time he got to his house, he was clearly very ill. He had neither strength nor appetite and for a week took almost no food. He found it hard to walk from his bedroom to his garden and back again. On 1 June he took the morning train up to Paris to see his doctor, who gave him some medicine. A few days later he was apologising to Louis Guillemardet that he had felt too ill to say goodbye before his first trip – now he had been ordered to return to Champrosay, live quietly and try to say nothing. 'Instead of looking at the chimneys of Paris, I have before my eyes the most beautiful countryside. You see it, rest, silence, and silence above all. It is because I recently did a lot of talking that, with the help of my cold, I got to the stage where I could not say a word without coughing.'[14] A few days later he told Schwiter how much he envied him his good health[15] and his activity. He feared that he would have a long convalescence. In July he was briefly more cheerful, because he told his _marchand de couleurs_, Haro, that he was improving, but very slowly.[16] When he wrote to Berryer on the 13th to congratulate him on his election as deputy of Marseille, he was more worried. He wrote with difficulty and at the moment of Berryer's triumph he had been spitting blood.[17] Just two days later he went back to Paris by special coach, leaning on Jenny, his head resting on cushions.

Once in place Furstenberg, he was put to bed. He refused to drink wine, but was ravenous for cherries, figs or bananas, for any kind of fruit, and on this occasion he asked for pale ale from a shop in rue Saint-Honoré, but all he wanted was to put the glass to his lips. The doctor let him have whatever he wanted. He asked for an ice cream, which made him delirious, and then he recovered again and said he felt much better.

A routine of almost daily medical consultations was instituted. Slowly news of his state of health got known. Joséphine de Forget came to visit him one day late in the month. He was too ill to see her, so instead he scrawled his last letter to her:

I do not need to tell you, dear friend, how charmed I am with your flowers. But the day you came, I felt dreadful. Writing is a pain, I can only thank you then from my heart. For two or three days there has been an improvement.
To you, dear friend,
E.D.
Thank you for the books.[18]

About the same time he also wrote his last letter to George Sand, wishing long life to Maurice's baby son Marc.[19]

He wanted to make his will. The notary could not come at once, so Delacroix worked out what he wanted to say and two days later, between one and three o'clock in the afternoon, he made known his intentions. He had already thought of a will as long ago as 1856. It did not take him long to make up his mind.

Achille Piron or, failing him, another old friend, Baron Charles Rivet, was made universal legatee. The two principal beneficiaries were: first Léon Riesener, to whom he left 20,000 francs, the property at Champrosay and his portrait of their common cousin Henri Hugues, with whom they had had their merry dinners thirty years before; and, secondly, Jenny, to whom he left 50,000 francs and his finest self-portrait. He did not forget his other relations, the Jacquinots and a cousin Flise he had met in Champagne; and to Philogène Delacroix he gave suitable military mementoes, a revolver and two presents – a golden ring and a sabre – which had been given his father by Prince Eugène de Beauharnais; and to Bornot he gave family portraits. Berryer, as a good Catholic, would have his engraving of Pope Pius VII from the oil by Lawrence. The Verninacs were to have everything associated with his sister – including the magnificent portrait by David – or his brother-in-law or Charles his nephew. He left Joséphine de Forget a miniature of her namesake the empress. There were bequests to George Sand and Elise Cavé, to Louis Schwiter, Louis Guillemardet, Thiers and Chenavard, to his god-daughter Marie Pierret, the faithful Andrieu and to his servants. He asked a group of friends to arrange a sale of the work in his studio and instructed each of them to chose an important drawing for himself. His tomb would be in the cemetery of Père Lachaise, a little apart, with no emblem or bust or statue. It should be modelled on the antique or Vignola or Palladio. In the hour of his death he did not forget the classical tradition.

On 6 August he or rather Jenny wrote his last letters: to Riesener, to Andrieu and to Berryer. A few days afer a member of the Institute came to enquire after the health of his *cher confrère*. Delacroix cried out in annoyance: 'Haven't these people caused me enough trouble, haven't they insulted me enough, haven't they made me suffer enough, my God!' The next day and night he was feverish, but on the 12th a mood of calm descended on him. That evening he was agitated again. He could scarcely see and, with his hand in Jenny's, he could hardly breathe. To ease his breathing his man-servant Jean tried to find him a better position in bed. From 2.30 a.m. he had his hand in Jenny's. In the early morning he heard the angelus ring out from Saint-Germain-des-Prés and made a slight movement. At seven o'clock it was all over. 'So died, almost smiling, on 13

August 1863,' wrote Théophile Silvestre, 'Ferdinand-Victor-Eugène Delacroix, a painter of great genius, who had the sun in his head and storms in his heart, who for forty years played the entire keyboard of human emotions, and whose grandiose, terrible and delicate brush passed from saints to warriors, from warriors to lovers, from lovers to tigers and from tigers to flowers.'[20]

A few days later Jenny heard from Madame Babut. She replied one week after Delacroix had died:

Madame,
I am very sad to tell you about the unhappiness that crushes me. I wanted to write to you straightaway, but I was ill with sadness and tiredness. I sent you notice of what had happened. My poor dear master had been ill for three months. The illness began with a cold as always and that reached his chest. The whole time I cared for him without leaving him for one instant. He kept his calm and serene mind till his last hour, recognising me, pressing my hands without being able to speak and he drew his last breath like a child.

I am, Madame, your very humble servant,
Jenny Leguillou[21]

Postlude

B Y then Delacroix was already buried. On Monday, 17 August at noon the funeral occurred at the church of Saint-Germain-des-Prés. A company of the National Guard, to which he had belonged, escorted the cortège. The parish priest sang the Requiem Mass for this great doubter; and afterwards the procession moved off to the Père Lachaise, where, as custom dictated, four members of the Institute acted as pall-bearers. There was no representative of the city of Paris, of which he had been a councillor. The tepid official discourse of the academician Jouffroy and even the more kindly thoughts of the friendly landscapist Paul Huet were soon forgotten. It was the words of a little-known mourner, Charles Baudelaire, which would worthily celebrate the great man who was gone. With Baudelaire were Henri Fantin-Latour and Edouard Manet. In 1864 Fantin-Latour would try to express their feelings towards the dead man in his painting *Homage to Delacroix* – it was the year when the enormously successful posthumous sale showed how many people shared his enthusiasm. 1863, however, belonged to Manet, for his *Déjeuner sur l'herbe* would be the sensation of the Salon des Refusés. Artists were still thriving on notoriety.

With Delacroix Romantic painting in France died too. The future lay with the young men who took their easels out into the fresh air and painted the life of the boulevards of Haussmann's Paris and the places where they and their friends took their recreation rowing, swimming, fishing or just chatting up the pretty girls who were their models, mistresses and even, later, their wives. Almost alone among them Manet was haunted by the art of the past, by the art of the Renaissance and by Spanish art – as he showed in *Spanish Guitar Player*, which had so impressed Delacroix in the 1861 Salon – and by Delacroix himself, whose *Barque of Dante* he had gained the artist's permission to copy. One still younger artist, Renoir, would follow Delacroix to Algiers. But none of the young rebels knew the classics like Delacroix or had read Shakespeare, Goethe, Scott and

Byron and none of them, except the lonely Cézanne, gave any thought to religion.

The culture of Delacroix is an even greater barrier to his reputation now than it was in 1863. He would have been contemptuous of many twentieth-century movements in the arts, which have distorted the Romantic belief in the imagination for which he stood. Art has been so individualistic as to be incommunicable. His own art usually tells a forgotten story, his paintings have not fared well over the years and most of his greatest murals are seen only by experts. In his portraits, unfortunately only too few, and in his watercolour sketches and in his studies of flowers and scenery he becomes accessible. His diary deserves to be considered at least a minor classic; and the volumes of his letters confirm that many of his contemporaries, of great and little importance in the life of the age, were delighted to be in contact with him.

For all his charm and courtesy and concern, he was aloof. In his personal life he had gradually drawn away from people as work took the place of all other concerns in his life. Being occupied was for him an obsession. He had been determined to be a great painter and after many struggles and disappointments he had become one. In the 1820s he had been the leader of Romantic revolt in the visual arts, the protagonist of Liberty. In the time of the Liberal monarchy he moved on to dramatise the precarious struggle of civilisation to survive. In the Second Empire he had confronted the ultimate challenge: the fight against God.

His life's work, as René Huyghe, his profoundest modern critic, has insisted, was a solitary combat. In the end Delacroix was willing to sacrifice romantic love and even human companionship for the sake of his art. When he had kept a Journal in the 1820s, he revealed how he lived then on his nerves' ends. But in the Journal of his old age there is a sense of cool detachment that comes from his ruthless devotion to the cause. He was still interested in people and grateful for his frequently sociable life, for his visits to the theatre, to the opera and to fashionable salons, and still more glad of his excursions to the provinces to stay with relations. Solitude, however, suited both his ambitious plans as an artist and a critic and his melancholy temperament. That he did not in the end give way to despair was not exactly the result of his faith, for about the meaning of life he was not sure. It was the effect of his dogged courage, his resolve to persevere.

His single-mindedness often made him seem daunting to those who met him casually, like Baudelaire or Manet; and in his later life he did not keep on cordial terms with his oldest friends, like Pierret or Riesener. The price he paid was loneliness. Among the eminent dead, not far from his mother and *cher Chopin*, his tomb is granite.

Sources and References

ABBREVIATIONS

Oeuvres Litt.: Eugène Delacroix, *Oeuvres Littéraires*, 2 vols. ed. Élie Faure (Paris, 1923)

J: Eugène Delacroix, Journal, 1 vol., preface by Hubert Damisch, ed. André Joubin and Régis Labourette (Paris, 1981)

Corr. Gen.: Correspondance Générale d'Eugène Delacroix, 5 vols., ed. André Joubin (Paris, 1936)

L.I.: Eugène Delacroix, *Lettres Intimes, correspondance inédite*, publiée par Alfred Dupont (Paris, 1954)

Johnson Corr.: Eugène Delacroix, Further Correspondence 1817–1863, ed. Lee Johnson (Oxford, 1991)

Escholier (1): Raymond Escholier, Delacroix, peintre, graveur, ecrivain, 3 vols. (Paris, 1926, 1927, 1929)

Escholier (2): Raymond Escholier, Delacroix et les femmes (Paris, 1963)

Huyghe (1): René Huyghe, *Delacroix ou le Combat solitaire* (Paris, 1964)
 ibid. trans. Jonathan Griffin (Thames and Hudson, London, 1963)

J. J. Spector (1): The Death of Sardanapalus (London, 1974)

J. J. Spector (2): The murals of Eugène Delacroix at *Saint-Sulpice* (New York, 1967)

Johnson: Lee Johnson, The Paintings of Eugène Delacroix, 6 vols. (Oxford, 1981–89)

Huyghe (2): René Huyghe, *Delacroix ou le Combat solitaire* (Paris, 1990)

PRELUDE

1. McMullen, *Degas, his life, time and work* (London, 1985), p. 27
2. Redon, *A soi-même, Journal 1867–1915* (Paris, 1979): entry for 1878 (about 1859), pp. 180–82
3. Perruchot, *Cézanne* (London, 1961), p. 284
4. Wayne Andersen, *Gauguin's Paradise Lost* (London, 1972), p. 253
5. Wayne Andersen, *ibid.*, p. 105

CHAPTER 1

1. Goncourt Brothers, *Journals*, ed. R. Ricatte, Monaco 1956, t. 11, p. 80: 2 March 1876
2. *J*, pp. 23–24: 12 September 1822
3. *J*, p. 424: 22 May, 1854

CHAPTER 2

1. Duff Cooper, *Talleyrand* (London, 1932), p. 100
2. *J*, p. 79: 11 May, 1824
3. *Escholier (1)* I, p. 14
4. *Corr. Gen.* I, p. 4 (ed. Philippe Burty for details)
5. Dumas, *Mes mémoires*, chapter CCXX. p. 747
6. Philarète Chasles, *Mémoires*, t.I, pp. 329–330
7. *Corr. Gen.* I, p. 63

CHAPTER 3

1. Vigny, *Servitude et grandeur militaires* (Éditions Alpina, Paris, 1961), pp. 42–43
2. *J*, p. 50: 26 January, 1824
3. *J*, p. 633: 25 January, 1857

CHAPTER 4

1. *Corr. Gen.* I, pp. 27–28
2. *Corr. Gen.* I, p. 32
3. *Corr. Gen.* I, p. 33
4. *Johnson Corr.*, pp. 6–7 (italics)
5. *Corr. Gen.* I, pp. 11–12, 14–15
6. *Corr. Gen.* I, pp. 19–20
7. *Corr. Gen.* I, pp. 55–56
8. *L. I.*, p. 90
9. *Corr. Gen.* I, pp. 72–73
10. *L. I.*, p. 119
11. *L. I.*, p. 125
12. *Corr. Gen.* I, pp. 105
13. *Corr. Gen.* I, pp. 114–15, 116–17, 126–27, 128, 132, 133–34, 134–36
14. *Corr. Gen.* I, p. 140
15. *Corr. Gen.* V, pp. 6–7, 11–12, 16, 20, 21–22, 24, 25, 31, 32–34
16. *Corr. Gen.* V, pp. 35–36, 61, 63, 66, 66–69, 69, 76, 105, 95, 100, 107, 109, 111
17. *J.*, p. 26: 13 September, 1822; p. 34: 15 April, 1823

CHAPTER 5

1. *J.*, p. 19: 3 September 1822
2. *J.*, p. 21: 5 September 1822
3. *J.*, pp. 22–24: 7 September 1822
4. *J.*, pp. 26–27: 24 September 1822, 5 October, 1822
5. *Corr Gen.* I, p. 132
6. *J.*, p. 21: 5 September 1822
7. *J.*, p. 39: May 1823
8. *J.*, p. 46: 12 January, 1824
9. *J.*, p. 49: 25 January, 1824
10. *Corr. Gen.* IV, p. 60
11. *Johnson*, vol. I, p. 75
12. Stendhal, *Salon de 1824*, Mélanges d'art III: Peinture (Oeuvres Complètes, t. 47, Édito-Service, Geneva, 1972) p. 39
13. *J.*, p. 78: 7 May, 1824
14. *Corr. Gen.* I, pp. 144–45
15. *J.*, pp. 25–26: 13 September 1822
16. *J.*, p. 31: 15 October 1822
17. *J.*, p. 61: 7 April, 1824
18. *J.*, p. 84: 1 June, 1824
19. *J.*, p. 21: 5 September, 1822
20. *J.*, p. 41: 10 November, 1823
21. *J.*, p. 37: May, 1823
22. *J.*, p. 40: 9 June, 1823
23. *J.*, p. 88: 17 June 1824
24. *J.*, p. 36: 16 May, 1823
25. *J.*, p. 44: 30 December, 1823
26. *J.*, p. 50: 27 January, 1824
27. *J.*, p. 804: 9 October, 1862
28. *J.*, p. 30: 12 October, 1822
29. *J.*, p. 62: 7 April, 1824
30. *J.*, pp. 71–72: 26 April, 1824
31. *J.*, p. 44: 1 January, 1824

CHAPTER 6

1. *Corr. Gen.* I, p. 37
2. *Corr. Gen.* IV, p. 57
3. Stendhal, *Racine et Shakspeare*, chapter III (Oeuvres Complètes, t. 37, Edito-Service, Geneva, 1970), p. 39
4. *Corr. Gen.* I, p. 76

5. *L.I.*, p. 84
6. *J.*, p. 54: 3 March, 1824
7. *J.*, p. 64: 11 April, 1824
8. *J.*, p. 72: 26 April, 1824
9. *Corr. Gen.* I, pp. 154–155
10. *Corr. Gen.* I, pp. 158, 160, 162–3, 166, 168–69, 171, 166–67, 165, 166, 167, 164, 171
11. *J.*, p. 504: 24 March, 1855
12. *Oeuvres Litt.* II, p. 159
13. *Corr. Gen.* IV, pp. 286–89
14. *Corr. Gen.* I, p. 173
15. *Corr. Gen.* IV, pp. 287, 291–2
16. *J.*, p. 383: 20 November, 1853
17. *J.*, p. 428: 27 May, 1854
18. *Corr. Gen.* I, p. 253
19. Merimée, *Correspondance generale*, établie et annotée par Maurice Parturier. t. 1, p. 122
20. *J.*, p. 189: 5 April, 1849
21. *J.*, intro. p. 15
22. *Corr. Gen.* I, p. 160
23. Lewes, *Life of Goethe*, pp. 135–36
24. *Corr. Gen.* I, p. 240
25. Huyghe (1), p. 188
26. Estève, *Byron et le romantisme français*, pp. 195–96
27. *J.J. Spector (1)*, pp. 68–70
28. *J.J. Spector (1)*, p. 83
29. *J.*, p. 627: 25 January, 1857; p. 731: 3 September 1858
30. *Corr. Gen.* I, p. 198
31. *Corr. Gen.* I, p. 216

CHAPTER 7

1. T.E.B. Howarth, *Citizen King: The Life of Louis-Philippe, King of the French*, (London, 1961), p. 141
2. Hélène Toussaint, *La liberté guidant le peuple*, p. 6
3. *Johnson Corr.*, p. 17
4. *L.I.*, p. 191
5. Merimée, *op. cit.* t. I, p. 121

CHAPTER 8

1. *Corr. Gen.* I, pp. 302, 303–4
2. *J.*, pp. 145–46: 26 January, 1832

3. *Corr. Gen.* I, p. 307

4. *Corr. Gen.* I, p. 307

5. *J.*, pp. 156–57: 21 February, 1832

6. Arama, *Le Maroc de Delacroix*, pp. 155–58

7. *J.*, p. 93: 29 January, 1832

8. *Corr. Gen.* I, pp. 310–11

9. John H. Drummond-Hay, *Western Barbary*, p. 65

10. *J.*, pp. 153–54: 12 February, 1832

11. *Corr. Gen.* I, p. 310

12. *Corr. Gen.* I, pp. 316–17

13. *Corr. Gen.* I, pp. 319, 318

14. John H. Drummond Hay, op. cit., p. 5

15. *J.*, p. 101: 8 March, 1832

16. *Corr. Gen.* I, pp. 320–22

17. *Corr. Gen.* I, p. 322

18. *Corr. Gen.* I, p. 323

19. *J.*, p. 106: 22 March, 1832

20. *J.*, pp. 106–107: 23, 24, 30 March, 1832

21. *Corr. Gen.* I, pp. 325–26

22. *Corr. Gen.* I, pp. 327–28; 321

23. *J.*, p. 108: 7 April, 1832

24. *J.*, pp. 111–112: 28 April, 1832

25. Dumur, *Delacroix et le Maroc*, p. 84

26. *Corr. Gen.* I, pp. 331–32

27. *J.*, pp. 112–13: 18, 19 May, 1832

28. *J.*, pp. 113–15: 23, 25–28 May 1832

29. *Corr. Gen.* I, pp. 331–32

30. *Corr. Gen.* I, pp. 329–30

31. Dumur, *op. cit.*, pp. 108–15

32. *ibid.*, p. 111

33. *Corr. Gen.* I, p. 334

CHAPTER 9

1. *J.*, p. 248: 10 July, 1850

2. *Johnson Corr.*, pp. 14–15

3. *ibid.*, pp. 16–18

4. *ibid.*, pp. 21–22

5. *Corr. Gen.* I, p. 375

6. *Corr. Gen.* I, p. 377

7. *Corr. Gen.* I, pp. 375–76

8. *L.I.*, pp. 19, 190–91, 194, 197, 198–99, 200

9. *L.I.,* pp. 202–204, 207

10. *Corr. Gen.* II, pp. 246–57, 249–50

11. *Escholier* (1) II, p. 230

12. *J.,* pp. 479–80: 4 October, 1854

13. *J.,* p. 392: 14 December, 1853

14. *J.,* p. 432: 8 June, 1854

15. *J.,* p. 421: 9 May, 1854

16. *Escholier (1)* II, pp. 214–16

17. *ibid.,* pp. 220–21

18. *ibid.,* pp. 218–19

19. *ibid.,* p. 210

20. Baudelaire: *L'Oeuvre et la vie d'Eugène Delacroix, Pour Delacroix,* p. 188

21. Silvestre, *Histoire des Artistes Vivants,* p. 69

22. *Escholier (2),* appendice B, p. 227; *Johnson Corr.* pp. 30–33; *J.,* p. 786: 27 July, 1860

23. *Escholier (1),* II, p. 92

24. *Escholier (2),* appendice C, p. 231

25. *Oeuvres Litt. I,* pp. 9–22

CHAPTER 10

1. *Corr. Gen.,* vol. I, p. 368, 370

2. *Escholier (2),* appendice A, p. 209, 210

3. *ibid.,* appendice A, pp. 212, 217

4. *Corr. Gen.* II, p. 178

5. *Huyghe (1),* pp. 534–35

6. *ibid.,* p. 536

7. *Corr. Gen.* II, p. 306

CHAPTER 11

1. Dumas, *Mes mémoires,* pp. 426–27

2. Dumas, *ibid.,* pp. 774–76

3. Jaubert, *Souvenirs,* pp. 35–36

4. Gautier, *Histoire du Romantisme,* pp. 202–203

5. Baudelaire, *Salon de 1846: Pour Delacroix,* pp. 86, 96

6. Baudelaire, *Les Phares: ibid.,* p. 48; *Exposition Universelle de 1855: ibid,* p. 133

7. Baudelaire, *L'Oeuvre et la vie d'Eugène Delacroix, ibid.,* pp. 148, 153, 154, 172, 174, 177, 179, 191

8. *Oeuvres Litt.* I, p. 91

9. *ibid.,* pp. 111–12

10. Balzac, *La Rabouilleuse,* ed. P. Citron (Paris, 1966), pp. viii–xiii

11. *J.,* pp. 147–48: 3–7 April, 1847

CHAPTER 12

1. Thackeray, *Paris Sketch Book* (London, 1900): Versailles, p. 299
2. Sérullaz, *Peintures murales*, p. 27
3. *ibid.*, p. 41
4. *Corr. Gen.* II, pp. 237–238
5. Berlioz, *Correspondance*, ed. P. Citron, IV, p. 568
6. Stendhal, letter of 21 March, 1839 (*Correspondance*), t. III, Gallimard, Paris, 1968), p. 277

CHAPTER 13

1. William Murdoch, *Chopin, his life*, (London, 1934), p. 222
2. George Sand, *Correspondance* (ed. G. Lubin), IV pp. 407–08
3. *ibid.*, IV, pp. 428–39
4. *Corr. Gen.* II, pp. 20–22
5. George Sand, *op. cit.*, IV, p. 482
6. *Corr. Gen.* II, p. 33
7. *Corr. Gen.* II, p. 70
8. *Corr. Gen.* II, pp. 206–07
9. *Corr. Gen.* II, pp. 104–05
10. *Corr. Gen.* II, p. 108
11. *Corr. Gen.* II, p. 110
12. *Corr. Gen.* II, p. 112
13. *Corr. Gen.* II, pp. 113–14, 150, 153, 155
14. *Corr. Gen.* II, pp. 236, 246
15. *Corr. Gen.* II, p. 283
16. William Murdoch, *ibid.*, pp. 286–287
17. *Selected Correspondence of Fryderyk Chopin*, ed. and trans. Arthur Hedley (London, 1962), p. 265
18. *Corr. Gen.* II, p. 316
19. *ibid.*, pp. 291–92
20. *J.*, pp. 143, 146, 147–48, 161: 12, 31 March, 1, 3, 5 April, 20 July, 1847
21. *Corr. Gen.* II, pp. 321–22, 330–31, 332
22. *Selected Correspondence of Fryderyk Chopin*, ed. and trans. Arthur Hedley (London, 1962), p. 346
23. *Corr. Gen.* II, pp. 342–44
24. *J.*, p. 173: 29 January, 1849
25. *J.*, pp. 182, 183, 186: 5, 8, 30 March, 1849
26. *J.*, pp. 189–90, 191, 192, 194: 7, 14, 21 April, 1849
27. *J.*, p. 214: 20 October, 1849
28. *J.*, p. 260: 24 October, 1849

29. *Selected Correspondence of Fryderyk Chopin*, ed. and trans. Arthur Hedley (London, 1962), p. 374
30. *J.*, pp. 222, 245, 286, 271–75, 330, 702: 13 February, 7 July, 1850; 2 February, 1852; 28 February, 1851; 20 April, 1853; 30 November, 1857
31. *Corr. Gen.* IV, p. 227
32. *J.*, p. 518: 20 June, 1855
33. *J.*, pp. 386–87: 28 November, 1853
34. *Corr. Gen.* IV, p. 139: II, p. 412; IV, p. 213; IV, p. 229
35. *J.*, p. 808: 4 May, 1863
36. *Corr. Gen.* IV, p. 380
37. George Sand, *Histoire de ma vie* (Oeuvres autobiographiques, II (Paris, 1971), pp. 261–62

CHAPTER 14

1. *Corr. Gen.* II, p. 387
2. *Corr. Gen.* II, pp. 402–03
3. *Corr. Gen.* III, p. 46
4. *Corr. Gen.* III, p. 149
5. *Corr. Gen.* III, p. 167
6. *Corr. Gen.* III, p. 380
7. *Corr. Gen.* III, p. 417
8. *Corr. Gen.* IV, p. 3
9. *Corr. Gen.* IV, pp. 39–40
10. *Corr. Gen.* IV. p. 43
11. *J.*, pp. 119, 139, 146: 22 January, 3, 30 March, 1847
12. *Escholier (2)*, p. 220
13. *Corr. Gen.* IV, p. 379

CHAPTER 15

1. *Corr. Gen.* II, pp. 343–44, 350
2. *Corr. Gen.* II, pp. 323–25
3. *Corr. Gen.* II, pp. 362–63, 363
4. *Corr. Gen.* II, p. 356
5. *Corr. Gen.* II, p. 363
6. *Corr. Gen.* II, p. 364
7. *Corr. Gen.* II, p. 369
8. *J.*, p. 140: 6 March, 1847
9. *J.*, p. 175: 5 February, 1849
10. *Corr. Gen.* II, p. 391
11. *Corr. Gen.* III, p. 95

12. *Corr. Gen.* III, p. 100
13. *Corr. Gen.* III, pp. 101–3
14. *Corr. Gen.* III, pp. 130–31
15. *Corr. Gen.* III, p. 118
16. *Corr. Gen.* III, p. 132
17. *J.*, pp. 275–76: 29 April, 1851
18. *J.*, p. 281: 14 June, 1851
19. *J.*, p. 328: 16 April, 1853
20. *J.*, p. 529: 3 August, 1855
21. *J.*, pp. 327–28: 15 April, 1853
22. *J.*, pp. 328: 15 April, 1853
23. David H. Pinckney, *Napoleon and the Rebuilding of Paris* (Princeton, 1958), p. 3
24. *J.*, p. 392: 14 December, 1853
25. *Corr. Gen.* IV, pp. 157, 257–58 (cf. *Johnson Corr.* 132)
26. Gautier, *Les Beaux-Arts en Europe*, 2 vols. (Paris, 1855) (Patricia Mainardi, *Art and Politics of the Second Empire*, New York and London, 1987, p. 82)
27. Stanley Weintraub, *Victoria* (New York, 1987), p. 246
28. *J.*, p. 512: 7 June, 1855
29. *J.*, p. 528: 29 July, 1855
30. *J.*, pp. 514–16: 17 June, 1855
31. *J.*, p. 520: 29 June, 1855
32. *J.*, p. 532: 18 August, 1855
33. *J.*, p. 532: 23, 25 August, 1855
34. *J.*, p. 239: 18 May, 1850
35. *J.*, p. 597: 3, 6 November, 1856
36. *Corr. Gen.* III, pp. 354–59

CHAPTER 16

1. *J.*, p. 205: 2 October, 1849
2. *Corr. Gen.* III, pp. 36–37
3. *Corr. Gen.* III, pp. 196–97
4. *J.*, p. 295: 5 April, 1852
5. *J.*, pp. 393–94: 24 December, 1853
6. *J.*, p. 433: 15 June, 1854
7. *J.*, p. 435: 25 June, 1854
8. *J.*, p. 437: 30 June, 1854
9. *J.*, p. 447: 3 August, 1854
10. *J.*, p. 533: 30 August, 1855
11. *Johnson*, vol. 5, p. 178
12. *J.*, p. 590: 27 August, 1856
13. *J.*, p. 648: 17 March, 1857
14. *Corr. Gen.* II, p. 373

15. *J.*, pp. 702–03: 20 December, 1857
16. *J.*, p. 704: 28 December, 1857
17. *J.*, p. 732: 11 September, 1858
18. *J.*, pp. 777–78: 6, 7, 9 April, 1860
19. *J.*, p. 791: 25 November, 1860
20. *J.*, p. 796: 1 January, 1861
21. *Corr. Gen.* III, pp. 253–54, 257–58, 256–57, 255, 258, 259–60
22. *Corr. Gen.* III, p. 270
23. Baudelaire: *Salon de 1846, Pour Delacroix*, p. 87
24. *J.*, p. 287, 393: 7 February, 1852, 24 December, 1853
25. *J.*, p. 550: 4 October, 1855
26. *J.*, pp. 458–74: August & September, 1854
27. *Corr. Gen.* I, p. 8
28. *J.*, p. 808: 4 May, 1863
29. *J.*, pp. 423–25: 21, 22 May, 1854
30. *J.*, p. 464: 7 September, 1854
31. *J.*, p. 491: 2 November, 1854
32. *Corr. Gen.* IV, p. 213
33. *J.*, pp. 804–05: 12 October, 1862
34. *Corr. Gen.* IV, pp. 63–64
35. *J.J. Spector (2)*, p. 165
36. *Corr. Gen.* IV, p. 253

CHAPTER 17

1. *J.*, pp. 243–248: 6–11 July, 1850
2. *J.*, pp. 248–65: July–August 17, 1850
3. *J.*, pp. 539–48: 18 September–2 November, 1855
4. *J.*, pp. 672–75: 9 August 1857
5. *J.*, p. 308: 14 September, 1852
6. *J.*, pp. 458–60, 462, 467: 27, 30 August, 3, 8 September, 1854
7. *J.*, pp. 549–50; 551–52: 3, 4, 9 October 1855
8. *J.*, pp. 535–39: 10–17 September 1855
9. *J.*, pp. 593–94: 8 October, 1856
10. *Corr. Gen.* III, pp. 26–27, 295
11. *Corr. Gen.* III, pp. 68–69
12. *Corr. Gen.* III, pp. 311–12
13. *Corr. Gen.* III, pp. 316, 334, 339, 391, 396, 411–413; *Corr. Gen.* IV, p. 89
14. *Corr. Gen.* IV, p. 235
15. *J.*, p. 344: 29 May, 1855
16. *J.*, pp. 349–50: 21 May, 1853
17. *J.*, pp. 349–50: 21 May, 1853
18. *J.*, p. 416: 28 April, 1854

19. *J.*, pp. 349–50: 21 May, 1853
20. *J.*, p. 341: 9 May, 1853
21. *Oeuvres Litt.* II, p. 18
22. *Oeuvres Litt.* II, p. 48
23. *J.*, p. 480: 4 October, 1854
24. *J.*, p. 636: 4 February, 1857
25. *J.*, p. 585: 11 June, 1856
26. *J.*, p. 189: 6 April, 1849
27. *J.*, p. 279: 6 June, 1851
28. *J.*, p. 352: 29 May, 1853
29. *J.*, pp. 279–80: 6 June 1851
30. *J.*, p. 628: 25 January, 1857
31. *J.*, p. 707: 23 February, 1857
32. *J.*, p. 623: 25 January, 1857
33. *J.*, p. 709: 23 February, 1858
34. *Corr. Gen.* IV, pp. 93–94
35. *J.*, p. 234: 1 May, 1850
36. *J.*, pp. 162–63; 5 September, 1847
37. *Corr. Gen.* III, p. 265

CHAPTER 18

1. *Corr. Gen.* IV, p. 272
2. *Corr. Gen.* IV, pp. 250–51
3. *Corr. Gen.* IV, pp. 318, 328–29
4. *Corr. Gen.* IV, pp. 285–89
5. *Corr. Gen.* IV, pp. 303–05, 301
6. *Corr. Gen.* IV, p. 274
7. *Corr. Gen.* IV, pp. 338–341
8. *Corr. Gen.* IV, p. 311
9. *Corr. Gen.* IV, p. 292
10. *Corr. Gen.* IV, p. 298
11. *Corr. Gen.* IV, pp. 282–83, 346–47
12. *Corr. Gen.* IV, p. 376
13. *Corr. Gen.* IV, p. 377
14. *Corr. Gen.* IV, p. 378
15. *Corr. Gen.* IV, pp. 378–79
16. *Corr. Gen.* IV, p. 379
17. *Corr. Gen.* IV, p. 380
18. Sérullaz, *Delacroix* (Paris, 1989), pp. 453–58
19. *Corr. Gen.* IV, pp. 380–82
20. Théophile Sylvestre: *Eugène Delacroix, documents nouveaux*, pp. 63–64
21. *Corr. Gen.* IV, p. 382

Bibliography

SOURCES

Delacroix, Eugène, *Oeuvres littéraires*, 2 vols., ed. Elie Fauré (Paris, 1923)
– *Les Dangers de la cour, nouvelle inédite* (Avignon, 1960)
– *Journal*, 2nd edition, 3 vols., ed. André Joubin (Paris, 1932)
– *Journal*, 1 vol., preface by Hubert Damisch, ed. André Joubin and Regis Labourette (Paris, 1981)
– *Lettres de Eugène Delacroix*, 2nd edition, 2 vols., ed. Philippe Burty (Paris, 1880)
– *Correspondance générale d'Eugène Delacroix*, 5 vols. (Paris, 1936)
– *Eugène Delacroix, Lettres intimes, correspondance inédite*, (Paris, 1954)
– *Eugène Delacroix, Further Correspondence, 1817–1863*, ed. Lee Johnson (Oxford, 1991)
– *The Journal of Eugène Delacroix*, trans. by Walter Pach (London, 1938)
– *The Journal of Eugène Delacroix. A selection*, ed. with intro by Hubert Wellington, trans. by Lucy Norton (London, 1951)
– *Selected Letters, 1813–1863*. Selected and trans. by Jean Stewart, with an intro by John Russell (London, 1971)

GENERAL WORKS

ESCHOLIER, RAYMOND, *Delacroix, peintre, graveur, écrivain*, 3 vols. (Paris, 1926, 1927, 1929)
HUYGHE, RENÉ, *Delacroix ou Le Combat Solitaire* (Paris, 1964)
– *Delacroix*, trans. by Jonathan Griffin (London, 1963)
HUYGHE, RENÉ, *Delacroix ou le Combat solitaire* (Paris, 1990)
JOHNSON, LEE, *Delacroix* (London, 1963)
– *The Paintings of Eugène Delacroix*, 6 vols. (Oxford, 1981–9)
JULLIAN, PHILIPPE, *Delacroix* (Paris, 1963)
MOREAU-NELATON, ETIENNE, *Eugène Delacroix raconté par lui-même*, 2 vols. (Paris, 1916)

PRIDEAUX, TOM, *The World of Delacroix* (The Netherlands, 1966)
SÉRULLAZ, MAURICE, *Dessins de Delacroix*, 2 vols. (Paris, 1984)
SÉRULLAZ, MAURICE, *Delacroix* (Paris, 1989)
SIGNAC, PAUL, *D'Eugène Delacroix au Néo-Impressionisme* (Paris, 1899)
TOURNEUX, MAURICE, *Eugène Delacroix* (Paris, 1902)
TRAPP, FRANK A., *The Attainment of Delacroix* (Baltimore, 1970)

CHAPTER BY CHAPTER

Prelude
LUCIE-SMITH, EDWARD, *Fantin-Latour* (Oxford, 1977)
MCMULLEN, ROY, *Degas, his Life, Times and Work* (London, 1985)
REDON, ODILON, *A soi-même, Journal 1867–1915* (Paris, 1979)

Chapter 1
COOPER, DUFF, *Talleyrand* (London, 1932)
ORIEUX, JEAN, *Talleyrand* (Paris, 1970)
SCHAMA, SIMON, *Patriots and Liberators* (London and New York, 1977)

Chapter 2
BERGERON, LOUIS, *L'Episode napoléonien* (Paris, 1972)
HOLTMAN, ROBERT B., *Napoleonic Propaganda* (New York, 1969)
PALMER, R.R., *The School of the French Revolution: a documentary history of the College of Louis-le-Grand and its director, Jean-François Champagne* (Princeton, 1975)

Chapter 3
BROOKNER, ANITA, *David* (London and New York, 1980)
CLARK, KENNETH, *Romantic Rebellion* (London, 1973)
EITNER, LORENZ E.A., *Géricault, His Life and Work* (London, 1983)
HONOUR, HUGH, *Romanticism* (London, 1979)
HUYGHE, RENÉ, *Le relève de l'imaginaire* (Paris, 1974)
JARDIN, A. and TUDESQ, A.J., *La France des notables*, 2 vols. (Paris, 1973)
ROSENBLUM, ROBERT, and JANSON, H.W., *Art of the Nineteenth Century, Painting and Sculpture* (New York, 1984)

Chapter 4
ATHANASSOGLOU-KALLMYER, NINA M., *Eugène Delacroix, Prints, Politics and Satire (1814–1822)* (New Haven and London, 1991)
JOUBIN, ANDRÉ, 'Lettres d'Eugène Delacroix à sa soeur Henriette' *(Revue des deux mondes*, 1937)

Chapters 5–6
ATHANASSOGLOU-KALLMYER, M., *French images from the Greek War of Independence, 1821–1830* (New Haven and London, 1989)

ESTÈVE, ESMOND, *Byron et le romantisme français* (Paris, 1907)

HAMILTON, G.H., 'Eugène Delacroix and Lord Byron' *Gazette des Beaux-Arts* (1943)

– 'Eugène Delacroix, Byron and the English illustrators' *Gazette des Beaux-Arts* (1949)

INGAMALLS, JOHN, *Richard Parkes Bonington* (London, 1979)

KEMP, MARTIN, 'Scott and Delacroix, with some assistance from Hugo and Bonington', *Scott Bicentenary Essays* ed. Alan Bell (Edinburgh, 1973)

LEWES, G.H., *The Life and Works of Goethe* (London, 1855)

PARTRIDGE, E., *The French Romantics' knowledge of English literature, 1820–48* (Paris, 1924)

POINTON, MARCIA, *The Bonington Circle: English watercolours and Anglo-French landscape, 1790–1855* (Brighton, 1985)

RICHARDSON, JOANNA, *Stendhal* (London, 1974)

SHAKESPEARE, WILLIAM, *Hamlet, with sixteen lithographs by Eugène Delacroix*, with a new introduction by Michael Marqusee (New York, 1976)

SPECTOR, J.J., *The Death of Sardanapalus* (London, 1974)

WAKEFIELD, DAVID, *Stendhal and the Arts* (London, 1973)

The Complete Illustrations from Delacroix's 'Faust' and Manet's 'The Raven', ed. Breon Mitchell (Toronto and London, 1981)

Chapter 7

HOWARTH, T.E.B., *Citizen-King: The Life of Louis-Philippe, King of the French* (London, 1961)

PINCKNEY, DAVID H., *The French Revolution of 1830* (Princeton, 1972)

DE SAUVIGNY, G. BERTIER, *La revolution de 1830 en France* (Paris, 1970)

TOUSSAINT, HÉLÈNE, *La liberté guidant le peuple* (Paris, 1982)

WARNER, MARINA, *Monuments and Maidens* (London, 1987)

Chapter 8

ARAMA, MAURICE, *Le Maroc de Delacroix* (Paris, 1987)

CORNAULT, CHARLES, 'La Galerie Poirel au Musée de Nancy', *Courier de l'Art* (Paris, 1882)

DRUMMOND-HAY, JOHN H., *Western Barbary* (London, 1844)

DUMUR, GUY, *Delacroix et le Maroc* (Paris, 1988)

JULLIAN, PHILIPPE, *The Orientalists* (Oxford, 1977)

SAID, E.W., *Orientalism* (New York, 1978)

SÉRULLAZ, MAURICE, *Delacroix, aquarelles et dessins de Maroc* (Paris, 1951)

STEVENS, MARY ANNE, ed., *The Orientalists* (London, 1984)

TERRASSE, H., *Histoire du Maroc* (Casablanca, 1952)

Chapter 12

BRYSON, NORMAN, *Tradition and Desire: from David to Delacroix* (Cambridge, 1984)

BURY, J.P.T., and TOMBS, R.P., *Thiers* (London, 1986)

SÉRULLAZ, MAURICE, *Les peintures murales de Delacroix* (Paris, 1963)

Chapters 9–11, 13–14

BALZAC, HONORÉ DE, *La Rabouilleuse* ed. P. Citron (Paris, 1966)

BAUDELAIRE, CHARLES, *Pour Delacroix* (Paris, 1986)

BERLIOZ, HECTOR, *Correspondance Générale*, 4 vols. ed. P. Citron (Paris, 1954)

DU CAMP, MAXIME, *Souvenirs littéraires* (Paris, 1882–3)

CATE, CURTIS, *George Sand* (Boston, 1975)

CHASLES, PHILARÈTE, *Mémoires*, 2 volumes (Paris, 1876–77)

CHOPIN, F., *Selected correspondence of Fryderyk Chopin*, trans. A. Hedley (London, 1962)

DUMAS, ALEXANDRE, *Mes mémoires*, 1863 (Paris, 1986)

ESCHOLIER, RAYMOND, *Delacroix et les femmes* (Paris, 1963)

GAUTIER, THÉOPHILE, *Histoire du Romantisme: Eugène Delacroix* (Paris, 1870)

HEDLEY, ARTHUR, *Chopin* (London, 1947)

HORNER, LUCIE, *Baudelaire, critique de Delacroix* (Geneva, 1956)

JAUBERT, MADAME, *Souvenirs* (Paris, 1881)

JORDAN, RUTH, *George Sand* (London, 1976)

LACOMBE, CHARLES, *Vie de Berryer* (Paris, 1894–95)

MOSS, A., *Baudelaire et Delacroix* (Paris, 1973)

SAND, GEORGE, *Histoire de ma vie*, 2 vols. (Paris, 1971)

SILVESTRE, THÉOPHILE, *Histoire des Artistes Vivants* (Paris, 1855)

SITWELL, SACHEVERELL, *Liszt* (New York, 1967)

Chapter 15

AGULHON, MAURICE, *1848 ou l'apprentissage de la république* (Paris, 1973)

CLARK, T.J., *The absolute bourgeois: Artists and Politics in France, 1848–51* (London, new edition, 1982)

MAINARDI, PATRICIA, *Art and Politics of the Second Empire: The universal expositions of 1855 and 1867* (New Haven and London, 1989)

PINCKNEY, DAVID H., *Napoleon III and the Rebuilding of Paris* (Princeton, 1958)

PLESSIS, ALAIN, *De la fête impériale au mur des fédérés* (Paris, 1979)

WEINTRAUB, STANLEY, *Victoria* (New York, 1987)

Chapter 16

SPECTOR, J.J., *The murals of Eugène Delacroix at Saint-Sulpice* (New York, 1967)

WALLACE, TIMOTHY ALLEN, *The religious paintings of Delacroix* (London, 1983)

Chapter 17

LICHTENSTEIN, SARA, *Delacroix and Raphael* (New York, 1979)

MRAS, GEORGE P., *Eugène Delacroix's theory of art* (Princeton, 1966)

SAGNE, JEAN, *Delacroix et la photographie* (Paris, 1982)

Chapter 18

SILVESTRE, THÉOPHILE, *Eugène Delacroix, documents nouveaux* (Paris, 1864)

Index